W9-CZJ-388

Millet to Matisse

Vivien Hamilton

Millet to Matisse

*Nineteenth- and Twentieth-Century French Painting
from Kelvingrove Art Gallery, Glasgow*

VIVIEN HAMILTON

*With essays by Frances Fowle, Irene Maver, Mark O'Neill,
Hugh Stevenson with Rosemary Watt, and Belinda Thomson*

Yale University Press New Haven and London
in association with Glasgow Museums

This catalogue was first published on the occasion of the touring exhibition organized jointly by Glasgow Museums and the American Federation of Arts.

Exhibition Itinerary

The Speed Art Museum, Louisville, Kentucky
6 November 2002–2 February 2003

The Frick Art and Historical Center, Pittsburgh, Pennsylvania
26 February–25 May 2003

Joslyn Art Museum, Omaha, Nebraska
18 June–14 September 2003

Albuquerque Museum, Albuquerque, New Mexico
8 October 2003–4 January 2004

Musée du Québec, Québec City, Québec
29 January–2 May 2004

Kalamazoo Institute of Arts, Kalamazoo, Michigan
19 May–15 August 2004

Published by Yale University Press, New Haven and London, in association with Glasgow Museums

ISBN: 0 300 09780 8 cloth
 0 902 75265 0 paper

Cover picture: Front: Claude Monet, *Vétheuil*, 1880, Oil on canvas, Glasgow Museums: Art Gallery and Museum, Kelvingrove. Back: André Derain, *Blackfriars Bridge, London*, 1906, Oil on canvas, Glasgow Museums: Art Gallery and Museum, Kelvingrove.

Contents

PREFACE

The internationally renowned Kelvingrove Art Gallery, one of the eleven institutions that comprise Glasgow Museums, houses what is widely acknowledged to be the most important municipal collection in Great Britain. *Millet to Matisse* brings together sixty-four of the finest examples of nineteenth- and early twentieth-century French painting from this celebrated collection, providing both an illuminating overview of developments in French painting of the period and the opportunity to view paintings rarely seen outside Scotland.

This exhibition would not have been possible without the generous cooperation of the entire staff of Kelvingrove Art Gallery. First and foremost, I want to thank Bailie Elizabeth Cameron, Convenor of Cultural and Leisure Services Committee of Glasgow City Council, who persuaded the city to make this historic loan. I want also to recognize Mark O'Neill, Head of Museums and Galleries, for his willingness to share so many of the Gallery's treasures with an American audience and thank him for his guidance, tireless spirit, and good humor. It has been an honor to work with Vivien Hamilton, Curator of European Art, Glasgow Museums, and a preeminent scholar of nineteenth-century art. Miss Hamilton's extensive knowledge of the Kelvingrove collection adds new insights into French painting and the fascinating Glaswegians who brought to Scotland much of the then avant-garde work included in this exhibition. Her unfailing enthu-siasm and generous cooperation have made it a real pleasure to work with her. Thanks also go to Celine Blair, Senior Collections Manager, and Jeff Dunn, Assistant Collections Manager, who skillfully managed the many complicated aspects of mounting the exhibition and preparing the paintings for the tour.

At the AFA, this exhibition has been realized through the efforts of numerous staff members. Special appreciation is owed to Thomas Padon, Deputy Director for Exhibitions and Programs, who initiated the collaboration with Kelvingrove and oversaw all aspects of the exhibition's organization; and Kathryn Haw, Curator of Exhibitions, who handled the myriad details that went into bringing the project to fruition with consummate skill. We also thank Nelly Silagy Benedek, Director of Education; Kathleen Flynn, Director of Exhibition Administration; Karen Convertino, Registrar; and Nina Callaway, Media Representative.

We would also like to acknowledge the venues on the tour – The Speed Art Museum, The Frick Art and Historical Center, the Joslyn Art Museum, the Albuquerque Museum, the Musée du Québec, and the Kalamazoo Institute of Arts – with whom it has been a great privilege to work.

Julia Brown
Director
American Federation of Arts

ACKNOWLEDGEMENTS

One of the great joys of working in a museum is that any task – be it a change in display, the mounting of a temporary exhibition or the preparation of a catalogue – is only possible through teamwork. Each member of staff brings their own invaluable experience and ideas and so helps make both the process and the achievement of the task a truly rich and enjoyable one.

All my colleagues on the staff of Glasgow Museums have, in some measure, contributed to the preparation of this exhibition and publication. In particular I should like to thank the museum assistants and museum officers based in Kelvingrove Art Gallery. It is they who have coped admirably with a confused or frustrated public when favourite paintings are off display and who, with our invaluable voluntary guides – especially Peggy Moorhouse and Norman Walker – have also generously shared with me their own thoughts on the paintings and have enlightened me as to the views of the public.

I have been fortunate in having a dedicated project team and my sincere thanks go to: the staff of our Conservation Department who have prepared the works for loan, David Thomson, Polly Smith and Eddie Rose; and to the external contractors who have worked with them, Owen Davidson, Lorraine Maule and Brian McKernan; in Registration, Celine Blair and Jeff Dunn have made the difficult and crucial planning process painless, efficient and good-humoured. A vital part of the preparations for both the exhibition and the publication has been new photography: Maureen Kinnear's expert organizational skills and common sense have made easy what seemed logistically impossible; Alan Broadfoot printed the photographs, scanned the new materials and – a computer wizard – patiently explained what is achievable with new technology; while our highly efficient Photographic Librarian, Winnie Tyrrell, labelled and carefully filed the hundreds of new photographs and ordered all the comparative images. The museum's management team welcomed the project, generously supported it throughout and have been readily available with words of wisdom and encouragement; for this I thank Ellen McAdam, Special Services Manager, Darryl Mead, Senior Curator and Mark O'Neill, Head of Museums and Galleries.

My thanks also go to Belinda Thomson, Irene Maver, Hugh Stevenson and Frances Fowle for the essays they have contributed, which give a fascinating context within which to study Kelvingrove's paintings. Colleagues in The Burrell Collection read through all the texts making suggestions for improvement. For their patient and generous wisdom I thank Rosemary Watt, Pat Collins and Liz Hancock. My thanks too to Enda Ryan at the Mitchell Library in Glasgow who helped Irene Maver and me to select images from their magnificent archives and who made the ordering process so painless.

The summary catalogue entries have been in the process of being drafted for many years, and my thanks go to past curators who recorded details of exhibition history or of relevant publications, and who wrote to dealers requesting further information. More recently I have had the assistance of graduate students in compiling these painstaking lists: Jennifer Roe, Lesley Martin, and Katerina Grant. The difficult task of transferring this data on to computer was carefully and good-humouredly carried out by Sandra Gibbs. For timely secretarial assistance I also warmly thank Linda Simi.

It has been a great pleasure to work with the American Federation of Arts. Their professionalism, experience and enthusiasm have made this project a joy. From our first enthusiastic meeting with Thomas Padon, Deputy Director for Exhibitions and Programs, through to our now regular contact with Kathryn Haw, Curator of Exhibitions, Karen Convertino, Registrar, Nina Callaway, Media Representative and Nelly Silagy Benedek, Director of Education, we in Glasgow Museums have admired and appreciated their skill in steering us through the multi-venue exhibition process and for their evident care in making sure the exhibition is the best that it can be. In the planning stages of the publication I was fortunate to talk with Michaelyn Mitchell, Director, Publications and Design, who shared with me important and creative suggestions for the publication.

At Yale University Press, London, I have been grateful for the support and enthusiasm of the Director, John Nicoll and his assistant Liz Smith, and for the kindly patience of both the editor Christopher Fagg, and Beatrix McIntyre who designed the book and oversaw its production.

And finally, at home, I have the benefit of a much-needed support mechanism. My thanks to Mum, Anne and Ron for supplies of regular sustenance be it of the wise and understanding kind or just making sure that I eat; Grant and Claire for teaching me to see in new and joyful ways and for reminding me about keeping things in perspective; May and Anne for ensuring I have fresh air (but not fresh air shots) and exercise; and Raymond, as ever, for his love, encouragement and understanding.

Vivien Hamilton
Curator, European Art
Glasgow Museums

INTRODUCTION

When Americans and Canadians visit Glasgow they often feel strangely at home, experiencing an alluring mixture of novelty and nostalgia. This is in large part because Glasgow, with its four- and five-storey red sandstone houses and its grid-pattern streets is physically reminiscent of the historic heart of many North American cities. As the best-preserved Victorian city in Britain, Glasgow's physical character was defined at the same time as that of cities such as Boston, Baltimore and Chicago. There are also, however, underlying cultural similarities which give rise to that sense of being at home in somewhere new. Glasgow is the creation of the same forces which caused the cities of North America and Europe to blossom during the nineteenth century. The bourgeois civilisation that flourished across Europe and North America and dominated the world had an underlying unity, based on the wealth created by energetic individuals. Glasgow is an Atlantic seaboard city, and when the sea rather than air dictated travel routes, it faced west and looked to the Americas for its trading partners. The Glasgow economy was built originally on importing American tobacco (including tobacco from slave plantations), and exporting luxury goods to the colonists. The capitalist economy which emerged in the eighteenth century and burgeoned in the nineteenth made Glasgow a boomtown with patterns of growth comparable to those of contemporary American cities – its population grew from 77,000 in 1800 to over 1,000,000 by 1900. A defining part of European and North American culture at this time was the creativity and energy of the bourgeoisie. This was demonstrated in the new ways they generated wealth, and in their invention of new art forms and new ways of consuming art, new forms of identity, especially civic pride, and new ways of giving it expression in monumental public institutions.

The tour of paintings from Glasgow to the United States and Canada which is the occasion of this book is another episode in a larger historical story, which started in one of the most dynamic periods in human history. Between the American and French Revolutions in the late eighteenth century and the First World War, the world economy was transformed by technological innovation, free trade, imperial conquest and systems of credit. Amongst Glasgow's many contributions to this development was James Watt's modification of the steam engine, which transformed it from being an inefficient pump to being the engine of the industrial revolution. Watt's own model of his invention is on display in Kelvingrove, just a few galleries along from where the paintings illustrated in this book usually hang. From 1850 onwards, industrialisation in Scotland, and especially in Glasgow, generated a new class of exceptionally wealthy entrepreneurs in iron and steel, chemicals, ship-owning and textiles. These powerful, dynamic individuals, some of whose stories are told in this book, became great art collectors. They were also deeply proud Glaswegians and sought immortality for themselves by leaving their collections to their city.

While Britain was the political superpower of the age, for many Western people France had established itself as the home of high culture in all the arts, but especially in painting. It is difficult to explain why such an array of artists of supreme talent emerged at a specific time in history. It is clearer, however, that they flourished because they were part of the prevailing culture, which included the system of art dealers to distribute their work, the interest in purchasing art amongst newly wealthy individuals, the creation of civic collections and museums, and the bequeathing of collections to these institutions.

Though bourgeois culture, by definition, arises in cities, there were different attitudes to the new forms of urban living which were created in the nineteenth century. England was the first country in the world to industrialise, and the first to have more than 50 per cent of its population living in cities, but its culture was always ambivalent about the urban experience. Though the Glasgow wealthy classes, like their English counterparts, took up aristocratic pastimes and lifestyles – with country estates, villas in the Clyde Estuary, yachting and collecting art – Glasgow was unapologetically urban to a far greater extent than English cities, and far more like urban America. The classic English reactions against industrialisation – the Pre-Raphaelite, Arts and Crafts and Garden City movements – did not really take root in Scotland. Glasgow was the only city in the United Kingdom to have its own distinctive and original version of Art Nouveau during this period, linking it to Brussels, Barcelona, Vienna and Budapest, rather than to Birmingham or Manchester. It is therefore significant that Glasgow's greatest artist – Charles Rennie Mackintosh – was an architect pioneering this *Glasgow Style*. While his English counterparts held the ideal that materials had their own integrity and needed to be shaped by appropriate craft methods, Mackintosh looked to the national architecture of Scottish tradition, infusing it with an almost modernist simplicity, and employed flowing lines inspired by metal rather than wood-working techniques, and highly stylised portrayals of nature – especially his characteristic rose motif – to create the perfect architectural interior.

There are also of course significant cultural differences between Glasgow and North American cities. Amongst the greatest of these is the role the wealthy donors expected the public authorities to play. While in the United States wealthy individuals and the trusts and foundations they support continue to be the major funders of public art collections and to sit on their boards, Glasgow's entrepreneurs expected the civic authorities to fund and manage the institutions they created. Thus Kelvingrove was built largely by private

enterprise and public subscription, and then handed over to the Corporation to run. While the United Kingdom as a whole stands somewhere between the United States and Europe in the degree to which private enterprise and the state are expected to take responsibility for public institutions, Scotland in general and Glasgow in particular tend more towards the European and Canadian sense of community ownership than England. This sense of shared ownership is part of an intense local identity – the Glasgow expression to describe being a native of the city is 'I belong to Glasgow'. 'Ordinary' Glaswegians are universally proud of their museums, and the city has a unique tradition of local visitation. The eleven civic museums – all of which have free entry – receive over two million visits a year from a population in the greater Glasgow area of 1.2 million. Another million visits are made by tourists.

In the period of history covered by Irene Maver's essay Glasgow was a city of global importance, dominating the world markets in building ships and locomotives. With the passing of the iron and steam phase of the industrial revolution Glasgow no longer held such an exalted place in the world economy. At the same time large firms run by wealthy individuals gave way to multinational corporations owned by shareholders, often with headquarters overseas. During the 1960s and 1970s, like many American cities, Glasgow went through a painful period of de-industrialisation, and today less than 14 per cent of its workforce is involved in manufacturing. Since the early 1980s Glasgow has achieved a remarkable revival in its fortunes. The first major step in this revival was the building of a museum, in 1983, to house the collection donated to the city by Sir William Burrell in 1944. It is difficult today, when art museums are a standard part of the urban regenerator's armoury, to imagine the courage this step involved: one of the poorest cities in Europe was investing £22 million in a new art museum, and committing the revenue to sustain it. The authorities con-

sciously aimed to change the perception of Glasgow as a rust-belt city, and laid the foundations for a new appreciation of the city's amazing legacy of architecture and art. In 1990 this rebranding and reappraisal was reinforced when Glasgow, against all the odds, won the accolade of European City of Culture. Glasgow is now the third most visited tourist destination in the UK, and is second only to London as a shopping destination. It is a major centre for financial services, design, film production, software and international conferences.

While Glasgow's art museums continue to be managed by the City Council, there is a revival of the nineteenth-century partnership with wealthy entrepreneurs and of the tradition of gifts to the civic collection. Amongst the works in a recent gift from Lady Fraser of Allander, from the collection of the late Lord Fraser, (Glasgow-born founder of a shopping empire, which originally included Harrods), are paintings by Boudin, Sisley and Renoir. This tour is possible because Kelvingrove is to be closed for two and a half years for a major refurbishment. The Trust established to raise funds for this massive project is chaired by Lord Norman Macfarlane of Bearsden and the Trustees include some of the leading business men and women in the UK, all of them with a strong affinity for Glasgow, and all of them committed to continuing the tradition of nineteenth-century philanthropy which created the legacy which Kelvingrove represents to generations of Glaswegians and visitors to the city.

We hope that American and Canadian visitors to the museums hosting our paintings will both enjoy the works for themselves and appreciate something of the energy of Glasgow and its cultural affinities with and differences from their own civic cultures.

Mark O'Neill
Head of Museums
16 April 2002

FRENCH PAINTING 1830–1930: AN HISTORICAL CONTEXT

Introduction

The collection of French painting housed in Kelvingrove Art Gallery gives a fascinating and valuable overview of the major styles and the prevailing genres that characterise the history of art in France from the mid-nineteenth to the early twentieth centuries. The chronological span of the paintings in the exhibition is a century, from approximately 1830 to 1930, and it includes landscapes, townscapes, seascapes, portraits, interiors and still-lifes. Certain examples among Glasgow's holdings, the portraits by Van Gogh and Matisse, for instance, or the landscapes by Seurat and Derain, played their part in shaping that history at key moments of stylistic change. Painters such as these consciously flouted convention and questioned tradition. They formed a chain of innovation which runs through the nineteenth and into the twentieth century, linking the names of Delacroix, Corot, Courbet, Manet and Monet to those of Cézanne, Van Gogh, Gauguin, Picasso and Matisse. It is a testimony to the richness of Glasgow's collection that works by all of these men, with the exception of Manet, can be found there, supported by paintings by many equally interesting but sometimes overlooked figures with substantial reputations in their own day. However, as the big names are often represented by a single painting or by relatively unfamiliar works, it is necessarily a somewhat oblique view of French art that the Glasgow collection offers. This brief historical and contextual essay aims to draw attention to the highlights of the collection and set it in a broader perspective.

France in the Nineteenth Century and Its Dominant Artistic Styles

Prior to the revolution of 1789, standards in French art had been set and maintained by the Académie Royale des Beaux-Arts whose members and students regularly offered up their work for public scrutiny at the Salon. This public exhibition was held in Paris, usually in April or May, biennially at first, then annually. Throughout the nineteenth century the Salon was such a vast display and so well entrenched in the Parisian calendar that other exhibitions were often timed to coincide with it. The system offered the young artist a clear set of stages in building a career, and a goal to work towards; through its complex hierarchy of awards and critical attention the Salon was for most the surest route to achieving commissions and public acclaim. However as the century advanced, increasing numbers of 'difficult' artists, not readily accepted by the Salon jury, found they could make their names outside the system. This encouraged rebellious young artists to cir-

cumvent the Salon by exhibiting independently. Whereas dissatisfaction with the official system had led to the occasional staging of a Salon des Refusés (famously in 1863 for example), France saw the establishment, in 1884 and 1890 respectively, of two alternative exhibitions – the Salon des Indépendants and the Salon de la Société Nationale des Beaux-Arts.

With the diversification of old exhibiting patterns came a relaxation of the old standards and hierarchies. Hitherto, art's purposes and status had been clearly defined within a distinct hierarchy. History painting – morally uplifting allegorical or biblical subjects involving heroic figures – was placed at the pinnacle of artistic achievement, still-life at the bottom, with portraiture, landscape and genre scenes placed on a descending scale between. But by the mid-nineteenth century the traditional heroic themes from the Bible, classical literature and history were increasingly replaced by anecdotal episodes from history and more ordinary themes from daily life; such realist themes, understandable by all, were judged to be better adapted to the modern democratic age. With the gradual acceptance from the 1850s onwards of less elevated subjects, the ground was prepared for the radicalism represented by the works of Manet and the Impressionists, who produced in the 1860s and 1870s some of the most daring, light-filled and fresh landscapes and modern figure subjects France had yet seen. The more traditional forms of art sanctioned by the French Académie were judged by many to have been definitively overthrown, rather as the system of monarchy had been overthrown by the forces of political progress.

The nineteenth century in France, as in the rest of Europe, was a period of intense social change, but in France's case it was also a period of political instability caused by the aftershocks of the Revolution of 1789. In 1800, having just overthrown the monarchy – Louis XVI was executed in 1793 – to the horror of the other crowned heads of Europe, France found herself in a state of isolation surrounded by hostile neighbours. Ever greater powers were granted to Napoleon Bonaparte as he undertook to defend the new Republic on the battlefield and bolster it with far-reaching internal reforms. By 1900, although a state of brooding conflict still characterised relations with Germany, France was seeking to reconcile her former enemies among the great European powers, Russia on the one hand and Britain on the other. In the interim France's system of government had ricocheted from the Napoleonic Empire to a restoration of the Bourbon monarchy, followed by an Orléanist monarchy with powers curbed by constitutional reform. From the short-lived second Republic (1848–51) emerged a reinstated Empire under Napoleon III. This in turn foundered in 1870 when France suffered a devastating defeat to the superior military powers of Prussia, and Napoleon's Empire ended in ignominious surrender. The ensuing internal

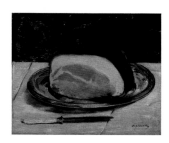

1. Edouard Manet, (1832–83)
The Ham, 1880
Oil on canvas, 32 × 42cm
Glasgow Museums: The
Burrell Collection

confusion led in early 1871 to the establishment of the Commune in Paris, where revolutionary fervour had once again erupted, but after only a few months it was bloodily quashed by the forces of the newly constituted Republican government. Thus the French nation's sense of itself underwent dramatic highs and lows, international humiliation in the wake of international triumph. Successive governments were reminded of the destructive power the mob possessed once unleashed, if grievances were allowed to ferment.

From the point of view of art, things would never again be the same as they had been under the Bourbons. Contempt for the extravagant decorative styles associated with the *ancien régime* in part account-ed, in the early years of the century, for the determina-tion to adhere to an extremely sober and rigid form of Neo-Classicism. Although Neo-Classicism had an impact throughout Europe, it was deemed to be espe-cially applicable to the newly enfranchised Republican citizens of France and was associated there with the studio of Jacques-Louis David, himself one of the key players during the revolutionary Terror. The influence of David's pupils lasted well into the middle of the cen-tury. The power of the nobility and the church, hither-to the major patrons of the arts, was significantly diminished. Hence both the frivolous decorative and the more serious devotional tasks traditionally allotted to painters fell away; although religious commissions did not dry up, the responsibility for their commission-ing passed to the state. In the wake of the restoration of the monarchy in 1814 came the Romantic reaction. It was once again permissable for the imagination to roam unfettered, colour was restored to the palette and pop-ular episodes from France's own medieval past were revisited by artists who hitherto had felt obliged end-lessly to rehash classical antiquity. This in turn led writers and artists, Delacroix and Ingres among them, to explore the possibilities for exoticism opening up with France's colonial expansion. Romanticism and Orientalism were countered in mid-century by Realism, a call to artists to defer to the robust and solid facts offered by nature rather than to continue to indulge their fantasies. The humble genres of still-life, landscape and peasant painting burgeoned under the Realist banner. In the 1870s Realism evolved into its extreme and refined variant – Impressionism – whose exponents specialised in the depiction of select aspects of modern reality, fleeting weather and light effects, scenes of suburban and urban leisure. And in the 1880s, French art underwent perhaps its most pro-found disjunction with the past. Seeing no way to build on Impressionism, a number of avant-garde artists pro-claimed the right to depart from the notion of record-ing what they could see and upheld the legitimacy of subjective distortion and arbitrary colour use as means of expressing subjective emotion and decorative beau-ty. So began the disjointed movement that would retro-spectively earn itself the name Post-Impressionism. The twentieth century ushered in Fauvism, with its emphasis on expressive colour, and then Cubism with its insistence on shifting, multiple viewpoints and structural complexity. The painters associated with the new movements, emancipated from their old recording

function, were becoming ever bolder in their willing-ness to manipulate reality for expressive effect.

Many attempts have been made to explain why the 'latter half of the French nineteenth century was one of the supreme moments of world-painting', as Osbert Sitwell put it in 1925, 'Never was there such an out-burst of exuberant fertility, never were there gifts of such immense variety.'[1] Probably the key aesthetic dis-junction with the past came with the acceptance of the doctrine of 'Art for Art's sake'. The new art of Manet and the Impressionists was deemed to exist for its own sake alone, and seemed to proclaim no other belief than in the supremacy of nature, articulated through light and colour. Upending the old hierarchy of genres, Manet could claim as much kudos for his ability to paint an asparagus stalk, a loaf of bread or a piece of ham (ill.1) as for his skill in rendering the human form. And rather than in the classics, he found his heroes among the down-and-outs of modern urban life as can be seen in *The Old Musician*, 1862 (National Gallery of Art, Washington). Henceforth, thanks to the gust of fresh air which the Impressionist revolution represented, French artists were judged to be no longer beholden to the past but free to paint how and what they chose.

Of course such a generalized account of stylistic change over-simplifies the story. The reverence for tra-dition, even a certain respect for the hierarchy of the genres, persisted into the twentieth century. Nor was the advent of Impressionism such an extreme revolu-tion. French art, despite its centralized organisation and respect for tradition and continuity, had always made room for original artistic contributions. In the eigh-teenth century, supremely talented artists like Watteau and Chardin had not been shunned but accommodated and even revered, despite the fact that their works had in a sense broken the rules, Watteau by his insistence on modesty of scale and delicacy of sentiment for scenes of courtly dalliance, Chardin by his treating humble kitchen utensils with the grandeur of a portrait. Under the *ancien régime* a disjunction had already emerged between what appealed to private taste and the kinds of art that were sanctioned by the public authorities.

Highlights of the Kelvingrove Collection

In the broadest sense the shift in emphasis from public to private taste can be observed in the collection of French paintings in Glasgow. The collection's strengths lie in the area of landscape, particularly landscape of the realist variety associated with the Barbizon school. The undated *Landscape with Cottages* (cat.38) by Georges Michel, one of the first artists to act on his belief that France was just as paintable as Italy, is a powerful asser-tion of the nineteenth-century's reverence for nature. His dramatic treatment of the flat panorama just north of Montmartre under a lowering sky recalls the great Dutch landscapists of the seventeenth century, not least Rembrandt. Irrespective of its modest scale, the haunting painting of rural labour by Jean-François Millet, *Going to Work*, 1850–51 (cat.39) is widely

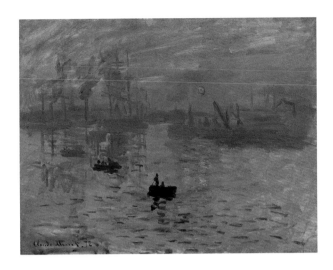

considered a masterpiece. And Millet's seminal importance as a painter of peasants is reinforced by the presence in the collection of works by artists who built on his reputation, Jules Breton, Léon Lhermitte and Jules Bastien-Lepage. Although there are two remarkable paintings by Cézanne from the 1870s, coverage is otherwise lacking of the typical Impressionist landscapes of that brilliant decade which witnessed the first Impressionist exhibitions. In 1874 audiences were confronted for the first time by works such as Claude Monet's *Impression – Sunrise*, 1872 (ill.2), Pissarro's *Orchard in Bloom*, 1872 (National Gallery of Art, Washington) and Sisley's *The Ferry of the Ile de la Loge – Flood*, 1872 (Ny Carlsberg Glyptotek, Copenhagen). These brightly hued informal compositions, celebratory of the moment and devoid of landscape's traditional narrative or romantic associations, forced the public and critics to rethink their approach to the contemplation of nature. At the same time, figure painting was also being reinvented by artists such as Renoir (ill.3) and Edgar Degas. Happily a surprising number of the protagonists of that first Impressionist show, and of the subsequent seven Impressionist exhibitions, are represented in Glasgow. There are fine works from the 1880s and 1890s by Monet, Pissarro, Guillaumin and Sisley. Glasgow can also boast an exceptional work by Mary Cassatt, *The Young Girls*, c.1885 (cat.10), and a lesser work by Gauguin, both of whom exhibited with the Impressionists from the late 1870s onwards. It has a remarkable group of oil studies by Georges Seurat, drawn from the elaborate preparatory work that led to his extraordinarily ambitious painting *Bathers at Asnières*, 1884 (cat.51.1).

The rejection of this major canvas by the Salon jury marked a turning point in Seurat's career, enforcing the break from his academic training and decision to steer a more independent course. Instead Seurat showed *Bathers at Asnières* at the first Salon des Indépendants in 1884. Invited by Pissarro to show with the Impressionists in 1886, it was Seurat's dominance of that exhibition that in essence brought to an end the Impressionists' period of close-knit group endeavour and launched Neo-Impressionism. At the centre of a group of landscapes Seurat showed his enormous *A Sunday Afternoon on the Island of La Grande Jatte, 1884*, 1884–86 (ill.4), an ordinary scene of suburban

leisure transformed by the artist's synthetic vision, enlarged to the scale of history painting and repainted in his newly devised dotting technique. This was intended to break down light to its constituent elements and capture its luminosity in a scientific way. In the absence of an example of a later Seurat marine such as *Port-en-Bessin, The Bridge and the Quays*, 1888 (Minneapolis Institute of Art) for instance, Glasgow has Signac's atmospheric *Sunset, Herblay, Opus 206* (cat.55) to represent mature Neo-Impressionism. Intriguingly Signac's painting takes a Monet motif and recasts it in the precise and patient dotting manner.

Glasgow has a strong group of paintings by other artists whose techniques were immediately influenced by the Impressionist revolution. The two canvases by the Dutch artist Van Gogh, for instance, both painted during his brief stay in Paris between 1886–88, reveal his rapid assimilation of modern French techniques. The Montmartre view (cat.27) shows an awareness of Impressionism in the bright palette and important sky, while the *Portrait of Alexander Reid* (cat.28), in the broken application of colour and insistent play on complementaries, shows awareness of the Divisionist theories of Seurat, Signac and the so-called pointillistes.

It was their robustness of colour and solidity of structure that made Cézanne's works so strikingly different from those of his contemporaries in the late 1870s and 1880s. If Cézanne's influence is not yet discernible in the early landscape by Gauguin, it is clearly detectable in the robust, highly simplified Breton landscape by Bernard. In *Ostre Anlaeg Park, Copenhagen*, 1885 (cat.26), Gauguin was still painting in an Impressionistic manner indebted to his master Pissarro with close-toned colouring and a dense weave of brushstrokes. By the same token the profoundly innovative techniques and palette of France's prime landscapist Claude Monet, whether one thinks of his beach scenes of 1867–70 or of his cliff and river views of 1880–90, find echoes in the works here by Moret, Friesz, Derain and Dufy. Indeed the Post-Impressionist phase is exceptionally well represented by early and late examples of Pointillism and by samples of the flat raucous colour which typified the work of the Fauves in the mid 1900s.

In addition to works marking stylistic shifts, there are some remarkable clusters of paintings by individual masters – Corot, Fantin-Latour and Vuillard – who are often sidelined in more mainstream historical surveys. None was an overtly revolutionary figure but each was

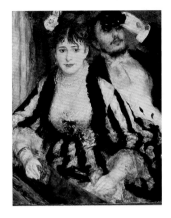

2. Claude Monet (1840–1926)
Impression – Sunrise, 1872
Oil on canvas, 48 × 63cm
Musée Marmottan, Paris

3. Auguste Renoir, (1841–1919)
The Loge, 1874
Oil on canvas, 80 × 63.5cm
Courtauld Institute Galleries, London

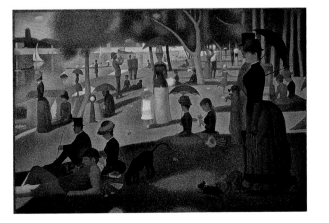

4. Georges Seurat (1859–91)
A Sunday Afternoon on the Island of La Grande Jatte 1884
1884–86
Oil on canvas, 207 × 308cm
Art Institute of Chicago

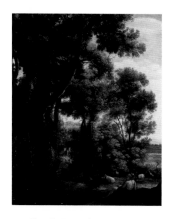

5. Claude Lorrain (1600–82)
Landscape with a Goatherd and Goats, c.1636–37
Oil on canvas, 52 × 41cm
National Gallery, London

responsible for discreetly changing the genres he made his own, establishing new approaches to form or techniques of applying colour. Such concentrations allow the viewer to gain a deeper understanding of these artists' special qualities. Each, in his work, could be said to combine poetic insight with observational skill and conscientious method, a blend that can perhaps be seen as distinctively French, one that epitomises the continuity within French art. Continuity as well as innovation is a feature of the Kelvingrove collection. We see evidence of the persistence of that humble individualist French tradition – Chardin living on, so to speak – in the cluster of still-lifes by Bonvin, Fantin-Latour, Cézanne and Braque. In a way too, the decorative values of the eighteenth-century Rococo live on in Renoir's feathery late landscape, decorative portrait and exquisite still-life with its porcelain surface.

How Representative Is the Collection?

As Frances Fowle's essay explains, the French paintings at Kelvingrove arrived there in the main thanks to gifts and bequests supplemented by a few judicious museum purchases. As a consequence they tend to be relatively small-scale, domestic works which tell us more about the activities of dealers in French art for export and the private tastes of individual collectors in Scotland than about official taste in nineteenth-century France. The range and adventurousness of the collection pays tribute to the salient role played around the turn of the century by the Glasgow dealer Alexander Reid, a passionate ambassador for modern French painting. How fitting that the galleries should have raised the substantial sum necessary to acquire his striking portrait by Van Gogh when it came on the market. A few of the works in the collection played a more public role and some featured at the Paris Salon – notably the early Pissarro landscape and the Corot *Pastorale* (cat.15). Taken together with Bastien-Lepage's *Poor Fauvette* (cat.1), a genre painting typical in terms of scale and finish of the works he showed regularly at the Salon, these three canvases allow us to chart some changing norms of French landscape practice and its critical reception from the 1860s through to the 1880s.

Pissarro's early riverscape was almost certainly exhibited as *The Banks of the Marne* (cat.44) at the Salon of 1864. It reveals the ambitious scale and density of handling expected of a Salon landscape, if not the typical degree of incident or historical interest. Pissarro had learned to execute such powerful, simplified compositions by studying the works of Courbet and, like Courbet, being politically out of step with orthodox taste and fired by radical ambitions, he was soon to make his mark through independent exhibitions, re-emerging in the 1870s at the centre of the Impressionist group. Although the painting was not singled out for critical comment, two years later in his Salon review Emile Zola was to hail Pissarro for his obstinate refusal to pander to popular taste, for his 'bleak and strong will' and 'extreme concern for the truth.'[2] It was apt that the future master of the

Naturalist novel should have been drawn to such unorthodox, uncompromising qualities.

Corot's even larger *Pastorale*, a clear reminiscence of the contemplative bucolic landscapes of Claude Lorrain (ill.5), was the subject of intense critical interest when it was shown at the Salon of 1873. Unlike the Pissarro, it represented the persistence of a retrograde, nostalgic vein in French landscape. For the critic Jules Claretie, the elderly Corot, for all his prodigiously poetic touch, deserved censure for painting such 'anaemic nymphs' and producing such a 'vague, almost indistinguishable and blurred picture,'[3] nothing more than a sketch. Tellingly, charges of lack of finish would be heaped at the door of the Impressionists only a year later. Taste had moved on again by the following decade, and favoured a greater poignancy and naturalism in the treatment of rural life. In April 1882 when the Impressionists' seventh exhibition was in progress featuring, among other works, Pissarro's *The Shepherdess*, 1881 (ill.6), Bastien-Lepage's *Le Père Jacques*, 1881 (Milwaukee Art Center) was showing at the Salon and his *Poor Fauvette* in London. The latter, a touching rural scene featuring a winsome child dressed in ragged attire tending a cow in a drab but finely detailed landscape, typifies the naturalist style Bastien-Lepage had very much established as his own. Part of the Glasgow collection since 1913, it was the first French nineteenth-century painting to be purchased by the gallery, a status which testifies to the enormous ascendancy this artist had gained during his short career, notably in Great Britain. It is no coincidence that the galleries of Edinburgh and Glasgow each bought a Bastien-Lepage in 1913 and Aberdeen another in 1927 (all of which had at one time belonged to the Scottish collector Staats-Forbes). Other French artists were arguably as successful on Britain's shores as at home – Fantin-Latour, Lhermitte, Monticelli and Boudin.

If the collection of French painting in Glasgow is compared with the range of nineteenth-century painting on show in a French municipal gallery of similar size (Lille or Nantes for example), one is more forcibly struck by its bias in favour of landscape and still-life and against figurative painting. There is a notable absence of paintings involving the nude, despite the fact that the nude was ubiquitous in French Salon painting of the period. Similarly there is a dearth of serious historical subjects and no examples of paintings by such key names as Henner, Gérôme, Laurens, Cabanel or Bouguereau. Examples of the anecdotal military and orientalist paintings which were highly popular genres in nineteenth-century France are to be found in Glasgow's permanent collections, although they have been omitted from this selection. Although the move in taste away from history painting was a tangible contemporary phenomenon, it is exaggerated in Glasgow, where the nearest we get to the high-art style associated with such painting is Jules Breton's impressive painting of a perennial agricultural subject, *The Reapers* (cat.8), which the gallery acquired in the 1980s. In fact the collection's range and lacunae bear a marked similarity to certain collections formed over the same period in North America. The Walters Museum in Baltimore for instance was formed at much the same

6. Camille Pissarro (1830–1903)
The Shepherdess, 1881
Oil on canvas, 81 × 64.7cm
Musée d'Orsay, Paris

period by a wealthy private collector and includes clusters of works by several of the same artists, notably the bias towards the later rather than the earlier Corot and towards the Barbizon painters. To some degree such collecting patterns should be seen as reflecting the taste of the Protestant, Anglo-Saxon industrial bourgeoisie.

Art for a Bourgeois Audience

The dominant social class in France throughout the nineteenth century was the bourgeoisie (usually translated as 'middle classes' but the term also has the connotation of 'town dweller'), although in general prosperity was more widely distributed across the social scale than before, bolstered by the country's agrarian wealth. Compared with her neighbours, France experienced a relatively slow rate of industrialisation, mainly concentrated in the north, and the growth of Paris, although phenomenal, proceeded with greater attention to city planning. Set against this steady urbanisation and the repeated eruptions of rebellion in the capital (1830, 1848, 1871), the spectacle of French rural life, where certain continuities could be relied upon, assumed greater importance. After all, not long before their establishment as prosperous city dwellers, many of the bourgeois who constituted the new art collectors had lived close to the land themselves. Small wonder that the landscape genre and peasant subjects enjoyed such favour.

Figures in landscape settings were an important theme in French nineteenth-century painting. Early on there was a fashion for picturesque Italian peasants in colourful costume, but from the mid-century French painters were increasingly turning their attention to their home-grown peasants – whose costumes (particularly those of the Bretons) could be equally picturesque and quaint. Corot's *Mademoiselle de Foudras* (cat.14), although not seeming to fit this category, is similar to his earlier Leonardesque studies of young Italian peasants whom he habitually represented in thoughtful, melancholic poses. Rather than in the height of fashion Mlle de Foudras is dressed in somewhat bizarre and fanciful garb, her dark hair threaded with wild flowers and leaves, perhaps in evocation of Flora.

Two artists in particular were responsible for elevating the theme of the working figure in the landscape, equating the peasantry with the gods and heroes of old – Gustave Courbet and Jean-François Millet. The way in which they conceived their works and the public reactions they provoked were intimately linked to the politics of the day. For in 1848–50 when Courbet first showed his life-size paintings of rough-looking rural figures seated around a table, of stonebreakers engaged in a thankless, repetitive and back-breaking task, or none too dignified mourners at a village burial, France was undergoing the 1848 revolution and its aftermath. Millet appealed to art lovers more readily than Courbet, not least in Britain. Where Courbet's self-important and comical *Peasants of Flagey returning from the Fair*, 1850 (Musée des Beaux-Arts, Besançon), seemed a calculated insult to bourgeois sensibilities, Millet's pastoral canvases seemed to offer a more time-

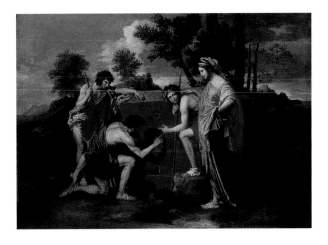

7. Nicolas Poussin (1594–1665)
The Arcadian Shepherds
c.1638–40
Oil on canvas, 85 × 121cm
Musée du Louvre, Paris

less and dignified vision. His oeuvre as a whole was seen as a welcome corrective to the worrying commitment to 'Art for Art's sake' that increasingly characterised advanced French art and was so alien to the Anglo-Saxon way of thinking. For Alice Corkran, writing in 1889, Millet was 'the painter of pictures suggestive of moral issues, and which are no less perfect as renderings of nature's moods. His perpetual theme is the moving drama of poverty and toil; of spiritual beings struggling with the harshness of material circumstances.'[4] These words apply well to the noble, archetypal quality of the striding couple in *Going to Work* (cat.39), which has been in the Glasgow collection since 1905.

Jules Breton's *The Reapers* (cat.8) offers an interesting parallel to the somewhat later rural subjects by Lhermitte and Bastien-Lepage. For one sees in all three, behind the seemingly humble peasant subject and the artist's identification with his local setting, evidence of the academic system of teaching. Breton's painting is characterised by the noble poses and elegant groupings of the figures and a classical frieze-like compositional arrangement. Chiaroscuro is deployed with confidence and it is clear that the artist approached his work carefully, making preparatory drawings of each figure from life, probably in the studio, and calculating their harmonious poses. The overall effect is a conscious reworking, even down to the details of costume, of the history paintings of Nicolas Poussin (ill.7), as was recognised by critics at the time. For Poussin's scantily clad or draped heroic figures Breton has substituted five anonymous, but individualised agricultural workers and a child from his local village of Courrières. Their elegance is in marked contrast with those earlier monumental, simplified but coarse rural labourers captured by Courbet or by Millet in *Going to Work*. Millet was to provide his own telling observation on that difference when he remarked of Breton that he only ever painted the girls who were not destined to stay in the village – in other words, the pretty ones who would marry and move away.

It is intriguing that the first notable French painting to enter the Kelvingrove collection, in 1896, was Corot's *Pastorale* (cat.15), a late atmospheric landscape whose elegiac title in a sense encapsulates what French landscape had traditionally been under the old academic system, when it was dominated by the legacy of

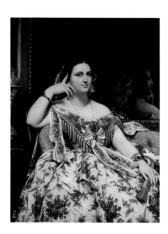

8. Jean-Auguste-Dominique
Ingres (1780–1867)
Madame Moitessier, Seated, 1856
Oil on canvas, 120 × 92cm
National Gallery, London

Claude Lorrain and Poussin. Up until Corot's time the defining moment of a young artist's career was when he visited Italy, whether or not he succeeded in winning the Rome Prize for landscape established, somewhat belatedly in comparison to the other genres of painting, in 1816. Corot's earlier landscapes were very different from *Pastorale*, characterised by the broad and structured vision he learned as a young painter stalking out classical motifs in the Roman campagna. Then, the making of numerous oil studies from nature was directed towards the composition of a suitably elevated subject for the Salon. Although he was contemporary with the generation of landscapists collectively dubbed the Barbizon School,[5] Corot's training within the Neo-Classical landscape tradition set him somewhat apart from the central members of that group, who were committed, on the contrary, to exploiting and celebrating the riches of nature within France and refused to people their views with fantastic or imaginary figures. Millet and Théodore Rousseau, although differing in many respects, are remembered for their joint devotion to that cause and associated particularly with the village of Barbizon. This modest village to the south-east of Paris prided itself on being the geographical cradle of the new school of landscape. It was poised on the edge of the ancient Forest of Fontainebleau which offered a wealth of natural motifs, notably magnificent trees whose champion Rousseau became, both in paint and in his activism as an early environmentalist.

Barbizon was but the first of a whole wave of artists' colonies to spring up in rural France at this period. Courbet became known for his strong association with the Jura and his native town of Ornans. The three peasant painters mentioned above all came from villages in the distinctly unpicturesque region of northern France, Breton from Courrières in the Pas de Calais, Lhermitte from Mont-Saint-Père in Artois and Bastien-Lepage from Damvilliers in the Meuse. All, as a direct result of the Barbizon movement, were equally committed to celebrating and being identified with their *pays*.

With Impressionism, artists turned aside from the time-honoured labouring and pastoral motifs favoured by their predecessors; they were more attuned to the unprepossessing corners of nature to be found on the edge of the city. Monet, Sisley and Pissarro made endless use of the motifs they found along the Seine and its tributaries or in the agricultural landscape a short distance from Paris. Where Monet tended to favour scenes of leisure, yachting and canoeing at Argenteuil for instance, Pissarro generally preferred working scenes. The earlier of Sisley's two paintings in the collection features the boatyard at Saint Mammès, on the Seine to the east of Paris, and a workaday scene on an industrialised stretch of the river is also the theme chosen by Signac in *Coal Crane, Clichy* (cat.54). Seurat followed their example, drawn to the shifting suburbs where tracts of wasteland met new housing developments and Van Gogh did the same. However, the painter said to have 'invented the suburb' at the start of the 1880s, Jean-François Raffaëlli, is not represented in the Glasgow collection, although he exhibited in the city on two occasions in the 1890s.[6] Never one to rest long

on his laurels, Claude Monet, in the 1880s, began to venture further afield. His *View of Ventimiglia*, 1884 (cat.41), a town near the border between France and Italy, is the result of his new strategy of painting more eye-catching touristic motifs.

Just as writers catered to the bourgeoisie's interests through the new genre of the novel, in a number of ways figurative painting adapted itself to the bourgeois patron. In particular, commercially astute painters responded to the increased demand for intelligible stories, for detail, for high levels of finish and focused on subjects drawn from the contemporary world, whether that world was familiar to the potential client or more exotic. Portraiture continued to flourish, but the legacy of its greatest exponent, Ingres (ill.8), exemplary master of detail and textural nuance, left his followers in an impasse, with little to offer as counterweight to the increasingly dominant role played by photography. By the late nineteenth century many portraitists were conscious of the futility of vying with the photographer in terms of mere verisimilitude, a crisis of faith which becomes increasingly apparent as one observes the differences between the portraits of Corot, Cassatt and Van Gogh and those of Vuillard, Matisse and Rouault.

In Corot's *Mademoiselle de Foudras*, 1872 (cat.14), attention to the physical facts of the model's appearance is still relatively traditional. Indeed the portrait bears a distinct similarity in pose and enigmatic expression to Leonardo's *Mona Lisa* (Musée du Louvre, Paris) and in simplicity of composition to certain of Rembrandt's female portraits. In the case of Van Gogh's portrait of his close friend Alexander Reid (cat.28), the wish to convey a personality through characteristic traits is strong, but so too is the will to experiment with colour and paint handling. As mentioned above, Reid, like the artist's brother Theo, was an art dealer and almost, one might suggest, an alter ego for Vincent given the similarity of the two men's appearance (ill.9).

With Vuillard, on the other hand, there is a more radical rejection of the conventional approach to portraiture. He pays almost more attention to the physical facts of the interior setting with its clutter and detail; with each of the paintings of figures in interiors the perplexed viewer has to reassemble the shape of the self-effacing (yet always specific and identifiable sitter[s]) from the confused surroundings. Kelvingrove can boast four Vuillards, all dating from the period around 1900 when the artist was emerging from his radically simplified Nabi phase and reinstating a more inclusive vision of reality. In all of them, he rejects the usual canvas support for cardboard or wood; supports with absorbent properties which enhanced the matt quality he wished to produce. By the 1920s, concern for likeness can no longer be said to be uppermost in the minds of Matisse or Rouault. As in the bold colouristic images Gauguin had brought back from Tahiti, these artists were guided by a determination to establish a pleasing two-dimensional design using decorative patterns. The figure was merely the pretext. They pay equal attention to face, figure, costume and setting and their portraits take on an iconic presence.

Still-life is another strong theme in the Kelvingrove collection. There are three fine examples of Fantin-

Latour's delicate and meticulous flower painting. The artist, like his friend Bonvin, was an ardent admirer of Chardin. He made the bulk of his income through still-life work, thanks to the support of his English friends Mr and Mrs Edwin Edwards, who both collected his work and acted as informal dealers on his behalf in London. The four paintings of apples by Bonvin, Courbet, Cézanne and Braque, all part of the remarkable McInnes bequest whose arrival, in 1944, enormously enhanced Glasgow's French holdings, may signify a particular predilection on the part of the collector. None of the paintings is large but it is a surprise to find the smallest carrying the bold red signature of Courbet, known earlier on for the monumental scale of his peasant paintings. It dates from his period of political imprisonment immediately following the fall of the Commune in 1871, and this fact reminds us that when a radical artist decides to take refuge in pure painting, tackling a seemingly value-free everyday object like an apple, it is not without its own historical and political significance. In these four still-lifes we see evidence of the persistence of that humble individualist French tradition – the Chardin legacy – that was a distinct selling point for certain dealers in French art in the period following the First World War. Matisse's table-top still-life (cat.37) and Marcoussis's sober and classical late Cubist still-life *Still-Life in Front of a Balcony*, 1928 (cat.34), which exemplify the *rappel à l'ordre* mentality that characterised post-First World War France, can also be seen as belonging within this same tradition.

There is also in the Glasgow collection a remarkable cluster of paintings dealing with urban or village topography. Sometimes the artists home in on the picturesque irregularity of an ancient street, as in Hervier's panoramic view *Village Scene, Barbizon* (cat.30), Boudin's *A Street in Dordrecht* (cat.5) or Lépine's plunging view of the *The Rue de Norvins, Montmartre* (cat.31). (It is no coincidence that Montmartre was one of the pockets of the city untouched by the major urbanisation scheme undertaken in the 1850s and 1860s by Baron Haussmann.) Van Gogh, who came to live there with his brother Theo, responded to its villagey character and repeatedly composed landscapes featuring the few remaining windmills on the *butte* (cat.27). His ramshackle views are in sharp contrast to the set-piece, ordered cityscapes of central Paris tackled by Vollon and Pissarro (cat.45 and cat. 60). Indeed both painters, from different viewpoints, show the Louvre's Pavillon de Flore which forms an angle in Vollon's view with the Palace of the Tuileries, built by Catherine de Medici in the sixteenth century. Although the Tuileries still seems to be present in Vollon's view, it lacks its central dome; he presumably painted it after it was famously destroyed by fire during the Commune of 1871 and before it was finally demolished in 1883.

If these views seem essentially truthful to appearances, even if the choice of motif was tinged with nostalgia for a world the artists feared was disappearing, by the last years of the century landscapists were more consciously exploiting the melancholy poetry to be found in the deserted city. This haunting quality is to the fore in Le Sidaner's *A Beauvais Square, Moonlight*

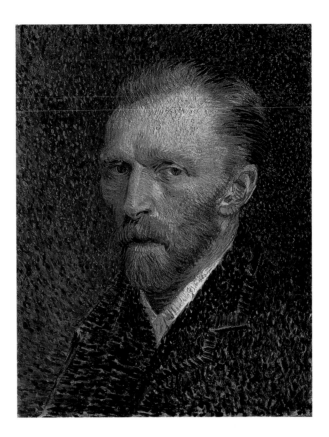

9. Vincent van Gogh (1853–90)
Self-Portrait, 1887
Oil on board, 41 × 32.5cm
Art Institute of Chicago, Joseph Winterbotham Collection

(cat.32). His generation had come to maturity in the 1880s in the context of Symbolism when poets such as Emile Verhaeren explored the mournfulness of empty streets. Maurice Utrillo's equally unpeopled *Village Street* (cat.58) could be mistaken for one of his many views of Montmartre, but in fact represents Auvers-sur-Oise. The presence, in the background, of the church famously painted by Van Gogh at the end of his career inevitably gives the subject a certain resonance. More animated are the views of Paris squares found in the paintings by Camoin and Picasso, the former a plunging view of the Place de Clichy on a rainy day, the latter a Bonnardesque response to the teeming life of the street vendors, nursemaids and children congregating at the foot of the *butte* Montmartre.

The experience of the south of France forced landscapists trained in the north to open their eyes to a different range of motifs and colours. Cézanne, while painting the landscape around his native Aix-en-Provence, found that the flickering Impressionist dabs he had been encouraged to practise by Pissarro in Auvers would no longer serve his purpose. He felt the power of the southern sun required an equivalent power in the application and contrasts of colour – in his *The Star Ridge with the King's Peak* (cat.12) he used acidic greens and warm oranges in contrasting blocks and strips. Cézanne's concern for the underlying structure of nature led his admirers to acclaim him as a modern classic, with a strength reminiscent of Poussin. A similar concern for structural clarity could be said to link the twentieth-century landscapes by Bonnard and Vlaminck, both represented in Kelvingrove by views setting a distant vista between symmetrical stands of tree trunks.

Glasgow's group of seascapes and port scenes also

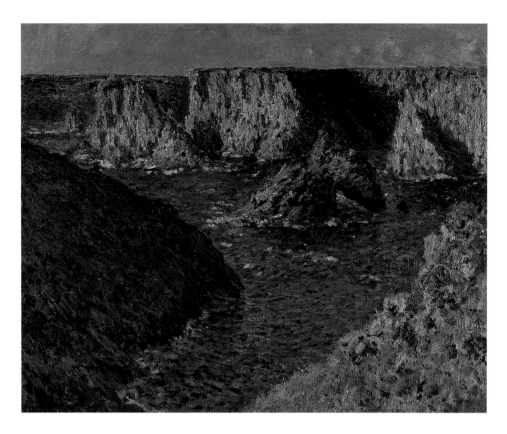

10. Claude Monet (1840–1926)
Rocks at Belle-Ile, 1886
Oil on canvas, 63 × 79cm
Musée des Beaux Arts, Reims

location by his Norman compatriot, Monet.

These geographically specific paintings from Kelvingrove take us on journeys that mirror the trends within French painting of the 1830–1930 period, from the centres of landscape activity in the Forest of Fontainebleau and in the Ile de Paris, to the more adventurous explorations of the Mediterranean and Breton coasts. While Paris remained the centre of artistic activity, the place where an artist's career was made or lost, we have seen that the growing importance of markets for art across the Channel and in Scotland, no less than in North America, played an increasing part in shaping French artists' careers and strategies. The warm reception for French painting in Scotland reflected in the strengths of this selection from Glasgow was due to the widely acknowledged diversity and excellence of French art and to the enthusiasm for cultural exchange that typified this period of economic dynamism. We may never be fully able to answer the question of why there was such an outburst of artistic talent during this period – perhaps it was the coexistence of an attitude of respect for existing traditions with a rebellious spirit willing to overturn redundant conventions. Nevertheless a combination of circumstances contributed to making Paris the Mecca for ambitious foreign artists: the Louvre housed the greatest collection of art in the world, the Paris teaching studios and exhibitions were unrivalled, and by the later 1870s the city itself, thanks to Haussmann's improvements, wore a sparkling and modern new look, outstripping its European rivals. These circumstances alone meant that France's native painters were never short of stimulation while the steady stream of talented painters arriving from abroad helped to keep Paris a fulcrum for new energies and innovative ideas.

provides evidence of French artists' famed willingness to experiment with colour. But it was not necessarily the natural motif that prompted the particular colours they chose. Confronting the Mediterranean at Bordighera for the first time in 1884, Monet felt impelled to heighten his use of pinks and blues. However, even when working in the north, this tendency to raise the colour pitch became more marked, notably in the series of cliff views he painted from Belle-Ile two years later (ill.10). The rough and rugged coast of Brittany attracted others in Monet's wake, among them Gauguin and Henri Moret. Boudin, late in life, visited Venice, that favourite haunt of marine painters but there is little to distinguish his tranquil grey-toned view from one of his Normandy beach scenes. On the other hand Marquet suggests a distinctive serene limpidity in his *Port of Algiers* (cat.35) by deploying a cool palette of blues and oranges. Derain, painting Blackfriars in London in 1906 (cat.19), sees it in a riotous kaleidoscope of prismatic colours similar to the palette he had discovered the previous year in the Mediterranean port of Collioure. This colouristic liberty is taken to an extreme in Dufy's purely decorative vision of *The Jetties of Trouville-Deauville*, 1929 (cat.21), a painting which seems to capture the light-hearted spirit of the times and of the holiday resort he knew well. Even so, one suspects Dufy had not entirely forgotten the daring experiments with pure flat *japoniste* colour made sixty years earlier at the same

[1] Osbert Sitwell, 'The Courtauld Collection', *Apollo*, II, August 1925, pp.63–9, cited in J. House, *Impressionism for England: Samuel Courtauld as Patron and Collector*, London, 1994, p. 241.
[2] Emile Zola, 'Mon Salon' (1866) cited in *Le Bon Combat*, Paris, 1974, p.74.
[3] Jules Claretie, 'Salon de 1873', in *L'Art et les artistes français contemporains*, Paris, 1876, p.186.
[4] Alice Corkran, 'William Stott of Oldham' in *Scottish Art Review*, vol.I, n.11, April 1889, p.322.
[5] It is worth noting that this designation was first used in print by the Scottish art historian and dealer, David Croal Thomson. The latter was one of the promoters of Corot's late 'light and airy' style as opposed to his early 'tight', 'niggled' and 'classical' style – opinions expressed in D.Croal Thomson 'Corot at Work' in *Scottish Art Review*, vol.I, n.3, August 1888, pp.51–3. It is fair to say that critical opinion today takes the reverse view.
[6] Octave Mirbeau was the first to acknowledge the artist's importance in this respect: 'Grâce à M.Raffaëlli, la banlieu de Paris – ce monde intermédiaire et bizarre, à la fois grouillant et abandonné, qui n'est plus la ville et qui n'est pas encore la campagne . . . a conquie sa place dans l'idéal.' From 'J-F. Raffaëlli', in *L'Echo de Paris, 28 May 1889*, cited in *Raffaëlli-Mirbeau: Correspondance*, 1993, p.107.

GLASGOW, 1860–1914: PORTRAIT OF A CITY

Origins and Early Economic Background

Compared with the history of other British manufacturing cities like Birmingham and Manchester, Glasgow's rise to prominence was rooted in the distant past. Even before the kingdom of Scotland emerged in the eleventh century, partly as a result of dynastic consolidation, the Clydeside community had become an important ecclesiastical centre, based around the cult of St Kentigern, or St Mungo, as this charismatic pioneer of Celtic Christianity is more popularly known. It is believed that Mungo's associations with the settlement of Glasgow were forged in the sixth century, and his inextricable identification with the town under Scottish sovereignty was testimony to what contemporaries saw as his beneficent and regenerative influence.[1] The first stone-built cathedral, consecrated in 1136, was evidence of Glasgow's growing status as a Roman Catholic bishopric. It was the bishops, then archbishops from 1492, who were the pivotal controlling influence in matters of jurisdiction, urban development and cultural orientation.

The foundation of Glasgow University in 1451 further added to the prestige of the community. For all that the city acquired a reputation for commercial enterprise by the late nineteenth century, a long-standing legacy of academic learning had underpinned this climate of innovation. Economic prospects were also bound up with Glasgow's early ecclesiastical profile. The population increased inevitably as employment opportunities diversified to cater for consumer demand. Glasgow became a prosperous market town, and during the fifteenth century the merchant class established a significant base in overseas trade, especially the export of cured fish to Europe.

St Mungo and salmon are the dominant motifs on the city's coat-of-arms, demonstrating the original source of power and wealth in Glasgow. The fish may have been unlikely fruits of trading success, but they symbolised the importance of the river Clyde in shaping a distinctive mercantile identity, which became more pronounced with population expansion. By the mid-sixteenth century there were 4,500 residents of Glasgow; over the next hundred years numbers rose to around 12,000, and the term 'second city' had emerged to characterise the community, placing it firmly behind Edinburgh in the hierarchy of Scottish towns. One visitor during the 1650s favourably described Glasgow as 'a city of a pleasant site, upon a river navigable for small boats', and added, 'the streets and houses are more neat and clean than those of Edinburgh'.[2]

This assessment, with its strong suggestion of tranquillity and order, belied the impact of politico-religious conflicts that had altered the local power structure over the preceding century. The Scottish

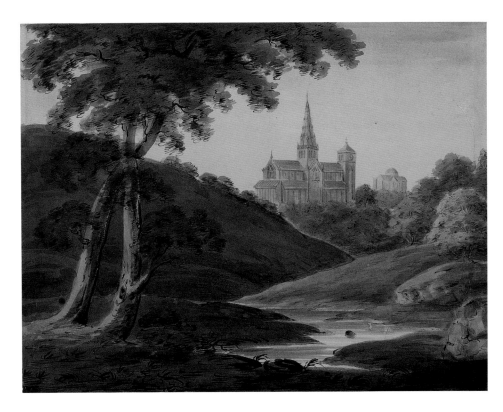

Reformation of 1560 had Protestantised Glasgow and secularised its leadership, enhancing the authority of the merchant and craft guilds in civic governance. Until 1690, when Presbyterianism was recognised by the state as the established faith of Scotland, religious tensions continued to afflict Glasgow. However, this did not ultimately undermine the new basis of control. The ecclesiastical town had become metamorphosed into the 'merchant city', with profound implications for subsequent economic development.

The 1707 Union of the Scottish and English parliaments represented far more than a constitutional expediency, at a time of profound uncertainty over the dynastic continuity of the British monarchy. For all that there were many in Glasgow who doubted the motivations behind the creation of the new United Kingdom, seeing an unequal partnership between Scotland and its more populous and prosperous English neighbour, distinct economic advantages could also be discerned. Above all, the Union legitimised Scottish trade with the English colonies, a matter of no small concern to Glasgow's ambitious overseas merchants.[3] English protectionism had previously excluded them from developing markets, notably in North America and the Caribbean, although the Glaswegians imaginatively showed entrepreneurial initiative through illegal trade and smuggling. The Union made no overnight difference to the city's economy, which was already undergoing change; it was the long-term impact that was important.

11. Anonymous, *Glasgow Cathedral, from the Molendinar Burn*, c.1800–40
Watercolour on paper
Mitchell Library, Glasgow

The western tower was demolished during the 1840s. To the right is the Royal Infirmary, a 1790s building designed by Robert Adam. This view shows the area prior to the onset of industrialisation which caused the Molendinar Burn to be channelled underground.

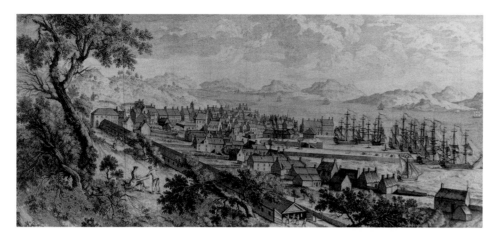

There were signs of Glasgow's burgeoning prosperity during the 1720s. Daniel Defoe, the English journalist, novelist and ardent pro-Union propagandist, was deeply impressed by the efficiency of Glasgow's commercial organisation. His only criticism about trading practices was ironic; there was apparently too much tobacco being imported from the American colonies and too much sugar from the West Indies. These commodities were in excess of the consumer needs of Scotland, and city merchants were consequently in the process of extending markets in Europe. Defoe also made a revealing point about the location of Glasgow, and how it favoured a swift sailing time for transatlantic vessels: 'The Glasgow men are no sooner out of the Firth of Clyde, but they stretch away to the northwest . . . and are oftentimes at the capes of Virginia before the London ships get clear of the Channel.'[4]

Glasgow's merchants began to consolidate their trading position from the 1740s, and the mid-eighteenth century has been described as the 'golden age' of the tobacco trade.[5] The period also paralleled a surge in Glasgow's population; from 23,500 inhabitants during the 1750s, there were 42,000 by the 1780s. Statistics also reveal the sheer volume of tobacco traffic; annual imports rose from eight million lbs (3,636 tonnes) in 1741 to forty-seven million lbs (21,362 tonnes) by 1771.[6] The transatlantic traders, who dealt primarily with the Carolinas, Maryland and Virginia, were the richest commercial elite to emerge in Scotland until the nineteenth century. Conspicuous consumption was a visible sign of their status, from their elaborate Palladian mansions in the city centre to their physical appearance. An account of the city, published in 1771, evocatively described the imposing impression that they made, 'Many of the merchants acquire vast fortunes, and they have such an inclination to business, that little besides it ever engages their attention. Those that trade to Virginia are decked out in great wigs and scarlet cloaks, and strut about on the [trading] Exchange like so many actors on a stage.'[7]

Significantly, tobacco was not their sole source of wealth. Prudent investments were made in land and shipping, and Glasgow's fledgling banking industry developed from the financial side of trade. Textiles represented a commercial growth area, predominantly linens, which had long been among the most important commodities to be manufactured locally. There was thus a two-way flow of trading goods, as Glasgow vessels brought over a range of domestic products for consumption in the colonies.

Up to the mid-1770s tobacco was central to Glasgow's economy, but in the wake of the American War of Independence and the severing of colonial ties, traders turned their attention elsewhere, notably to the Caribbean and the British territory of Canada. While links with the United States plantations were eventually re-established, the impact of war had undoubtedly jolted Glaswegian confidence. It was in this uneasy climate that the Glasgow Chamber of Commerce was founded in 1783; reputedly the first such organisation in the world to actively promote and protect a city's trading interests.[8] Its varied membership and activities indicated that the city's economic base was broadening. In this respect West India trade represented a pivotal link between the old commercial base of tobacco and the new manufacturing base of textiles. Until the 1800s, the bulk of the raw cotton used in textile processing was grown in the Caribbean, and it was only thereafter that cheaper and more plentiful sources of supply were sought in the United States and East Indies.

Cotton textiles were seen as promising a new direction in manufacture, as was suggested by the Glasgow entry for the *Statistical Account* of the 1790s, '[The industry] which seems, for some years past, to have excited the most general attention, is the manufacture of cotton cloths of various kinds, together with the arts dependent on it. For this purpose cotton mills, bleachfields, and printfields, have been erected on almost all the streams in the neighbourhood, affording water sufficient to move the machinery.'[9] The buoyancy of the industry, and especially opportunities for handloom weaving, helped to boost the city's population to over 77,300 by 1801. Self-made manufacturing entrepreneurs, like the cotton magnate James Finlay, were successful symbols of the changing economic power base. Yet there was no blanket displacement of one social group by another. Families that had made their fortunes in the 'old money' of tobacco and sugar continued to play a prominent part in the city's affairs well into the nineteenth century.

12. Robert Paul (Foulis Academy, Glasgow)
A View of Port Glasgow from the South East, 1768
Engraving
Mitchell Library, Glasgow

A view of the tobacco fleet in the harbour of Port Glasgow, which before the development of the River Clyde was, with Greenock, the main port for the city.

13. Archibald McLauchlan, 18th century
John Glassford and Family at Home in the Shawfield Mansion, Trongate, c.1767
Oil on canvas, 198.1 × 221cm
Glasgow Museums: The People's Palace.

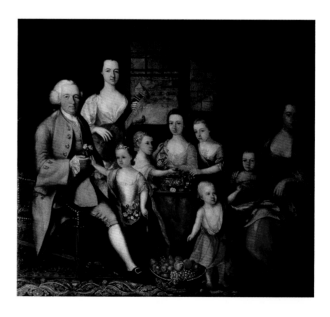

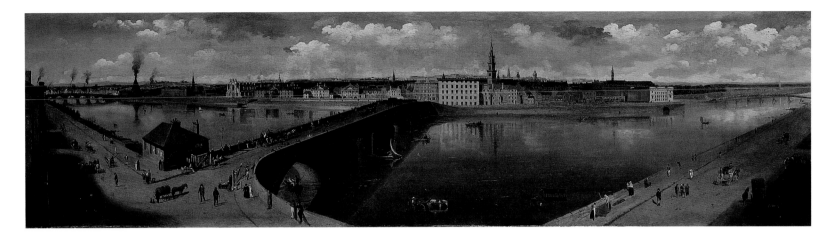

Industrial Glasgow

Water power was superseded by steam technology from 1800, which meant that the focus of Scotland's textile industry became decisively urban. That rich deposits of coal and iron lay in close proximity to Glasgow's East End helped to concentrate large-scale, steam-driven textile production in communities like Bridgeton and Calton. Global opportunities encouraged support for economic liberalism, notably via the Chamber of Commerce, and Glasgow was an early example of a 'free trade' city, where merchants and manufacturers assertively eschewed barriers to market competition. Such an approach was encouraged because industry had comparative advantages, especially relating to the level of labour costs and worker availability. In British terms, Glasgow was a low-wage city; a characteristic that continued into the 1900s. Not only was the labour supply economical, but it was also plentiful. The workforce was continually being augmented, notably by Lowlanders from the west of Scotland, migrants from the Highlands, and the Irish.

This last group became numerous after the introduction of passenger steam-shipping services from the 1820s, and by mid-century almost a fifth of Glasgow's population was Irish-born. The effects of in-migration were reflected in the city's brisk demographic growth. During the 1820s Glasgow overtook Edinburgh in population numbers. From 202,400 inhabitants in 1831, figures rose to 477,700 in 1871 and 784,400 by 1911. The major boundary expansion of 1912, which incorporated several important, contiguous industrial districts, boosted the number of Glaswegians to over a million. Emphatically Britain's 'second city' after London in terms of size, by 1914 Glasgow had also one of the largest, most densely populated urban populations in Europe.

Textile production, especially cotton, reached its zenith in Glasgow during the 1850s. However, levels of employment did not erode significantly until the 1880s, when vigorous competition from home and abroad forced a contraction of output. Even so, the sector was relatively resilient, and by 1911 some 17 per cent of the city's industrial workforce was still involved in textile manufacture.[10] Moreover, at the time when textiles dominated the economy during the first half of the nineteenth century, entrepreneurs were already diversi-

fying into more lucrative growth areas. There was fabulous profit to be made from iron, with the result that foundries and blast-furnaces began to appear in and around the city, manufacturing an eclectic range of products from textile machinery to gas and water pipes and domestic hardware. The arrival of railways from the 1830s helped to consolidate this link, as the new mode of transport brought the raw materials from the Lanarkshire hinterland direct to the heart of the city. By mid-century 90 per cent of Britain's pig-iron exports came from the west of Scotland, with control centred firmly in Glasgow.

Railways themselves generated a major industry for Glasgow, with locomotive engineering works concentrated to the north of the city in Springburn and Cowlairs. Also to the north, in Possilpark, the Saracen Foundry of Walter Macfarlane employed a workforce of 1,200 by the end of the century. According to an advertising feature promoting Macfarlane's in 1891, iron-work had more than just a functional purpose. Describing their castings as 'sharp, clean and full of character', their elaborate wrought-iron bandstands, horse-troughs, fountains and lamp-posts embellished the landscape of towns and cities throughout the world.[11]

Glasgow's subsequent success in marine engineering and shipbuilding developed from this position of strength in the iron industry. Steam-engine builders, most famously Robert Napier, became involved in pioneering shipbuilding companies. His cousin, David Napier, was also an innovative influence on shipping design. The development of the iron hull from the 1820s created opportunities for the Napier family, and their technical flair made Glasgow the specialist focus of this branch of shipbuilding.[12] Not surprisingly, their example encouraged emulative businesses to be set up along the Clyde. From a base of zero in the 1800s, over twenty such enterprises had been established in the Glasgow area by 1860.

At this time the Clyde yards produced 70 per cent of all iron tonnage launched in Britain, but during the later decades of the century steel became favoured because of its flexibility. From the 1870s demand for shipping helped to secure the fortunes of William Beardmore & Company; a monumental steel enterprise, requiring huge resources and capital. Beardmore's 'Forge', as the industrial complex was known, wholly changed the character of the East End weaving com-

14. John Knox (1778–1845)
Panorama of the City of Glasgow, c.1820
Oil on canvas, 30.5 × 119.5cm.
Glasgow Museums: The People's Palace

15. *Conservatory, Carlston, Kelvinside*
Designed and manufactured by Walter Macfarlane & Co., Saracen Foundry, Glasgow
Mitchell Library, Glasgow

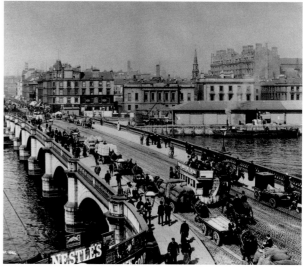

16. D. Muirhead Bone
(1876–1953)
*View Across the River Clyde,
from Cessnock Dock to Glasgow
University*, 1911, from *Glasgow,
Fifty Drawings*,
Mitchell Library, Glasgow

17. T. & R. Annan
*View of Glasgow Bridge, from
the South Side*, June 1892
Mitchell Library, Glasgow

18. Anonymous (perhaps
intended as a shop sign),
Portrait of Sir Thomas Lipton,
1890s
Oil on wooden panel
Glasgow Museums: The
People's Palace

munity of Parkhead. Specialising in the production of armour plate and ships' plates, the company was an exemplar of west of Scotland heavy industry, and became one of Britain's prime munitions manufacturers during the First World War.

These developments meant that during the last quarter of the nineteenth century Glasgow's economic fortunes were firmly identified with the river Clyde. In his portrait of the city in 1876, journalist Robert Gillespie went so far as to suggest that 'what the Nile was to Egypt, the Clyde is to Glasgow', the two rivers representing a civilising source of prosperity and progress.[13] The Clyde was also Glasgow's vital global outlet, connecting the city directly with sea routes to familiar destinations in the British Isles and Europe, as well as more remote and exotic territories.

There were, of course, already long-established trading links, notably with North America, but the period was significant for consolidating the commercial opportunities associated with the British imperial mission. The opening of the Suez Canal in 1869 meant that Asia became readily accessible to shipping, while Queen Victoria's newly proclaimed status as Empress of India in 1877 symbolised the extent of British interests within the sub-continent. As for the exploitation of Africa, the pioneering explorations of David Livingstone inspired a new generation of Europeans and Americans eager to venture into the interior after his death in 1873. Intriguingly, the Clyde and the Nile were connected through the ambitions of this celebrated Scot. Born in Blantyre, a Lanarkshire community close to Glasgow, Livingstone's great (if unfulfilled) quest was to discover the source of the Nile.

Shipbuilding was the manufacturing component of the Clyde's success during the late Victorian period. The term 'Clyde-built' became a metaphor for sturdy excellence and versatility. As one enthusiastic commentator put it in 1901: 'The builders have the skill and experience, and the yards have the appliances which are

required for any type of war vessel, trading vessel, or pleasure craft.'[14] It was ironic that up to the boundary extension of 1912 the concentration of the industry lay just outside Glasgow, in Govan and Partick. These were prime examples of late Victorian boomtowns, and among the most populous urban communities in Scotland by the 1900s.

The shipbuilders had settled outside Glasgow partly because of the pressure for harbour space in the city centre. Trade and shipping represented the long-standing commercial component of Clydeside prosperity, although it was only in 1810 that Glasgow had been recognised by parliament as a seaport in its own right. For much of the eighteenth century the river had been too narrow and shallow for ships of substantial tonnage to dock directly at Glasgow, but civic determination to create a working harbour led to massive civil engineering projects that were still ongoing by the 1900s. Queen's Dock, which opened with elaborate ceremony in 1877, was used to accommodate many of the city's major shipping lines, from the Mediterranean steamers of J. & P. Hutchison to the long-haul sailing ships of the Loch Line, which plied the route to Australia.[15] Glasgow also became a major embarkation point for emigrant ships, especially to North America.

Trade was a reciprocal process. The ships built on the Clyde carried goods and people across the world, but imports were also crucial, especially raw materials and foodstuffs. Until the 1900s, grains and flour from North America were Glasgow's leading import commodities, showing the extent of demand for staple items like bread. By 1911 the food, drink and tobacco sector employed 12.5 per cent of the industrial workforce, and had become the third most important area of manufacturing behind metals and textiles. While new technology allowed for the importation of canned and refrigerated meat from as far away as Argentina and New Zealand, domestic produce also remained important. The Irish trade, a central feature of the west of Scotland economy, specialised in the supply of beef, pork, ham, eggs and butter.

The international success of Sir Thomas Lipton, undoubtedly Glasgow's best-known grocer, was derived from his shrewd marketing of these popular

comestibles. Significantly, both his parents came from Ulster, although he had learned his flamboyant sales technique from working in the United States. Lipton's tea was the outcome of his investment in Ceylon plantations, where he was able wholly to control production both as planter and retailer. His slogan, 'Direct from the Tea-Garden to the Teapot!' echoed the traditional concern of Glasgow's entrepreneurs to maximise economies of scale in trading.[16] Late nineteenth-century transport developments, notably in shipping, had helped to stimulate the rise of the mass market, with ever more exotic sources of supply.

City Improvements and the Health of Glasgow

In 1913 there was an unprecedented volume of Clyde shipbuilding output, suggesting the inevitable progress of the industry as markets diversified. However, in reality Glasgow's economy had been prone to sharp fluctuations from the 1870s, with production levels driven by the vagaries of international demand. The impact of recession and unemployment was also compounded by distinctively local circumstances, as in October 1878, when the City of Glasgow Bank sensationally collapsed. In his official report of Glasgow's *Vital Statistics* for that year, William West Watson, a prominent civic official, wrote dramatically of the 'gloom and despondency' that this searing scandal had cast over the city.[17] The bank had accrued a colossal debt of over £6 million, much of it sustained through injudicious speculation, from land transactions in Australia to railway investments in the United States. The managers and directors were found guilty of fraud

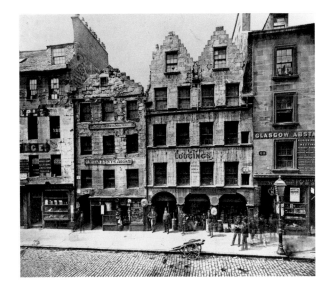

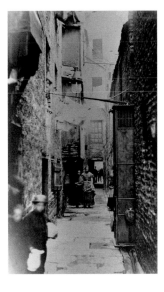

and imprisoned, but as Watson pointed out, thousands of depositors had been left destitute. Glasgow's reputation as a commercial city was seriously tarnished, while there was profound cynicism about the probity and integrity of middle-class business leaders. Moreover, the cloud of depression hovered over the city well into the 1880s. Among the casualties of the bank collapse was the property and building trade, which ground to a halt after a period of relative buoyancy. Ambitious municipal plans for city improvements slowed down, prompting renewed controversy over the best way of dealing with Glasgow's corrosive urban environment, especially the housing of the working classes.

During the seventeenth and eighteenth centuries, Glasgow had acquired a reputation as a physically attractive city, and visitors often compared it with the English university town of Oxford.[18] This was not surprising; although Glasgow's own university was founded in 1451, its custom-built college buildings, dating from the mid-seventeenth century, strikingly blended southern and Scottish architectural influences. At the end of the eighteenth century there was a sustained period of speculative building in Glasgow, especially to the west, when prestigious 'New Town' developments emulated the success of Edinburgh's recent structural transformation. Yet even by the 1800s writer James Denholm was referring to dwellings in the area of the Drygate, near to the cathedral, as the looming and decrepit legacy of the unenlightened past.[19] Deterioration in the older parts of the city became more marked with rapid population increase, which led to the phenomenon of 'backland' building. Available space behind existing properties was used to accommodate the maximum number of people, while larger houses, sometimes originally of quality, were drastically subdivided.

Glasgow traditionally was a compact city, but as the nineteenth century progressed it became congested and unhealthy, at least in the warren of narrow alleyways – the notorious 'wynds and closes' – that were clustered around Glasgow Cross. For certain civic leaders and social activists, notably from the churches, Glasgow's unsavoury slum heartland undermined the well-being of the entire community. As far back as 1845 the cru-

20. Thomas Annan (1829–87)
*Old Building, High Street, c.*1860
Mitchell Library, Glasgow

21. Thomas Annan (1829–87)
*Close, no.37 High Street, c.*1860
Mitchell Library, Glasgow

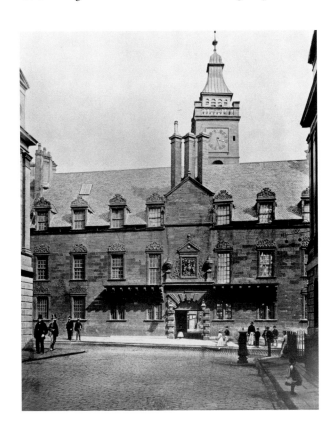

19. Thomas Annan (1829–87)
*The College, from College Street, c.*1860s
Mitchell Library, Glasgow

sading *Glasgow Examiner* newspaper was arguing: 'The authorities ought to have taken steps long ago to purchase these wynds, and to have levelled these wretched houses, and in their place erected others properly ventilated and watered.'[20]

The availability of water was an abiding concern of the civic authorities, given the health needs of the rising population. Epidemic diseases like typhus and cholera were particularly virulent between the 1830s and 1850s, and dirt and overcrowding were identified as the main reasons for their recurrence. In an attempt to mitigate their dangers, the use of soap and water was zealously promoted, and hygiene was ultimately a key factor in the inauguration of the great municipal water supply from Loch Katrine in 1859. This impressive, if costly, public utility was crucially important for the progress of the city's health, because abundant fresh water became available to all sections of the community. That Loch Katrine was set in the spectacular Perthshire Highlands, fifty-five kilometres from the city, also symbolised much to Glaswegians about purity, regeneration and unpolluted air.[21]

'Breathing space' was a phrase that summed up the rationale behind public-health policy from the post-Loch Katrine period. In 1872 Dr James Burn Russell, the first full-time Medical Officer of Health (MOH) in Glasgow and Scotland, was appointed as head of a new sanitary department under municipal control. As his most recent biographer has explained, Russell took on a missionary role in the quest for health improvements, and the 'semi-asphyxiated city' was among his many memorable descriptions of Glasgow's corrosive and choked environment.[22] As he put it, heavy industry had combined with the domestic use of coal fires to produce a permanent 'sea of smoke' over Glasgow. By the second half of the nineteenth century diseases of the lung, notably pulmonary tuberculosis, were among the major causes of mortality, notably in the congested inner-city districts.

From 1866 the City Improvement Trust was a pioneering civic attempt at the wholesale restructuring of some of the most dilapidated and insalubrious areas of Glasgow.[23] Approximately thirty-six hectares to the north and south of the river Clyde were targeted for development, and borrowing powers of over £1.25 million were granted by central government. The scheme was the practical application of the ideas originally voiced in the *Glasgow Examiner* for eradicating the slums. However, since the 1850s, the success of the Loch Katrine water supply had legitimised the principle of direct municipal intervention, and allowed for more ambitious and wide-ranging plans to be implemented. An important role model was the physical transformation of Paris under the regime of Emperor Napoleon III. A civic delegation led by Lord Provost John Blackie, junior, had visited the French capital during the summer of 1866 and was profoundly impressed by the imposing new buildings, broad thoroughfares and wholesome atmosphere. Many recommendations came out of the visit, including the provision of more parks and open spaces for Glasgow, along French lines. Fresh air was considered essential for reinvigorating the population, and the Parisian pastimes of street

promenading and outdoors café culture were viewed with particular approval. In sharp contrast, the delegation declared that opportunities for 'amusement and exercise' in Glasgow were conspicuously lacking. Children had nowhere to play except 'dirty gutters', and the only resort for adult refreshment was the disreputable spirit shop.[24]

There was clearly a moral as well as public health dimension to the proposed improvement of Glasgow. Yet, writing in the 1880s, the influential city architect, John Carrick, suggested that aesthetic considerations had also been to the fore.[25] An enthusiastic practitioner of Neo-Classical building design, as favoured in mid-century Paris, Carrick transformed districts like the Gallowgate and the Gorbals into monumental examples of rectilinear street formation. The free flow of transport was another major consideration, at a time of intensely competitive railway expansion and the introduction of Glasgow's horse-drawn tramway system. Concern to create a cosmopolitan and modern city, as a visible expression of civic progress, meant that relatively little of the old town was preserved. Even the architecturally significant university buildings were demolished, and replaced by a railway goods yard. An extensive new campus was erected in Glasgow's middle-class West End, where the healthy hilly location was deemed to have a more appropriate educational ambience for professors and students.

As for the wynds and closes, their demolition began in earnest from 1870, and it was made explicit by MOH Russell that a deliberate policy of population dispersal was being conducted, in pursuit of 'hygienic' welfare.[26] By 1877 over 25,000 people had been moved out of City Improvement Trust areas, and half of the condemned properties had been pulled down. Referring to the visual impact on the landscape, William West Watson enthused: 'The transformation must strike the casual visitor or returning wanderer as something marvellous.'[27]

Of course, 1878 was a depressed year, characterised by the City of Glasgow Bank scandal and one of the bitterest winters in living memory. Mortality levels were particularly high, with 'chest diseases' identified as the most lethal.[28] The prolonged economic recession had serious implications for city-improvement strategy, which stagnated for a decade. During the 1880s pressure for renewed action was exerted from a number of quarters, with MOH Russell campaigning ardently against the pervasive problem of overcrowding. He was determined to alter Glasgow's status as Britain's second most congested city, behind Liverpool. A further disturbing aspect of housing deficiency was the fact that 25 per cent of Glasgow's population lived in one-room houses and apartments, known locally as 'single-ends'.

In 1888 the civic leadership eventually bowed to sustained pressure, and took the controversial decision to construct, rather than simply demolish, residential dwellings. This was the first tentative foray into the sphere of municipal housing, which was bitterly attacked by landlords and building interests as undermining the private property market. From this time the housing issue was one of the most contentious in city politics, becoming central to the campaigning platform

of the Labour party in the 1900s. Between the 1880s and 1910s the Trust constructed a number of model tenements for the working classes, but these were of minimal significance in addressing the housing needs of the population. Yet more positively, parts of the inner city had been transformed architecturally, with the Trust leaving a legacy of French-inspired structural achievement that survives into the twenty-first century.

Territory, Architecture and the Landscape

Writing in 1866 about the need for Glasgow Corporation (the town council) to prioritise city improvements, John Blackie, Jr., suggested that the proposed reconstruction represented 'the only means to remove the barrier between the east and west ends of the town'.[29] He was referring to Glasgow's segregation according to residential polarities, with working-class communities concentrated in the east and the affluent middle classes favouring the west. Blackie's blunt assessment was to some extent exaggerated; for instance, the elegant Georgian terrace of Monteith Row was emphatically an 'East End' address that continued to be viewed as a symbol of old-style gentility. Guy McCrone's *Wax Fruit*, a trilogy of novels depicting Glasgow's middle-class life during the last quarter of the nineteenth century, enshrined this image. The heroine, Bel Moorhouse, and her upwardly mobile merchant husband resided in Grosvenor Terrace, in the exclusive West End district of Kelvinside, while her mother happily continued to dwell in the faded splendour of Monteith Row.

Indeed, during the 1850s, Victorian building speculators had been attracted to the east as well as to the west, especially as an ambitious project was underway to transform the undeveloped lands of Dennistoun into a gentrified East End suburb. Architect James Salmon advertised his plans as emulating 'the best continental models', complete with 'squares, boulevards and fountains', showing how deeply ingrained were French and other European influences on Glasgow's building and design.[30] Yet the development of Dennistoun ultimately proceeded as a scaled-down and less elaborate version of the original proposals. The district's close proximity to the smoke of East End factories deterred prospective residents, who were overwhelmingly attracted to more fashionable and healthy suburbs in the west and south.

Glasgow's westward expansion began during the late eighteenth century, and Blythswood was one of the earliest examples of a planned middle-class suburb from the 1790s.[31] However, as the new century progressed, elite residences were erected even further from the city. Land for building was readily available in a cluster of outlying pastoral estates, seen as lucrative speculative opportunities by their proprietors. Among the most extensive were Woodside, Kelvingrove, Gilmorehill and Dowanhill.

The frequency of the word 'hill' in local place-names reveals much about the allure of the west during the nineteenth century, as physically, it was (and is) much more elevated than the east. The irregular, contoured landscape thus allowed for several striking architectural developments. One of the most spectacular was on Woodlands Hill, overlooking Glasgow's first custom-designed municipal park at Kelvingrove, laid out during the 1850s. Architect Charles Wilson imaginatively exploited the steep crest of the hill to display his French-inspired terraces to best advantage, while the Italian tower of the Free Church College combined with the English tower of Park Parish Church to create a monumental impression on the skyline. Not surprisingly, the new Park district contained some of the most opulent town houses in Glasgow, and in 1876 Robert Gillespie provided a revealing insight into aesthetic influences on material culture, 'The interior of your wealthy Glasgow merchant's residence is now-a-days the abode of taste and refinement. You shall find on his walls well selected pictures from the studios of famous artists. The appointments of his rooms are all in strict artistic keeping, from the tint on the walls to the colour of the carpet and the shade of the hangings. His house and its furniture bear throughout evidence of careful study in adapting means to an end, and every little arrangement has been dictated by a sense of artistic propriety.'[32]

Another prominent symbol of Glasgow's middle-class values was the new university at Gilmorehill, designed by architect Sir George Gilbert Scott in Neo-Gothic style. Gillespie commented that the university tower provided an unparalleled bird's-eye panorama of the city, albeit in early morning, 'before the smoke from the thousand and one factory chimneys obscures the atmosphere.'[33] Yet ironically, when the university was formally opened in 1870, it was situated so far westwards that it was actually outside Glasgow's boundaries. This embarrassing disjunction of town and gown was remedied two years later, when parliament sanctioned assorted territorial additions to the city. However, these were relatively small-scale, and by 1872 Glasgow extended over only 2,442 hectares. The current (2002) figures of 17,730 hectares place the city's modest nineteenth-century growth in clearer perspective, and show why Victorian Glaswegians were so preoccupied with the mismatch between territorial constraints and the rising population.

The quest to secure more 'breathing space' consequently did not just relate to city-centre restructuring, but to the sustained, civic-led campaign from the 1870s to extend Glasgow's boundaries. The areas targeted for annexation were predominantly working-class communities, like Govan and Partick, as well as middle-class suburbs, such as Hillhead in the west and Pollokshields to the south. These were all recent urban growth areas, which had benefited from the rapid progress of the city's roads and transport infrastructure. Above all, commuting to the city from the suburbs became a realistic and affordable option when a street tramways system opened for traffic in 1872. The first routes penetrated deep into the west and the south, but by 1894, when Glasgow Corporation took over operations from the private tramways company, an intricate network of tramlines was connecting the city. By 1901 the trams were functioning by means of electric traction, and Glaswegians proudly (and not unreasonably) boasted that they had one of the most efficient public transport systems in the world.

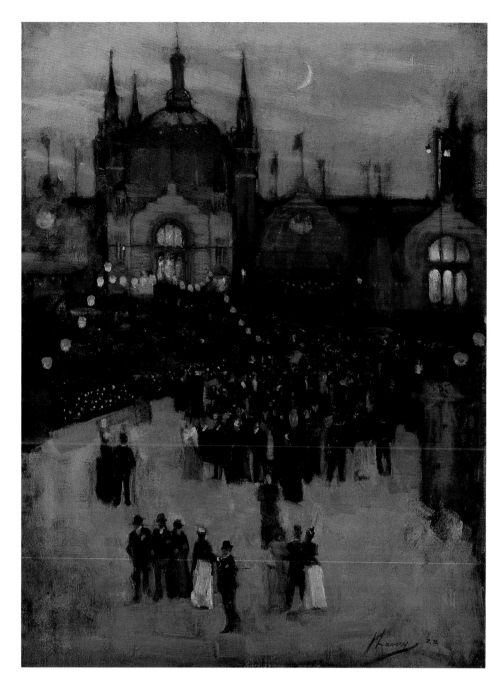

22. Sir John Lavery
(1856–1941)
Glasgow Exhibition, 1888
Oil on canvas, 61 × 45.7cm
Glasgow Museums: Art Gallery
and Museum, Kelvingrove

rate new municipal headquarters in George Square. Architect William Young designed the City Chambers according to Marwick's exacting specifications. Predominantly Italian in style, with corridors of Carrara marble and rich wood panelling throughout the interior, the edifice strongly echoed the opulence of Renaissance city-states. In only her second visit to Glasgow, Queen Victoria formally opened the City Chambers in August 1888. The royal visit coincided with Glasgow's first International Exhibition, another ambitious, civic-led booster event held in Kelvingrove Park.[35] While its short-term purpose was to place the city firmly at the centre of global attention, the exhibition also had a practical rationale in raising sufficient funds to construct new municipal art galleries – the future Kelvingrove. Amidst all the emphasis on Glasgow's cultural and industrial achievements, it was scarcely surprising that in 1888, after intense deliberations, a parliamentary boundaries commission resolved to support the city's case for annexing the suburban territories.

Glasgow Corporation had won the boundary war of attrition, although Govan and Partick remained outside the city until 1912. The majority of smaller suburbs acquiesced to joining with Glasgow, their dignity assuaged by generous financial inducements. However, at least one group positively welcomed annexation; the wealthy residents of Kelvinside looked forward to more efficient policing arrangements as part of Glasgow. The added areas virtually doubled the city's size to 4,800 hectares in 1891, while in 1912 the second phase of 'Greater Glasgow' expansionism increased total territory to 7,763 hectares. The effect of this radical transformation was to give Glasgow a multi-faceted identity as a conglomeration of communities, rather than as the starkly divided city depicted by Blackie in 1866. Slums and overcrowding had by no means been eradicated, and an outbreak of bubonic plague in 1900 jolted official confidence about the progress of public health reform, even though the spread of the disease was quickly contained. Yet the anxieties were counterbalanced by the positive impression evoked by the new entity of 'Greater Glasgow'.

James Hamilton Muir eloquently conveyed the diversity of contemporary life in his snapshot view of the city, *Glasgow in 1901*. On the one hand, he saw working-class districts as treasure stores for the 'glory' of industry: '. . . the crazy workshops struggling over acres of outskirts, the gaunt, blind barns that hide the smelting, forging, and casting, and squat here and there in the distant views of the town's environs'.[36] On the other hand, his description of West End society at night reaffirmed Glasgow as cosmopolitan and stylish: 'Now trees appear screening the terraces, and through them [the observer] notes the waiting carriages, warm lights shining through open doors that mean the West End the world over'.[37] At the time Muir was writing, Kelvingrove Park was the site of yet another prestigious International Exhibition, which buoyantly celebrated the city's prospects for the new century, especially the fruits of trading connections with the Empire.

Muir devoted a substantial segment of *Glasgow in 1901* to the city's architecture, from the overall impact

The achievement of the spatially enlarged city, popularly known as 'Greater Glasgow', was a prolonged affair, which initially generated a passionate campaign of resistance from the suburbs.[34] The prospect of higher Glasgow taxes held little appeal for residents, while there was a genuine sense of local patriotism in communities that regarded themselves as quite distinct from their more populous neighbour. In response, civic leaders and other prominent citizens assiduously promoted the benefits of amalgamation. Sir James D. Marwick, the Corporation's distinguished and formidably efficient town clerk, directed public relations. The Glaswegians adopted a two-pronged argument; the city's cosmopolitan focus was repeatedly contrasted with suburban parochialism, while it was suggested that administrative economies of scale would result in better amenities and public services all round.

As a deliberate monument to 'Greater Glasgow', plans proceeded during the 1880s for building an elabo-

of the built environment to the contribution of individual architects. He concisely summed up the characterising feature of local building, 'our stone is *real* stone', which made Glasgow's appearance 'the most consistently dignified of any industrial city save London'.[38] However, there was also a downside; stone, rather than brick or stucco, sometimes brought unrelieved monotony and dullness to the landscape, particularly as Glasgow's favoured residential building form was the tenement. As Muir aptly described it, in the northern and eastern districts street after street of tenements gave the effect of 'pigeon holes for working families'. He was not referring to the bleakness of the slums, but rather the functional design of solid dwellings that had been erected in areas like Possilpark towards the end of the nineteenth century, to accommodate the fast-rising industrial population.

Conversely, Muir acknowledged that Glasgow had produced a number of gifted architects. For instance, Alexander 'Greek' Thomson was considered to be a mid-Victorian pioneer, whose prolific output of residential, commercial and church buildings demonstrated masterly qualities. Muir criticised Thomson's style as 'old-fashioned', but subsequent architectural appraisals have been much more enthusiastic.[39] His Greek and Egyptian influences distinctively blended monumentalism with exoticism, while his deeply held evangelical Presbyterian convictions added a visionary dimension to his ideas of urban form. Intriguingly, although Muir did not mention him, Glasgow's most celebrated architect, Charles Rennie Mackintosh, was at the peak of his powers during the 1900s. His immediate circle included his wife and sister-in-law, Margaret and Frances Macdonald, whose innovative design abilities have been overshadowed by Mackintosh's subsequent reputation as the creator of the 'Glasgow Style'.[40] His most famous building, Glasgow School of Art, was commenced in 1897. Its various stylistic influences, including English Arts and Crafts, Celtic and Japanese, suggest much about the complexity and variety of cultural ideas within the city by the turn of the twentieth century.

Culture and Recreation

In 1891 James Paton, the curator of Glasgow Corporation Art Galleries, gave a detailed assessment of the project to construct a new building to display the municipal art collection. The site for this showpiece was Kelvingrove Park, and Paton declared his commitment to transform the area into the centre of 'artistic and technical instruction in the city, the home of the Glasgow institutions of Science and Art, the source of intellectual and aesthetic cultivation, for the whole mass of the citizens'.[41] In this respect, he was furthering a process initiated some forty years previously. Since 1852, when the Corporation had acquired the lands of Kelvingrove and other West End estates, the park had served as a tangible symbol of Glasgow's regeneration. It was popularly depicted as the antidote to the claustrophobic inner city, providing an untainted and wholesome environment. Any enhancement to the aesthetic appearance of Kelvingrove during the 1890s could only add to its beneficial impact.

There was perhaps an element of civic salesmanship in the determined promotion of this paragon of health and natural beauty, as the purchase of the park and its subsequent upkeep and development had proved more costly than councillors originally intended. However, over time, Kelvingrove proved to be a pioneering example of municipal recreation strategy, and its salubrious West End location was eminently suitable for holding three prestigious international exhibitions, in 1888, 1901 and 1911. In the event, Paton's lofty cultural objectives were never fully realised; for instance, Glasgow School of Art was eventually built in the more central district of Garnethill. Nor did the new Art Galleries, opened in 1901, meet with universal approval; James Hamilton Muir bluntly declared that the exterior 'has neither breadth nor majesty'.[42] Yet, for all the criticisms, it was evident that by the 1900s Glasgow's parks and open spaces had become vital, not just for embellishing the urban landscape, but for the cultural and recreational well-being of the community.

Kelvingrove was not the first substantial open space within the city. Glasgow Green had a much longer pedigree, as the traditional common lands of the medieval town. Situated to the east of the city, bordering the river Clyde, by the mid-nineteenth century the Green was considered to be emphatically the resort of the working classes. Indeed, Glasgow's notorious east-west divide was reflected in the distinctive character of the Green and Kelvingrove Park. East End residents derided western pretensions, especially the strong moral overtones associated with the much-vaunted purity of Kelvingrove's atmosphere. The Green was not seen as having the same 'elevating' qualities. In particular, the boisterous extravaganza of Glasgow Fair was held on the Green, during the city's main working-class summer holiday. Moral reformers became increasingly concerned about the annual incursion of showfolk and their array of fairground attractions, believing that they encouraged excessive and uninhibited behaviour. The tension between 'rough' and 'respectable' culture reached a climax when the Fair was prohibited on the Green in 1871.

It is revealing that in 1866 John Blackie, Jr., had written about 'the prodigious amount of moral mischief' that pervaded the wynds and closes, and why he believed slum clearance was the best means of restoring social values.[43] The experience of Paris had reinforced how parks and open spaces could help in this process. Ten years later, with city improvements underway, Robert Gillespie referred to how the recreational pursuits of the 'orderly' and 'disorderly' working man were shaped by distinctive patterns of behaviour. Noting that there were now four public parks in Glasgow, he continued: 'In these the orderly working man, his wife, and his bairns, or his sweetheart, is fond of parading on Sunday dressed in his best. . . . In his case the elevation of the masses has distinctly begun'.[44] His feckless alter ego, on the other hand, succumbed all too easily to drunkenness, which had the effect of bringing him 'every now and then to the bar of the police court, either

for being absolutely incapable, actively aggressive, or for beating his wretched wife'.

Perceptions of respectability were reflected in the different attitudes to family, indicating the Victorian preoccupation with the home environment. The behaviour of young people, who represented the city's future, was similarly seen as important. From the 1870s James Burn Russell zealously campaigned for more recreation grounds in order to provide an outlet for youthful energies via robust sport, like association football. Without such opportunities, Russell darkly hinted: 'Pent up in common stairs and back courts, without a space they can call their own, [boy's] play inevitably becomes in great part mischief.'[45]

The pervasive fear of 'moral mischief' was countered through a variety of measures, some controlled by the municipal authority, others, notably the temperance movement, through voluntary and religious agencies. Drunkenness was identified as one of the scourges of Victorian Glasgow, and its eradication was the mission of dedicated and influential activists. For instance, Lord Provosts Sir William Collins and Sir Samuel Chisholm were indelibly identified with the temperance crusade. Collins made much of his status as the city's first teetotal civic head between 1877 and 1880, when he was irreverently known as 'Water Willie'. His protégé, Chisholm, was intimately bound up with the progress of the City Improvement Trust and its housing operations from 1888, and was instrumental in introducing prohibition in all Corporation properties from the 1890s. Chisholm steadfastly believed that every social evil in Glasgow could be attributed to the baleful effects of alcohol, and described the city's slums as 'the masterpiece of the drink traffic'.[46]

As historian Bernard Aspinwall has shown, the temperance crusade flourished in Glasgow before 1914, and was given practical and motivational support from the American temperance movement.[47] Organisations such as the Good Templars, characterised by their elaborate regalia and ritual, were introduced to Scotland from the United States in 1869, and thereafter established a popular base of support in Glasgow. Earlier organisations, like the children's Band of Hope, survived well into the twentieth century. For all the prohibitionist strictures of civic leaders like Chisholm, temperance societies were socially significant for working men and women, as they offered a lively programme of entertainments. Singing, soirées and excursions formed only part of a range of organised, drink-free activities.

Compulsory education provided further hopes in Glasgow that 'moral mischief' could be eradicated among the young. After years of official government investigation into the deficiencies of Scotland's educational provision, particularly in populous urban communities like Glasgow, a new system of elected School Boards was inaugurated in 1872.[48] Although some denominational schools did not come under the Glasgow Board's authority, notably those for Roman Catholics, all city children between the ages of five to thirteen were obliged to undertake elementary education. Despite the persistent problems of truancy and an initial gross inadequacy in the number of school buildings, the resulting transformation in standards was profound. Increasing

the leaving-age to fourteen in 1901 ensured that they continued to rise. Seventy-five new Board schools were constructed in Glasgow between 1874 and 1916, and Charles Rennie Mackintosh designed two of them – Martyrs' Public School and Scotland Street School – both now open to the public and part of the Museums Service. At the same time, the appearance of several prestigious and select non-Board schools demonstrated the voracious demand for education from wealthy suburbanites; for instance, Westbourne School for 'young ladies' and Kelvinside Academy were opened in the West End during the 1870s.

Improved educational provision meant a sharp increase in literacy standards, which in turn helped to boost the fortunes of Glasgow's press. Initial stimulus had been given in 1855, with the removal of a prohibitive government stamp duty, the so-called 'tax on knowledge'. This allowed broadsheets like the *Glasgow Herald*, founded in 1783, to go daily. Improved printing technology and transport developments by the last quarter of the century meant that circulation soared. In his memoirs, the novelist and journalist Neil Munro provided considerable insight into Glasgow's press expansion at this time. Until the 1880s there was a distinctly masculine dimension to newspaper reporting, as it was assumed that women took little interest in the media. However, evening newspapers, such as the *Evening Times* and *Evening Citizen*, identified a market opportunity, and their columns began to feature more 'gaiety and gossip'. As Munro wryly put it, this attracted 'considerably more readers than whole pages of Parliamentary or Stock Exchange intelligence'.[49] Humorous and satirical magazines, such as *The Bailie*, *Chiel* and *Quiz*, also began to proliferate during the late nineteenth century. By the 1900s Glasgow had one of the largest mass readerships in the United Kingdom, and new popular newspapers, such as the *Daily Record*, founded in 1895, provided a foretaste of twentieth-century tabloid journalism.

The growing appetite of Glaswegians for newspapers and journals was not only indicative of a literate population; it also revealed that the period was an era of assertive consumer culture. Increased wages and generally stable prices allowed for more disposable income, leading to greater sales competitiveness. Of course, periods of recession cut across the consumer boom, but Glasgow's retail and service sector was increasingly of economic significance. The accessibility of transport had helped to open out the city centre for shopping; in 1874 the new department store of Copeland & Lye was enticing patrons with the information that 'the Cowcaddens Tramway Cars pass the door every five minutes'.[50] The previous Christmas, John Anderson's Royal Polytechnic store was advertising 'piles upon piles of the rarest toys', which reposed in its 'spacious magic caves'; a fairy-tale sales pitch specifically directed at 'juvenile members' of the family.[51] Similar large-scale establishments, such as Walter Wilson's Colosseum, gave Glasgow a leading reputation for retail excellence, while from the 1860s the co-operative movement represented a consciously collective enterprise, providing a range of affordable goods to the working classes.

Consumer culture also related to the food and drink

trade. Increasing emphasis was placed on quality as well as quantity. For instance, J. & R. Tennent, of Wellpark Brewery, set a new vogue in drink habits by bringing German expertise to Glasgow and producing light lagers from the 1880s. Reflecting this trend, public house owners had become acutely sensitive to temperance attacks, and made concerted efforts to promote a more favourable image. From their earlier functional appearance, drinking establishments became attractively decorated, with spacious interiors, although in general they remained all-male preserves.

Women were catered for in Glasgow's celebrated tearooms, which, according to the detailed appraisal of James Hamilton Muir, had become a cultural phenomenon by 1901. In particular, he singled out the 'ingenious and beautiful decorations' of Kate Cranston's tearoom in Buchanan Street, the city's most prestigious shopping thoroughfare.[52] The elaborate stencilling work was, in fact, designed by Mackintosh, although contemporaries described their effect as typically 'Kate Cranston-ish'. The formidable doyenne of the Glasgow catering trade came from a radical, pro-temperance family, showing how Victorian cultural preferences could shape a successful business enterprise.

Leisure as an industry was reflected in many ways by the late nineteenth century. Transport developments allowed for greater mobility, and not just for the city's dedicated shoppers. The expansion of rail and steam-shipping services meant that excursions and vacations became a popular summer-time option, especially to Clyde Coast resorts such as Largs or Dunoon. Competitive sport, above all the passionately supported game of association football, also benefited from improved transportation because teams could travel increasingly further afield. Railways allowed for professional, London-based theatre companies to penetrate northwards, and shipping services brought celebrated performers from around the world. Imposing, custom-designed playhouses, with programmes ranging from classical drama to variety, emerged in Glasgow from the 1870s. By 1910 the city had fifteen such theatres.

New 'electric' cinema technology had also made a deep impression on the popular consciousness. In 1896 the first public picture-show had attracted crowds to the Ice Skating Palace in Sauchiehall Street.[53] Initially a novelty that interspersed variety acts, the progress of the industry was rapid. The Charing Cross Electric Theatre, Glasgow's first purpose-built cinema, opened in 1910. It was a telling indicator that the new entertainment had established a permanent and lucrative base in the city.

Of course, Glasgow Corporation continued to offer opportunities for leisure in the city. As a further sign of rising literacy levels, a branch library service was inaugurated from 1898, largely on the initiative of Daniel Macaulay Stevenson, a future Lord Provost.[54] The Mitchell Library, the largest public reference library in Europe, had opened in 1877, as the result of a bequest by Stephen Mitchell, a Glasgow tobacco manufacturer. At the same time, the acquisition and embellishment of municipal parks continued. Partly in response to criticism that Kelvingrove Park was attracting the lion's share of civic funding, the People's Palace was opened

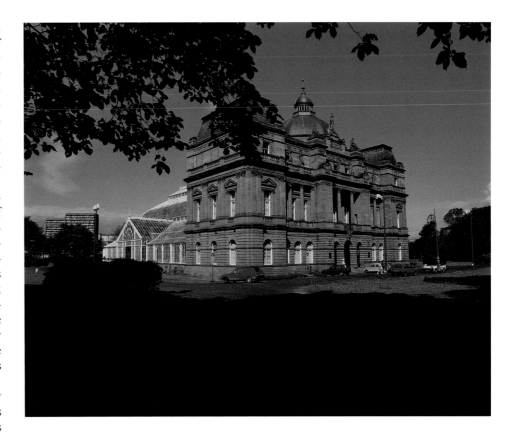

23. *The People's Palace*
Glasgow Museums

on Glasgow Green in 1898. A mixture of museum, art gallery and public hall, with winter gardens attached, its purpose, as James Paton suggested, was to present 'recreative, innocent, and elevating attractions to the humble and untutored'.[55] The provision of 'rational' recreation was still clearly to the forefront of civic thinking. The area of the city's parks and open spaces quadrupled from 146 hectares in 1872 to 632 hectares in 1914, at a period when the total territory of Glasgow expanded to accommodate over a million inhabitants.

Politics and the 'Model Municipality'

Historian John McCaffrey has described Scotland's political orientation during the mid-Victorian period as so firmly identified with Liberalism that it was virtually a one-party state.[56] Glasgow was no different; members of parliament and town councillors, elected since 1868 by all male householders, overwhelmingly declared their Liberal allegiance. When elections were contested, the candidates often represented different wings of the Liberal party, rather than distinct opposition parties, like the Conservatives. Liberal ideology extended over a spectrum of opinion that ranged from patrician Whigs, who believed in reform as a safeguard against social fragmentation, to libertarian radicals, who believed in assertive individualism and minimal state control.

Undoubtedly, Glasgow's brand of Liberalism derived much from the strong free-trade sentiments that been expressed even in the late eighteenth century, although the evolution of party organisation was a much later phenomenon. Yet factors such as religion and cultural values were also important. In civic policy, the influence

of evangelical Presbyterianism had been evident from the early nineteenth century. Devotion to the public service was part of a deeply ingrained religious ethos, which identified the need for a harmoniously integrated society, under enlightened, paternalistic leadership. Thus, City Improvement Trust operations may have had a material rationale, in terms of opening out the urban heartland for the benefit of commerce, but the moral commitment of evangelical Liberals like Lord Provost John Blackie, junior, was genuine. This visionary ideal also had the benefit of alerting Glaswegians to their social responsibilities and providing a focus for unity centred upon community identity.

By the 1880s, however, Glasgow's mid-Victorian Liberal hegemony was fracturing. There were complex reasons for the tensions that emerged, although it was perhaps inevitable that such a multi-faceted organisation should have been prone to internal conflict. Strong personalities, in a party that promoted the motivational virtues of individualism, could easily clash over the best means of furthering policy and ideas. That Liberalism was also identified with the Glasgow commercial establishment, as represented by a close circle of wealthy businessmen, provoked resentment within the increasingly assertive labour movement. The collapse of the City of Glasgow Bank was a chastening sign that there could be distorted values at the top.

By 1888 James Keir Hardie, one of the pioneers of British Labour politics, had become disenchanted with the Liberal party's failure to promote working-class trade union activists, such as himself. In Glasgow that year he helped to found the Scottish Labour Party (SLP) a radical organisation that took a distinctively 'independent' stance from orthodox Liberalism.[57] The first political organisation in the United Kingdom to call itself 'Labour', the SLP merged with the British-wide Independent Labour Party (ILP), formed in 1893. Two years later Glasgow's first ILP town councillor, P. G. Stewart, was returned to the City Chambers. By 1914 he had been joined by a small but purposeful group of Labour colleagues.

The fledgling Labour organisations included erstwhile Liberals like Hardie, and there could still be shared objectives, notably with radical Liberals. Both sides promoted issues like land reform, social welfare and Scottish and Irish Home Rule. The Irish question was an important theme in Glasgow's politics, given the substantial percentage of the population who were Irish-born or of Irish parentage. For instance, John Ferguson, originally from Belfast, was an active Irish nationalist, but also a founder member of the SLP and an outspoken and crusading town councillor from 1893. His prominence was a sign of the gradual but growing integration of the Irish community in Glasgow.

Conversely, there were those who strenuously opposed Irish Home Rule, seeing dangers to the integrity of the Union between Great Britain and Ireland, which might eventually break up the British Empire. In 1886 the declared Home Rule commitment of the Liberal Prime Minister, William Ewart Gladstone, caused a damaging rupture in the party. The dissident anti-Home Rulers immediately formed a new party, the Liberal Unionists, which in Glasgow collaborated with the minority Conservatives to challenge the Liberal power base. So successful was the connection that the two organisations merged in 1912, and became a potent force in electoral politics into the mid-twentieth century. Many prominent Glaswegians identified with Unionism, attracted by its vigorous promotion of imperialism and social reform.

A number of pre-1914 Lord Provosts were Liberal Unionists, such as Sir James Bell, a wealthy shipowner, who in 1896 produced an elaborate and detailed volume celebrating 'Greater Glasgow' and a century of civic achievement. In his introduction he itemised the services that had come directly under municipal control, including police, sanitary and recreation provision, plus the utilities of water, gas, electricity and tramways.[58] Until the consolidation of London County Council's administration by 1900, Glasgow Corporation employed the largest municipal workforce in the United Kingdom, totalling some 10,000 staff. As Bell pointed out, this scale of operations equalled that of 'a modest kingdom'.[59]

From the 1880s such intensity of commitment was designated 'municipal socialism', and its best-known practitioner was the three-times Mayor of Birmingham, Joseph Chamberlain. As the national leader of the Liberal Unionists, there was a clear ideological connection between Chamberlain and Lord Provost Bell, although municipal socialists were just as likely to be Liberal and Labour supporters. Moreover, civic interventionism in Scotland related to the long-standing tradition of the public good and the concern for regulation that characterised urban administration from at least the sixteenth century. There was thus continuity as well as change in approaches to Glasgow's municipal governance by the 1900s. However, the efficiency and excellence of municipal organisation made a profound impression on contemporaries, locally and internationally. By 1905 one promotional publication was claiming that 'the Glasgow citizen does few things without the aid of the Corporation', and went on to enumerate a lengthy list of public services provided for the inhabitants, literally from the cradle to the grave.[60]

Yet there were ambiguous responses to the ubiquity of civic provision in Glasgow. Some saw it as social welfare at its most beneficent, and lauded the city as the 'model municipality'. Albert Shaw, an American journalist and civic reformer, was one zealous publicist for the Corporation, and gave Glasgow pride of place in his 1895 investigation of the British municipal system. He noted with approval that the elected councillors were overwhelmingly men of business, 'upright, respected and successful citizens', devoted to the cause of public service.[61] Municipal politics was seen as remarkably untainted, and the rhetoric of cleanliness and order ran throughout Shaw's assessment of Glasgow. An evocative example was his description of the municipal wash-houses, popularly known as the 'steamies', where women could do the family laundry at the cost of twopence an hour. On the other hand, some critics saw municipal socialism as a euphemism for social control, and 'the oppressor of the West' became one of the more negative epithets used to describe the Corporation.

Thus, in the campaign for boundary expansion during the 1900s, aimed at incorporating the populous shipbuilding communities of Govan and Partick, concern was repeatedly expressed about the Corporation's 'imperialist' aspirations. One anti-annexationist pamphlet bluntly stated, 'there is no command to the citizens of Glasgow to go forth and possess the earth', although as the self-proclaimed 'Second City of the Empire' there was clearly irony in this argument for limiting local horizons.[62] Working-class support for the Labour party further intensified anxieties about the concentration of civic power; it was believed, over time, that control could conceivably fall into the hands of those who favoured municipal socialism of a more robustly red variety.

Another change in the long-term basis of civic representation by the early twentieth century was the right of women to stand for election as councillors. This was given legislative sanction in 1907, although it was not until 1911 that two Glasgow women put themselves forward as candidates. These pioneers were Margaret Ker and Marion Blackie, the niece of John Blackie, junior. Although unsuccessful, they reflected the growing assertiveness of well-qualified women who wished to participate in the city's representative institutions. The process had been ongoing since 1872, when women were allowed to participate in School Board elections. Ten years later the municipal vote was granted, giving female electors significant political influence in middle-class districts like the West End. Electoral rights were extended to county councils and parish councils in 1895. Scottish local government was therefore opening up for women, but the process was deliberately piecemeal, in order to avoid the impression that men's dominant position was being undermined.

This meant that the contentious goal of the female parliamentary franchise was not achieved until 1918 and then only for women over the age of 30. The sluggishness of progress provoked the women's suffrage movement to expose the hypocrisy of national and local politicians who fudged the issue of women's rights. Unlike the pro-suffrage ILP, the Liberal party was deeply divided over the matter. A campaign of militancy was inaugurated from 1908, when the Scottish headquarters of the Women's Social and Political Union (WSPU) was set up in Glasgow.[63] Although not immediately successful in its aims, the presence of the WSPU was a sign of fast-changing times, as the old political certainties of Glasgow were pugnaciously challenged in the years leading up to the First World War.

Conclusion

Glasgow, as an urban entity, altered profoundly between 1860 and 1914. During this period the city quadrupled in territory. The population also continued to grow, partly as a result of Glasgow's boundary expansion, partly because the city was a magnet for those seeking employment and other opportunities in one of Europe's most successful industrial communities. Glasgow's leading citizens had a very clear idea of their own self-image, which related back to the city's

deep roots as an ecclesiastical and trading centre. History and progress were dual motivating influences in the development of Glasgow, and particularly characterised the policies of municipal government. Above all there was a sense of confidence in the city's economic and civic achievements. In 1932 the writer J. J. Bell looked back over fifty years to his childhood in Glasgow, and summed up the period as 'the most fortunate decades the middle-class of this country has known'.[64] Yet, as this essay has shown, Glasgow's politically dominant middle classes also had anxieties, about the deteriorating urban fabric, about the health of the community, about the fluctuations of the city's economy. There were contrasting sides to Glasgow, even at a time when its reputation became firmly, if not enduringly, established as 'the Second City of the British Empire'.

[1] John Macqueen, 'The dear green place: St Mungo and Glasgow, 600–1966', in *Innes Review*, XLIII, 1992, pp.87–97.

[2] Anonymous quote from *The Perfect Politician* (1658), in the appendix to John McUre *A View of the City of Glasgow*, Glasgow, 1830 [1736], p.365.

[3] Gordon Jackson, 'Glasgow in transition, c.1660 to c.1740', in T.M. Devine and Gordon Jackson (eds), *Glasgow, Volume I: Beginnings to 1830*, Manchester, pp.74–6.

[4] Daniel Defoe, *A Tour Through the Whole Island of Great Britain*, London, 1971, p.610.

[5] T. M. Devine, 'The golden age of tobacco', in Devine and Jackson (eds), *Glasgow, Volume I: Beginnings to 1830*, pp.139–83.

[6] *Ibid.*, p.140–1.

[7] Quote from *Spencer's English Traveller* (1771), in George Macgregor, *The History of Glasgow: From the Earliest Period to the Present Time*, Glasgow, 1881, p.352.

[8] Stana Nendadic, 'The middle ranks and modernisation', in Devine and Jackson (eds), *Glasgow, Volume I*, pp.293–4.

[9] Sir John Sinclair, *The Statistical Account of Scotland, 1791–99: Vol. VII, Lanarkshire and Renfrewshire*, Wakefield, 1973, p.296.

[10] Richard Rodger, 'The labour force', in W. Hamish Fraser and Irene Maver (eds), *Glasgow, Volume II: 1830 to 1912*, Manchester, 1996, p.168.

[11] Stratten and Stratten [publishers], *Glasgow and Its Environs: A Literary, Commercial and Social Review Past and Present, with a Description of Its Leading Mercantile Houses and Commercial Enterprises*, London, 1891, pp.98–9.

[12] James Napier, *Life of Robert Napier of West Shandon*, Edinburgh and London, 1904, pp.148–59.

[13] Robert Gillespie, *Glasgow and the Clyde*, Glasgow, 1876, p.24.

[14] James Hamilton Muir, *Glasgow in 1901*, Glasgow and Edinburgh, 1901, pp.122–3.

[15] John Riddell, *The Clyde: The Making of a River*, Edinburgh, 2000, p.209.

[16] Sir Thomas Lipton, *Leaves from the Lipton Logs*, London, 1931, p.177.

[17] William West Watson, *Report Upon the Vital, Social and Economic Statistics of Glasgow for 1878*, Glasgow, 1879, p.9.

[18] See, for instance, the quote from Ray's *Account of Glasgow (1661)* in McUre, *A View of the City of Glasgow*, p.307.

[19] John Denholm, *The History of the City of Glasgow and Suburbs*, Glasgow, 1804, p.125.

[20] *Glasgow Examiner*, 10 May 1845.

[21] Irene Maver, *Glasgow*, Edinburgh, 2000, pp.90–2.

22 Edna Robertson, *Glasgow's Doctor: James Burn Russell, 1837–1904*, East Linton, 1998, p.22.

23 Brian Edwards, 'Glasgow improvements, 1866–1901', in Peter Reed (ed.), *Glasgow, the Forming of the City*, Edinburgh, 1999, pp.84–8.

24 Glasgow City Archives DTC 14.2.2, *Notes on Personal Observations and Inquiries in June, 1866, on the City Improvements of Paris, etc: with Appendix*, (privately printed municipal report, 1866), p.18.

25 John Carrick, 'Introductory chapter on the progress of Glasgow', in David Robertson [publisher], *Glasgow Past and Present*, vol.I, Glasgow, 1884, p.xxxi.

26 James Burn Russell, 'An address delivered at the opening of the section of public medicine at the annual meeting of the British Medical Association, Sheffield, August, 1876', in A. K. Chalmers (ed.), *Public Health Administration in Glasgow: A Memorial Volume of the Writings of J. B. Russell*, Glasgow, 1905, p.130.

27 Watson, *Report Upon the Vital, Social and Economic Statistics of Glasgow for 1878*, p.104.

28 *Ibid.*, p.16.

29 John Blackie, jnr, *The City Improvement Act: A Letter to the Lord Provost of Glasgow*, Glasgow, (privately printed), 1866, p.14.

30 Quoted from James Salmon's 1854 feuing plan for Dennistoun in Peter Reed, 'The Victorian suburb', in Reed (ed) *Glasgow, the Forming of the City*, pp.78–80.

31 Thomas A. Markus, Peter Robinson and Frank Arneil Walker, 'The shape of the city in space and stone', in Devine and Jackson (eds), *Glasgow, Volume I*, pp.124–5.

32 Gillespie, *Glasgow and the Clyde*, pp.15–16.

33 *Ibid.*, p.14.

34 Maver, *Glasgow*, pp.176–8.

35 Perilla Kinchin and Juliet Kinchin, *Glasgow's Great Exhibitions, 1888, 1901, 1938, 1988*, Wendlebury, 1988, pp.17–54.

36 Muir, *Glasgow in 1901*, p.21.

37 *Ibid.*, p.5.

38 *Ibid.*, p.136.

39 *Ibid.*, pp.140–1; but see the introduction Gavin Stamp and Sam McKinstry (eds), *'Greek' Thomson*, Edinburgh, 1999, p.xv.

40 Jude Burkhauser, 'The Glasgow Style', in Jude Burkhauser (ed.), *Glasgow Girls: Women in Art and Design, 1880–1920*, Edinburgh, 1990, pp.81–106.

41 James Paton, 'An Art Museum: Its Structural Requirements', in *Proceedings of the Philosophical Society of Glasgow*, XXII, 1890/91, p.138.

42 Muir, *Glasgow in 1901*, p.149.

43 Blackie in *The City Improvement Act*, p.5

44 Gillespie, *Glasgow and the Clyde*, p.21.

45 James Burn Russell, 'The children of our city – what can we do for them?', in Chalmers (ed.), *Public Health Administration in Glasgow*, p.316.

46 Quoted in the *Glasgow Herald*, 9 October 1902.

47 Bernard Aspinwall, 'The demon drink – the drift to prohibition', in Aspinwall, *Portable Utopia: Glasgow and the United States, 1820–1920*, Aberdeen, 1984, pp.106–50.

48 W. Hamish Fraser and Irene Maver, 'Tackling the problems', in Fraser and Maver (eds), *Glasgow, Volume*

II: 1830 to 1912, p.417.

49 Neil Munro, *The Brave Days: A Chronicle from the North*, Edinburgh, 1931, pp.137–8.

50 *The Bailie*, 16 September 1874.

51 *The Bailie*, 24 December 1873.

52 Muir, *Glasgow in 1901*, pp.166–7.

53 Bruce Peter, *100 Years of Glasgow's Amazing Cinemas*, Edinburgh, 1996, pp.1–3.

54 Glasgow Corporation, *Municipal Glasgow: Its Evolution and Enterprises*, Glasgow, 1914, p.89.

55 Paton, 'An art museum: its structural requirements', p.137

56 John McCaffrey, *Scotland in the Nineteenth Century*, Basingstoke, 1998, p.53.

57 Maver, *Glasgow*, p.152.

58 Sir James Bell and James Paton, *Glasgow, Its Municipal Organisation and Administration*, Glasgow, 1896, pp.xviii–xxiii.

59 *Ibid.*, p.xxiii.

60 Alan J. Woodward, *Glasgow's Industrial Souvenir*, Glasgow, 1905, pp.23–4.

61 Albert Shaw, *Municipal Government in Great Britain*, New York, 1895, p.77.

62 Quoted in S. G. Checkland, *The Upas Tree: Glasgow, 1875–1975*, Glasgow, 1975, p.29. The term originally appeared in the *Scottish Law Review* during 1905.

63 Elspeth King, *The Hidden History of Glasgow's Women: The Thenew Factor*, Edinburgh and London, 1993, p.93.

64 J. J. Bell, *I Remember* (Edinburgh: Porpoise Press, 1932), p.21.

A SHORT HISTORY OF KELVINGROVE
AND ITS COLLECTION OF FRENCH ART

The Art Gallery and Museum, Kelvingrove, situated just west of Glasgow city centre, is famed for its art collections. The Old Masters, which include fine Dutch, Flemish and Italian – especially Venetian – paintings, were largely given or bequeathed by important local collectors. The principal masterpieces were nearly all acquired before the present building – known to generations of Glaswegians as the 'Art Galleries' – was opened in 1901. The French collection is more particularly a twentieth-century phenomenon, its period of greatest expansion being in the years 1939–54, when the most significant Impressionist and Modern paintings were acquired. The collections of British, especially Scottish painting, have been built up by gift and by purchase over a longer period. As might be expected, Glasgow has an exceptional group of work by the Glasgow Boys, the 'school' of painters – inspired by James McNeill Whistler and contemporary French Realist art – which achieved international acclaim during the years 1880 to 1900. The debt owed by Scottish art to early twentieth-century French painting is epitomized by another group of artists, the Scottish Colourists, whose work was supported by Glasgow patrons in their lifetime.[1]

The present Art Gallery and Museum first opened its doors to the public on 2 May 1901, when it formed a major part of the Glasgow International Exhibition. For an understanding of how it came to be built one has to start the story in 1854. In this year Archibald McLellan (b.1797) died. Coachbuilder, art collector and prominent Glasgow citizen, McLellan bequeathed to the people of Glasgow his collection of over 400 paintings, along with the building in Sauchiehall Street – known still as the McLellan Galleries – for their display. Although he was insolvent at the time of his death, the Town Council, after heated discussion, agreed to meet the demands of McLellan's creditors, thereby securing the collection and building as intended. They both became the property of the City in 1856.

The McLellan paintings still form the backbone of Glasgow's Old Master collection. Dutch and Venetian schools are well represented, with one of the chief masterpieces being *The Adulteress Brought Before Christ*, attributed to Giorgione (then thought to be by Bonifazio Veronese). One major French painting, *St Maurice (or St Victor) with a Donor* by The Master of Moulins (then described as *St George* by Mabuse), entered the collection with the McLellan Bequest. This beautiful and rare work is one of only two by the artist held in British collections.

The first rudimentary catalogue of McLellan's collection prepared by curator Charles Heath Wilson in 1855 listed 427 paintings, of which some thirty were attributed to French artists.[2] A process of selection took place over the following years, involving the sale or disposal of paintings considered of lesser importance.

24. Mark Dessurne (active 1851–65)
Interior of McLellan Galleries, Glasgow, c.1860
Pencil and watercolour, 33.5 × 48.1cm
Glasgow Museums

By the 1880s, when the first official register of the collection was begun, 286 entries remained, of which fifteen were by French artists, mostly of the seventeenth and eighteenth centuries. The best surviving work of this period is *The Four Seasons*, formerly attributed to Simon Vouet (1590–1649).

Early views of the interiors of the McLellan Galleries show a typical Victorian hang, with pictures ranged one above the other. In the beginning the collection does not seem to have been greatly appreciated by the people of Glasgow. The rooms were used primarily for receptions and dances, and the paintings and sculpture were seen as an unnecessary encumbrance. When the Glasgow Institute of the Fine Arts was founded in 1861, its annual exhibitions were held in the McLellan Galleries, and the historic collection was taken down to accommodate them. At the time there was more interest in contemporary art than in the art of the past, although some artists, among them Sir Daniel Macnee, were enthusiastic advocates of the city's holdings.[3] Paintings continued to be added by gift and bequest, including in 1877 the collection formed by the portrait painter John Graham-Gilbert.[4]

In 1882 the City's collection was given a seal of approval by the report of J. C. Robinson, Her Majesty's Inspector of Pictures. Thereafter, as the museum's Annual Report observed, Glaswegians 'discovered that they possess an Art Gallery, which, in several respects, is entitled to rank with famous galleries, and an institution which they may not only enjoy themselves, but point out with pride to strangers as one of the sights of the city.'

The City Industrial Museum had opened in 1870 in the former Kelvingrove Mansion, a fine building of 1783 in the Adam style which had been absorbed into the new West End, or Kelvingrove Park. James Paton (1843–1921) was appointed the first overall Superintendent of Museums in 1876 in charge of the McLellan or Corporation Galleries of Art and of the Kelvingrove Museum, as the two institutions became

known. Paton, previously Assistant Keeper at the Edinburgh Museum of Science and Art, deserves to be much better known for his contribution to the arts in Glasgow. Under him the Galleries were greatly improved, and an innovative series of special exhibitions was held.

In a pamphlet published in 1886 Paton and James Hunter Dickson, Chairman of the Museum and Galleries Committee, commented on the present position of the Kelvingrove Museum and Galleries of Art in Glasgow. Their damning conclusion was that both buildings were overcrowded, and that the McLellan Galleries were a serious fire hazard which endangered the collection and hindered their proper use, 'The urgent want of the Art Galleries and Museum of Glasgow is an installment of a permanent building erected on a convenient and accessible site, sufficiently isolated to secure it from the risk of fire.' Their preferred site was in Kelvingrove Park.

Their zealous words were heeded by Glasgow's civic leaders. The International Exhibition of 1888 was held in Kelvingrove Park, backed by Glasgow's business and professional elite. This huge undertaking was both a statement of national and local pride and a rival to recent exhibitions in Edinburgh and Manchester; it was also a vehicle for funding the much-needed new Art Gallery, Museum and School of Art. The main temporary building of the International Exhibition, in an Oriental style by architect James Sellars (1843–88), stood virtually on the site chosen for the new building, facing the River Kelvin and overlooked by the University of Glasgow.

The exhibition ran from 8 May to 10 November 1888, was visited by 5.75 million people, and raised a healthy profit of over £40,000. The Association for the Encouragement of Art and Music in the City of Glasgow increased this figure by public subscription to over £120,000, and then – in 1891 – launched an open architectural competition for the new building. The adjudicator was the English architect Alfred Waterhouse R. A. (1830–1905), and the date for submission of six short-listed designs was 31 March 1892. Again Paton's role was crucial. He toured recently opened art museums in Europe and Great Britain, gathering information to include in the brief for the new Kelvingrove. The brief required: a Central or Music Hall giving easy access to all parts of the building; a suite of top-lit Art Galleries; Museum Halls, some roof-lit, some side-lit saloons; and a School of Art with separate entrance (later dropped from the scheme). Throughout, the construction was to be fireproof, and was to cost £120,000.

The result was announced in 1892, the winners being John W. Simpson and E. J. Milner Allen, joint architects, of London.[5] They described their design as 'an astylar composition on severely Classic lines, but with free Renaissance treatment in detail.' In other words, it was an eclectic mix of styles taken from a variety of sources. The overall impression is Neo-Gothic, with the steep pitched roof, elaborate towers and turrets giving a dramatic and ever changing outline. This was no doubt calculated to appeal to the taste of the adjudicator, Alfred Waterhouse, who was famed for his

Neo-Gothic essays such as the Natural History Museum at South Kensington in London. The details, however, both inside and out, are classically inspired. Perhaps the best description of the resultant style is Hispanic Baroque. Indeed, the two main towers are inspired by those of the great pilgrimage church of Santiago de Compostela in the north-west of Spain.

Ground was broken on 9 August 1893, and the basements were complete by June 1895. On 11 September 1896 the works were transferred to the Town Council for completion, as the Association had exhausted its funds – the final cost was to be in excess of £250,000. Looking ahead, the Council made the bold decision on 18 February 1897 to approve a second International Exhibition on the site, timed to coincide with the opening of the new Galleries in 1901. With a deadline established, the foundation stone was laid by George, Duke of York, on 10 September, and a scheme for sculptural adornment was devised by the senior architect, Simpson, and the renowned sculptor, George Frampton RA.[6] A competition for sculptors was held, and the result, announced on 2 December 1898, awarded Frampton the commission for the prestigious bronze group at the main entrance depicting Saint Mungo as Patron of the Arts, together with the low sandstone reliefs in the spandrels of the portico.[7] The bold modelling of the former and the delicious *fin de siècle* flavour of the latter mark this ensemble as one of the most appealing in late Victorian sculpture. The north entrance is topped by four huge carved figures by Derwent Wood RA, depicting Music, Architecture, Sculpture and Painting.[8] The portico and the two soaring main towers were embellished with bronze winged-figures, sadly since lost, of Victory, Glory and Fame by local man A. MacFarlane Shannan.[9] Other figures by lesser sculptors and low reliefs adorn the exterior; they bespeak arts and learning, local and national pride. Reliefs in the interior are adorned with names from Scottish history and learning, the ancient guilds of Glasgow and the great masters of European music – all symbols of the uses for which the building was intended.

The enduring character of the new building was determined by the materials used. The *Architectural Review* gave a good description in 1901, 'The masonry is of Locharbriggs red stone outside and of white Giffnock inside. The roofs are covered with

25. Joseph Henderson (1832–1908) *James Paton*, 1897 Oil on canvas, 68.6 × 57.2cm Glasgow Museums: Art Gallery and Museum, Kelvingrove

26. *Kelvingrove Mansion (City Industrial Museum)*, c.1870 Glasgow Museums: Art Gallery and Museum, Kelvingrove

Westmoreland green slates on iron framing, and, whenever possible, wood construction has been avoided. A great part of the roof covering is of concrete laid with Val de Travers asphalt. The flooring throughout is fireproof. The galleries are all laid with narrow widths of polished Moulmein teak, and all the courts, promenades, and Central Hall are paved with polished Italian, Belgian and Norwegian marbles in varying designs. The joinery throughout is of picked American walnut. There is a central court and two wings east and west, with galleries running all round, the whole very ample, spacious, and dignified.' The Central Hall is of imperial proportions and by far the grandest part of the interior. Its barrel vault with sunken panels preserves the original rich colour scheme of gold, deep red and sky blue, and the marble floor echoes the design. The east and west courts have grand staircases, but the actual galleries are understated so that prominence can be given to exhibits. The attractive red sandstone from the Locharbriggs quarry, near Dumfries, was to be seen throughout Glasgow from the 1890s, when it superseded the blond stone of the Giffnock quarry on the south side of the City. It is quite usual to see the two types combined in one building at this time, with preference given to the red. The core construction of Kelvingrove, as revealed inside the basement area, is of red brick; the facing stone of the interior is in parts just eight inches (20cm) thick. The vault of the Central Hall is an early example of cast concrete. The only obvious concession to the contemporaneous Art Nouveau style is to be seen in the elegant curves of the door fitments and in the brass light fittings of the courts. These are much admired to this day, although large glass globes have replaced some of the delicate bell-shaped shades. We are not certain who was responsible for their design.

Ask any Glaswegian about Kelvingrove, and he or she will probably repeat the urban myth that the museum was built the wrong way round, and that as a result the architect leapt to his death from one of the towers. The truth is that the building was intended to be a feature of Kelvingrove Park, facing north over the River Kelvin up to the imposing Neo-Gothic pile of Glasgow University. The fact that most visitors enter from what is now the main road, Argyle Street, may account for this enduring myth.

Kelvingrove never looked more splendid than it did on opening day, 2 May 1901. The temporary buildings of the International Exhibition presented a feast of white, gold, red and green. The main Industrial Hall, designed by James Miller (1860–1947) in a florid Spanish Renaissance style, was a perfect foil to the adjacent sturdy new red sandstone building by Simpson and Allen. Other pavilions in even more exotic or whimsical styles decorated the Park – and a gondola from Venice plied on the River Kelvin. The opening of the Exhibition and of the Art Gallery and Museum was performed by Princess Louise, Duchess of Fife, eldest daughter of the new King Edward VII. The party wore half-mourning because of the death in January of Queen Victoria, and there was less bunting perhaps than usual, but it was still a great occasion.

For the duration of the Exhibition the new building hosted a huge loan display of British art of the nine-

teenth century, reflecting the Victorian taste for anecdotal subjects. The loans, however, also included an impressive number from Scottish collectors, of modern foreign oils (over 200, mostly French) and watercolours (over 100, mostly Dutch). The ground floor was given over to Scottish history, with one gallery for photography. The most eye-catching section was the Central Hall, which fulfilled its intended long-term purpose of Sculpture Court. For the opening day a large supply of potted plants and palm trees was brought in to complement the marbles, plasters and bronzes by contemporary British and European sculptors (including Rodin). These provided an exotic visual feast, as is seen in the superb souvenir photographs taken by the famous Glaswegian photographer, James Craig Annan (1864–1946).

The International Exhibition lasted until 9 November, attracting 11.5 million visitors. The resulting profit of £39,000 was set aside for the promotion of art and science in the city, becoming effectively the Museum's purchase fund for many years to come.

After closure the site was cleared of the temporary buildings and returned to parkland. The old Kelvingrove House had been demolished in 1899 during preparations for the exhibition, a decision which caused controversy at the time and has been much lamented since. The Corporation (McLellan) Galleries remained open until 20 September 1902, receiving 79,000 visitors in their last nine months. Then began the huge task of installing the displays in the new Art Gallery and Museum in time for opening on 25 October. The layout was simple, a result of Paton's planning: Fine Arts on the upper floors; Natural History in the East Wing; Technology and Archaeology in the West Wing; Sculpture in the Central Hall. The Lord Provost of Glasgow, Sir John U. Primrose, declared the institution open before 4,000 citizens, and interest was so great that 300,000 visitors passed through its doors before the end of the year. Admission was free, opening was from 10am until 9.30 pm and the magnificent organ by Lewis & Co. (London) played on Wednesday and Saturday evenings. The inauguration was celebrated by an exhibition of pictures and other works of art by French and British artists of the eighteenth century; over sixty artists were represented, and lenders included The Duke of Westminster and J. Pierpont Morgan.

On opening day in 1902 there were 850 oil paintings in the City's collection, of which some thirty were listed as French. Among them was Corot's *Pastorale* (cat.15) and works by Troyon and Jacque, part of the important group given in 1896 by the family of the

27. James Sellars (1843–88)
Perspective View of the Principal Buildings of the Glasgow International Exhibition, 1888
Pen, watercolour and wash, 34.5 × 116cm
Glasgow Museums: Art Gallery and Museum, Kelvingrove

great railway locomotive builder and art connoisseur James Reid. These form the nucleus of the nineteenth-century French collection. Of the 850 oil paintings in the City's collection, the vast majority had been given or bequeathed, only 18 having been bought from funds made available by the City. The most important of these purchases was Whistler's portrait of *Thomas Carlyle, Arrangement in Grey and Black, Number 2*, the partner to the portrait of Whistler's *Mother* (Louvre, Paris). The first work by the artist to enter a public collection, the portrait of Carlyle was bought in 1891 for £1,050, following representations made by James Guthrie and the Glasgow Boys.[10]

The new building was an enormous success. Typical annual attendance figures through the 1880s and 1890s at the old Kelvingrove Museum of 200,000 and at the Corporation Galleries of 100,000 were transformed into 1.1 million for the calendar year 1903, repeated in 1904. In the same year an annual drawing competition for children was instigated, initially confined to Natural History objects but soon broadened to encompass everything in the museum. Its success in introducing young people to the collections has ensured its continuation to the present day, with the winning entries displayed in its own annual exhibition.

By the outbreak of war in 1914 there were over 1,000 oils in the collection. A pattern was set of buying from the annual exhibitions of the Royal Glasgow Institute of the Fine Arts. The buying committee was quite conservative, favouring 'exhibition pieces' – large figure-subjects, landscapes or seascapes by Scottish and English artists. Prices were fairly high, but the purchase fund created from the 1901 Exhibition profits

proved more than capable of meeting all the demands made on it.

In 1905 came the bequest of James Donald, a local chemical manufacturer, which included French Barbizon and Realist pictures, a good foundation on which the Gallery's Impressionist collection was later to be built. The outstanding work is Millet's *Going to Work* (cat.39). Other French pictures received at this time were by Diaz and Corot (from Mrs Isabella Elder, founder of Queen Margaret College for Women at Glasgow University) and Monticelli (from J. C. Alston). In 1913 an inspired purchase was made of Bastien-Lepage's *Poor Fauvette* (cat.1) for £1,470, the highest price paid to that date, by the City, for a work of art. This painting is of added significance for Glasgow's collection because of the influence exerted by this artist on the Glasgow Boys. In the same year John Richmond lent five of his French paintings, among which was Pissarro's *Tuileries Gardens* (cat.45), which must have looked very modern indeed at that time; it was to be presented many years later, in 1948. In 1925 the shipping magnate William Burrell gifted forty-eight paintings and drawings, including twenty-three by important French artists such as Bonvin, Courbet, Daumier, Millet, Boudin, Degas and Vuillard. These were later absorbed into the magnificent collection given to Glasgow by Sir William and Lady Burrell in 1944.[11]

Another significant benefaction was the Hamilton Bequest, which came into effect in 1927. This combined the estates of the late John Hamilton, storekeeper, and his two sisters Elizabeth and Christina, to fund the purchase of a group of paintings to be displayed in the gallery at Kelvingrove. The Trustees decided to leave the estate invested and to use the income to fulfil the wishes of the Hamiltons, with over eighty paintings having been presented to the museum since 1927. Funds initially provided an average of three paintings per year, mainly of the historic and contemporary British schools. French works were also acquired, including *Yellow Chrysanthemums* by Fantin-Latour in 1929 (cat.22), *Moonrise* by Harpignies in 1932 and the problematic *Expulsion of Adam and Eve from Paradise*, bought in 1933 as by Delacroix. The French pictures from the collections of Donald and Burrell may have encouraged the Trustees to choose these, as well as the renowned later French acquisitions, to enrich the City's collection.

When Glasgow Corporation advertised for a new Director of Art Galleries and Museums on 1 April 1939, it was clear that they were looking for an energetic person well versed in the arts to enliven the cultural life of the City. The man appointed on the casting vote of the Convener was Dr Tom J. Honeyman (1891–1971), a Glaswegian who had been employed with Alex Reid & Lefèvre, art dealers, in Glasgow and London; for ten years prior to that he had been a medical practitioner. His term of office was to be eventful in many ways, particularly in the realm of his first love, French art.

Honeyman was already well known in Glasgow artistic circles. When Reid & Lefèvre organized an exhibition of French art at the McLellan Galleries in 1934, he

almost succeeded in persuading the Hamilton Trustees to buy Van Gogh's *The Peasant* for the Kelvingrove collection but – as Honeyman commented – 'they had the money but not the foresight!'. He did, however, sell Cézanne's *Château de Medan* (ill.56) to William Burrell from the exhibition he organized at the same venue in 1937, and this masterpiece was to become the property of the City in due course.

Shortly before he took up his post, Honeyman was asked by John Fleming, Assistant Director, to advise on the selection for Kelvingrove of ten paintings from the estate of the late William J. Chrystal, partner in a Glasgow chemical company. Although the majority of Chrystal's collection was of Scottish genre paintings, landscapes and seascapes in the academic tradition, Honeyman was able to adjust the final choice to include nine French works, 'the cream of later developments in taste', by Daubigny (2), Monticelli (2), Fantin-Latour (2), Corot, Lhermitte and Ziem.

Soon after his appointment, the new Director had to face the problems of wartime. Restrictions such as the blackout, added perhaps to a slackening of interest in the Museum, resulted in visitor figures for the year July 1939–June 1940 of 228,000, the lowest ever on record. Then came the need for removal and safe storage of the valuable Old Master collection, and in March 1941 a land mine dropped nearby, the blast damaging both exhibits and building. These setbacks were, however, put to advantage by an energetic response. Objects previously hidden from view in store were given a new lease of life by being put on display, and a series of temporary shows was hosted, many of them with a morale-boosting theme to encourage the war effort. From 1939 until 1946 the annual exhibitions of the Royal Glasgow Institute of the Fine Arts were held in Kelvingrove, instead of their normal venue at the McLellan Galleries.

1941 saw the foundation of the Schools Museum Service (now the Museum Education Service), one of the first of its kind in Britain. Funded by the Corporation Education Department, it led to a huge increase in use of the collections and in the quality and quantity of visits by young people. The museum took over the running of the annual drawing competition and entries soared from 76 in 1939 to over 5,000 in 1944. Popular lectures were reintroduced, and publicity of any kind was sought through the press, advertising and radio. Attendance figures rose to over 900,000 in 1942–43. The Glasgow Art Gallery and Museums Association (now the Friends organization) was formed in 1944 and created a lively interest in events, lectures and private views. It also produced a quarterly journal, *The Scottish Art Review*. Picture conservation also began during the war years.

Of all the wartime exhibitions, Honeyman's favourite was – not surprisingly – *The Spirit of France*, held in June 1943, which included many paintings which subsequently made their way into the City's collections. The major Scottish public galleries, local collectors and friendly British dealers contributed 83 works in a stunning selection of the best French artists of the preceding 100 years, from Corot to Dufy – a fine gesture considering the very real risks of the time. This period saw the acquisition of many of the pictures which estab-

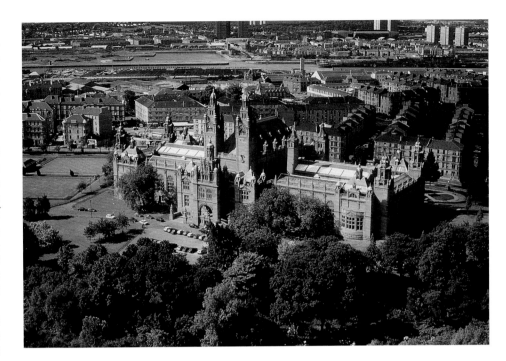

30. *Art Gallery and Museum from University Tower*, c.1990 Glasgow Museums: Art Gallery and Museum, Kelvingrove

lished Glasgow Art Gallery as the prime British gallery outside London for the study of French nineteenth- and early twentieth-century art. The collector William McInnes, a Glasgow shipowner, bought Matisse's *Woman in Oriental Dress* (cat.36) in 1940 and presented it to mark the appointment of his friend Honeyman as Director. In 1944 McInnes bequeathed his entire art collection – paintings, drawings, prints, silver, ceramics and glass – to the City. There are thirty-three French pictures in the bequest, and it is this group which accounts for much of the cream of the City's collection: Monet, Renoir, Van Gogh, Cézanne and Picasso, and a particularly fine Degas pastel of ballet dancers. McInnes also championed the work of the Glasgow Boys and the Scottish Colourists, of whom Leslie Hunter was his favourite.

A few minor gifts of French paintings from other local collectors were also received during wartime. These included work by Lhermitte, Mettling, and Le Sidaner. In addition, the sons of the connoisseur Leonard Gow gave Rodin's bronze *The Fall of an Angel* in 1944. The bargain of the era was surely Derain's *Blackfriars Bridge* (cat.19), bought on Honeyman's advice from Reid & Lefèvre in 1942 with £150 from the Gallery's annual purchase grant.

A major event of this period was the gift in 1944 by Sir William and Constance, Lady Burrell of their fabulous collection, which included a large group of important French nineteenth-century paintings. A sum of money was included in the gift to provide a building for the display of the collection. The City fathers pondered before accepting, mindful of the responsibilities which went with the gift. A number of conditions were attached, chief among which was that the collection was to be housed on a site not less than sixteen miles from Glasgow Royal Exchange in the city centre. Sir William's concern for the care and conservation of the works of art led him to try and ensure that they were situated in an environment with clean air.

Why was Glasgow chosen to receive such a munificent

31. *The Burrell pictures in the French Gallery, Kelvingrove*, 1957 *The Scotsman*, 28 August 1957

32. *Dr. T. J. Honeyman*
Private Collection

gift? Burrell did consider other options, including London County Council's proposal for a new building by the Thames, but in the end he chose his native city where he had made most of his fortune. The influence of Honeyman was vital. The two men had first met in 1929 through business at Reid & Lefèvre, and Burrell had provided a reference for the new Director in 1939. Honeyman's achievements in post, his great knowledge of art and his evident concern for the well-being of the valuable objects in his care were deciding factors, as Burrell readily acknowledged.

Significant purchases were made by the Hamilton Trustees during the war years. The number was small, but the quality was high. In addition to Rossetti and Romney, the work of Utrillo, Monet (the shimmering *View of Ventimiglia* [cat.41]), Sisley and Gauguin entered the collection. It was on Honeyman's recommendation that these works were acquired. His eye for quality and his contacts with the trade enabled him to secure some outstanding paintings when prices were affordable. Relations with the Hamilton Trustees were always good and they represented a major vehicle for Glasgow in the purchase of paintings.

In the years immediately following the war a number of exhibitions were held. Two of these were of great significance to the local public and are still talked about today. They are remembered both for the quality of their art, and also for the queues of visitors snaking around the outside of the Gallery. The *Picasso-Matisse* exhibition, organized by the Direction Générale des Relations Culturelles and toured under the joint auspices of the British Council and the Arts Council, had an attendance of 90,893 in the short period of 25 January until 10 February 1946. Twenty-four works painted by Picasso during the war and twenty-five by Matisse dating from 1896 to 1944 were on display. Modern art was something completely new to most of the Glasgow public, and many turned up out of curiosity – perhaps even to mock. The newspapers had a field day with editorials, cartoons and letters, mostly of indignation, and a variety of public comments: 'devilish and frightening'; 'just crazy'; 'If only they would paint something I understand (sigh!)'; 'If I was his model I'd be awful angry' (young woman); 'Let me oot a' here, I'm beginning to like them!'. Scottish artists were more measured in their statements. 'Picasso reveals terrific content in his work. His pictures are powerful decorations' (Benno Schotz, sculptor).[12] 'First impressions? Force and power. But is it worth while? Some of this stuff reminds me of Buchenwald.' (Hugh Adam Crawford,[13] Head of Drawing and Painting at Glasgow School of Art). The *Evening Citizen* newspaper observed: 'The 'arty' are all for it; the plain, ordinary folk are baffled and mostly against it.' Nevertheless, the show was a great publicity coup and raised awareness of trends in contemporary art and interest in the Gallery in general.

The second exhibition was devoted to Van Gogh, previously shown at London's Tate Gallery and in Birmingham. It was less controversial, and a rare and special treat for art lovers in the difficult period of post-war rebuilding. It attracted 103,347 visitors in just four weeks. A total of 100 paintings and eighty draw-

ings were exhibited, an amazing selection of almost all of the artist's best-known works. Engineer van Gogh, the son of Vincent's brother Theo, was a major lender and visited the exhibition. Robins Millar, the newspaper critic of both the *Citizen* and of the *Daily Express (Scotland)*, wrote: 'Dutch Van Gogh is, indeed, comparable to Scottish Robert Burns. Together they are of the few whose divine gift has been to bare the ego to essentials, address the feelings of the simple, at the same time creating beauty exquisite enough to stimulate the most sophisticated.' He rejoiced, 'This is the happiest, perhaps most stirring, exhibition of one man's painting ever seen in Glasgow.'

In November 1948 a separate post of Director of Museums was created, and Honeyman was designated as Director of Art Galleries, a move which he supported initially, as it freed up more time to devote to his main love, art.

The reputation of the Gallery continued to attract major benefactions. In 1948 Sir John Richmond gave the Pissarro *Tuileries Gardens* (cat.45) which had been on loan many years before, as well as the delightful Vuillard *Woman in Blue with Child* (cat.61), and works by Le Sidaner, Vollon, the Glasgow Boys, and of the Scottish Colourists. Then in 1950 came the gift from the Trustees of the late David W. T. Cargill of three superb paintings selected by Honeyman – Corot's *Mademoiselle de Foudras* (cat.14), Courbet's *Baskets of Flowers* (cat.16), and Seurat's *Boy Sitting in a Meadow* (cat.52). The remainder of Cargill's collection, built up partly on Honeyman's advice in his previous career as a dealer, included Cézanne, Renoir, Van Gogh, Seurat, Toulouse-Lautrec and Gauguin. It was sold, mostly in America, and the proceeds were used to augment the Cargill Fund, a trust which continues to support the arts throughout Scotland.

There were occasional setbacks, failures or disappointments in the area of Gallery acquisitions. One of these concerned William Cargill, the half-brother of David. Honeyman had helped him with advice on the storage, display, documentation and conservation of his collection, placing some of the expertise of the Gallery at his disposal. But his hopes that one day the collection, like that of McInnes, might come to Kelvingrove, were dashed later in the 1950s. Cargill felt then that Glasgow's inaction on making a home for Sir William Burrell's collection gifted in 1944, together with a shift of resources towards the Museum as opposed to the Art Gallery side of its activity, showed a lack of commitment to art. When he died in 1962, his collection was sold for over £1million, including £105,000 for a Degas.

Cordial relations with the dealer A. J. McNeill Reid led to his gift in 1951 of a Degas bronze *Grande arabesque, premier temps*. A bust by Renoir of his wife was added by purchase from Reid & Lefèvre in 1954. The Hamilton Bequest continued to add significantly to the French and British collections in the post-war period: an early Signac in 1946, a Sickert view of Dieppe in 1949, and in 1951 a Guillaumin and the early Pissarro. Then in 1953 came Mary Cassatt's charming *The Young Girls* (cat.10). Two French pictures were bought using the Gallery's own purchase fund in 1951,

the Marcoussis still-life from Roland, Browse Delbanco, and another Guillaumin offered by Glasgow dealer Ian MacNicol. Rising prices were beginning to dictate a change in buying policy, with preference being given towards lesser-known or fringe artists.

The annual report of 1952 stated that the whole French Gallery had been redisplayed with nineteenth- and twentieth-century paintings, many from the Burrell gift, and could rightly boast 'one of the most comprehensive exhibitions in this country of this important period in French Art'. The most publicized event in this same year was undoubtedly the purchase of Salvador Dali's iconic painting *Christ of St John of the Cross*. Painted one year earlier, in 1951, it was on display in the Reid & Lefèvre Gallery in London when Honeyman first saw it. The Corporation Committee was enthusiastic when purchase was proposed. The City Treasurer established that the 1901 Exhibition Surplus Fund held just enough to cover the price of £8,200 and that it could be used for this purpose. Despite protests occasioned by aesthetic and financial considerations, the acquisition went ahead, with the price including copyright – a master stroke in light of the income later generated through reproductions. Detractors included both traditional and modernist art critics, who felt the painting had no place in twentieth-century art and saw it as another of Dali's tricks. Students from Glasgow School of Art presented a large petition at the City Chambers, but were not heard by Committee. They felt the money could be better spent on buying a variety of lower-priced works, and on encouraging young local artists by providing regular exhibition space. Some citizens thought, mistakenly, that the huge sum could be diverted to social causes. Generally, however, the public accepted the new purchase with pride and wonderment. When it went on display in June 1952 in a special gallery setting, they contributed gladly to the art fund collection box placed nearby. Honeyman, whose friendship with Dali stretched back to his London exhibition of 1936, defended the picture vigorously, describing it as 'an art event' in itself. It is amazing to reflect that season ticket holders of the International Exhibition of 1901 helped to pay for this picture over fifty years later.

The publication of a catalogue of French Paintings in 1953 under the aegis of Glasgow Art Gallery and Museums Association listed 352 pictures from the Kelvingrove and Burrell collections. Only a selection of the best could be shown at a given time, but worth noting are the strong holdings of Degas (23), Daumier (19), Monticelli (19), Bonvin (16), Boudin (14), Corot (13), Millet (13), Fantin-Latour (12) and Courbet, Géricault and Manet (9 each).

Perhaps the most significant event in 1953, though, was the resignation of Tom Honeyman on 'medical advice' – his autobiography explains that he had lost the support of certain powerful local politicians. Honeyman's achievements were recognized in some of the honours bestowed upon him by the City: the St Mungo Prize (for contributions to the amenities, welfare and prosperity of Glasgow) in 1943; election as Rector of Glasgow University in 1953; Honorary LLD, Glasgow University, 1956; and the Lord Provost's Award for Visual Arts in

2000. The latter was awarded posthumously in recognition of the enduring effects of his efforts and was graciously accepted on his behalf by his daughter in a ceremony at the City Chambers of Glasgow.

The well-known writer and aesthetician Quentin Bell, in a series on Britain's *Forgotten Galleries* in *The Listener* in 1959, enthused about the French pictures: 'Room V makes Glasgow unique among municipal galleries,' he declared. 'Almost all the French painters of importance, from Géricault to Derain, are represented, some of them abundantly. A collection such as this is beyond the dreams of other galleries.' He singled out for praise Seurat's 'impressively monumental' *Boy Sitting in a Meadow* (cat.52), with the words, 'despite the competition of Degas and Cézanne, Corot, Courbet and Géricault, it seems almost the finest thing in the gallery.'

Acquisitions continued despite the rise in prices on the market. The Hamilton Trustees bought a Marquet in 1955, a Camoin in 1957 and a Moret in 1962. A similar but smaller fund, that of the Bequest of Lady Moore, enabled the purchase of a Théodore Rousseau in 1957 and of a Maximilien Luce in 1975. Annual purchase grants were introduced by the Corporation after 1952, as the acquisition of the Dali had exhausted the last of the 1901 Exhibition Surplus Fund. In 1958 and 1959 these were used to buy paintings by Vlaminck, Friesz and Michel. The era of star gifts was not past – 1959 saw the presentation by the trustees and heirs of Elizabeth Macdonald of Rouault's *Circus Girl* (cat.49). It was given in memory of her husband, Duncan Macdonald, art dealer with Alex Reid, and a very old friend of Honeyman. Only a year later Mr and Mrs A. J. McNeill Reid gave their Dufy, *The Jetties of Trouville-Deauville* (cat.21).

The influence and generosity of the Reid family has been manifest at Kelvingrove for many years. In 1963–64 Mr and Mrs Reid lent a selection from paintings which hung usually in their home, in an exhibition entitled *Pictures to Live With*. Mostly British and French, these were not all by famous names, but among the outstanding pictures was Van Gogh's *Portrait of Alexander Reid* (cat.28). It remained on extended loan for a year after the exhibition, and in 1974 it was offered for sale by Reid & Lefèvre on behalf of Graham Reid, son of Mr and Mrs McNeill Reid. The asking price of £166,250 was – in view of the painting's importance – a modest one but it was, by far, the highest paid by Glasgow for a work of art. The picture was reserved to enable a fund-raising committee chaired by Tim B. Honeyman (son of Dr Tom) to secure the sum. By this time Government funds were available for British public galleries to assist art purchases up to 50 per cent of the price and the National Art Collections Fund donated £7,500. An unexpected contribution of £42,500 came from a London Trust. Smaller sums were given by a huge number of individuals and organizations, including members of the Gallery's Friends Association, leaving the City to pay a balance of less than £14,000 to secure the portrait.

With the departure by 1983 of Burrell works of art from Kelvingrove to their new building, adjustments had to be made in many displays, especially in the two French galleries. These were repainted and re-hung so

that the full range of the Kelvingrove collection could be seen for the first time in nearly 40 years. The main gallery was named the T. J. Honeyman Room in 1985 in honour of the past Director, as it contained so many of the treasures which he had such a great part in bringing to Glasgow. Recent significant new acquisitions included, in 1984, Breton's *The Reapers* (cat.8) and, the following year, Bernard's *Landscape, Saint-Briac* (cat.2). The two most recent French acquisitions are Leon-Albert Hayon's *Young Woman at Her Window*, 1874 purchased by the Hamilton Trustees in 1994, and Boudin's *Venice: Santa Maria della Salute and the Dogana Seen from Across the Grand Canal* (cat.6), presented by the family of W. F. Robertson of Glasgow (1882–1939) in 1996.

During the last two decades of the twentieth century, with the demise of the heavy industry which had been for centuries the basis of the City's prosperity – and which had helped fund its magnificent civic collections – Glasgow sought ways to re-invent itself as a 'post-industrial' city. Various campaigns were mounted and initiatives instigated, with the City's civic riches being one of the main focal points. The opening of the wonderful new home for The Burrell Collection in 1983 proved a turning point. The campaign continued with a series of citywide festivals, beginning with the Garden Festival in 1988. In 1990, Glasgow was European City of Culture – a surprise nomination to the many sceptics – but the year was an outstanding success. It proved that the City was justified in using its wealth of art – from its civic collections as part of a themed festival, or by one-off special exhibitions – to promote itself to an international audience.

In the run-up to the centenary of the Kelvingrove building in 2001, preparations began for a complete refurbishment and radical redisplay of the grand old building under the title of New Century Project; it is projected that the entire scheme will cost in the region of £25.5million. The award early in 2002 of a grant of £12.8million from the Heritage Lottery Fund has ensured that this imaginative and colossal project to take the much-loved Kelvingrove into the twenty-first century can proceed. The year 2006 is the expected date for the completion of this exciting project. The importance of the art collections, especially the French paintings, will remain as a magnet for visitors from home and abroad, and the revitalisation of Kelvingrove will ensure that visitors' experience will be equal to the exceptional quality of the works of art housed there.

[1] The Scottish Colourists: Samuel John Peploe (1871–1935), Francis Campbell Boileau Cadell (1883–1937), George Leslie Hunter (1877–1931) and John Duncan Ferguson (1874–1961).

[2] Charles Heath Wilson (1802–82). Artist, architect, teacher, writer and administrator. Director of Edinburgh School of Art and Head of Glasgow School of Design from 1849.

[3] Sir Daniel Macnee (1806–82). Leading Scottish portrait painter of his day, based in Glasgow and later Edinburgh. President of Royal Scottish Academy 1876, knighted 1877.

[4] John Graham-Gilbert (1794–1866). Glasgow portrait painter, born John Graham, assumed name Graham-Gilbert on marriage in 1834. President of West of Scotland Academy and a founder of Glasgow Institute of the Fine Arts, 1861. His art collection, which included Rembrandt's *Man in Armour*, was bequeathed to Glasgow Corporation by his widow.

[5] Sir John W. Simpson (1858–1933) was born in Scotland and settled in London. President of Royal Institute of British Architects 1919–20, Knighted 1924. Joint designer with Edmund John Milner Allen (1859–1912) of Art Gallery and Museum, Kelvingrove, 1892–1901.

[6] Sir George James Frampton (1860–1928). English sculptor, best known for his Peter Pan statue in Kensington Gardens, London. Devised (with John Simpson) scheme for sculptural decoration of Art Gallery and Museum Kelvingrove, Glasgow, and executed some of it himself. Knighted 1908.

[7] Saint Mungo, meaning 'dear one' was bishop of Glasgow in the 7th century AD. He is the patron saint of the City. The elements of the City's coat of arms – tree, bird, bell and fish holding a ring in its mouth – are all associated with the legends of Saint Mungo.

[8] Francis Derwent Wood (1871–1925). English sculptor, responsible for carved allegorical figures on Art Gallery and Museum, Kelvingrove, Glasgow. Modelling Master, Glasgow School of Art 1897–1901. Professor of Sculpture, Royal College of Art, London 1918–23.

[9] Archibald MacFarlane Shannan (1850–1915). Glasgow sculptor, responsible for (now lost) allegorical bronze figures on towers of Art Gallery and Museum, Kelvingrove, Glasgow, and for statue of Lord Kelvin in Kelvingrove Park (1913).

[10] Sir James Guthrie (1859–1930). Scottish painter, a leading figure of the avant-garde group known as the Glasgow Boys in 1880s and early 1890s. President of Royal Scottish Academy 1902–19.

[11] The Burrell Collection: The treasures of Sir William (1861–1958) and Constance, Lady Burrell's collection are, in addition to the French paintings, the arts of the Ancient Civilizations, the Near and Far East, and especially European art, covering textiles, metalwork, glass, woodwork, stone and ivory and ceramics as well as pictures. The Gothic period is the jewel, with some of the finest tapestries and stained glass in any public collection. The gathering in and storage of the collection, and its eventual display, was to be a major preoccupation for the City authorities for nearly 40 years after accepting its gift in 1944. It proved particularly difficult to find a site for the new building which met the stringent conditions of Burrell's Deed of Gift, and of his Will. The generous gift in 1966–67 by Mrs Anne Maxwell Macdonald and her family of 361 acres of Pollok Estate, along with the historic Pollok House and its magnificent collection of Spanish paintings, gave the rural setting with clean air desired by Burrell, albeit that Pollok was well within the City's boundaries. An open competition was held to design the building and the award-winning home for The Burrell Collection was opened to international acclaim in October 1983. After The People's Palace (1898) and the Art Gallery & Museum Kelvingrove (1902), The Burrell Collection is Glasgow's third purpose-built museum. The architects were Barry Gasson, John Meunier and Brit Andreson.

[12] Benno Schotz (1891–1984). Glasgow sculptor, born in Estonia, Head of Sculpture, Glasgow School of Art, 1938–61. Appointed Queen's Sculptor in Ordinary for Scotland 1963.

[13] Hugh Adam Crawford (1898–1982). Scottish painter. Teacher, later Head of Painting, Glasgow School of Art, 1925–48. Head of Gray's School of Art, Aberdeen, 1948–54. Principal of Duncan of Jordanstone College of Art, Dundee, 1954–64.

West of Scotland Collectors of Nineteenth-Century French Art

Developing Tastes

Divided between Kelvingrove Art Gallery and The Burrell Collection, Glasgow's collection of nineteenth-century French art is one of the most significant in Europe. The majority of works were brought into Scotland around the turn of the nineteenth century, when families such as the Coatses, the Burrells and the Gows made vast personal fortunes through investments in textiles and shipping. Throughout this period a new class of wealthy merchants and industrialists was emerging in and around Glasgow, anxious to invest in the trappings of aristocracy. They built magnificent houses as symbols of their rising status and equipped them with rich furnishings: Oriental carpets, screens and ceramics; antique furniture, silver and other *objets d'art*; and on the walls a selection of fine pictures.

In the second half of the nineteenth century Glasgow was the second city of the British Empire, enjoying huge economic expansion thanks to the growth of engineering, shipbuilding, textiles and chemical industries as well as other commercial enterprises. It is not surprising, therefore, that the majority of Scottish collectors came from the west coast, the Glasgow hinterland, although wealth was also generated in other Scottish cities such as Aberdeen (granite and flour), Dundee (jute and jam) and even the small town of Kirkcaldy, where the linoleum industry produced a huge fortune for the Nairn family. Many of these newly established families sought to emulate the great aristocratic collectors of the eighteenth century, who acquired their pictures and other works of art on the Grand Tour. To this end, they invested initially in Old Masters and the more established British artists such as Turner and Constable. In time, however, they became bolder in their tastes, looking to the Continent for their purchases and even brushing shoulders with the avant-garde. As a result, this period in Scotland saw the rise of the art market and the ascent of the dealer, acting as both intermediary and adviser to this modern breed of mercantile collector.

One of the earliest of the west coast collectors was Archibald McLellan (1797–1854),[1] the son of a Glasgow coachbuilder, who amassed a huge collection of several hundred works. These were mainly Italian, Dutch and Flemish Old Masters, all reflections of a fairly orthodox taste but including the intensely moving *Adulteress brought before Christ* (c.1508–10), attributed to Giorgione. With the characteristic beneficence which comes with achievement, and in order to perpetuate his own memory in grand style, McLellan generously bequeathed the entire collection to the City of Glasgow and promptly died insolvent, leaving Glasgow Corporation to foot the bill.

None of these early west coast collectors was interested in contemporary art, apart from the work of their fellow Scots. Fewer still were interested in French art, either modern or ancient. John Bell (d.1881), a typical Glasgow collector of this period, owned about 800 paintings, including works from the Italian and Spanish schools, as well as Dutch and Flemish art. Similarly, both William Euing (1788–1874) and Adam Teacher (1838/9–98) formed collections of Dutch and Flemish Old Masters, but showed little interest in French art, with the exception of Eugène Pavy's Orientalist paintings in the Teacher collection. Even the collection formed by the portrait painter John Graham-Gilbert (1794–1866) contained only one French picture, an idealised seventeenth-century landscape by Gaspar Dughet. British auction sales in the first half of the nineteenth century also reflect this lack of interest and William Buchanan, the most influential dealer of this period, makes scant reference to French art in his writings. Apart from a handful of works by Poussin and Claude, French art was generally unfashionable in Scotland at this time; and although in France eighteenth-century Rococo artists including Watteau, Boucher and Fragonard were enjoying a considerable revival, such art was considered too frivolous by the Presbyterian Scots. An exception is the enchanting *Fêtes Vénitiennes*, c.1717–19, by Watteau, which was owned by Lady Murray of Henderland and bequeathed to the National Galleries of Scotland in 1861.

By the mid 1870s, however, with the emergence of a new type of collector – altogether more sophisticated, educated and well travelled – a new taste for modern continental art began to form. Economic, social and educational links had been established with the Netherlands for centuries and, perhaps understandably, the dominating taste initially was for nineteenth-century Dutch art. The Hague School painters, as they were called, were interested mainly in landscape and genre scenes, which they painted with a concern for the changing effects of light and weather, and the Scottish collectors found much in their work with which they could identify. The Dutch were strict Protestants, the Scots likewise were brought up in the Calvinist tradition. The Dutch genre scenes of the kind produced by Joseph Israëls and Adolphe Artz were familiar to collectors through Scottish artists like Sir David Wilkie, drawing on the tradition of seventeenth-century Dutch art. Dutch landscapes, predominantly grey in tonality, also appeared familiar to the Scots collectors, reflecting the climate so common to both countries.

The first modern Dutch paintings to be shown publicly in Scotland were exhibited at the Royal Glasgow Institute of the Fine Arts during the 1860s, and by the 1870s Hague School paintings were being shown on a regular basis and had been absorbed into several collections. The tonal seascapes of Jacob Maris (1837–99) had a special appeal for the west coast collectors, many of whom were keen sailors. However, the most popular

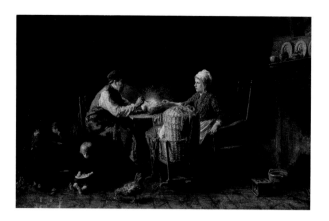

33. Josef Israëls (1824–1911)
The Frugal Meal, 1876
Oil on canvas, 88.9 × 138.7cm
Glasgow Museums: Art Gallery
and Museum, Kelvingrove

artist was probably Josef Israëls, whose nostalgic genre scenes have much in common with the work of the Scots artist G. P. Chalmers (1833–78). A typical work is *The Frugal Meal*, *c.*1876, (ill.33) owned by James Reid of Auchterarder (1823–94) – a humble scene of peasant life, painted without any hint of sentimentalism and bathed in Rembrandtesque light.[2]

Nearly all important British collections of this school were formed by Scots,[3] and although in England there were three prominent collectors – Sir John Day (1826–1908), James Staats Forbes (1823–1904) and Alexander Young (d. *c.*1910) – two of these, Forbes and Young, were Scots by birth.[4] James Staats Forbes was born in Aberdeen and worked for the Great Western Railway. His job took him to The Hague, where he was to spend eighteen years altogether, during which period he formed a close friendship with Josef Israëls. During his lifetime he acquired as many as 175 paintings by this artist, as well as a number of works by Jacob Maris and Anton Mauve. Young was born in Scotland and, although resident in London, made regular trips to Glasgow, where he was a client of the dealer Alex Reid. He collected mainly Barbizon paintings and his collection included fifty-three Corots and forty-three Daubignys. However, he also had a large number of Hague School paintings, including some fine pictures by Mauve, and works by Jacob and Willem Maris, Josef Israëls and Bosboom.

Apart from Forbes and Young the most important early Scots collectors of Hague School paintings included James Donald (1830–1905), A. J. Kirkpatrick (d.1900), T. G. Arthur (1857–1907) and John Reid (1861–1933) in Glasgow, R. T. Hamilton Bruce in Edinburgh and Alexander MacDonald (1837–84)[5] and John Forbes White (1831–1904)[6] in Aberdeen. White in particular was a key figure in encouraging a taste for the Hague School in Scotland. A flour miller, White was also an aesthete, author and an intellectual, versed in Greek and Latin and with a clear idea of his own tastes in art. He formed a close friendship with the Dutch artist Alexander Mollinger (1836–67), a follower of the Hague School, and in 1866 arranged for the young Scots painter George Reid (1841–1913) to visit the Netherlands and study under Mollinger. After Mollinger's premature death from consumption, White brought a large number of his works back to Scotland and sold them to Scottish collectors. He returned to Holland on several occasions and brought

back works by Artz, Israëls, Mauve, Jacob Maris, Roelofs and Bosboom. In 1870 he invited Joseph Israëls to stay at his summer residence, Seaton Cottage on the river Don, and introduced him to a close circle of Scottish artists, including George Reid, Hugh Cameron and G. P. Chalmers.

Despite the developing taste for Dutch and French art, the majority of collectors in the 1870s and 1880s continued to invest mainly in Scottish art. The dominating taste was for Romantic landscapes and rural genre scenes, although the historical genre pieces of artists such as W. Q. Orchardson (1832–1910) and John Pettie (1839–93) were also popular. The dramatic landscapes of Horatio McCulloch (1805–67) and the Turneresque visions of Sam Bough (1822–78) found particular favour with Scottish collectors, as did sentimentalising genre scenes of Scottish low-life of the type produced by Thomas Faed (1826–1900). The more Realist genre scenes created by Hugh Cameron (1835–1918) and G. P. Chalmers were also admired and collected by the Scots and made them more receptive to the work of Hague School painters such as Israëls.

All these artists, from Horatio McCulloch to G. P. Chalmers, indulged in a form of rural nostalgia, but the introduction of French art into Scottish collections during the 1870s and 1880s brought about a gradual shift in taste towards a more lyrical style of painting. The most popular artist was undoubtedly Camille Corot, whose pastoral idylls were collected in large numbers by the Victorians, and especially Alexander Young, who owned as many as fifty-three works by this artist. John Forbes White, however, was the first Scottish collector to acquire a Corot painting. This was *The River (La rivière)*, which had been shown at the International Exhibition in London in 1871 and which White had bought in *c.*1872–73 from the French dealer Durand-Ruel for £40.[7] His most important Corot purchase was *Pastorale*, 1873 (cat.15), a large poetic landscape which he bought from the Scots dealer Daniel Cottier (1839–91)[8] (whom he had previously employed as a stained glass designer) for £950 in September 1874.[9] White adored this picture, which represents a kind of pastoral arcadia populated by nymphs and satyrs: an image of pure escapism. He admired it for its subject-matter and its brilliant technique and described Corot as a 'master of light, air, breadth, simplicity and harmony'.[10] He was deeply unhappy when financial circumstances forced him to sell the picture in 1892 to James Reid of Auchterarder.[11]

After White, the next Scottish collector to invest in the work of Corot was James Duncan of Benmore. Duncan owned Corot's *Landscape with Figures (La Toilette)* (Private Collection, Paris) which, according to the dealer David Croal Thomson, was exhibited at the Glasgow Institute in 1872. Thomson records that it was the first Corot publicly exhibited in Scotland and 'gave rise to much discussion'.[12] However the only work by Corot to be shown at the Institute in that year was catalogued as *Morning* and was on sale (and therefore not on loan from a private collection) for £262. It was not until 1876 that Duncan loaned what was more probably *La Toilette*, catalogued simply as *Landscape with*

Figures. It shows a semi-nude figure being attended to by her maid in a woodland setting; in the background a third figure leans against a tree reading poetry. In Thomson's view it was 'not an attractive picture, and the result of the landscape having been painted outside while the figures were added in the studio, makes it a very uncomfortable kind of picture.'[13]

It is possible that Duncan, like White, bought *La Toilette* from Daniel Cottier, who held an important exhibition of the work of Corot, described as the 'largest collection ever made' in London[14] at 2 Langham Place in June 1875, shortly after the artist's death in February of that year. Although a stained glass manufacturer by trade, Cottier had moved into picture dealing by 1873. He stocked work by Courbet, Daubigny, Bonvin and others, which he obtained through the Goupil gallery in Paris,[15] and he also specialised in the work of the Hague School.

Although similar in many ways to the Hague School, Barbizon pictures were not received in Scotland with the same enthusiasm as the work of their Dutch followers. Only very few nineteenth-century French paintings were brought into Scotland during the 1860s and 1870s and initially the most popular French artists were Academic artists such as William Bouguereau (1825–1905) and Thomas Couture (1815–79). Also popular was the animal painter Rosa Bonheur (1822–99), who famously dressed in men's clothes in order to gain access to abattoirs, horse fairs and cattle markets. She gained her reputation as a brilliant *animalier* through her most famous painting *The Horse Fair* (Metropolitan Museum of Art, New York) which was shown at the Paris Salon of 1853. Her work was in Scottish collections as early as 1861 when Thomas Coats of Ferguslie lent *Sheep in a Meadow* to the Glasgow Institute.

Pictures by Corot and Charles François Daubigny (1817–78) were shown at the Glasgow Institute in the early 1870s,[16] but, as a general rule, it was not until after the death of these artists that the work of the Barbizon School was shown in Glasgow on a regular basis. The artists who were most popular during the 1880s were Corot and Diaz de la Peña, both of whom died in the mid-1870s and whose pictures share a certain lyrical quality, despite their dissimilar style. While Corot's work is characterised by an interest in light and, in his later works, the poetic evocation of landscape, Diaz was preoccupied with colour and surface texture and moved from a neo-Rococo style to a more Realist approach to landscape. An important precursor to Impressionism, he often experimented with complementary colours, building the pigment up in layers of thick impasto and even applying the paint straight from the tube in order to obtain a more brilliant effect.

Comparable with the lyrical works of Corot and Diaz, the escapist *fantaisies* of Fantin-Latour and Monticelli also became extremely popular in the late nineteenth century, perhaps because they represented a dramatically contrasting world to the Scottish industrial landscape at that time. John Forbes White, for example, bought Fantin-Latour's *Dream of Italy* to complement his Corot *Pastorale*. Nevertheless, a parallel taste

for more realist subject-matter was also developing. John McGavin, an early collector of Diaz, preferred his landscapes of the Forest of Fontainebleau to his more frivolous Rococo works.[17] He began collecting the work of the Barbizon school in the late 1870s, focusing initially on Corot and then adding Millet to his repertoire by 1881. A close contemporary, James Duncan of Benmore, also preferred Corot, Millet and Courbet – whose work he acquired from the mid 1870s onwards – to Diaz, Monticelli and Fantin. Even John Forbes White, the lover of Corot, preferred Realist paintings and was an early collector of Courbet.[18] A. B. Stewart and J. G. Sandeman were also early collectors of Courbet and owned work by the great master of Realism, as well as still-lifes by Fantin-Latour as early as 1878. As we shall see, this shift of taste towards more modern subject-matter was to have an important impact on collecting patterns in the last two decades of the nineteenth century.

The International Loan Exhibitions: a Reflection of Taste

The International Exhibitions of 1886 and 1888

As the century progressed art collecting became increasingly important in Scotland. New exhibiting bodies sprang up all over the country: in Glasgow, Paisley and Kilmarnock on the west coast, and in Edinburgh, Aberdeen and Dundee on the east. Both the Royal Scottish Academy and the Royal Glasgow Institute held annual art exhibitions – although the RGI was the more progressive establishment, providing a frequent platform for modern foreign art. Moreover, the catalogues for these exhibitions give a clear indication of developing taste on the west coast of Scotland, since they include a large number of works that were loaned from private collections.

In 1886 the Edinburgh collector R. T. Hamilton Bruce organised a special foreign loan section at the Edinburgh International Exhibition. A large number of Scottish collectors contributed works by French and Dutch artists to this exhibition, and also to the Glasgow International two years later. Together with the Institute catalogues, these two exhibitions provide a unique insight into artistic taste in Scotland towards the end of the nineteenth century.

The most important single contributor to the 1886 exhibition was undoubtedly James Staats Forbes, who loaned works by Josef Israëls and the Maris brothers, as well as a number of works by artists of the Barbizon School. During his lifetime Forbes collected well over 2,000 paintings, two-thirds of which consisted of nineteenth-century Dutch and French works.[19] Above all, he was an enthusiastic collector of Corot and by 1904 had amassed as many as thirty-seven works by this artist. He also owned Bastien-Lepage's *Poor Fauvette*, 1881 (cat.1), which was exhibited at the Fine Art Society in London in 1882 and would exercise a huge

influence on artists of the Glasgow School, such as James Guthrie and John Lavery.

The majority of French pictures included in the Edinburgh exhibition were contributed by collectors living and/or working in central Scotland. Apart from R. T. Hamilton Bruce, these included the Edinburgh collectors Alexander Bowman and Arthur Sanderson, and the Glasgow collectors Thomas Glen Arthur, Andrew J. Kirkpatrick and James Donald. All three west coast collectors came from industrial or manufacturing backgrounds: Arthur was director of Arthur & Co., an important haberdashery firm in Glasgow; Kirkpatrick and Donald both made their money from chemicals, an industry which had developed during the nineteenth century from the bleachworks that serviced the textile industry. Kirkpatrick was chief partner of Middleton & Kirkpatrick, an old Glasgow firm of chemical merchants; Donald was a partner in the Glasgow chemical manufacturing firm of George Miller & Co. Their wealth was considerable and they no longer felt the insecurity of the previous generation of industrialists; they were prepared to invest in modern art as well as in Old Masters, and during the 1890s two of these collectors – Arthur and Kirkpatrick – were to acquire Impressionist works. The third Glasgow collector, James Donald, was one of the earliest Scots to amass a comprehensive collection of Barbizon pictures, and the 1886 exhibition is a testament to his developing taste for nineteenth-century French art, as well as a tribute to his dealer, Craibe Angus (1830–99).

Angus was the Glasgow agent for Daniel Cottier, who apparently set him up in business in 1874, specialising in Hague School paintings and the work of the Barbizon School. He also stocked the work of the Glasgow Boys and Old Masters by artists such as Velasquez, who enjoyed an upsurge in popularity during the second half of the nineteenth century. Through Cottier he had access to a steady supply of Barbizon paintings, acquired through the Goupil gallery in Paris. Cottier's London agent, Elbert van Wisselingh, also had contacts in Amsterdam (where his father owned and ran his own art gallery) and was able to supply Hague School paintings to the London gallery and to Angus in Glasgow; a factor which played an important part in developing the market for both Dutch and French nineteenth-century art in Scotland.[20]

Both Cottier and Van Wisselingh sent works to the 1886 exhibition, and the importance of the Edinburgh loan collection as a reflection of taste in Scotland was widely recognised. The exhibition was reviewed both for the *Magazine of Art* and the *Saturday Art Review*. The critic R. A. M. Stevenson, a cousin of Robert Louis Stevenson, commented on the importance of Corot, who was well represented by no fewer than nineteen works. These included two pictures from James Donald's collection: *Evening* (Art Gallery and Museum, Kelvingrove)[21] and *The Woodcutter*, c.1865–70 (cat.13). The light tonality, sketchy handling and sense of movement in *The Woodcutter* lends the picture the freshness and spontaneity of a *plein-air* work; and it is notable that, whereas many Scots collectors of this period, such as James Staats Forbes and A. B. Stewart (1836–80),[22] admired Corot's later, poetic works, his dancing nymphs

and arcadian visions, Donald's taste was for the more Realist works. Rural labourers, rather than mythical creatures, inhabit the landscapes in the Donald collection: a solitary crayfisher working in the river, or a peasant woman tending cattle.

In addition to Corot, Daubigny was one of the best-represented landscape artists at the exhibition.[23] Donald owned a fine example of Daubigny's work, *Lake with Ducks*, 1873 (cat.18),[24] which typically captures the warm glow of twilight with an almost Impressionist palette of pinks and lilacs.

The exhibition included only a handful of works by other Barbizon artists such as Dupré, Théodore Rousseau, Millet and Troyon. Donald exhibited two works by Rousseau, recognised by this date as 'the centre figure of the Barbizon School'[25]. *The Forest of Clairbois*, c.1836–39 (cat.50), is a dense and vigorous work, thickly painted in contrasting shades of brown and green. Its characteristic foliage and broad technique draw on the tradition of Ruisdael, a factor which played an important part in Rousseau's early acceptance by British collectors.

This link with the tradition of Dutch seventeenth-century painting may also account for the popularity of Constant Troyon's work with Scots collectors. Troyon's animal paintings look back to the work of Cuyp and Paulus Potter, but his ability to capture the effect of a misty autumn morning, or the steam rising off the backs of a herd of cattle on a cold winter's day, was entirely modern. John McGavin owned a painting by Troyon as early as 1878 and both Arthur and Donald included examples of his work in the 1886 exhibition: Donald loaned *Sheep* of 1855 (Art Gallery and Museum, Kelvingrove), one of several animal pictures in his collection; Arthur, on the other hand, showed *Fishing Boat off Honfleur*, a far less typical seascape of the Normandy coast.

In general, pictures of the sea held a strong appeal for the west coast collectors. Both Kirkpatrick and Donald exhibited seascapes by Jules Dupré, Donald's an extremely dramatic work entitled *The Headland* (ill.34). Whereas Romantic artists such as Turner might have focused on the fate of a passing clipper, dashed to pieces against the treacherous rocks, Dupré expresses the power of the elements more subtly and abstractly through a rich palette and vigorous handling of paint. Kirkpatrick's Dupré, catalogued simply as *Marine*, was a similar type of stormy seascape, reflecting the collector's general preference for seascapes and atmospheric effects. Kirkpatrick was an early collector of the work of Jongkind, whose Normandy seascapes and nocturnes had a huge impact on the young Monet. He loaned two such works by Jongkind to the 1886 exhibition, including an atmospheric seascape entitled *Moonlight*.[26]

The most resonant nocturne at the exhibition was probably Millet's pastel, *The Sheepfold*, 1868 (ill.35), owned by Donald.[27] A waning moon casts an eerie glow over the remote misty plain between Barbizon and Chailly, as the shepherd encourages his flock into the fold. Millet's major works were becoming well known in Britain through the publication of monographs on the artist and, even before Donald, his work had been

absorbed into the collections of James Duncan and John McGavin.[28] Alfred Sensier's 1881 monograph and *Millet's Woodcuts and Etchings*, published in the same year, with a preface by W. E. Henley both recognised Millet's genius and judged him one of the leaders of the Barbizon School. His large-scale figurative works translated easily into black-and-white, and his reputation was soon made through the dissemination of his images and widespread discussion of their literary and symbolic content.

Sensier described Millet's shepherds as follows: 'The shepherd is not a countryman after the pattern of the labourers and other fieldworkers; he is an enigma, a mystery; he lives alone, his only companion his dog and his flock . . . He is the guardian, the guide, the physician of the flock. Besides he is a man of contemplation.' In this way Sensier was dispersing the modern image of the downtrodden rural worker and attempting to perpetuate a romantic notion of the shepherd as the 'man of contemplation', a sanitised and nostalgic vision of the peasant which might well have appealed to the urban collector of the late nineteenth century.

Certainly, images of goose girls and cowherds, especially by Troyon, are often to be found in Scottish collections, but there are also examples of more Realist images of working life. James Duncan of Benmore, for example, owned a Millet painting entitled *Sheep-Shearing* which he loaned to the Royal Glasgow Institute in 1880. And the jewel of Donald's collection was Millet's *Going to Work*, c.1850–51 (cat.39),[29] a masterpiece of French Realism, even if the peasants do appear to relish the hard day's work which awaits them.

Despite Millet's rising popularity, the most widely represented artist at the 1886 exhibition was Matthijs Maris (1839–1917), who was represented by no fewer than twenty-two works. Maris's popularity is testimony to the Scots' predilection for the Hague School and for 'escapist' art. His subjects are often poetic fantasies, set in a remote dreamworld, totally divorced from reality and closer to Symbolism than to the work of the other Hague school painters. Many of Maris's works were loaned by the Dutch dealer Elbert van Wisselingh, who invited the artist to live and work in London. He found Maris rooms in St John's Wood and provided him with a

regular salary, leaving him free to paint. In return, Maris provided the dealer with an inexhaustible stock of pictures, which he sent north to Craibe Angus in Glasgow.

As far as French art was concerned, the nearest equivalent to Maris lay in the lyrical and even, at times, mildly erotic *fantaisies* of Narcisse Diaz de la Peña and Adolphe Monticelli (1824–86), who were well represented at the Edinburgh exhibition.[30] Both artists were extremely popular with Scottish collectors, representing as they did a dramatically contrasting world to the Scottish industrial landscape during the second half of the nineteenth century. Diaz was an excellent self-promoter and enjoyed enormous commercial success during his lifetime, but there is no evidence of his work appearing in Scotland until after his death in 1876. The earliest collectors of Diaz's work were John McGavin and Andrew Kirkpatrick, who exhibited Diaz landscapes at the Royal Glasgow Institute in 1880 and 1881, respectively.

Diaz's style is closely comparable to that of Monticelli who developed his brilliant colour and thick impasto under the tutelage of the older artist. Monticelli's work found its way into Scottish collections largely through the efforts of Daniel Cottier, who met the artist through Matthijs Maris while he was living in London during the 1880s.[31] Cottier was captivated by his jewel-like *fête champêtres* and exhibited three pictures, including *The Ravine* (ill.36), at the International of 1886, coincidentally the year of Monticelli's death. Both Cottier and van Wisselingh had already found a ready market for the Marseilles artist's paintings among the Scots industrialists, including T. G. Arthur and William Connal. At the time, Monticelli's work was still relatively unknown in France, and it has often been remarked that Scots were among the first to appreciate his distinctive approach. T. G. Arthur and the Stirling-born William Connal

34. Jules Dupré (1811–89)
The Headland
Oil on canvas, 72.4 × 91.4cm
Glasgow Museums: Art Gallery and Museum, Kelvingrove

35. Jean-François Millet (1814–75)
The Sheepfold, 1868
Charcoal and pastel on paper, 72.1 × 95cm
Glasgow Museums: Art Gallery and Museum, Kelvingrove

36. Adolphe Monticelli
(1824–86)
The Ravine,
Oil on canvas, 36.8 × 26.7cm
Glasgow Museums: The
Burrell Collection

were among the earliest collectors of Monticelli, along with R. T. Hamilton Bruce and Arthur Sanderson. In keeping with the general aesthetic of Monticelli's work, Sanderson also collected the more poetic paintings of Corot and Fantin-Latour, while Connal preferred the 'neo-Symbolist' works of Burne-Jones, G. F. Watts and Albert Moore.

In May 1888 Glasgow decided to stage its own International Exhibition, designed in an Oriental style and on such a grand scale that it successfully put its east coast neighbour firmly in the shade. The Fine Arts Section occupied the south-east end of the Main Building and included 2,700 exhibits displayed in ten galleries, of which seven were reserved for paintings. As with the Edinburgh Exhibition, these were divided into British and Foreign, loan and sale collections.

Even in the two years that separate the Edinburgh and Glasgow exhibitions, a definite shift is detectable away from Hague School paintings and in favour of French art. A number of new French artists, previously virtually unknown in Scotland, were represented at the Glasgow exhibition. Names such as Bastien-Lepage, Rodin and even Degas appeared in the catalogue,[32] and while Corot and Diaz were still the most popular figures, further interest was being developed in the works of the more Realist artists.

In Gallery 5 a section was devoted to Foreign Pictures on sale. Among these was a work by Eugène Boudin – an artist virtually unknown in Glasgow – entitled *Etaples – Low Water*, priced at £65. It is possible that this work was loaned by the dealer Alex Reid, since he was developing an interest in Boudin around this time.[33] Reid is known to have loaned another French work, Puvis de Chavannes's *Ludus Pro Patria*, 1883 (ill.37), exhibited as *Ancient Picards Practising with Lances*, which he had bought from the French dealer Durand-Ruel.[34]

The biggest lender to the 1888 exhibition was the London collector Alexander Young (d. *c.*1910), who loaned twenty-seven works, mainly Barbizon paintings, and also Josef Israëls's *Fisherman Carrying a Drowned Man* (National Gallery, London)[35] which had caused a sensation at the London International Exhibition of 1862.

Once again, T. G. Arthur, James Donald and A. J. Kirkpatrick made important contributions to the exhibition. Arthur loaned seventeen works, including a number that had been shown in Edinburgh. These included Jacob Maris's *Souvenir of Dordrecht* (ill.38), Joseph Israëls's *Sleeping Child*, a Vollon still-life of

strawberries and Troyon's *Off Honfleur – Sunset*. Arthur had contributed mainly Hague School paintings to the 1886 exhibition, but the pictures he sent to Glasgow reveal his developing taste for French art, including two additional works by Troyon, *Goose Woman*, a characteristic 'herdsman' image, so typical of the artist and *Cattle* (Art Gallery and Museum, Kelvingrove), the latter a fresh and loosely handled work which was later acquired by Donald.

Arthur was a keen huntsman and his collection also included *The Chase*, an unusual work by Diaz which shows hounds at full cry. In general, however, he appears to have preferred Diaz's more Rococo works and he chose to exhibit *Conquering Love* (*L'Amour Vainqueur*), wrought in Diaz's characteristic highly coloured and richly impastoed style, rather than a more Realist subject. He also loaned similar subjects by Corot, including *The Bather* and *Dance of the Nymphs* (*Danse des Nymphes*).

In addition to these he included a nocturne by Rousseau and still-lifes by Fantin-Latour and Courbet, whose work was still relatively unknown in Scotland. Indeed, only two other works by Courbet were shown at the 1888 exhibition – a second still-life, which was loaned by John Forbes White, and *Houses by a River*. This last picture was probably *Women Washing Clothes at the Riverside* (Glasgow Museums: The Burrell Collection), a small riverscape with houses in the background, which belonged to Andrew Kirkpatrick.[36]

Apart from James Duncan of Benmore, who lent a Courbet landscape to the Glasgow Institute in 1883, Kirkpatrick was one of the earliest Scottish collectors of Courbet's broadly handled landscape scenes, which had so much impact on artists such as Pissarro during the 1860s.[37] Indeed, a number of works in Kirkpatrick's collection reveal his developing interest in the lighter palette and looser handling of Impressionism. For example, he owned Corot's *Shipping – Sailing Barges* (Glasgow Museums: The Burrell Collection), a Boudinesque river scene where sky and water dominate the composition. He also owned two landscapes by Hervier, including *Village Scene, Barbizon* (cat.30), a small-scale *plein-air* work with all the freshness and high tonality of an Impressionist work. In the following decade Kirkpatrick would become one of the first British collectors to invest in the work of Monet and Sisley.

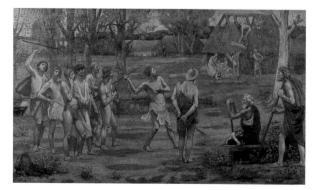

37. Puvis de Chavannes
(1824–98)
Ludus Pro Patria, 1883
Oil on canvas 13.5 × 197cm
Walters Art Museum, Baltimore

Collecting in the 1890s: The International Exhibition of 1901

During the 1890s the taste for French nineteenth-century art developed significantly in Scotland. This was due both to the enormous wealth being generated in Glasgow and other industrial centres such as Dundee, and to a growing awareness of the importance of the Barbizon School. In 1891 the Scots-born dealer David Croal Thomson published the first comprehensive study of this group of artists, including chapters on Corot, Rousseau, Diaz, Millet and Daubigny and reproducing works from the collections of James Staats Forbes, Sir John Day, Alexander Young, John Forbes White, R. T. Hamilton Bruce, James Duncan of Benmore and T. G. Arthur.

An increasing number of dealers in Glasgow were specialising in French art. The most established Glasgow dealers, apart from Angus, were Thomas Lawrie & Son (founded in 1872) and Kay & Reid (dealing since 1877), who both stocked nineteenth-century French art. During the 1880s and early 1890s several new businesses opened in Glasgow and began to sell Hague School and Barbizon paintings. These included George Davidson & Co, John B. Bennett & Sons, James Connell & Sons, Alex Reid, the Van Baerle brothers and W. B. Paterson & Co. Of these only a handful specialised in French art. The van Baerle brothers, for example, were associated with Hollender & Cremetti in London and through them were able to hold regular exhibitions of modern French paintings during the 1890s. E.&E. Silva White were part of a franchise known as The French Gallery, which was run by Wallis & Son in London. Alex Reid also devoted his gallery, La Société des Beaux Arts, almost exclusively to French art, and even styled himself *directeur* on all promotional material. Whereas the majority of dealers in Glasgow received their stock of French art from London associates, Reid, who had trained in Paris under Theo van Gogh at Boussod & Valadon, acquired his French paintings directly from Parisian dealers.

Many collectors relied on one or two advisors, but some, such as William Chrystal, bought from a variety of dealers. Chrystal was chairman of the Glasgow chemical manufacturing firm J.&J. White Ltd., but his main passions in life included sailing, Highland cattle, travel and art. The bulk of his collection was formed between 1882 and 1915 and included both Barbizon and Hague School paintings. During the 1880s Chrystal was collecting mainly Scottish art and making only modest investments: 14 guineas to £60 per picture. By 1888 he was spending between £50 and £100 on individual works; and in January 1889 he bought *Lobster Fishers* by William McTaggart for £295 from Thomas Anderson. In the same month he invested in his first Hague School picture, a watercolour by Artz entitled *Sunday Afternoon*, which Anderson sold him for £84. His interest in Dutch art was short lived, but he made one of his most ambitious purchases, Josef Israëls' *Waiting for the Boats*, the following month. The dealers, E.&E. Silva White convinced the collector that he was getting a bargain, and Chrystal noted with sat-isfaction that, whereas he had paid £320 for the Israëls, the previous owner had paid 500 guineas, an indication of the fluctuating market for these pictures.

Silva White also sold Chrystal his first French painting, Monticelli's *The Orange Game* (ill.39) for £210. This work – which shows a group of women, some engaged in the game, others reclining or adopting languorous poses – is typical of Monticelli's neo-Rococo style. Chrystal was clearly delighted with his first French painting and displayed it on a special easel in the drawing room at Auchendennan, his home near Balloch (ill.40). He then purchased a second, more fantastical Monticelli, *Fête Champêtre* (Art Gallery and Museum, Kelvingrove) only four days later from Thomas Anderson for £115 10s.

Chrystal acquired the bulk of his French collection during the course of only two years. The variety of artists in which he invested reflects his widely eclectic tastes. In March 1889, for example, he bought Lhermitte's *La Veille* or *Evening Work* (ill.41),[38] a genre scene depicting a group of women and young children gathered together in a modest cottage interior, spinning yarn by the guttering light of a lamp. The theme of the humble worker is typical of the subject-matter that appealed to Scots collectors of this period, many of whom came from humble origins themselves and believed strongly in the Protestant work ethic.

In complete contrast to *Evening Work*, Chrystal's next purchase was a mildly erotic work ascribed to Corot and entitled *The Bathers* (Art Gallery and Museum, Kelvingrove).[39] It shows a group of nude female bathers or nymphs taking a dip in a cooling stream, while to the right the picture opens out onto the translucent waters of a lake. Traditional in composition, the work is typical of Corot's muted palette and soft, atmospheric handling.

The following year Chrystal expanded his collection of Barbizon pictures, acquiring works by Dupré, Daubigny, Charles Jacque, Diaz, Troyon and Théodore Rousseau. He bought Jules Dupré's *Evening by the Oise* from Thomas Lawrie & Son on 3 March 1890 for £525, but the majority of works were bought from E.&E. Silva White. These included Daubigny's *Seascape at Villerville* of 1876 (Art Gallery and Museum, Kelvingrove),[40] a broadly painted and highly abstract work, painted with Impressionist freedom. The sea is highlighted with bold streaks of pink and turquoise, while the gathering clouds are daubed with lilac and yellow *taches*. Chrystal bought a second Daubigny nocturne entitled *Evening* (*Le Soir*) in October, along with Théodore Rousseau's *Charmiers sous des Grands Arbres*.[41] During the course of the following two months he added two animal paintings: *Sheep in*

38. Left: Jacob Maris (1837–99) *Souvenir of Dordrecht, c.*1884 Oil on canvas, 71.1 × 125.5cm Glasgow Museums: The Burrell Collection

39. Adolphe Monticelli (1824–86) *The Orange Game* Oil on wooden panel, 25.6 × 52.4cm Glasgow Museums: Art Gallery and Museum, Kelvingrove

40. *Interior at Auchendennan with* The Orange Game *on an easel* Private Collection

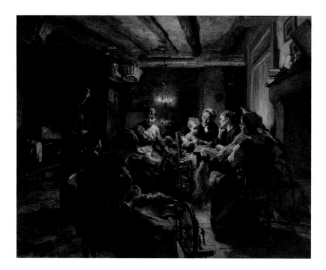

41. Léon Lhermitte
(1844–1925)
Evening Work, 1888
Oil on canvas, 93.3 × 122cm
Glasgow Museums: Art Gallery
and Museum, Kelvingrove

Landscape by Charles Jacques[42] and a picture of cattle by Troyon which he bought from from E. & E. Silva White for £350.[43]

Towards the end of the year Chrystal purchased a Courbet landscape of Lake Geneva which he bought from E.&E. Silva White for £410. During his political exile (after his involvement in the Paris Commune) at la Tour-de-Peilz in Switzerland, Courbet had paid off his debts by painting the lake and its historic Château de Chillon, specifically for the tourist market. Chrystal's painting was a spectacular, picturesque view of the mountains plunging down into Lake Geneva, the kind of image which might very well have appealed to a collector with a love of sailing and a taste for travel. The picture was given a prominent position above the mantelpiece in the drawing room at Auchendennan (ill.40).

During the 1890s Chrystal continued to add to his collection, acquiring works by Millet, Ziem, Harpignies and Fantin-Latour. In particular he admired Fantin-Latour's still-lifes and owned at least three flower paintings including *Larkspur* (cat.23) and *Roses, 'La France'* (cat.24). Fantin-Latour's London agent Edwin Edwards had been sending his work up to Glasgow since 1875, and during the 1880s and 1890s his still-lifes were shown almost annually at the Royal Glasgow Institute. Glasgow dealers such as J. B. Bennett and Charles Moody kept a regular stock of his work and another source was through his Paris dealer, Gustave Tempelaere, whose son, Jean, was a close friend of Alex Reid. In 1897 Reid staged the first one-man exhibition of Fantin-Latour's work to be held in Glasgow and Edinburgh.[44] After Fantin-Latour's death in 1904 Reid continued to stock his work, his clients including Chrystal, the Edinburgh collector Dr John Kirkhope, the London-based collectors Mr and Mrs R. A. Workman, the Glasgow shipowner William Burrell and Leonard Gow and William McInnes, both partners in the Glasgow shipping firm of Gow, Harrison & Co. Some of the more adventurous collectors, such as McInnes, were attracted both to Fantin-Latour's popular flower paintings and to Fantin's more lyrical 'neo-Symbolist' works, inspired by the music of Wagner, Schumann and Berlioz.

42. J. Craig Annan
(1863–1946)
View of the International Exhibition, 1901
Glasgow Museums: Art Gallery
and Museum, Kelvingrove

The International Exhibition of 1901

Since the bulk of Chrystal's collection was formed during the 1890s, and he exhibited occasionally at the Royal Glasgow Institute, it is curious that he did not choose to lend any of his French collection to the Glasgow International Exhibition of 1901. The International Exhibition in Kelvingrove Park was Scotland's most impressive exhibition to date. The Main Building was an Eastern Palace with red roofs, green 'copper' cupolas and a golden central dome, featuring gigantic floating angels in shades of green, pale red and violet and sculpted figures on ship's prows. The Fine Art section was advertised as 'the greatest Art Collection ever gathered under one roof'[45] and housed in Simpson and Allen's newly completed sandstone gallery, described in the catalogue as 'one of the most elaborate edifices devoted to Art in Europe.'[46]

A large number of French nineteenth-century works were loaned to the exhibition, including twenty-one works by Corot. Despite this, the boom period for sales of Corot had passed, and in December 1901 a correspondent for *The Bailie* remarked on the declining market for this artist: 'Alas and alack for the acres of Corot that exist in and around Glasgow, or, at least, alas and alack for their owners! The market price of his pictures is coming fast down. Buyers are told by dealers to lay in a stock of canvases by Harpignies. A year or two ago a picture by Harpignies was rejected at Burlington House; his prices were of the most moderate character. Today – well, today dealers get what they ask for his work.'[47]

Only four works by Harpignies were shown at the 1901 exhibition and in the main the exhibition was a reflection of past rather than developing tastes. Many of the works shown had entered Scottish collections during the 1890s, but more established collectors such as James Donald, T. G. Arthur and J. Carfrae Alston (d.1909?) also contributed a significant number of works. The interest in nineteenth-century French art was now beginning to affect collectors outside the west of Scotland and pictures were sent in by collectors such as the Edinburgh accountant J. J. Cowan (1846–1933), who loaned a Monticelli *Fête* and the Kirkcaldy linoleum manufacturer John Nairn, who contributed works by Boudin and Daubigny. However, the most significant of those who exhibited at the 1901 exhibition were mainly west coast collectors, including W. A. Coats, William Burrell and Arthur Kay.

William Allen Coats (1853–1926) was the fourth son of Thomas Coats of Ferguslie and a director of J. & P. Coats, a thread manufacturing company based in Paisley. The company went public in 1890, so that, despite the fact that Thomas Coats had eleven children, each child was extremely wealthy in his own right. Two of William Coats's brothers – Thomas (Glen-Coats) and George (later Baron Glentanar) – also collected French art and contributed to the International Exhibition of 1901.

W. A. Coats loaned works by Corot, Daubigny, Rousseau, Troyon, Jongkind and Monticelli, who was one of his great passions. At his death in 1926 Coats owned as many as thirty-one works by this artist, as well as twenty works by Corot. He also owned six

Géricaults, over thirty Bosbooms and a number of other Hague School paintings.[48]

Coats's taste for artists such as Bosboom and Monticelli reflects the influence of the dealer Alex Reid, who enthusiastically promoted both artists during the 1890s.[49] He became so obsessed with Monticelli and so successful in promoting his work that he was widely known as 'Monticelli Reid'.[50] As has been mentioned above, Reid did not introduce the Scots to Monticelli's work but was capitalising on a taste which had already been established. And although he succeeded in inflating the price of Monticelli's pictures during the 1890s he was forced to compete with a number of other Glasgow dealers. His biggest rival for the Monticelli market was Craibe Angus, but other dealers such as Thomas Lawrie and W. B. Paterson also stocked his work.

W. A. Coats loaned more Monticellis than any other collector to the International Exhibition in Glasgow in 1901. We know from existing receipts that he was buying from a number of different Glasgow dealers, including Lawrie and Angus and Paterson, and that Reid was hard pressed to attract his custom. Between 1890 and early 1899 Coats bought fifteen Monticellis from each of these three dealers[51] but in 1899 he appears to have switched his affiliations and thereafter bought all his Monticellis from La Société des Beaux Arts. One of the finest works in his collection is *The Destruction of Pompeii*, which he bought in 1900 for an impressive £1,200 and which now hangs in Paisley Art Gallery.

One collector who developed a particular taste for Monticelli was William Burrell (1861–1958), who bought regularly from Craibe Angus and Reid. Burrell loaned two paintings by Monticelli to the 1901 International Exhibition, *Scene from the Decameron* and *The Bazaar, Marseilles* c.1868 (both Glasgow Museums: The Burrell Collection), which he bought from Reid during the 1890s. Other Monticellis he acquired included *Fête Champêtre, Strolling Players*, and *The Ravine* (ill.36), the same work which was exhibited in Edinburgh by Daniel Cottier in 1886.

By 1901 taste had extended beyond the Barbizon School to artists such as Boudin and Daumier. T. G. Arthur lent Daumier's *The Banks of the Seine* (*Bords de la Seine*), (National Museum of Wales, Cardiff), a dramatically lit work, featuring a man on horseback being startled by a dog, which had been in his collection since 1891.[52] Apart from Arthur, only London-based collectors such as Constantine Ionides invested in Daumier's work at such an early date.[53] Even in France, Daumier was regarded more as a caricaturist than as a painter, and Ionides, who was advised by the French painter Legros (based in London), limited his collecting to Daumier's drawings. Thus, although this was the only Daumier that Arthur was to invest in, he was possibly the first British collector, and certainly the first Scot, to acquire a Daumier painting.

A keen horseman, Arthur was no doubt attracted by the subject rather than the handling of Daumier's work. It is likely that he acquired his picture from Alex Reid, who included Daumier's work in mixed exhibitions of French art during the 1890s. A. J. Kirkpatrick, another early collector of Daumier, bought two works

43. Honoré Daumier (1808–79)
The Bathers, c.1846–48
Oil on wooden panel
25.4 × 32.1cm
Glasgow Museums: The Burrell Collection

by Daumier during this period. He acquired *The Bathers*, c.1846–48 (ill.43) as early as 1894 and also bought *The Wayfarer* from an exhibition of French nineteenth-century art held at La Société des Beaux Arts in February 1897.

William Burrell collected at least six works by Daumier during the 1890s, of which two pictures, *Don Quixote* (Glasgow Museums: The Burrell Collection)[54] and *The Heavy Burden* (Glasgow Museums: The Burrell Collection) were lent to the 1901 exhibition. The former is typical of Daumier's loose handling and gift for caricature, and again reveals his dramatic use of light and shade, so effective in his drawings and lithographs. Daumier was an anecdotal artist, and it was perhaps this aspect of his work, often coupled with a humorous observation of life, which appealed to Burrell. By this date Burrell's collection included at least two other works, *Susannah and the Elders*, c.1878 (Glasgow Museums: The Burrell Collection), based on the apocryphal story from the Book of Daniel, and *The Artist at His Easel* (Phillips Collection, Washington D.C.), both of which he bought from Alex Reid during the 1890s.[55] However, Burrell, perhaps sensing that the fashion for Daumier was far from universal, soon tired of his pictures, and in 1902 he offered four works from his collection for auction at Christie's in London. These included *Don Quixote*[56] and *The Artist*,[57] which he sold along with *A Woman Going to Market on a Donkey* and *The Good Samaritan*.

Another artist who made an appearance at the 1901 exhibition was Boudin. Boudin had died in August 1898, and in March 1899 the contents of his studio were sold at the Hôtel Drouot in Paris.[58] During the 1880s and 1890s Paul Durand-Ruel had had almost exclusive rights to Boudin's work, but now large numbers of his pictures became freely available, and dealers such as Alex Reid were determined to create a market in Scotland, where Boudin was little known. Since the majority of Boudin's paintings and watercolours were small, they were cheaper than the *grandes machines* of the Salon painters (it was said that you could acquire any work by Boudin for as little as £50),[59] and were more appropriate for a domestic setting. Added to this, Boudin's subject-matter had an instant appeal for the Scottish collectors. His seascapes

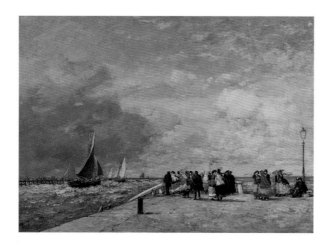

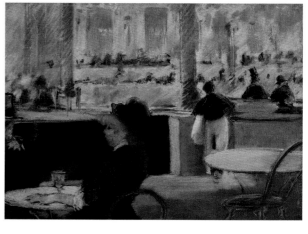

44. Eugène Boudin (1824–98)
The Jetty at Trouville, 1869
Oil on canvas, 64.8 × 92.8cm
Glasgow Museums: The
Burrell Collection

45. Far right: Edouard Manet
(1832–83)
*A Café, Place du Théâtre-
Français*, c.1876–78
Pastel on linen, 32.4 × 45.7cm
Glasgow Museums: The
Burrell Collection

and studies of ports and harbours drew the attention of the yachting fraternity on the west coast; and his studies of fashionable holidaymakers on Trouville beach appealed to the bourgeois Glasgow industrialists, perhaps even more than the peasants of Israëls and Millet.

At the same time, by introducing the west coast collectors to Boudin's studies of the urban bourgeoisie, Reid was not only appealing to their own vanity, but preparing them for the urban subject-matter of Impressionist art. Moreover, Boudin's luminous, all-over light-toned palette proved an ideal introduction to *peinture claire*, which was so crucial to the development of Impressionism.

Reid had been dealing in Boudin's work since well before 1900, and his earliest recorded purchases date from December 1888.[60] In 1894 he acquired *The Deauville Road* (*La Route de Deauville*), 1881 (Paisley Museum and Art Gallery) from the *vente* Penot at the Hôtel Drouot.[61] In this work, so close to Pissarro in composition and tonality, Boudin employs the Impressionist broken brushstroke.[62] In general it is a conservative work, employing the traditional compositional device of a road curving into the distance in order to establish a sense of perspective. But, although it employs naturalistic colours, the work is light in tonality and full of movement. The real subject of the scene is the grey stormy sky and the changing light and atmosphere in the surrounding countryside. As such, it is an excellent example of the way in which Boudin's work bridges the gap between the Barbizon School and Impressionism.

In 1899, shortly after the sale of Boudin's studio, Reid sold several more works by Boudin to John Nairn, as well as A. J. Kirkpatrick and Alexander Young.[63] Nairn lent his Boudin, *Le Pardon*,[64] to the 1901 exhibition, which also included *The Jetty at Trouville*, 1869 (ill.44) owned by Major William Thorburn, a collector from Peebles. Following Thorburn's death this picture was acquired by Reid and included in an exhibition of Boudin's works in December 1912. The scene was described by the press as 'a group picturesquely clustered on a windy jetty, a patch of joyous white cloud above the jetty, and over the waters a darker sky presaging storm, and boats with sails full blown beating against the wind'.[65]

The west coast collectors, having already developed a

taste for the seascapes of the Hague School, and especially the work of Jacob Maris, were enchanted by Boudin's light and airy paintings of the area around Trouville and Deauville. Between 1900 and 1913 Reid held no fewer than five one-man exhibitions of the artist's work, selling to a wide selection of clients. In April 1900 he sold a number of paintings to collectors such as J. J. Cowan and W. A. Coats, the latter a keen sailor. The prices were predictably low, averaging about £80 per work. A comparable painting by the Dutch artist Jongkind, whose style is so close to that of Boudin, and for whom Coats and Kirkpatrick had already developed a taste, could have expected to fetch over twice that amount.

Apart from Boudin and Daumier, another relatively unknown artist to be represented at the 1901 exhibition was François Bonvin (1817–87). Both Arthur and Kirkpatrick had sent some of his genre paintings to the annual exhibition of the Royal Glasgow Institute during the 1890s, but at the 1901 exhibition George Burrell and Arthur's business partner, Arthur Kay, each loaned still-lifes, of bloaters and oysters respectively.[66] Kay owned an important collection of Dutch seventeenth-century art and would have appreciated Bonvin's debt to the still-life tradition. At the same time, the French artist, through his sense of colour and broad handling of paint, provided an important link with modern still-life and the work of Cézanne. That Kay was one of the first Scots collectors to appreciate modernism is demonstrated by his early purchase of Manet's pastel, *A Café, Place du Théâtre Français* (ill.45)[67] one of only eight Impressionist works to be shown at the 1901 exhibition.[68] The picture shows a young woman (probably a prostitute) and her male companion drinking in a bar, a subject which even at the dawn of the new century was still considered to be shocking. This was by no means the only Impressionist work in Kay's collection, and, despite the poor showing at the International Exhibition of 1901, the Scots, as we shall see, were among the earliest in Britain to acquire a taste for Impressionism.

Impressionism and West of Scotland Collectors

Introduction

The Scots have long been recognised as among the earliest collectors of Impressionism in Britain; but, apart from William Burrell, the significance of many of these early connoisseurs and their contribution to developing taste in Britain has been largely overlooked. Glasgow merchants and industrialists were investing in the work of Manet, Degas, Monet, Sisley and Pissarro long before better-known collectors outside Scotland, such as Hugh Lane and the Davies Sisters, were even aware of Impressionism. Scots such as David and William Cargill amassed major collections of Impressionist and Post-Impressionist art which were easily on a par with the Courtauld collection, but which were dispersed after their deaths.

The Colourist tradition in Scottish art may partly account for this early taste among Scots collectors for the brilliant palette of Impressionist art. Certainly they were more receptive than their English counterparts, whose predilections for the detailed Realism of Victorian narrative art scarcely prepared them for the subject-matter and style of modern French painting. But the bold investments of these early collectors were motivated to a large extent not only by aesthetic sensibility, but by the current economic climate in Scotland and the efforts and enthusiasm of one man, the Glasgow dealer Alex Reid (1854–1928). Apart from Paul Durand-Ruel, Reid was the only individual to promote Impressionist art in Britain in any serious way before the turn of the century; and before 1923 he was the only dealer to sell Impressionist art in Scotland.

Works by Degas began trickling into British collections during the 1870s,[69] thanks in the main to the efforts of the Paris dealer Durand-Ruel, who fled to London during the Franco-Prussian War. Durand-Ruel succeeded in selling pictures by Degas to two British collectors, Henry Hill (1812–92) of Brighton and Constantine Ionides,[70] and held regular exhibitions of French art at his New Bond Street Gallery between 1872 and 1875.[71] However, public resistance to Impressionism was strong and it was not until the 1890s that a handful of London galleries began to stock Impressionist pictures. English collectors (most buying through personal contacts) became more adventurous, one or two investing in the work of Monet and even Van Gogh.[72] However most early collectors preferred the conservatism of Degas. The artist Walter Sickert, for example, owned two works by this artist as early as 1891, and Louis Huth included Degas's *Le Foyer de la Danse à l'Opéra* (Musée d'Orsay, Paris) in the Glasgow International Exhibition of 1888, the first Impressionist work to be seen in Scotland.[73]

It was during this period that Reid set up his Glasgow gallery, La Société des Beaux-Arts, and succeeded in selling pictures – not only by Degas, but by Monet, Sisley and Pissarro – to a number of Scottish collectors, including Thomas Glen Arthur, Arthur Kay, Andrew Maxwell and A. J. Kirkpatrick. However,

during the 1890s the pattern of collecting in Britain remained extremely fragmented and many of the more important purchases made by these pioneering Scottish collectors were disposed of, most ending up in American collections.

Apart from William Burrell, who was investing in Manet and Degas in the 1890s, the better-known British collectors of Impressionist and Post-Impressionist art began collecting during the early decades of the twentieth century. The trigger may have been a huge exhibition of nineteenth-century French art, including 277 Impressionist works, held by Durand-Ruel in 1905. Shortly after this date the Davies sisters in Wales, advised by the dealer, critic and curator Hugh Blaker, began to take an interest in Impressionist art.[74] Between 1908 and 1928 they acquired about 200 paintings, nearly half of which were by modern French artists, many bought from the Paris dealers Bernheim-Jeune. The collection included Renoir's outstanding work *The Parisienne* of 1874 (National Museum of Wales, Cardiff), bought in 1913, and they invested in Cézanne as early as 1918. Contemporary with the Davies sisters, and described by Douglas Cooper as 'the first serious purchaser of Impressionist pictures in England',[75] the Irish collector Hugh Lane amassed his collection of Impressionist art between 1905 and 1915. On Lane's death in 1915 (he was drowned in the *Lusitania* disaster), his collection passed to the National Gallery in London.[76] This inspired the textile manufacturer Samuel Courtauld to build up his own collection of Impressionist and Post-Impressionist art, although it must be noted that a large number of works in his collection also passed through Alex Reid's hands.[77]

The later Scots collections were formed by rich industrialists such as William Burrell, David and William Cargill, William McInnes, Leonard Gow and Sir John Richmond. Not all of these collections have remained intact: the Cargill collections were sold and only a handful of works remain in Glasgow collections. Sir John Richmond's collection is divided between Edinburgh and Glasgow and, together with the Maitland bequest, forms the backbone of the French paintings collection at the National Gallery of Scotland. Of the major Scottish collectors only McInnes and Burrell opted to leave their entire collections to Glasgow Corporation. Nevertheless, Glasgow boasts one of the most important collections of French nineteenth-century paintings in Europe, a tribute to the west coast collectors' early taste for the avant-garde, as well as the vision and persuasiveness of dealers such as Alex Reid.

Early Collectors of Impressionism

The French dealer Paul Durand-Ruel exhibited Impressionist paintings in London during the 1870s, but it was not until 1889 that the first British dealer attempted to follow suit. In April 1889 the Goupil Gallery in London, under the directorship of David Croal Thomson, held a show of about thirty works by

Claude Monet. This was Monet's first one-man exhibition in Britain, and an attempt by the Paris firm of Boussod & Valadon to promote Monet's work in this country. Yet despite Monet's rising popularity in France, the British public was still largely suspicious of Impressionism. Thomson recalled, 'this exhibition had no success whatever, and after the private view day, when it was filled with complimentary visitors, no one came at all. For three long weeks the collection remained open and was well advertised, yet during that time only one visitor paid for admission.'[78] The general feeling was that the work of the Impressionists was accessible to only a small section of the population and that '*le gros public*, even in Paris, where artistic quality is generally so readily recognised, would as soon think of dining off caviare as of satisfying itself with these strange and wayward productions.'[79]

The first attempt to sell Impressionist art in Scotland was in November 1890 when the London dealers Dowdeswell's staged an exhibition of fine paintings, including works by Degas, Manet and Whistler, at T. & R. Annan's gallery in Glasgow. The International Exhibitions of 1886 and 1888 had drawn attention to the growing number of collectors in Scotland, and Dowdeswell's were no doubt anxious to tap into a new and potentially lucrative market. However, there is no record of any sales from this exhibition.

Nevertheless, exactly a year later Alex Reid made his first attempt to introduce Impressionism to the British public.[80] Of all the Glasgow dealers, Reid had the closest connections with France, largely due to his associations with Boussod & Valadon, where he worked for about eighteen months from 1886 to 1888. He was placed under Theo van Gogh in the modern paintings section of the gallery at 19, Boulevard Montmartre[81] and through him was introduced to Impressionist art. During 1887 alone, Theo handled works by Degas, Monet, Sisley, Pissarro, Gauguin and Guillaumin. Reid would also have been able to see Impressionist pictures at Durand-Ruel's gallery in the Rue Laffitte.

Shortly after Reid joined the firm, Theo invited him to move into his apartment at 54, Rue Lépic, along with his brother Vincent, who painted and sketched Reid on several occasions (cat.28). For a few months the three lived in relative harmony and Reid even joined Vincent on painting expeditions. However, when the latter, in a fit of depression, tried to involve the dealer in a suicide pact,[82] Reid was forced to find alternative accommodation.

Boussod & Valadon allowed both Reid and Theo to buy and sell works 'on the side' and while in Paris Reid made a number of purchases. His great passion during this period was the work of Monticelli; he also bought works by Boudin and Puvis de Chavannes, as well as a number of Japanese prints which he took back to Glasgow in November 1889. He also began taking an interest in the work of the Impressionists and bought at least two works by Manet, *La Brioche* (Private Collection, New York) and *A Good Glass of Beer* (*Le Bon Bock*), 1873 (ill.46). The more outstanding picture is *Le Bon Bock* which he bought for £250 and sold towards the end of his stay to the French collector Jean-Baptiste Faure for twice the original price.[83]

In the spring of 1888 Reid made a brief trip back to

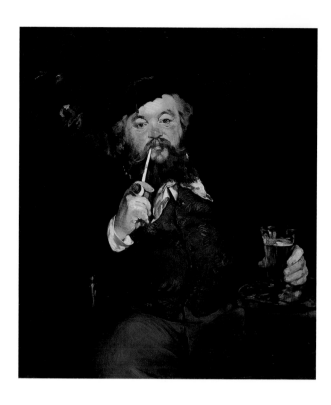

Glasgow to see the Glasgow International Exhibition. He took with him two works by Van Gogh: *Basket of Apples* 1887 (St Louis Museum, St Louis) and a portrait of himself which has never been traced.[84] According to the artist A. S. Hartrick, 'Reid got into serious trouble with his father for acquiring or investing in some of Van Gogh's work, but I cannot believe he gave much money for them, or I should have heard about it from the painter! It was the contact with such atrocities, as they seemed, that roused the ire of the parent: for, in view of the elder picture dealer, Reid was destroying his taste for what was saleable.'[85] James Reid sold both works to an unknown dealer for £10.

While living in Paris, Reid often discussed with the Van Gogh brothers the possibility of selling Impressionist art in Britain. Vincent and Theo contemplated using Reid as their agent in Scotland and even planned to hold an exhibition of Impressionist works, which Reid would set up on their behalf. Nothing came of this, but when Reid returned to Glasgow in the spring of 1889 he immediately began to plan his first Impressionist exhibition.

Although Reid had invested in Manet during his stay in Paris, it was to Degas (1834–1917) that he now turned. English collectors such as Henry Hill and Constantine Ionides had already bought works by Degas from Durand-Ruel during the 1870s, and it made sense for Reid to introduce the Scottish collectors to Impressionism through this artist, whose draughtsmanship and subject-matter – especially his ballet dancers and racehorses – were more accessible than the sketchy landscapes of the *plein-air* Impressionists.

In December 1891, at Arthur Collie's gallery in Old Bond Street, he exhibited 'a Small Collection of Pictures by Degas and others'.[86] The exhibition included seven pictures by Degas together with one each of the *plein-air* Impressionists, Sisley, Pissarro and Monet, as well as a selection of works by other nineteenth-cen-

tury French artists, such as Corot, Daubigny, Millet, Monticelli, Hervier and Ribot. The exhibition ran till 8 January 1892 and in February Reid took the show north to Glasgow, expanding the catalogue with works by Puvis de Chavannes, Courbet and Whistler.

Despite the interest that the exhibition aroused, both in London and Glasgow, the only Impressionist picture to be sold while the exhibition was running was Degas's *At the Milliners* (ill.47), which was bought by the Glasgow collector T. G. Arthur for £800 – about the price of an average Monticelli. Arthur's work invited much comment from the press, perhaps because, as one critic put it, it was 'the least attractive of all; but...quite the most characteristic'[87] painting in the exhibition. The dramatic cropping of the shop-girl, 'her figure cut in half by the hard line of the mirror',[88] was particularly disturbing.

Although only one work was sold at Reid's exhibition this one sale was of extreme importance to the development of Scottish taste; for once Arthur had shown the picture to his business partner, Arthur Kay, it wasn't long before Kay, too, had upstaged his friend by making an even more daring purchase. Shortly after the close of the Glasgow exhibition, he acquired one of Degas's most controversial paintings, *In a Café* (*L'Absinthe*), 1875–76 (ill.48) which he bought from Reid. The picture formed part of the Henry Hill collection, which was sold at Christie's in London in February 1892. It is typical of Degas's more Realist works and shows a prostitute seated in the Café de la Nouvelle Athènes in Paris, gazing miserably at a glass of absinthe.

The story of Kay's acquisition of this work, originally known as *Au Café*, is recounted in his memoirs: 'When *Au Café* was shown on the easel, it was hissed – *sifflé*, say the French. I believe disapproval of a great masterpiece, thus shown, must be almost unique. I stood back, where I could not be seen, in order to watch a dealer [Reid] I thought might bid for this picture. I felt it would be wiser to let him become buyer, and offer him a profit afterwards, rather than run him up in the auction. This policy worked; he bought the picture.'[89]

Reid sold *L'Absinthe* to Kay, who took it home and

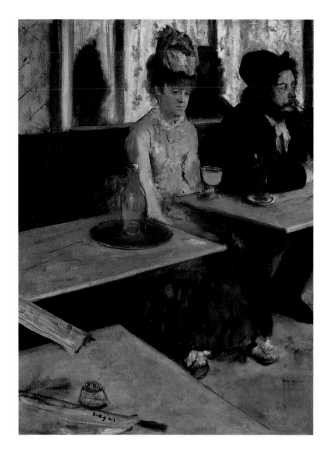

48. Edgar Degas (1834–1917)
In a Café (L'Absinthe)
c.1875–76
Oil on canvas, 92 × 68cm
Musée d'Orsay, Paris

hung it 'in a position where [he] could see it constantly'.[90] However, the unfavourable reaction that the picture provoked among his peers soon persuaded Kay to return it to Reid. The shrewd dealer not only persuaded Kay to keep the picture, but to buy a second Degas, *Dancers in the Rehearsal Room with a Double Bass*, *c*.1882–85 (Metropolitan Museum of Art, New York) which had remained unsold from the Degas exhibition.

Having successfully introduced Degas to two Glasgow collectors, Reid began to concentrate on promoting the *plein-air* Impressionists. His next sale of an Impressionist work was Monet's *View of Vétheuil in Winter*, *c*.1879, a small snow-scene, freely worked and displaying the distinctive loose handling and light tonality of high Impressionism. The picture was bought by Andrew Maxwell, a Glasgow iron and steel merchant, some time before November 1892,[91] when *The Bailie* reported 'Among the latest additions to the gallery of one of our chief Glasgow collectors is an example of Claude Monet, a picture distinguished by all the more distinctive characteristics of the great impressionist.'

We know from contemporary periodicals and exhibition catalogues that other Impressionist works were filtering into west coast collections during the 1890s. In 1894 the *Art Journal* reproduced a Degas pastel entitled *Prima Ballerina* (*La Première Danseuse* or *The Encore*), *c*.1881 from William Burrell's collection. The following year Burrell's brother George lent a Degas picture of ballet dancers to the annual exhibition of the Royal Glasgow Institute. In 1897 and 1898 A. J. Kirkpatrick exhibited landscapes by Monet and Sisley (*A Country Village*, 1898).

Despite these early purchases, Scottish collectors in

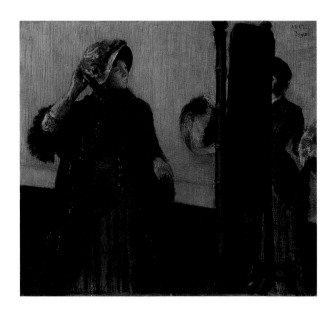

47. Edgar Degas (1834–1917)
At the Milliners, 1882
Pastel on paper, 75.6 × 85.7cm
The Metropolitan Museum of Art, New York

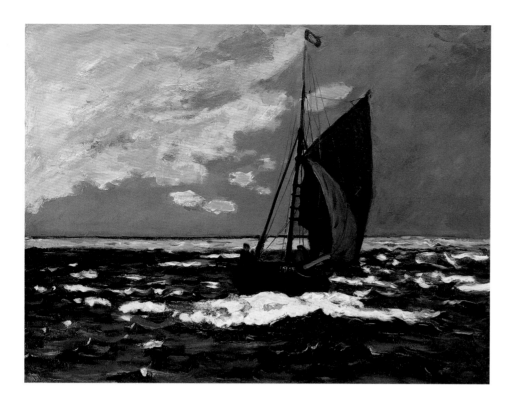

49. Claude Monet (1840–1926)
A Freshening Breeze, 1867
Oil on canvas, 48.9 × 64.8cm.
Sterling and Francine Clark
Art Institute, Williamstown

tle interest in Impressionism in Scotland. For the first few years of the twentieth century Glasgow was affected by a period of economic depression. Much of the city's wealth was associated with shipbuilding, and after the outbreak of the Boer War in October 1899 freight rates became very depressed, largely because of the release of ships to the transport services involved in the war. Collectors became reluctant to invest in avant-garde art, since it did not guarantee a safe investment. Added to this, some of the more progressive collectors, such as A. J. Kirkpatrick and T. G. Arthur, had either died or ceased collecting, and the next generation of collectors had yet to appear. Between 1900 and 1914 William Burrell bought very few examples of nineteenth-century French art, and the collectors who invested in Impressionist art during this period were the exception rather than the rule.

Later Collectors of Impressionism 1910–1925

The vogue for Impressionist art is sometimes regarded as a post-war phenomenon and yet by 1912 Impressionist paintings were already beginning to sell in France at impressive prices. The famous Rouart sale, which took place that year, marked a turning-point. Degas's *Dancers at the Bar,* 1876–77 (Metropolitan Museum of Art, New York) was sold to Mrs Montgomery Sears for a staggering £19,140 plus commission; Renoir and Manet, too, achieved prices in the region of £3,000–£4,000, while Monet, Sisley and Pissarro (in order of popularity) lagged slightly behind. The following year, in 1913, two further sales took place in Paris: the Nemés sale and the second Rouart sale. Once again Degas and Manet achieved high prices and, according to Gimpel, Maurice de Rothschild bought a Renoir *Dancer* for £20,000.[93]

Behind this sudden enthusiasm for Impressionist art lurked a growing awareness of Post-Impressionism, and in particular the further innovations of Cubism. In 1910 and 1912 Roger Fry held his famous Post-Impressionist exhibitions at the Grafton Galleries in London. The first exhibition was devoted to the work of Cézanne, Van Gogh and Gauguin. The 1912 exhibition included works by younger artists such as le Douanier Rousseau, Derain and Rouault, and focused on the work of Matisse and Picasso. It was not long before the reverberations from these exhibitions were felt in Scotland, and in the summer of 1913 a small collection of Post-Impressionist and Futurist works was shown at the 52nd annual exhibition of the Royal Glasgow Institute. These included works by Matisse, Cézanne, Russolo and Severini, as well as Roger Fry, Duncan Grant and Cadell. In the autumn of 1913 an article in *Scots Pictorial* focused on the work of the Post-Impressionists, and in particular on Cézanne, Gauguin, Van Gogh and Matisse; and in December the annual exhibition of the Society of Scottish Artists at the Royal Scottish Academy in Edinburgh included works by all these artists, as well as by Sérusier, Severini, Russolo and Picasso.

In November 1913, responding no doubt to this new enthusiasm for avant-garde art, the now London-based dealer W. B. Paterson brought an important exhibition

general were not immediately drawn to full-blown Impressionism. The majority lived in large, rather gloomy, oak-panelled houses, and the brilliant colours and sketchy handling of Impressionist art sat rather uneasily among the so-called 'glue-pot' painters who were then in fashion. In general collectors were happier with the early Pre-Impressionist works by artists such as Manet and Degas, and Monet's early seascapes held a particular appeal for the west coast sailing fanatics.

A typical purchase from this period was Monet's *A Freshening Breeze,* 1867 (ill.49) which was bought by the Glasgow steel manufacturer Andrew Bain (1844–1926) and exhibited at the 1901 International Exhibition. Bain owned four racing yachts and was commodore of the Royal Western Yacht Club, and it seems more than likely that it was the subject-matter of the painting rather than the style that appealed to him. A similar early Monet, *Seascape: Night Effect,* 1864 (National Gallery of Scotland, Edinburgh), was bought by D. McCorkindale of Carfin Hall (d.1903) sometime before November 1903, when his collection was sold in Glasgow.[92] Both works could have come from an exhibition of French paintings held by Reid at La Société des Beaux-Arts in December 1898. The show may also have included Manet's striking *Portrait of Victorine Meurent,* 1862, which William Burrell exhibited at the 1901 International Exhibition – and another Manet of the same date, *Deck of a Ship* (National Gallery of Victoria, Melbourne), which the Edinburgh Collector J. J. Cowan (1846–1933) bought from Reid in 1901 for £230.

Clearly, it was no easy task for Reid to persuade Scottish collectors to invest in High Impressionism and the majority of so-called Impressionist works acquired by these early collectors employ a dark palette, more akin to the art of the Hague or Barbizon schools than to Impressionist art.

From 1901 until Degas's death in 1917, there was lit-

of Impressionist art up to Glasgow. The show, which took place at the Grand Hotel in Charing Cross, comprised sixty-three works, including pictures by Monet, Renoir, Pissarro, Sisley, Degas and one work by Gauguin. This was the first occasion on which a dealer had shown Gauguin's work in Scotland.

By 1913, therefore, the Scots' attention had been drawn to the relative conservatism of Impressionism. Nevertheless, only a handful of collectors invested in Impressionist art before the First World War. In 1911 Sir John Richmond, a director of the Glasgow engineering firm of G. & J. Weir, acquired Pissarro's *Tuileries Gardens*, 1900 (cat.45). Two years later George Burrell exhibited a Degas *Dancer* at the annual exhibition of the Royal Scottish Academy and in the same year, Alex Reid exhibited Degas's *Three Dancers* (*Les Trois Danseuses*) *c*.1896–1905 (ill.50) at the Royal Glasgow Institute.

For the next few years, however, the war appears to have brought a halt to sales of Impressionism and it was not until 1918, after the *vente Degas*, that the market began to pick up again. In this year Reid sold a number of Degas *danseuses* to William Burrell and to two new and important London-based collectors of Impressionist art, Mr and Mrs R. A. Workman. The Workmans also bought Degas's famous *Portrait of Diego Martelli*, 1879, which now hangs in the National Gallery of Scotland.

The prices being realised by Degas's paintings were rising all the time, and only the wealthiest of collectors could now afford to buy his works. Perhaps for this reason Reid decided to introduce the Scots to the work of Edouard Vuillard. Vuillard is similar in many ways to Degas, with a fine sense of composition and a fondness for pastel, but with a more developed feeling for colour and pattern. Reid anticipated that Vuillard's highly decorative *intimiste* interiors would appeal to a public which had already developed a taste for Degas, but who were perhaps unwilling to pay the huge prices which Degas's work now fetched at auction.

In May 1919 Reid held an impressive one-man exhibition of Vuillard's works in Glasgow. Thirteen of the eighteen works exhibited were sold,[94] many for relatively low prices. The centrepiece of the exhibition was probably *The Dining Room, Rue de Calais*, 1915 (Glasgow Museums: The Burrell Collection) which was bought by William Burrell for £265.

The exhibition also attracted a number of new Scots collectors, including the shipowner William McInnes, a partner in the Glasgow firm of Gow, Harrison & Co. McInnes bought Vuillard's delicate pastel *Lunch in the Country, Les Pavillons*, *c*.1911 (ill.51), notable for its unusual asymmetrical composition, before the exhibition even opened.[95]

Reid went on to include a further nineteen works by Vuillard in a huge show of Impressionist art which was held at the McLellan Galleries in Glasgow in 1920. One of the finest works in the exhibition was Vuillard's *Woman in Blue with Child*, *c*.1899 (cat.61), which was bought by Sir John Richmond.[96] Other purchases at this exhibition included *The Red Roof, l'Etang-la-Ville*, 1900, now in the Tate Gallery, which was acquired by R. A. Workman; and William McInnes's partner,

Leonard Gow, purchased two untraced works, *The Cashmere Cloth* (*La Nappe de Cachemire*) and *In Front of the Tapestry* (*Devant la Tapisserie*).[97]

Another new collector, D. W. T. Cargill, bought Vuillard's *The Open Window*, *c*.1899 (National Gallery of Scotland, Edinburgh). Cargill, a director of the Burmah Oil Company, founded by his father, went on to form one of the finest collections of Impressionist and later French paintings ever assembled in Scotland, including works by Seurat, Toulouse-Lautrec, Van Gogh, Gauguin, Cézanne, Utrillo and Derain.

Reid's 1920 exhibition also included pictures by Monet, Pissarro, Sisley, Renoir and Guillaumin.[98] William Burrell bought Pissarro's *The Outskirts of Auvers* (*Environs d'Auvers*) which he later sold, but William McInnes bought two works which remained in his collection until his death. These were Monet's *Vétheuil*, 1880 (cat.40) and Sisley's *Village Street, Moret-sur-Loing*, *c*.1894 (cat.57), both excellent examples of High Impressionism. The most expensive work in the exhibition was Corot's *Mademoiselle de Foudras*, 1872 (cat.14), catalogued as *Portrait of a Young Girl*, which was priced at £15,000. This important work may have had an important influence on Picasso and was later acquired by D. W. T. Cargill. In comparison to the Corot, the most expensive Impressionist work was Renoir's *Melon and Flowers* (*Melon et Fleurs*), a much smaller work, priced at £3,500.

The following year Leonard Gow emulated the example of his younger business partner and acquired his first two Impressionist pictures, a Degas dancer and Manet's *The Ham*, 1880 (ill.1). McInnes bought his own *Dancers on a Bench* (Art Gallery and Museum, Kelvingrove) at the same date, and may even have accompanied Gow to Reid's gallery. In the same year, D. W. T. Cargill bought an early Monet of Honfleur and Degas's *Jockeys Before the Race*, *c*.1881, a spectacular work similar in composition to Arthur's *At the Milliner's*. Apart from the Degas, which cost £2,100, all of these pictures cost between £925 and £1,300. In 1922, however, Gow made one of the most expensive purchases to date when he acquired Manet's *La Brioche* for £10,500. This was the same work which Reid had briefly owned in Paris in 1887.

By this date Reid had met the French dealer Etienne

50. Edgar Degas (1834–1917)
The Three Dancers, *c*.1896–1905
Pastel on paper, 51 × 47cm.
Glasgow Museums: The Burrell Collection

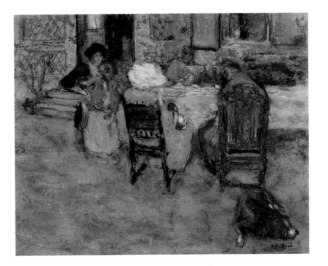

51. Edouard Vuillard (1868–1940)
Lunch in the Country, *c*.1912
Pastel on paper, 47.9 × 66cm
Glasgow Museums: Art Gallery and Museum, Kelvingrove

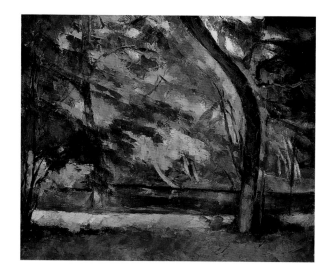

52. Paul Cézanne (1839–1906)
The Etang des Soeurs, Osny,
*c.*1875
Oil on canvas, 60 × 73.5cm
Courtauld Institute Galleries,
London

Bignou, who provided him with instant access to a large source of Impressionist and more modern French pictures. He also began to buy from Paul Rosenberg, who sold him works by Manet, Renoir and even Picasso. In January 1923 Reid included works by Bonnard, Cézanne, Gauguin and Othon Friesz in a small exhibition in Glasgow. The Colourist painter Leslie Hunter wrote to his agent Matthew Justice in Dundee, 'Old Reid is now taking a lively interest in the new men. He has a £3,000 Cézanne landscape at present, subtle and fine.' This may have been Cézanne's *The Etang des Soeurs à Osny,* 1877 (ill.52) which Reid included in a major Impressionist exhibition entitled *Masterpieces of French Art* which opened in the summer of 1923 at Agnew's in London and later moved up to Glasgow. The centrepiece of the Glasgow show was Manet's *Le Bon Bock,* the picture which he had bought for £250 in 1887 and which was now on sale for 140 times that amount. The exhibition also included Gow's *La Brioche,* another picture he had owned while living in Paris, and the London show included Manet's *La Prune (Plum Brandy),* c.1877, (National Gallery of Art, Washington) so reminiscent of the notorious *L'Absinthe* which Reid had sold to Arthur Kay in 1892. Reid also included works by Degas, Sisley, Monet, Pissarro and Renoir, an artist in whom he had shown little interest up till this date. McInnes may well have bought *The Painter's Garden* (cat.47) from this exhibition. William Burrell certainly acquired Degas's *Le Foyer de la Danse à l'Opéra,* 1882 (Glasgow Museums: The Burrell Collection), which he bought for £2,500 and the exhibition also included Cargill's *Jockeys.*

It is clear from the type and quality of works included in Reid's Impressionist exhibitions that a new type of collector was emerging on the west coast of Scotland. In contrast to earlier collectors such as Kay and Arthur, who invested mainly in early works by Degas and Manet, they were beginning to invest in truly Impressionist works, and D. W. T. Cargill and William McInnes went on to build up important collections of Impressionist and Post-Impressionist art. In many ways they were similar to the generation of collectors who had emerged in Glasgow in the 1880s and 1890s. For the most part they came from industrial backgrounds, but they were socially more established than the previous

generation. Many took an intelligent interest in the pictures they bought and many possessed a keen eye, making them far less reliant on the dealer.

Sir John Richmond is probably the best example of this more knowledgeable collector. He was a gifted painter (he once exhibited a picture at the Glasgow Institute under the pseudonym R. H. Maund) and at the age of sixteen he edited an edition of Chatterton's poems. As well as enjoying a successful career as an engineer he became President of the Royal Glasgow Institute, Chairman of Glasgow School of Art and a Trustee of the National Gallery of Scotland. He was a shrewd judge of art and a great supporter of the Glasgow School, on whom he once lectured at the Royal Academy in London in 1939. The first picture that caught his eye was Whistler's *The Fur Jacket,* which was exhibited at Alex Reid's gallery in 1893, but which he could not then afford to buy. The bulk of his collection of nineteenth-century French paintings was bought from Reid, and he went on to buy a number of important Impressionist works such as Monet's *Church at Vétheuil* (National Gallery of Scotland, Edinburgh) and Pissarro's *Kitchen Garden at the Hermitage, Pontoise,* 1874 (ill.53), both acquired before 1926, and several other works by Vuillard.

Another collector of this type, William McInnes, was described by T. J. Honeyman, erstwhile director of Glasgow Art Gallery, as 'a man without ostentation, modest in his bachelor way of living, fearless in criticism, but without bitterness'.[99] According to Honeyman, he developed an eye for art through travelling abroad and through reading, and in time became 'an informed and discriminating buyer with confidence in his own judgement.'[100] McInnes developed a close relationship with the Scottish Colourist Leslie Hunter, who persuaded him to invest in the work of the Fauve artist Henri Matisse. In June 1925 McInnes bought *The Pink Tablecloth* (cat.37),[101] a stunning still-life arrangement of anemones on a table top, the whole canvas saturated in brilliant pink pigment. In the same year he bought Cézanne's *Overturned Basket of Fruit,* c.1877 (cat.11) and Van Gogh's *The Blute-Fin Windmill, Montmartre,* 1886 (cat.27), all from Alex Reid's gallery. He went on to buy works by Seurat, Bonnard, Braque and Picasso.

D. W. T. Cargill's collection was even more impressive than that of McInnes – he owned works by Degas,

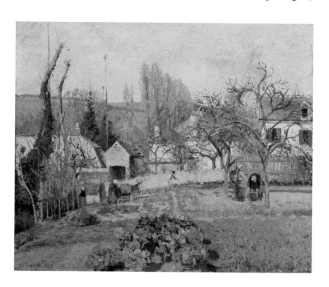

53. Camille Pissarro (1830–1903)
Kitchen Garden at the
Hermitage, Pontoise, 1874
Oil on canvas, 54 × 65.1cm
National Gallery of Scotland,
Edinburgh

Manet, Monet, Sisley, Renoir, Cézanne, Van Gogh, Seurat, Toulouse-Lautrec, Gauguin, Derain and many others. Honeyman described him as 'a kindly man . . . burly in build, baldish, with a fringe of dark hair and a short trimmed moustache. His voice was gentle, and he never indulged in lengthy sentences. His questions, answers and comments were short and to the point.'[102] He was modest about the quality of his collection and yet was always happy to entertain a fellow art lover. Unfortunately for Glasgow, his collection was dispersed at the beginning of the Second World War and Glasgow Art Gallery was left with only three pictures, which were presented by the Cargill Trust. These were Courbet's *Baskets of Flowers* (cat.16), the beautiful Corot, *Mademoisellelle de Foudras* (cat.14) and Seurat's *Boy Sitting in a Meadow* (cat.52). The bulk of the collection was sold in the United States and Renoir's *La Serre*, which Cargill had bought in the 1930s for £6,000, was sold at the Georges Lurcy sale for $200,000 (£70,000).

By contrast with his half-brother David, William Cargill was shy and reclusive. He was a keen sportsman in his youth, but after the death of his mother he 'retired into a reserved, solitary mode of living, spartan almost to the point of eccentricity'.[103] He cared little about his personal appearance and didn't believe in doctors. He was an important collector of Impressionist and Post-Impressionist art, but much of his collection lay neglected for years in packing cases and cupboards or hidden under beds. It was thanks to T. J. Honeyman that the collection was eventually brought to light and put into some kind of order. Cargill owned a number of major works, including Monet's *The Railway Bridge at Argenteuil*, 1874 (private collection, Switzerland), Degas's *The Green Dancer* (Courtauld Institute of Art, London), and Gauguin's *Breton Girls Dancing* (*La Ronde des Petites Bretonnes*) 1888 (ill. 54).

Another 'spartan' collector was William Burrell, who was notoriously mean and reputedly threw the main electric switch at Hutton Castle at 10pm every evening, regardless of who was staying, in order to save electricity. Like W. A. Cargill he kept a large amount of his collection in packing cases, and carpets were piled one on top of the other in the house. Honeyman once commented, somewhat wryly, 'If Sir William Burrell had

been less of a hunter after bargains, or had been more aware of what was happening to art and artists, and had been occasionally more courageous or less prejudiced, the painting section of his fabulous collection would have been even more notable than it is.'[104]

Some of his major later purchases include Sisley's *The Bell-Tower at Noisy le Roi: Autumn*, 1874 (ill.55) which he bought for £1,450 in 1929 and Cézanne's *Le Château de Medan*, 1880 (ill.56), a key work of the artist's 'constructive' period, which he acquired in 1937 for £3,500. However the cream of his collection of nineteenth-century works are by Degas. There are twenty-two works by Degas in The Burrell Collection today, of which twenty were bought between 1921 and 1937. Of these the most important are the portrait of the French writer and critic Duranty, 1879, which he bought in 1923 for £1,900 and the stunning ballet painting, known as *The Rehearsal*, 1874 (ill.57), which he bought in 1926 from Reid & Lefèvre for £6,500.

T. J. Honeyman once observed, with regard to these Glasgow collectors, that 'the bigger the collector and the more famous the collection, the less the evidence of taste. Connoisseurs they may have become, but . . . the taste was that of the dealer, the agent or the scholarly adviser. The smaller, the more intimate the collection, the more the evidence of taste and feeling and the less concern with cost and market appreciation.'[105] Undoubtedly this was a sideswipe at Burrell, and it was the less ostentatious collectors such as McInnes and Richmond whose taste he clearly valued.

Postscript

Alex Reid retired from dealing in 1924 and died in 1928. During the 1920s he had withdrawn more and more from the business, in order to make way for his son, A. J. McNeill Reid. In 1926 T. J. Honeyman joined McNeill Reid in the Glasgow gallery and remained there until 1932 when trade became so bad that they were forced to close. The General Strike of 1926 and the Wall Street Crash in 1929 had heralded a period of prolonged depression and there was a dramatic slump in the art market. Both the Cargill brothers acquired the bulk of their collections during this period when the price of pictures was dramatically deflated.

In 1926 Alex Reid's gallery had amalgamated with the Lefèvre Gallery in London to become known as the Reid & Lefèvre Gallery, with A. J. McNeill Reid, Ernest Lefèvre, Etienne Bignou and Duncan Macdonald as the founding directors. McNeill Reid then worked in the London gallery until 1939 and held two important exhibitions of Impressionist art in Glasgow in 1934 and 1937. Collectors such as William Burrell, William McInnes, and the Cargill brothers continued to buy from Reid & Lefèvre in London, and Burrell also bought from David Croal Thomson, Wallis & Son and Knoedler in London and from a number of French dealers such as Georges Bernheim, Georges Petit and J. Allard.

By the beginning of the Second World War the majority of these important early collections had been formed. Leonard Gow died in 1936 and many of his finest works

54. Paul Gauguin (1848–1903)
Breton Girls Dancing, Pont-Aven, 1888
Oil on canvas, 71.4 × 92.8cm
National Gallery of Art, Washington

55. Alfred Sisley (1839–99)
The Bell-Tower at Noisy-le-Roi, Autumn, 1874
Oil on canvas, 45.7 × 61cm
Glasgow Museums: The Burrell Collection

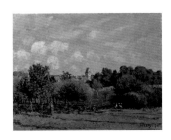

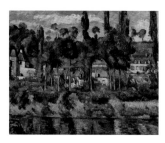

56. Paul Cézanne (1839–1906)
The Château de Medan,
*c.*1879–80
Oil on canvas, 59.1 × 72.4cm
Glasgow Museums: The
Burrell Collection

57. Edgar Degas (1834–1917)
*The Rehearsal, c.*1874
Oil on canvas, 58.4 × 83.8cm
Glasgow Museums: The
Burrell Collection

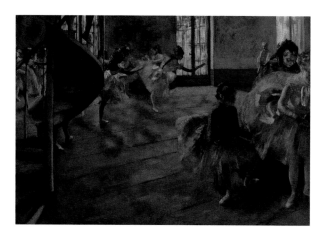

are now in the Burrell collection. McInnes died during the war and left his paintings collection to Glasgow Corporation in 1944. In the same year William Burrell donated some 6,000 items to the city, including his collection of French nineteenth-century art. Sir John Richmond followed suit in 1948, gifting a selection of works from his collection. Glasgow benefited hugely from these bequests, but the city also missed out on two of the most important collections of Impressionist and Post-Impressionist art ever assembled in this country. When D. W. T. Cargill died in 1939 his collection was dispersed for a small fortune at sales in London and New York. His brother William contemplated leaving his collection to Glasgow Corporation, but, unimpressed by the way they had handled the housing of The Burrell Collection, he decided to sell it at auction. It sold for a record £1,043,590 in June 1963, a huge loss to the city. The golden era of collecting in Scotland was over.

[1] For information on Archibald McLellan, see Elspeth Gallie, 'Archibald McLellan', *Scottish Art Review*, vol.V, n.1, 1954, pp.7–12.
[2] This picture was exhibited at the Glasgow Institute in 1877 and 1879, when it was owned by W. I. Brown, but was later acquired by John Reid (1861–1933), who owned an important collection of Hague School paintings. For information on John Reid, see *Catalogue of the Collection of Pictures of the British, French & Dutch Schools Belonging to John Reid, with Notes by James L. Caw*, Glasgow, 1913.
[3] For an account of the early taste for Hague School pictures among Scots collectors, see Frances Fowle, 'The Hague School and the Scots – A taste for Dutch pictures', *Apollo*, August 1991, pp.108–11.
[4] For a recent discussion of both collectors, see Sarah Herring, 'The National Gallery and the collecting of Barbizon paintings in the early twentieth century', *Journal of the History of Collections*, vol.13, n.1, 2001, pp.77–89.
[5] Alexander Macdonald was a wealthy granite quarrier from Keppleston, Aberdeenshire. His collection included works by Mollinger, Artz and Israëls, some of which were exhibited in Aberdeen as early as 1873. For further information on Macdonald, see Charles Carter, 'Alexander Macdonald 1837–84 – Aberdeen Art Collector', *Scottish Art Review*, vol.V, n.3, 1955, pp.23–8. See also Jennifer Melville, 'John Forbes White and George Reid: Artists and Patrons in North-East Scotland', unpublished Ph.D., thesis, University of Edinburgh 2001, esp. pp.37–40 and 140–8; and Jennifer Melville, 'Art and Patronage in Aberdeen, 1860–1920', *Journal of the Scottish Society for Art History*, vol. 3, 1998, pp.16–23.
[6] For the most recent research on John Forbes White, see Jennifer Melville, *op. cit.*, 2001. See also I. M. Harrower, *John Forbes White*,

Edinburgh and London 1918; *idem*, 'Joseph Israëls and his Aberdeen Friend', *Aberdeen University Review*, vol XIV, 1927, pp.108–22; Charles Carter, 'Art Patronage in Scotland: John Forbes White', *Scottish Art Review*, vol.VI, n.2, 1957, pp.27–30; and Melville, *op. cit.*, 1998, pp.16–23.
[7] Melville, *op. cit.*, p.83.
[8] For information on Cottier, see W. E. Henley, 'Daniel Cottier 1838–91' in *Catalogue of ancient and modern Pictures . . . (Sale of Pictures of the late Mr. Cottier of London)*, Paris (Galleries Durand-Ruel) 27–28 May 1892, pp.IX–XIII; and Brian Gould, *Two Van Gogh Contacts – E. J. van Wisselingh, art dealer; Daniel Cottier, glass painter and decorator*, Naples Press, Bedford Park, 1969.
[9] White's recently discovered, handwritten account of his collection, confirms that the picture was purchased from Cottier on 3 September 1874 for £950. See Melville, *op. cit.*, Appendix B.
[10] Ina Mary Harrower, *John Forbes White*, Edinburgh & London, 1908, p.40.
[11] James Reid's son bequeathed the picture to Glasgow Art Gallery in 1896.
[12] D. C. Thomson, *The Barbizon School*, London 1891, p.45. *La Toilette* is reproduced on p.43 of Thomson's book.
[13] *Ibid.*, p.45.
[14] *Athenaeum* 1875, p.740.
[15] Cottier's collection was auctioned in Paris in 1892. The catalogue was dominated by Corot and Daubigny, a testament to Cottier's early taste for the art of the Barbizon School.
[16] These were as follows: 1872 Corot's *Morning* (n.515), on sale for £262; Daubigny's *Banks of the River Oise* (n.303), on sale for £210; 1876 Corot's *Landscape with Figures* [*La Toilette*] (n.445), lent by James Duncan of Benmore; 1878 Daubigny's *The Pond* (n.122), on sale for £44; 1879 Corot's *The Windmill* (n.15), lent by John McGavin.
[17] He lent a Diaz landscape to the Glasgow Institute in 1880 (n.512), the earliest recorded loan of a Diaz picture from a Scottish collection.
[18] According to White's own notes, he bought a still-life of fruit by 'Courbet (the Communist)' from Daniel Cottier for £24. Melville suggests that this purchase was made at the same time as the Corot *Souvenir*. It was exhibited at the Glasgow International Exhibition in 1901.
[19] For a discussion of James Staats Forbes' collection of French pictures, see E. G. Halton, *The Studio*, vol.36, n.153, December 15,1905, pp.30–47 ('The Barbizon Pictures') and pp.218–32 ('Third and Concluding Article').
[20] Van Wisselingh continued to act as Cottier's agent in London until 1884 when he inherited his father's business in Amsterdam, but in 1887 he married Craibe Angus's daughter Isabella, thus establishing a permanent link between Glasgow and Holland.
[21] N.1079, catalogued as *Sunset*.
[22] Although often referred to as an Edinburgh collector, Alexander Bannantyne Stewart lived at Rawcliffe, Langside, Glasgow. The house had a large picture gallery attached to it, 'hung round with choice examples of the works of living artists' (*Memoirs and Portraits of One Hundred Glasgow Men*, vol.II, Glasgow, 1886, pp.233–4.).
[23] Other examples of Daubigny's work were lent by James Staats Forbes, the Hon Mr. Justice Day, Alexander Young and Robert Stewart of Ratho.
[24] N. 1089, catalogued simply as *Landscape*.
[25] *Art Journal*, 1894, p.259.
[26] He also showed a comparable moonlit view of Venice by Ziem.
[27] An oil version of this picture was bought by William Walters of Baltimore, another mercantile collector, during the 1880s.
[28] James Duncan loaned *Sheep-Shearing* to the Royal Glasgow Institute (n.31) in 1880 and *A Boat at Sea* (n.28) in 1882; John

McGavin loaned *Going Home* (n.35) in 1881. Apart from Donald, the only collectors to lend work by Millet to the Edinburgh exhibition were James Staats Forbes, Constantine Ionides and the Hague School painter H. W. Mesdag.

[29] Donald acquired the picture for £1,200 from the French dealers Boussod & Valadon and loaned it to the RGI in 1883 (n.38).

[30] Eight works by Monticelli and fourteen works by Diaz were included in the exhibition.

[31] Maris and Monticelli were so close at this time that they were even known to work together on the same canvas.

[32] Bastien Lepage's *Pas Mêche* (n.675 – National Gallery of Scotland) was lent by H. J. Turner and Degas's *Maître de Ballet* (n.836) was lent by Louis Huth.

[33] He bought Boudin's *Bassin de l'Eure* from Durand-Ruel in December 1888.

[34] Reid bought this work from Durand-Ruel on 1 March 1888 for 5,000 francs.

[35] No. 742, catalogued as *The Shipwrecked Mariner*.

[36] This work was included in the sale of A. J. Kirkpatrick's collection in 1914 (lot 290).

[37] Kirkpatrick's collection also included a Courbet still-life of *Pomegranates* (Glasgow Museums, The Burrell Collection, 35/67). As well as the Courbet, Kirkpatrick loaned twelve works to the 1888 Exhibition, most of which continued to reflect his love of atmospheric seascapes. In addition to works by Jongkind, Dupré and Ziem which had already been shown in Edinburgh, he contributed a Mesdag seascape, a riverscape by James Maris and the Courbet washerwomen.

[38] Chrystal bought this picture on 26 March from Thos. Anderson for £228.

[39] Chrystal bought this work on 5 April from E. & E. Silva White for £380.

[40] Bought for £130 from E & E Silva White on 2 April. The following year he lent it to the Glasgow Institute (n.291).

[41] Both were bought from E. & E. Silva White. The Rousseau cost £160.

[42] Acquired from the London dealers Hollender & Cremetti on 5 November for £395.

[43] He later sold this picture back to the dealers.

[44] This show was held at Reid's gallery in Glasgow in May 1897 and at Aitken Dott in Edinburgh in July.

[45] P. Kinchin and J. Kinchin, *Glasgow's Great Exhibitions*, Oxford 1988, p.64.

[46] *Ibid.*, p.57.

[47] Megilp in *The Bailie*, 4 December 1901, p.7.

[48] Following his death in 1926, W. A. Coats's collection was exhibited by the dealer W. B. Paterson at the Royal Society of British Artists in London in January 1927. See *Catalogue of Pictures and Drawings being the entire collection of the late W. A. Coats Esq., Wm B. Paterson, 5 Old Bond Street, London W1, January 1927*.

[49] For an account of Reid's sales of Monticelli's work, see Frances Fowle, 'Vincent's Scottish Twin – The Glasgow Art Dealer Alexander Reid', *Van Gogh Museum Journal* 2000, pp.91–9.

[50] The Glasgow artist George Henry makes frequent references to 'Monticelli Reid' in his correspondence with E. A. Hornel. See, for example, letter dated 17 March 1892, when, on the occasion of Reid's engagement to Ada Stevenson, Henry reports to Hornel, 'Monticelli Reid is going to marry Miss Loo's big sister'. Ref 2/18, E. A. Hornel Library, Broughton House, Kirkcudbright.

[51] Information from private family papers.

[52] He lent *Bords de la Seine* to the annual exhibition of the Glasgow Institute in 1891 (n.242).

[53] See R. Pickvance, 'Daumier in Scotland', *Scottish Art Review*, vol.XII, n.1, 1969, p.14.

[54] This work was later included in a sale of some of Burrell's collection at Christie's, London, on 14 June 1902 (lot.7).

[55] He bought *Susannah and the Elders* from Reid in April 1899 for £120. In 1927 he recalled to Reid's son that he had bought *The Artist at his Easel* from Alex Reid in the 1890s (See R. Pickvance, *op. cit.*, p.29).

[56] Included in sale on 14 June 1902 (lot 7).

[57] Bought by Reid for £43 1s from Christie's, 16 May 1902 (lot 141).

[58] See *Atelier Eugène Boudin. Catalogue des tableaux, pastels, aquarelles et dessins, dont la vente après aura lieu . . . les 20 et 21 mars 1899*, Hôtel Drouot, Paris. Preface by Arsène Alexandre.

[59] See G. Reitlinger, *The Economics of Taste*, vol.I, London, 1961, p.258.

[60] Reid's earliest recorded purchases of Boudin date from December 1888 when he bought *Bassin de l'Eure* from Durand-Ruel and *Camaret, Voiliers à l'Ancre* of 1873 (private collection) from the Dutch dealer Elbert van Wisselingh.

[61] This work was later acquired by James Fulton.

[62] V. Hamilton, *Boudin at Trouville*, London, 1992.

[63] The prices ranged from £48 to £170.

[64] Catalogued as *Le Pardon*, n.1433.

[65] *Glasgow Herald*, 14 December 1912. Reid bought the picture from the sale of Thornburn's collection at Christie's on 14 June 1912 for £178 10s. It was later acquired by William Burrell (in 1919) for £720.

[66] These were entitled *Bloaters* (n.1393, Kay) and *Oysters and Still-Life* (n.1395, Burrell).

[67] Kay acquired the pastel from the French dealer Ambroise Vollard.

[68] Of the eight Impressionist works on show, four were lent by Durand-Ruel, one by an English collector and three by Scottish collectors. These were Monet's *Storm at Etretat*, Pissarro's *Rouen: Le Coté Ste. Catherine*, Renoir's *Girl Reading* and Sisley's *Snow Scene*. A collector called C. J. Galloway also loaned Pissarro's *Crystal Palace*. Apart from Kay, the only collector to lend a work by Manet was William Burrell, who exhibited the *Portrait of Victorine Meurent* (Boston, Museum of Fine Arts) (n.1409, catalogued simply as 'Girl's Head'). The only other Impressionist work to emerge from a Scottish collection was Monet's *Freshening Breeze* (n.1311, Sterling and Francine Clark Institute, Mass.), which was lent by Andrew Bain.

[69] For early collectors of Impressionist art in Britain, see Christopher Lloyd, 'Britain and the Impressionists' in *Impressionism. Paintings Collected by European Museums*, exhibition catalogue, Atlanta, Seattle and Denver 1999.

[70] Andrew Watson is completing a Ph.D., thesis at Aberdeen University on Constantine Ionides's collection of French paintings.

[71] See Kate Flint (ed.), *Impressionists in England: The Critical Reception*. London and Boston 1984, and esp. appendix 'Impressionist Works Exhibited in London 1870–1905', pp.356–75. By 1876 Hill owned no fewer than seven works by Degas, including six ballet scenes. (See Ronald Pickvance, 'L'Absinthe in England', *Apollo*, May 1963, pp.395–8; and Ronald Pickvance, 'Henry Hill: An Untypical Victorian Collector', *Apollo*, December 1962, pp.789–91.).

[72] The Fisher Unwins and Esther Sutro owned works by Van Gogh during the 1890s and Arthur Studd acquired one of Monet's *Grainstack* pictures (Wildenstein 1217A) as early as 1891. Many of these early acquisitions by British collectors ended up in the collection of Count Isaac de Camondo.

[73] Other early English collectors included Arthur Studd, J. Burke of London, George Moore, James Staats Forbes, Lord Grimthorpe and Sir William Eden (see Douglas Cooper, *Courtauld Collection*, London 1954, pp.60–76). Samuel Barlow of Stakehill, Lancashire,

owned at least four works by Pissarro (see Cecil Gould, 'An Early Buyer of French Impressionists in England', *The Burlington Magazine*, vol.108, March 1966, pp.141–2). For a detailed list of Impressionist works absorbed into British collections during this early period, see Madeleine Korn, 'Collecting Modern Foreign Art in Britain Before the Second World War', unpublished Ph.D., thesis, University of Reading, 2001, esp. Appendix 1, pp.245–328; for biographies of individual collectors, see *ibid.*, Appendix 3, pp.346–415.

[74] On the Davies Sisters' collection, see John Ingamells, *The Davies Collection of French Art*, National Museum of Wales, Cardiff 1967; see also Bethany McIntyre, *Sisters Select. Works on Paper from the Davies Collection*, National Museums and Galleries of Wales, Cardiff, 2000.

[75] Cooper, *op. cit.*, 1954, p.66.

[76] On Hugh Lane's collection see Thomas Bodkin, *Hugh Lane and His Pictures*, Dublin 1932; and Barbara Dawson, 'Hugh Lane and the Origins of the Collection' in *Images and Insights*, exhibition catalogue, Hugh Lane Municipal Gallery of Modern Art, Dublin 1993, pp.13–31.

[77] On the Courtauld Collection see Cooper, *op. cit.*, and John House, *Impressionism for England: Samuel Courtauld as Patron and Collector*, Exhibition catalogue, Courtauld Institute Galleries, London 1994.

[78] W. T. Whitley, ed., 'The Art Reminiscences of David Croal Thomson', vol.1, unpublished text, Barbizon House 1931, p.54. The visitor in question was the artist John R. Reid, who paid one shilling admission.

[79] Anonymous review, *The Times*, 18 April 1889.

[80] For an account of the early reception of Impressionism in Scotland, see Frances Fowle, 'Impressionism in Scotland: an acquired taste', *Apollo*, December, 1992.

[81] For an account of Reid's association with Theo van Gogh, see Frances Fowle, 'Vincent's Scottish Twin – The Glasgow Art Dealer Alexander Reid', *Van Gogh Museum Journal* 2000, pp.91–9.

[82] This episode is recounted by Robert Macaulay Stevenson in a letter to D. S. MacColl, Glasgow University Library, Special Collections, ref.S431.

[83] Years later, in 1923, Reid bought this same work back from the dealer Paul Rosenberg and exhibited it in Glasgow and London, with a price tag of £35,000.

[84] Referred to in D. Cooper, *Alex Reid & Lefèvre 1926–76*, London 1976, p.6.

[85] A. S. Hartrick, *A Painter's Pilgrimage Through Fifty Years*, Cambridge, 1939, p.50.

[86] The catalogue for this exhibition exists, located in the National Art Library, London.

[87] Press-cutting from McNeill Reid files, Acc.6925, National Library of Scotland.

[88] *Saturday Review*, 2 January 1892.

[89] Arthur Kay, *Treasure Trove in Art*, Edinburgh, 1939, p.27.

[90] *Ibid*.

[91] Maxwell exhibited this work as *Effet de neige* at the annual exhibition of the Royal Glasgow Institute in 1895 (n.51). It had entered his collection by 1894, when it was mentioned by Robert Walker in 'Private collections in Glasgow and the west of Scotland – Mr Andrew Maxwell's collection', *Magazine of Art* (1894), pp.221–7. By this date, Monet's work was beginning to achieve quite high prices in France. Reid paid Durand Ruel 4,500 francs for the Monet on 12 March 1892.

[92] McCorkindale's collection was sold by Morrison, Dick & McCulloch at 98 Sauchiehall Street, Glasgow, on 6 and 7 November 1903.

[93] G. Reitlinger, *The Economics of Taste: The Rise and Fall of Picture Prices 1760–1960*, vol.III, London, 1970, p.301.

[94] All eighteen works were bought from Bernheim-Jeune in March and April 1919.

[95] This work was bought as *Le Déjeuner* by William McInnes on 6 March 1919 for £250. Two other (untraced) works, *La Maison* and *Pot de Fleurs*, were bought by the Dundee dealer John Tattersall, also in March.

[96] Richmond also bought *Enfant au Tablier Blanc* from the same exhibition for £600.

[97] He bought *La Nappe de Cachemire* for £200 and *Devant la Tapisserie* for £400.

[98] The Impressionist works in the 1920 exhibition were catalogued as follows:

117	La Côte de l'Hermitage – Pissarro.
120	Rue de Village – Guillaumin.
142	Louveciennes – Effet de Gèl – Pissarro.
143	Environs d'Auvers – Pissarro.
144	Vue de Londres, Effet de Neige – Pissarro.
145	La Cathédrale – Monet.
146	Le Ballet – Degas.
147	Nymphéas – Monet.
148	Diego Martelli – Degas.
149	Nymphéas – Monet.
150	Vétheuil – Monet.
151	Croyant, Gelée Blanche – Guillaumin.
152	Pommes – Renoir.
153	Melon et Fleurs – Renoir.
154	Tête d'Homme – Renoir.
155	Au Sablon – Sisley.
156	Rue de Village – Sisley.

[99] T. J. Honeyman, *Art and Audacity*, London 1971, p.124.

[100] *Ibid*.

[101] McInnes bought *Anemones* from Alex Reid's gallery in June 1925 for £525.

[102] Honeyman, *op. cit.*, 1971, p.128.

[103] T. J. Honeyman, *Patronage and Prejudice*, W. A. Cargill Memorial Lecture in Fine Art, University of Glasgow 1968, p.5.

[104] *Ibid.*, p.22.

[105] *Ibid.*, p.18.

CATALOGUE

Catalogue 1

Jules Bastien-Lepage (Damvillers, 1848–84, Paris)

Poor Fauvette, 1881

Oil on canvas

162.5 × 125.7cm

Whereas Millet painted the life of the peasants of rural France in general, Bastien-Lepage was interested in the realistic depiction of one individual at a particular time and place. Here the place is the flat, open countryside of Damvillers in north-eastern France. One of only a few of his major canvases not to be shown at the Paris Salon, *Poor Fauvette*, like many of Bastien's mature paintings, depicts a single, expressive figure in a barren winter landscape. Dressed in rags and dwarfed by a tall thistle and a leafless tree, a 'little wild girl' guards a cow. Unlike the more conventional compositions of Millet and Breton (cat.39 and cat.8), where the figures are seen against the sky, we look down here on the girl and then up to a distant panorama – heightening our sense of encounter with the child.[1]

The young Russian painter Marie Bashkirtseff described in her *Journal* a visit to Bastien's studio in January 1882: 'there hang his pictures to fill me with admiration, awe, and envy. There are four or five of them all life-size, and painted in the open air . . . one of them represents a female cowherd of eight or ten years of age in a field; there is a bare tree with the cow beneath it; the poetry of it is very impressive, and the eyes of the little girl have an expression of infantine and rustic reverie which I do not know how to describe.'[2]

Another early commentator, Richard Muther, wrote that *Poor Fauvette* was 'perhaps the most touching example' of Bastien's 'brooding devotion to truth'. He described the landscape 'with frozen tree and withered thistles, stretching round like a boundless Nirvana. Above there is a whitish clear, tremulous sky, making everything paler, more arid and more wearily bright; there is no gleam of rich luxuriant tints, but only dry stinted colours; and not a sound is there in the air, not a scythe driving through the grass, not a cart clattering over the road. There is something overwhelming in this union between man and nature . . . As an insect draws its entire nature, even its form and colour, from the plant on which it lives, so is the child the natural product of the earth upon which it stands, and all the impulses of the spirit are reflected in the landscape.'[3]

Bastien's evident psychological involvement makes his paintings accessible, despite their stark themes. In 1901, the critic W. C. Brownell noted that Bastien's 'favourite problem, aside from that of technical perfection, which equally haunted him, is the rendering of that resigned, bewildered, semi-hypnotic, vaguely and yet intensely longing spiritual expression to be noted by those who have eyes to see it in the faces and attitudes now of the peasant, now of the city pariah.'[4]

Bastien visited London regularly and his paintings, widely exhibited in Britain, were extremely influential, particularly on the group of artists known as the Glasgow Boys. When *Poor Fauvette* was exhibited at the Royal Academy in 1909, it was seen by the novelist D. H. Lawrence, who wrote that, 'Bastien Lepage, the French Peasant painter, had three terrible pictures . . . Grey pictures of French peasant life – not one gleam, not one glimmer of sunshine . . . The little girl – *Pauvre Fauvette* – minding her gaunt cow beneath a gaunt bare tree, wrapped in a horrid sacking, she, too, is *navrante*. That little pinched face looking out of the sack haunts me and terrifies me and reproaches me. Oh – that it should be true. It seems that the great sympathetic minds are all overwhelmed by the tragic waste, and pity, and suffering of it.'[5]

[1] Three versions of the work are known to have been painted. Glasgow's version was sent to London for exhibition in March 1882; a second version was shown at Petit's gallery in 1882–83 and a watercolour was exhibited in a posthumous exhibition held in 1885. Various drawings are also known. Further information can be found in Marie-Madeleine Aubrun, *Jules Bastien-Lepage 1848–84, Catalogue Raisonné de l'Oeuvre*, 1985, pp.212–5.

[2] Marie Bashkirsteff, *Journal*, Paris, 1890, entry for 21 January 1882, pp.242–3.

[3] Richard Muther, *History of Modern Painting*, 1896, pp.23–4.

[4] For a full discussion of the meaning of the work see Kenneth McConkey's excellent article from which this is quoted, '"Pauvre Fauvette" or "Petite Folle": A Study of Jules Bastien-Lepage's "Pauvre Fauvette"' in *Arts Magazine*, January 1981, pp.140–3.

[5] Quoted in the exhibition catalogue *Young Bert*, Castle Museums, Nottingham, 1972, pp.36–7.

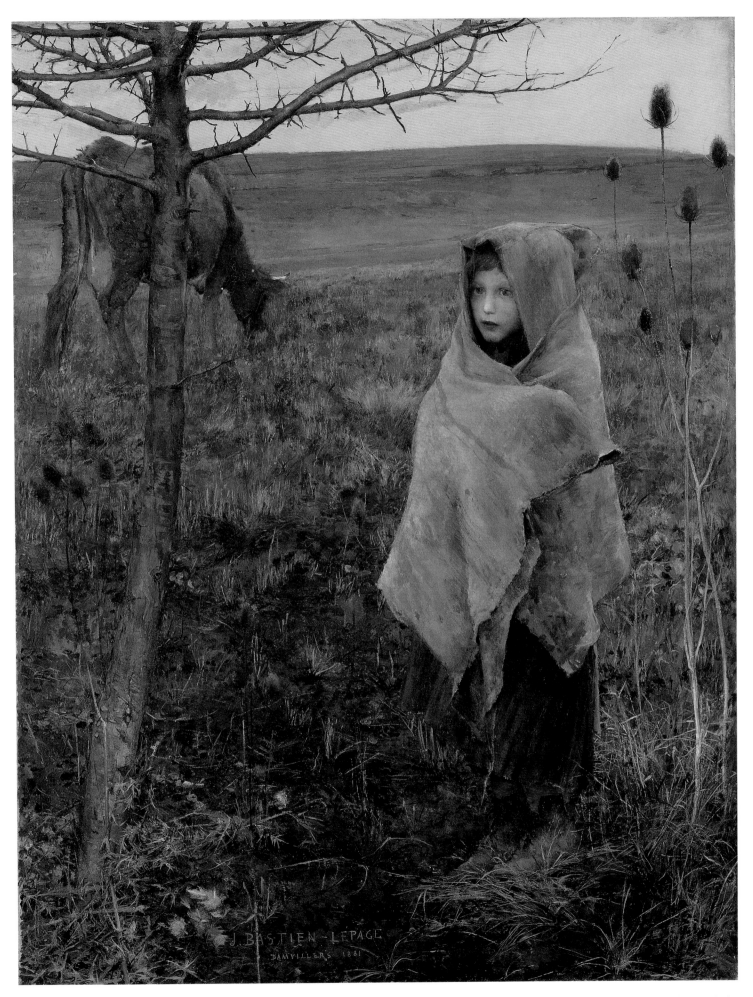

Catalogue 2

Emile Bernard (Lille, 1868–1941, Paris)

Landscape, Saint-Briac, c.1887–89

Oil on canvas

53.8 × 65.0cm

Emile Bernard was one of the most talented of the group of artists that, for a few years from 1886, gathered around Paul Gauguin at Pont-Aven, an artists' colony in Brittany. Bernard and Gauguin shared a common goal as they rejected Impressionism, with which they had both experimented. They sought a new visual vocabulary for the expression of their emotions and ideas, one that would free their work from being a literal representation of the external world. The style they developed, one of simplified form and colour and bold contours, is known as Synthetism. It was influenced by their knowledge and taste for Japanese and Epinal prints, Gothic tapestries and the decorative arts. Convinced that the elder artist was stealing the credit for the development of this new style, Bernard finally broke with Gauguin in 1891.

Although Bernard is said to have painted outside from nature during the summer of 1882, his first sustained work *en plein-air* seems to have taken place in the summer of 1886 during a walking tour in Normandy and Brittany. It was on this tour that he first stayed at Saint-Briac in Brittany at the inn of one Mme Lemasson. Fascinated by the art and architecture, and by the customs and traditions of the region, Bernard returned to Saint-Briac, near Saint-Malo, in the spring of 1887, and again in the early summer of 1888 and in August of 1889. Although there is almost nothing in this painting to give us a clue as to where it was painted, that it is a landscape in Saint-Briac we know from the evidence of Bernard's unpublished inventory in which he notes that the apple trees in the painting were located near Saint-Briac.[1] It is difficult to make out the date of the work inscribed in a dark brick-red on the lower right, but it is usually read as being '89'. It is just possible, however, that the work was painted during his earlier visits of 1887 or 1888, as the bare spindly trees in the foreground and the cold pale blue of the sky suggest spring or early summer.

This earlier date would accord well with the development of Bernard's technique. Although there is a deliberate simplification of form in his description of the large rounded bushes contained by heavy dark-blue contours, the colours remain close to those of nature. They are not yet the unrealistic flat areas of bright colour that he would use in 1889. The brushstrokes are also more pronounced, Bernard using thin parallel vertical or diagonal strokes of bright green over the flat yellow preparatory layer in the grass under the trees to the right.

In his many writings Bernard recorded the events of the innovative times he had lived through, and recounted his friendships with artists like Cézanne, Gauguin, Toulouse-Lautrec and Vincent van Gogh. He had corresponded with van Gogh throughout the late 1880s; in 1893, recognizing the importance of these letters, Bernard published a selection of those he had received.

[1] Quoted in entry in Sotheby's sale catalogue, *Impressionist and Modern Paintings and Sculpture, Part II*, 5 December 1984, lot 128.

Catalogue 3

Pierre Bonnard (Fontenay-aux-Roses, 1867–1947, Le Cannet)
The Edge of the Forest, c.1918

Oil on wooden panel

37.3 × 45.9cm

Bonnard has been called the 'last of the Impressionists' and indeed described himself as that to Matisse. Unlike the Impressionists, however, Bonnard painted from memory and from sketches, never from life, 'The presence of the object, the motif, is very disturbing to the painter at the time he is painting. Since the starting-point of a picture is an idea, if the object is there at the moment he is working, the artist is always in danger of allowing himself to be distracted by the effects of direct and immediate vision, and to lose the primary idea on the way.'[1]

While the light palette, the free brushwork and the sense of space in this small landscape show his knowledge of Impressionist technique, Bonnard uses colour to evoke a mood rather than to record atmospheric changes. 'The colours move across the surface of his paintings in constantly shifting interplay, lending an extraordinary fascination to common subjects. Familiar sights – the pervading greenness of a landscape, the intensification of colour in objects on a lightly overcast day – are given vivid life.'[2] Although some of his paintings were completed quickly, Bonnard's art was painstaking and meditative, and he returned to most of his paintings again and again. In later life he said that he was just beginning to know how to paint and exclaimed that a 'painter should have two lives, one in which to learn, and one in which to practice his art.'[3]

Bonnard's compositions have a certain theatricality, as the artist enjoyed framing his views through windows and verandas or, as here, through a curtain of slender trees to left and right. It is difficult to know where this work was painted. Usually he repeats similar views, but this seems to be a unique view; but of where? From about 1909 he made annual trips to the south of France, eventually buying a house in Le Cannet. Although the colours here suggest the cool but hazy warmth of a spring day, the trees and the landscape beyond suggest that it may be a view painted either from his grandfather's property in the Dauphiné, in the hamlet of Le Grand-Lemps which has this mix of flat and hilly areas, or near his own home at Vernonnet, near Vernon, in the valley of the Seine.

Like Renoir and Matisse, Bonnard was not afraid of being accused of painting too happily and decoratively. He told Tériade 'One is not always transported with joy by what one sees, but a painter must be able to discern some agreeable connection between one thing and another, and to find a place for it in his painting. We can abstract beauty out of everything.'[4]

[1] Quoted in John Rewald's essay in the exhibition catalogue, *Pierre Bonnard*, Museum of Modern Art, New York and Cleveland, 1948, from A. Lamotte, 'Le bouquet de roses; propos de Pierre Bonnard, recueillis en 1943', *Verve*, vol.V, nos.17–18, 1947.

[2] James Elliott, 'Bonnard and his Environment' in exhibition catalogue, *Pierre Bonnard*, Museum of Modern Art, New York and Cleveland, 1964, p.25.

[3] Monroe Wheeler, 'Bonnard', in *ibid*., p.20.

[4] *Ibid*., p.18.

Catalogue 4

François Bonvin (Paris, 1817–87, Saint-Germain-en-Laye)
Still-Life with Apples and Silver Goblet, 1876

Oil on canvas

33.0 × 41.1cm

Bonvin was drawn to the Realist movement early in his career when he met the novelist and critic Champfleury and the artist Gustave Courbet. Sharing their commitment to the recording of external appearances, Bonvin avoided using his imagination for inspiration, preferring to work from what he could see in the world around him. For Bonvin even the simplest object was a pretext for painting.

In this wintry still-life he combines everyday objects – apples, chestnuts, a pot, spoon and silver beaker – in a frontal composition, the simple shapes of the objects ranged rhythmically along the edge of a narrow ledge. Seen against a stark, dark background and observed close to and at eye level, Bonvin plays with the elliptical shapes, delighting in the distorted reflections of the apples in the beaker and in the shiny surface of the copper pot. The objects and setting have been chosen with care, the rich reds and warm browns bathed in a cool light that helps unify the composition.

Until the 1850s the genre of still-life had occupied a lowly position in the strict hierarchy of Salon categories. Bonvin, with Fantin-Latour, Ribot and Vollon amongst others, played an important role in the revival and development of the genre in the second half of the century. This revival owed much to the paintings of Chardin, a number of whose works had recently entered the Louvre. Here Bonvin's composition, the dark tones and even his choice of objects show how much he was indebted to Chardin.

Bonvin's choice of subject was also partly dictated by his circumstances. Bonvin referred to 1876 as a 'wretched year' with many deaths among his immediate family and friends, and with his own health problems, suffering from bouts of flu and his struggle with 'stones'. Confined to home, it was only natural that he would paint still-lifes.

By the end of the century Bonvin's reputation was eclipsed as the art-buying public grew to admire the work of Courbet and Manet. Despite the support of his dealer Gustave Tempelaere, interest in Bonvin's work diminished and his financial situation deteriorated in the last few years of his life. However, Bonvin's works were much sought after by Scottish collectors, and today there are many paintings by the artist in both public and private Scottish collections. Many were purchased, like this one, through the Glasgow dealer Alex Reid.

4.1
Jean-Siméon Chardin (1699–1779)
*Still-Life, c.*1728–30
Oil on canvas, 27.9 × 36.8cm
Glasgow Museums: The Burrell Collection

Catalogue 5

Eugène Boudin (Honfleur, 1824–98, Deauville)
A Street in Dordrecht, 1884
Oil on wooden panel
41.0 × 32.7cm

Boudin was one of the most important precursors of Impressionism. It was he who encouraged the young Monet to work outside from nature, saying that everything 'that is painted directly and on the spot has always a strength, a power, a vivacity of touch which one cannot recover in the studio.'[1]

Like many of his oils, *A Street in Dordrecht* is painted on a small wooden panel. Because they were easily portable, Boudin could take several panels with him on an excursion and, seated on his collapsible stool, work facing his motif. Aware of the practical limitations of painting out of doors, Boudin maintained a studio in Paris where, each winter, he would put the finishing touches to the works he brought back from his travels. Although his paintings have a feeling of immediacy, of spontaneity, Boudin was obsessed with the notion of finish. In a letter to one of his students he said, 'I have told you many times – an impression is gained in an instant but it then has to be condensed following the rules of art or rather your own feeling and that is the most difficult thing – to finish a painting without spoiling anything.'[2]

Boudin spent most of the year working in Brittany and Normandy but he also travelled regularly to Holland, visiting Rotterdam, The Hague, Scheveningen and Dordrecht. Wherever he worked, his subject-matter remained essentially the same because, on the whole, the places he visited were chosen precisely because they offered him a new aspect of a familiar subject. Here it is only the draped Dutch flag that confirms this as a Dutch scene rather than, for example, the French town of Caudebec.

A narrow, busy street was a favourite motif, for it presented him with a variety of artistic challenges, including that of incorporating the human figure into a townscape. Here he suggests the diversity of activity of the local people going about their everyday life – neighbours chatting in doorways, governesses pushing baby-carriages and children playing on the pavement. Yet Boudin avoids anecdote, preferring instead to capture the characteristic movements, gestures, attitudes and costumes of the individual figures. Typical of Boudin's work, this painting vibrates with subtle nuances of light and colour, tiny and hasty specks of pure pigment simultaneously dramatising the surface and bringing the whole into harmony.

In a career that lasted just over 50 years Boudin produced over 4,000 paintings and more than 7,000 drawings, watercolours and pastels. On one occasion, accused of being over-productive, Boudin replied, 'I could work less but then what would I do in between? I would get bored. My only pleasure is painting.'[3] Although he never commanded high prices, small works like this sold well.

[1] Quoted in Gustave Cahen, *Eugène Boudin, sa vie et son oeuvre*, Paris, 1900, p.181.
[2] From a transcript of a letter to Braquaval of 25 October 1889, private collection.
[3] *Op.cit.*, p.128.

Catalogue 6

Eugène Boudin (Honfleur, 1824–98, Deauville)

Venice: Santa Maria della Salute and the Dogana Seen from Across the Grand Canal, 1895

Oil on canvas

36.0 × 55.3cm

Throughout his life Boudin worked ceaselessly and single-mindedly to transcribe what he called the 'simple beauties of nature.' The task he set himself was not an easy one – to capture the restless motion of water and clouds, the transient gleams of light playing on waves and the characteristic movement of boats and ships. Boudin was fascinated by the sea. From his earliest years in Honfleur and Le Havre until his last days in Deauville, the busy, ever-changing life of ports were for him a subject of tremendous appeal and infinite variety.

Each year painting on his native Normandy coast, he also spent a few months further afield in Brittany, Holland or Belgium. It was not until the end of his life that, afflicted by ill-health, he sought out warmer climes, visiting the south of France and Venice. He first visited Venice in 1892, returning for two very productive seasons in 1894 and 1895. The work shown here dates from his last visit and, as he has inscribed the painting, we know the exact day, 20 June, 1895.

Despite his age and poor health Boudin was working as hard as ever, outside in front of his motif each day 'only returning to eat and to sleep.' As late as June 1896 a letter reveals that he was still struggling to capture aspects of nature, 'If I regain a little strength I am going to start doing skies again and try once more to struggle against this thing which is so difficult to deal with: light . . . the part of it we get on canvas counts for so little.'[1] It was this quest for perfection that led him to tackle scenes like this over and over again – although satisfying the demands of his dealers and collectors must also have played a role.

The magnificent light and the ever-present water of Venice appealed to the elderly Boudin. Here he delights in the play of the dark reflections of the gondolas and the poles on the gently moving water, using both the gondolas and the line of poles to march the viewer back into depth, to the dome of the Salute. The predominantly grey-blue tonalities of the scene on this dull summer day are lifted by subtle notes of red, green and a rich nut-brown. His marvellous freshness of touch, the surface flickering with small and regular strokes, gives this picture the unified atmosphere he struggled to capture throughout his career. Although he includes numerous small figures in a view such as this – from the groups strolling on the quayside to the passengers in the gondolas – Boudin is content to paint the view as he sees it without trying to tell a story.

In 1900 the critic Felix Buhot summed up the artist's achievement: 'Boudin's art is the kind of art which wins you over, not by its audacity of expression or the obtrusive violence of its touch but by its beauty, which combines intimacy, delicacy and truth; innovative in a way because it developed towards the open air, towards impression. He was one of the few artists capable of retaining a separateness and discreetness in his rendering of both the play and reflection of light and the outline of people and objects; his palette of greys and blues, his exquisite shading, his consistent harmony were neither conventional nor formulistic – rather, they were an accurate reflection of nature glimpsed sensitively.'[2]

Included in the 1899 Boudin retrospective, this work was sold in 1920 by Alex Reid to the Glasgow collector W. F. Robertson (1882–1939) whose family gifted the painting to the museum in 1996.

[1] From a transcript of a letter to Braquaval of 16 June 1896, private collection.
[2] Felix Buhot, *Journal des Arts,* 14 July 1900.

Catalogue 7

Georges Braque (Argenteuil, 1882–1963, Paris)
Dish of Fruit, Glass and Bottle, 1926
Oil on wooden panel
44.0 × 54.8cm

The Cubists Picasso and Braque revolutionised painting. Abandoning the single viewpoint of Western perspective, where a painting gave the illusion of being like a view through a window, the Cubists worked both from what they saw and from what they 'knew' to be there. They combined multiple viewpoints so that the different sides of an object could be shown simultaneously from above, from below, from behind or from straight on. As he experimented with the potential of these fractured objects, Braque, in the years 1908 to 1928, largely abandoned painting landscapes, choosing instead to explore the pictorial possibilities of still-lifes featuring the simple and humble objects of everyday life – fruit and flowers, glasses and plates and musical instruments. Although his early works are difficult to 'read', by the 1920s his still-lifes become more naturalistic and accessible and, like *Dish of Fruit, Glass and Bottle*, are small, horizontal in format and domestic in scale.[1]

Braque reputedly kept a bowl of fruit in his studio, not just for a much-needed snack, but because he frequently returned to compositions on this theme whenever he needed to clear his mind while struggling with some more complex visual idea. For Braque, like Picasso, the artist's task was not to copy slavishly something seen but to create a spatial reality independent of factual reality. In *Dish of Fruit, Glass and Bottle*, the tactile space, the spaces that surround the objects, are as important, and as palpable, as the objects themselves. The glass, bottle and fruit are bisected by darker shadows, giving a sensation of relief, of volume, to the flat silhouettes and also a sense of ambiguity.

There is a wonderful calm about this painting, even a feeling of permanence, of timelessness. Rich tones of brown are enlivened by fawn and ochre, by soft velvety green and gold, and by the dazzling white of the chequered cloth set against the black shadow of the plate. The imitation wood graining – a visual pun – was learnt by Braque from his father and grandfather who were *peintres-décorateurs*, traditional French artisan-decorators. From them, Braque learned to use subtle and varied textures that give his paintings effects of great richness and variety with a minimum of means.

There was never anything visionary, mystical or symbolic in his work, as Braque aspired to make great art out of the debris of everyday life. As Douglas Cooper has written, 'There is nothing difficult or reprehensible in Braque's pictures, no riddle, no abstruse philosophical references, no hidden moral or meaning . . . If we look, he will teach us to see, and this after all is the highest function of the true artist.'[2]

Dish of Fruit, Glass and Bottle was purchased from the artist by the Parisian dealer Paul Rosenberg, who then sold it to the Glasgow dealer A. J. McNeill Reid around 1928. Reid sold the painting to William McInnes in 1933. Reid later recalled this sale with mixed feelings: 'The splendid middle period Braque *Still-Life* Mr. McInnes persuaded me, rather reluctantly, to part with from my private collection in one of my weak moments. It is in good company but I certainly have my regrets. It cost me £200 when it was painted and, as one the same size and no better in quality, belonging to my late partner's widow, was recently sold in Sotheby's for £15,000, I would have been much wiser to have held on to it.'[3]

[1] Throughout 1924–25 Braque painted many similar still-lifes. Particularly close is G. Isarlov, *Catalogue des Oeuvres de Georges Braque*, Paris, 1932, n.394.
[2] Quoted in the notes to Magdalena M. Moeller's catalogue essay 'The Conquest of Space: Braque's Post-Cubist Work After 1917' in the exhibition catalogue *Braque*, Guggenheim Museum, 1988.
[3] A. J. McNeill Reid, 'The French Room at Kelvingrove', *Scottish Art Review*, vol.VII, 1960, p.19.

Catalogue 8

Jules Breton (Courrières, 1826–1906, Paris)

The Reapers, 1860

Oil on canvas

77.2 × 115.3cm

One of the most successful French painters of the nineteenth century, Breton made his name with realistic paintings depicting the hardships of life for the urban poor and, from the 1850s, after his return to his native Courrières, with scenes of rural life. When *The Reapers* was exhibited in London in the spring of 1860, the critic of *The Art Journal* described it as 'a harvest scene, in the foreground of which are a company of peasant women, coarse in person and attire, but in movement, action and sentiment equal to the impersonations of the Greek Sculptors.' Breton's knowledge of the classical tradition, from the painters of the Italian Renaissance to the seventeenth-century French master Nicholas Poussin (1593/4–1665) is apparent from the way he has depicted the serene, rather static figures and in his use of a controlled, orderly, horizontal composition.

Breton's subject may be drawn from life but the way he has chosen to paint the scene is not realistic. Although both the setting and costumes suggest that these handsome women are peasants returning from toil in the fields, they have a grace and an elegance that belies their lowly status. The child, her apron full of wild flowers, and the five young women form a kind of procession slowly moving out of the picture to the left. Breton is hinting here at some sentimental storyline. The two forlorn women bringing up the rear of the procession have their arms entwined, their gestures those of mutual support in some unknown grief. But is Breton suggesting a romance gone wrong rather than sorrow and pain caused by the harshness of their existence? As one art historian has observed, Breton's success was partly the result of his having restricted himself 'to the depiction of the female peasant, and, especially in later years, to an extremely classicised yet alluringly sensual version of the young peasant girl.'[1]

The son of a steward of a large estate, Breton, like Millet, was very attached to his native soil. Unlike the earthy realism of Millet's peasants, however, Breton's reapers pander to a bourgeois myth of the countryside. Although Breton never hid his debt to Millet, he decried the poverty of Millet's colour and his 'awkward and woolly technique.' In his memoirs Breton justifies their divergent vision of the rural world on the basis of the difference of the characters they had studied. His own peasants, he wrote, resurrect 'the age of the biblical patriarchs' while those of Millet arise from a 'strange, almost prehistoric dream.'[2]

The Reapers was sold at Christie's in London in 1861 and was bought by Hugh Lupus Grosvenor (1825–99), heir to the Marquis of Westminster. The painting was the first major work by the artist to enter a British public collection.

[1] Linda Nochlin quoted in Griselda Pollok, 'Revising or Reviving Realism?' in *Art History*, vol.7, n.3, September 1984, p.367.
[2] Breton on Millet, quoted in the exhibition catalogue *Origins of Impressionism*, 1994–95, Paris and New York, p.342.

Catalogue 9

Charles Camoin (Marseille, 1879–1965, Paris)

The Place de Clichy, Paris, 1910

Oil on canvas

65.3 × 81.5cm

Camoin, along with Derain, Matisse, Vlaminck and Marquet, was a member of the group known as the Fauves. This term of derision – meaning 'wild beasts' – was coined by a journalist on seeing their works at an exhibition at the Salon d'Automne in Paris in 1905. Their bold and dramatic canvases portrayed traditional subjects – landscapes and human figures – but with radically simplified forms and heightened colours in a deliberate rejection of Impressionism. Their aim was to communicate the emotions they experienced in front of nature and not merely to transcribe what they could see before them.

Something of Camoin's Fauvist style can be seen here in this view of a Parisian square. He dares to reduce the distinctive buildings to bold blue and black outlines where small, hasty blocks of paint are enough to indicate windows and doorways. In his choice of subject, Camoin betrays a continuing loyalty to Impressionism. Where Renoir would have painted at street level and involved the lives of the passers-by, Camoin remains distant, far removed from the scene.

From a high viewpoint we look down on a wet and wintry Place de Clichy. In the foreground is the dark silhouette of the Moncey monument. This bronze group, the work of Doublemard, was erected in 1869 to commemorate the site of the Barrière de Clichy, which on 30 March 1814 was defended against the Russians by pupils from the école Polytechnique and the Garde Nationale under Moncey. The strong dark and simplified shapes of the buildings and statue are set off against the lightening sky, while human activity is suggested in tiny, quick, slashes of black. A brilliant draughtsman, Camoin suggests the misery of these people, capturing their gestures and mood with their bowed heads and shoulders. He suggests too something of the pace of city life in the hasty reflections shining from the wet streets. Smoke rises weakly through the watery sky, and the bold outline of a distant chimney suggests the industry of the city. On the whole Camoin's subjects reflect his preference for painting the joys of living. It can be no accident that here he chooses to show the moment after rain. The strong notes of orange, burgundy and blue in the buildings behind the statue suggest they are catching a newly appeared sun.

The powerful sense of structure and volume in this painting reminds us of the important formative influence of Cézanne on Camoin's work. Early in the new century, the young artist spent some three months on military service at Aix-en-Provence. Encouraged by the dealer Vollard, he called on Cézanne and continued to visit him almost daily throughout his stay. Camoin then kept in touch with Cézanne who counselled him by letter to study from nature. In 1905 and 1906 Camoin returned to Aix to paint alongside Cézanne, whom he admired for the balance, simplicity, austerity and 'grandeur' of his compositions.

Catalogue 10

Mary Cassatt (Allegheny City, Pennsylvania, 1844–1926, Le Mesnil-Théribus)
The Young Girls, c.1885

Oil on canvas
46.5 × 56.0cm

Mary Cassatt was renowned in her lifetime and is beloved today for her sensitive portraits of mothers and children. Although Cassatt herself did not marry and never had any children of her own, she was surrounded by the many children of her family and friends. Almost the first question we ask in front of this painting is, who are these children? Are they sisters? The frustrating answer is that we do not know. Although Cassatt has definitely worked from two real children, for there can be no denying the individuality of their personalities, they may have been painted more for what they convey about childhood than as portraits.[1]

This endearing work shows Cassatt's ability to treat a traditional subject in an unconventional way. Using a canvas format normally reserved for landscapes, Cassatt shows the two young girls seated against a broad and rapidly painted green background. Suggestive of a sunlit garden setting it may have been painted in the artist's studio. The older girl has her left arm protectively around the younger's shoulders; their young faces gazing unsmilingly up and out of the picture to the right.

The work has an enduring quality because there is nothing that ties it to a particular place or time. The setting is unspecific. The girls' red-blonde hair is the natural, un-styled crop and tangle of childhood, and they wear white gowns hastily suggested by broad strokes of white, pale green and blue, rather than their own clothes. The sketchy quality of the open and free brushwork suggests that the background and the girls' gowns were painted quickly, probably in one session. It is possible that the artist spent more time on capturing the lively and somewhat vulnerable expressions on the small round faces, eagerly yet apprehensively looking up to their mother or a governess who is holding their attention and encouraging them to keep still while the artist painted.

Although the painting is signed, its sketchy quality and the fact that the ground layer can be seen throughout gives it an appearance of being unfinished. The seeming incompleteness, however, can be read as being appropriate to the painting's theme. There is a freshness and a vitality both in the spontaneous brushwork and in the gentle naturalness of the girls' pose that gives this painting an essentially modern character, the immediacy of everyday life.

[1] There is a related work in the Mayer Collection in Chicago which may be a study for this work or simply another version.

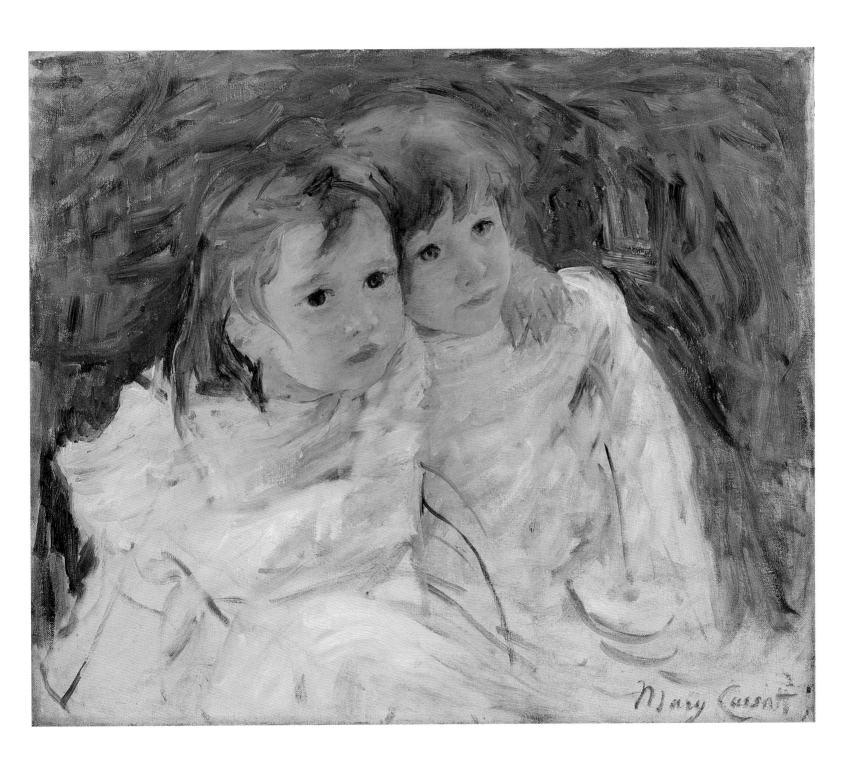

Catalogue 11

Paul Cézanne (Aix-en-Provence, 1839–1906, Aix-en-Provence)
Overturned Basket of Fruit, c.1877

Oil on canvas

17.0 × 33.2cm

Throughout his life Cézanne worked in three genres – landscape, portraiture and still-life. Setting himself particular artistic challenges, he would move from one to the other until he had successfully conquered every problem. Unlike the Impressionists, Cézanne cared little about capturing the changes that light and atmosphere wrought on his motif. Instead, he concentrated on using colour, rather than light, to convey the underlying forms of his chosen objects.

This tiny oil is one of a group of small studies of fruit painted in the late 1870s as the artist's mature style was beginning to emerge. Cézanne uses strong, blocky brushstrokes, heavily laden with paint, to describe the forms of the fruit, the straw basket and the textured surface they have spilled out on to. The brushstrokes are not yet regular or deliberately directional, the small scale of the canvas and the informality of the composition allowing the artist to experiment with an energetic freedom of touch. Similarly, there is an unexpected brilliancy of colour from the juxtaposition of complementary colours, small notes of red against green on the apples, and the yellow of the orange or grapefruit against the blue of the tablecloth.

While something as natural as a period of bad weather may have prompted Cézanne to paint a work such as this, it is as likely that he saw it as a useful tool to practise self-discipline and to test his powers of concentration. There is no suggestion, however, that such paintings were tackled in haste – the thickly worked surface of this small oil tells us Cézanne spent several sessions on it. Indeed, from Vollard's memoirs we know that Cézanne's slow pace meant that the apples regularly decayed before a painting could be finished and that this upset the artist.

The first owner of Vuillard's *Woman in Blue with Child* (cat.61), Thadée Natanson, reviewed Vollard's first Cézanne exhibition in November 1895 and wrote tellingly of Cézanne's apples: 'For the love that he put into painting them and that made him sum up all his gifts in them, he is and remains the painter of apples, smooth, round, fresh, weighty, bursting apples from which colour flows, not those one would like to eat or that *trompe l'oeil* makes appealing to the gourmand, but with ravishing forms. It is he who has given them shining dresses of red and yellow, who has made tiles of reflecting light on their skins, who has encompassed in a loving stroke their rotundity, and has created from them a delicious, definitive image.'[1]

[1] *La Revue Blanche*, 1 December 1895, p.500, quoted in John Rewald, *The Paintings of Paul Cézanne: A Catalogue Raisonné*, London, 1996, vol.1, p.232.

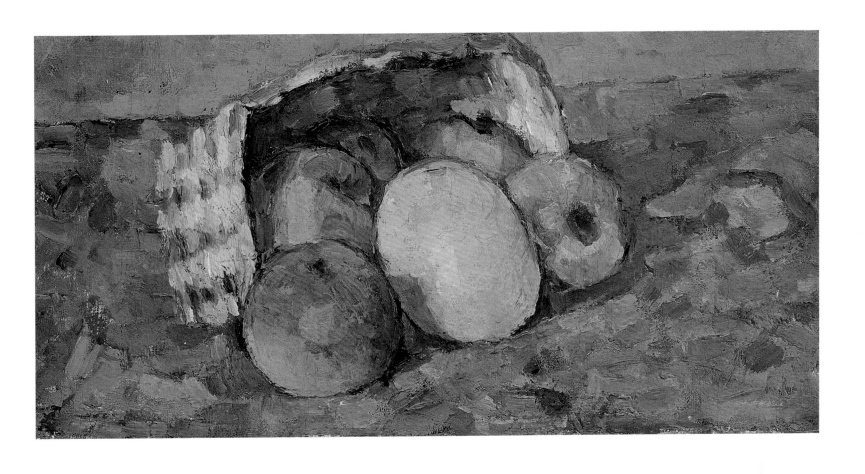

Paul Cézanne (Aix-en-Provence, 1839–1906, Aix-en-Provence)

The Star Ridge with the King's Peak, c.1878–79

Oil on canvas

50.4 × 60.2cm

Cézanne's early paintings, romantic or violent subjects drawn from his imagination, were dark, brooding and tortured. It was only after 1872 that, encouraged by Pissarro, he learned to draw his inspiration from nature and began to paint outside using the lighter palette and broken brushstroke of the Impressionists. Cézanne, however, never shared the Impressionists' interest in capturing the fleeting and transient. He was more concerned to seek out the inherent structure in a landscape and paint it in a way that was true to his sensations in front of nature.

This landscape shows a view of the range of mountains, *La Chaîne de l'Etoile*, just to the south of Aix-en-Provence, the city in the south of France where Cézanne lived and worked.[1] Like many of Cézanne's paintings this work has not been finished. Indeed, Cézanne seems to have felt that the painting was a failure. While the band of houses, buildings and hills in the middle ground have been worked on over a number of sessions, the area of grass in the foreground, the distant mountain range and the broad expanse of sky have been thinly painted. The artist has clearly abandoned the painting and, no doubt to signal his dissatisfaction, seems to have slashed the area of sky above the houses on the right where the repairs to a long vertical tear can be seen.[2]

The fact that this painting is unfinished allows us a fascinating glimpse into Cézanne's working method. During the later 1870s he explored the possibility of combining colour and form using brushwork. Here, particularly in the buildings and trees, he uses regular square strokes that would become the constructive brushstroke that he employed throughout the 1880s. Notice, for example, the simple squares and rectangles of pale blue that are used to indicate the doors and windows that pierce the walls of the buildings. Although Cézanne had difficulties 'realising' his creative intentions and chose to abandon this painting rather than struggle further, we can still enjoy the rich colour harmony he has established, where he has played the warm oranges of the buildings and strips of earth against the deep, dark greens of the fields and near hills. He has suggested aerial perspective by setting these darker shades against the pale blue of the distant hills. As we see often in Cézanne, strokes of colour from one area of the canvas find a place elsewhere, enlivening and animating the whole surface.

Why should Cézanne have abandoned this work? It was painted during a stay in the south of France that lasted from early 1878 until March 1879. He may have been unhappy with the work, but perhaps on his return from Paris in November 1881, he simply never had sufficient time to finish it. Perhaps, in the meantime, he had found new challenges to tackle. The painting was purchased in Paris by the Glasgow dealer A. J. McNeill Reid who recorded that 'Evidently Cézanne was not quite satisfied with the *Gardanne* since, when we bought it from Vollard, the famous French dealer, the sky had been slashed by the artist, a thing Cézanne was wont to do if something did not come just as he wanted it to do. It was eventually most skilfully restored by Helmut Ruhemann and it would take an expert eye to find out where the damage had been.'[3] As the eminent Cézanne scholar John Rewald noted, what is interesting about this is that Cézanne's dealer 'apparently preferred to sell a painting in the condition in which he had obtained it from the artist or, as, doubtless, in this case, from his heirs, rather than repair it.'[4]

[1] There is a photograph of the motif in John Rewald, *The Paintings of Paul Cézanne: A Catalogue Raisonné*, London, 1996, vol.1, n.399, p.266. For related paintings of the same motif, see Rewald n.526 (Barnes Foundation, Merion) and n.605 (Sammlung Oskar Reinhart, Winterthur). For a drawing of the motif see Joseph J. Rischel, *Cézanne in Philadelphia Collections*, Philadelphia, 1983, pp.62–3.

[2] According to Rewald, *ibid.*, p.241, Cézanne slashed works in 'his frequent fits of frustration'; see also Rewald nos. 234, 294, and 381.

[3] A. J. McNeill Reid, 'The French Room at Kelvingrove', *Scottish Art Review*, vol.VII, n.3, pp.18–19.

[4] Rewald, *op.cit.*, p.266.

Catalogue 13

Camille Corot (Paris, 1796–1875, Ville d'Avray)
The Woodcutter, c.1865–70

Oil on canvas

49.7 × 65.0cm

One of the most versatile and successful French landscape painters of the nineteenth century, Corot spent most of his life working in three places – at Barbizon, in Paris and at the family property at Ville-d'Avray. This small painting is typical of Corot's late landscapes which evoke the atmosphere rather than the detail of the contemporary countryside. In the foreground a red-hatted woodcutter is busy working on the many branches scattered around him. A small group of figures – presumably other woodcutters – can be glimpsed between the trees. Striking notes of pink, blue and green suggest wild flowers growing in the foreground, and Corot has used the end of his brush to scratch into the still-wet paint to suggest further tendrils of vegetation. Beyond the trees a still lake reflects the pale blue and white of the cloudy sky.

With a clearly defined foreground, middle ground and background this painting is classical in its composition, however, it is Pre-Impressionist in its handling and observation of light. Etienne Moreau-Nelaton, Corot's first biographer, observed in 1905 that 'Corot never broke with tradition. Whereas Rousseau and Dupré deliberately set free aesthetics and renounced all attachment to the Poussinesque French landscape of the past, Corot never burned his bridges . . . always going to nature for his inspiration, [Corot] remained faithful to a point to the formula of his artistic ancestors. He accomplished this *tour de force* by being at the same time the last of the classical landscapists and the first of the Impressionists.'[1]

Corot always made himself available to young artists for help and advice. Renoir considered him to be the 'great genius of the century . . . He was called a poet. But what a misnomer! He was a naturalist. I have studied him ceaselessly without ever being able to approach his art.'[2] Calm, serene and cheery by nature, Corot was fond of advising his pupils 'If before nature God does not speak to you, it means that your hour has not yet come or that you have mistaken your way. Go and search elsewhere.'

The Woodcutter is typical of the type of works by Corot that were sought out and cherished by collectors. As one writer observed: 'Without fuss, without fracas, a landscape by Corot can be hung in a room and looked at *for ever*. How many paintings can be looked at these days, for a month, without boring the owner?'[3] Works by both Corot and Daubigny could have been seen on exhibition at the Glasgow Institute as early as 1872. Six years later the Corporation Galleries held a loan exhibition that included paintings by both the Hague School and Barbizon artists.

[1] Quoted in Michael Clarke, *Corot and the Art of Landscape*, London, 1991, p.7.
[2] Quoted in R. Gimpel, *Diary of an Art Dealer*, London, 1986, pp.13–14.
[3] Quoted in Clarke, *op.cit.*, p.73.

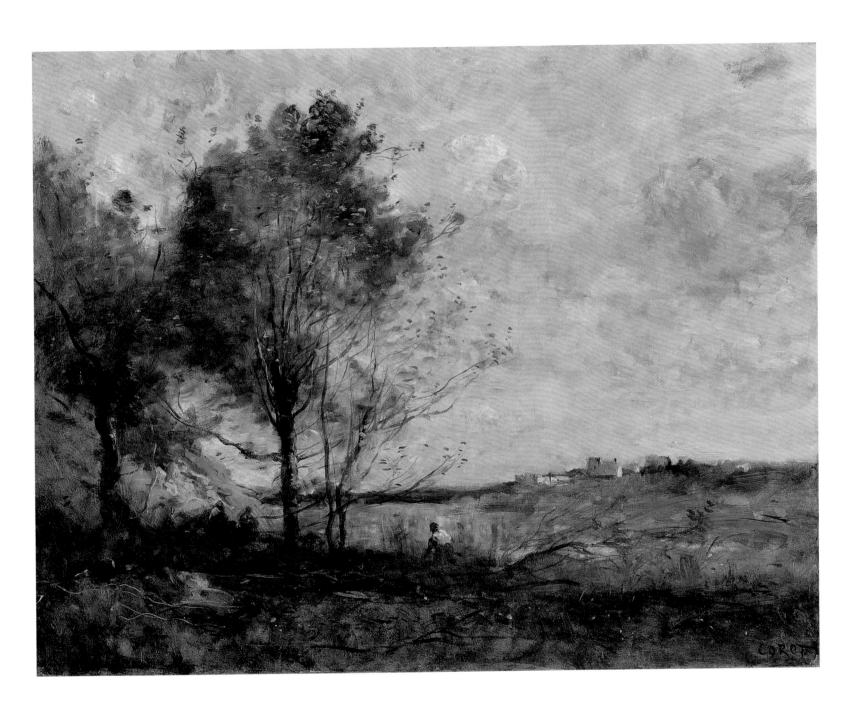

Catalogue 14

Camille Corot (Paris, 1796–1875, Ville d'Avray)
Mademoiselle de Foudras, 1872

Oil on canvas
89.5 × 59.8cm

Although Corot's landscapes played an important role in the development of realistic landscape painting in nineteenth-century France, he was at heart a classicist. His late landscapes like *Pastorale* (cat.15) are 'souvenirs,' depicting a wistful Arcadia markedly different from the realistic landscapes of contemporaries like Courbet. In late portraits, such as *Mademoiselle de Foudras*, he is more a poet than a realist. The sitter's pose, costume and the nostalgic mood are influenced by the art of the Italian Renaissance and by Dutch seventeenth-century portraitists whose work the elderly artist studied in the Louvre.

It is possible that Corot painted works such as *Mademoiselle de Foudras* to test his skills against those of the Old Masters he so admired, such as Leonardo, Raphael and Rembrandt. Like *The Woman with the Pearl, c.*1858–68 (Louvre, Paris), *Mademoiselle de Foudras* bears a certain similarity to the *Mona Lisa* (Louvre, Paris), her hands and arms held gently in her lap and her face bearing a haunting, enigmatic expression. The chain of wild flowers enlivening her dark hair suggests that she is an allegorical figure, and she is reminiscent of both Leonardo's *La Belle Ferronière* (Louvre, Paris) and Govert Flinck's *Flora* (Louvre, Paris). The demure tilt of her head and the tinge of melancholy in her distant expression suggest a debt to 'love portraits' such as the so-called *La Fornarina*, 1512 (Uffizi, Florence), now known to have been painted by Sebastiano del Piombo but previously thought to be by Raphael.

From contemporary evidence we know that Corot painted half-length, life-size portraits such as *Mademoiselle de Foudras* from models in his studio, often over a period of a week – a week that he seems to have considered a holiday! Why were they painted? Was Corot pitting himself against the masters, or was there a commercial demand for such works? We do not know. Although she has the attributes of an allegorical Renaissance figure there is still something essentially modern in Corot's portrait of this young woman, the daughter of a tobacconist who kept a shop at the Rue Lafayette, near the Faubourg Poissonière in Paris. Her dark, deep-set eyes and her pensive expression give the painting a powerful psychological quality that we associate with portraiture, even if the neutral setting and the clothes she wears – an embroidered Greek coatdress with wide sleeves (*kavádi*) and an embroidered waistcoat – are not her own.

Picasso, who had become interested in the works of Corot in the 1910s, made a free pencil sketch of *Mademoiselle de Foudras* in 1920. It is not known whether he actually saw the painting in a Parisian dealer's gallery – either Bernheim Jeune or Durand-Ruel – or whether he worked from a photograph.

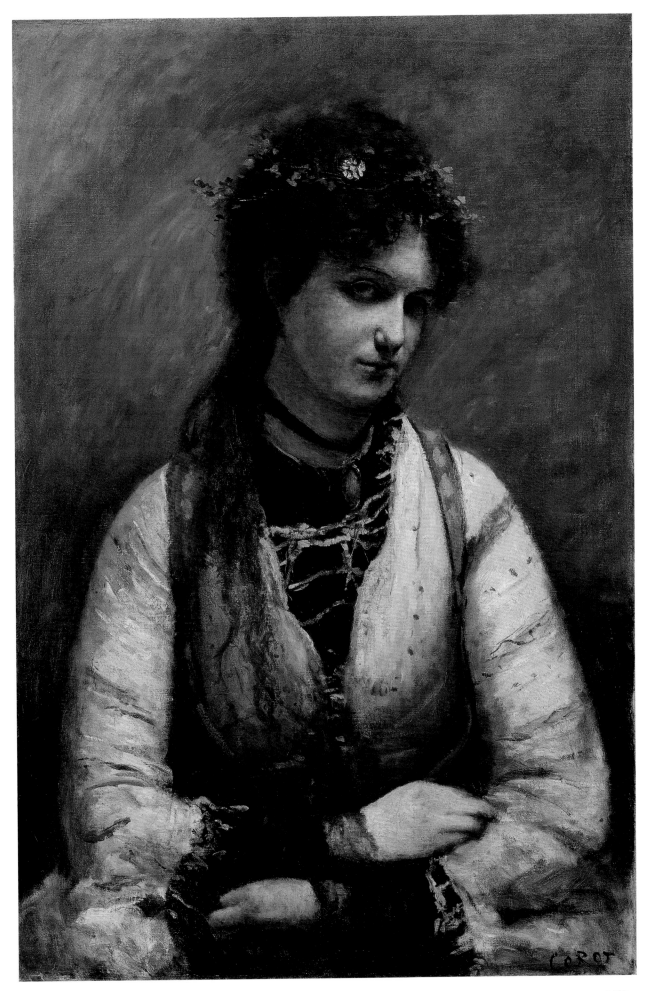

Catalogue 15

Camille Corot (Paris, 1796–1875, Ville d'Avray)

Pastorale, 1873

Oil on canvas

173.0 × 144.0cm

Although many aspects of his work anticipate Impressionism, Corot remained devoted to the Salon and the ideals it embodied. His Salon pictures, like *Pastorale*, clearly reveal his respect for the French classical landscape tradition rather than the realistic northern Dutch landscapes favoured by the Barbizon School. This large landscape, painted near the end of Corot's life, was exhibited at the Paris Salon in 1873. In size and subject it is typical of the type of landscape admired by the Salon-going public and was completely at odds with what the young Impressionists were painting at this date. Many of the art critics indeed preferred Corot's informal landscape studies to such a Salon work. Others objected to the idealised subject matter, the novelist and critic Emile Zola commenting that if 'M. Corot agreed to kill off, once and for all, the nymphs with which he populates his woods and replace them with peasant women I would like him beyond measure.'[1]

Painted in the studio, the motifs in *Pastorale* – the setting, the dancing figures and the music-making faun at the left – were all drawn from earlier works.[2] Corot was at heart a classicist and most of his mature landscapes, like *Pastorale*, evoke a wistful arcadia that is many removes from the realism of the landscapes of Rousseau or Courbet. In the past the painting was known as *Souvenir d'Italie*, the idealised setting and the schematic treatment of the flowers, grass, and trees evoking memories of Italy – which Corot had visited in the 1820s and again in 1834 and 1843. It also was perceived to show the influence of Claude Lorrain (1600–82) of whom Corot once said, 'When one sees one of Claude's paintings, one seems to be seeing a real sunset. That is the effect I want to produce – I want to render the vibration of nature.'[3]

The critic Jules Castagnary, reviewing Corot's *Pastorale*, proclaimed, 'Corot is the patriarch of the French landscape. He has been painting for fifty years. If fame came late to him, talent did not. In the revolution begun by Constable's two paintings, he was there, enrolled with the innovators. He saw the school born and saw it grow, himself developing and evolving . . . When one thinks that the hand that placed these deft touches carries the weight of seventy-seven years, such fortitude comes as a surprise and a marvel. The illustrious old man is the lone survivor of a vanished past.'[4]

It was the Parisian art dealer Cléophas who lent this work to the Salon in 1873. Shortly thereafter it was purchased by the Scottish collector John Forbes White, who owned it until February 1892. In a diary entry for that month, Forbes White noted his feelings at his parting with his 'great Corot', 'This is the last day of the Corot on my walls. Tomorrow it comes down to be packed for Glasgow. It has been my friend and adviser for 18 years, my standard of ideal, yet true, landscape; true because it conveys accurately and fully a great amount of the facts and appearances of Nature, yet ideal because it is the composition of a great artist, selecting and subordinating. The human eye is here rather than the lens of the camera . . . It is early morning; the rosy-fingered dawn is seen in the amber-touched cloud that floats lightly over the grey lake and the villa on the height. The mist lies on the bosom of the olive-covered hill beyond the great trees and their open arches under which four Nymphs dance and play the tambourine in the abandon of the joy of life.' The following day, with the painting out of its frame, Forbes White further observed, 'The upper corners of the canvas are scarcely covered with paint, all is thin – first intention; no attempt to carry it beyond this spontaneous action. The clouds in flecks are put in by one dexterous sweep of the wrist. The splendid cloud overhanging the lake is a confused mass of dove, rose, amber, yellow and grey, which at a fair distance resolves itself into lovely colour . . . All is suggestive; a master revelling in the fantasie he is playing, in the harmony he is evolving.'[5]

[1] Quoted in Michael Clarke, *Corot and the Art of Landscape*, London, 1991, p.85.
[2] For a discussion of related works, see the important entry on the painting in the exhibition catalogue *Corot*, Paris-Ottawa-New York, 1996–97, n.150, pp.350–1.
[3] Quoted in the exhibition catalogue, *Impressionism, Its Masters, Its Precursors and Its Influence*, London, 1974, p.29.
[4] Quoted in the exhibition catalogue, *Corot, op.cit.*, p.350.
[5] Ina Mary Harrower, *John Forbes White*, Edinburgh, 1918, pp.38ff.

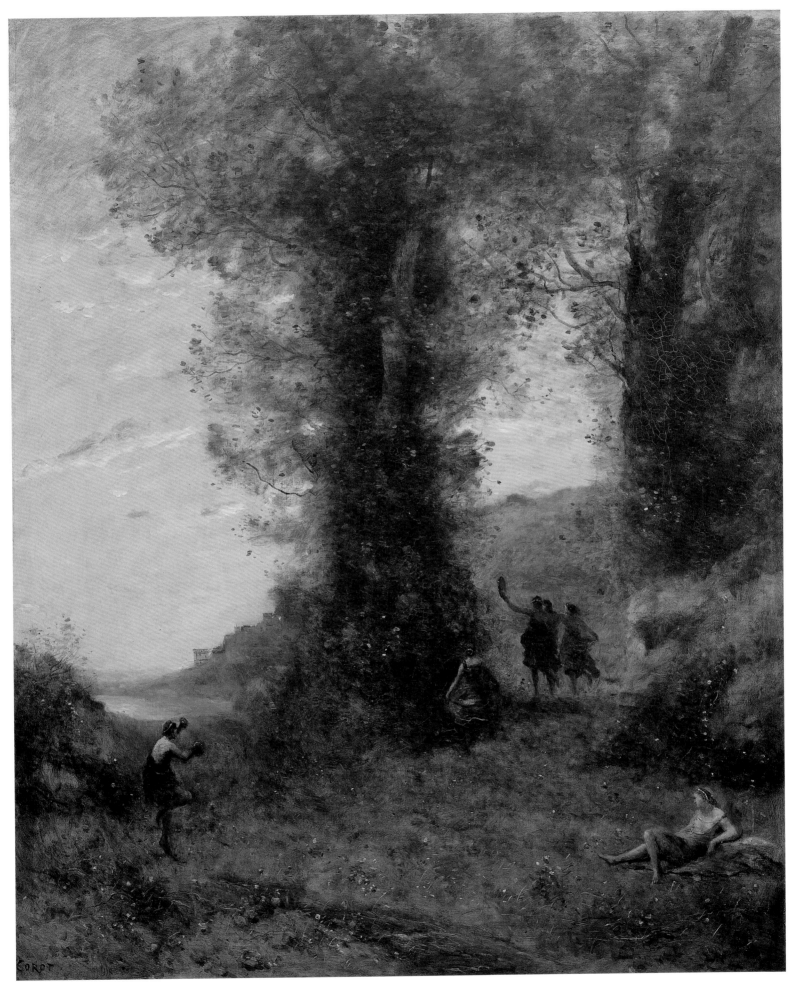

Catalogue 16

Gustave Courbet (Ornans, 1819–77, La Tour de Peilz, Switzerland)

Baskets of Flowers, 1863

Oil on canvas

76.9 × 101.7cm

One of Courbet's most beautiful still-lifes, *Baskets of Flowers* was painted during or shortly after Courbet's stay at Saintes, in the Charente, near the Atlantic coast. Initially intending only a two-week visit, Courbet was to stay in the Saintonge for eleven months, from late May 1862 until April 1863. Through the writer Jules Castagnary, Courbet had met the collector and amateur artist Etienne Baudry, who invited Courbet to stay at his home, the Château de Rochemont. Courbet's stay in the Saintonge was one of the happiest and most productive periods of his life, with the artist enjoying his host's lavish hospitality and the welcome attentions of a number of women.

With the exception of two earlier paintings, flowers had played a secondary role in Courbet's work. Baudry's keen interest in horticulture, his greenhouse and his extensive gardens were undoubtedly the inspiration for the remarkable flower compositions that Courbet painted as a result of this visit. After his return to Paris at the beginning of May 1863, Courbet mentions, in a letter to a friend, that he has already completed four flower-pieces and that he is still 'pitting myself against flowers.' Two weeks later the novelist Emile Gaboriau visited Courbet's studio and was overwhelmed by the paintings of 'marvellous flowers, ravishing in their freshness and brilliance . . . almost scented, they would make the flower beds of the Chaussée d'Antin look pale.'[1] Might *Baskets of Flowers* have been one of the works he saw?

In his choice of subject and in the way he tackles it – painting a large and luxurious bouquet against a simple dark background – Courbet shows his debt to the flower still-lifes by the Dutch artists of the seventeenth century, whose works he had seen in the Louvre and during his travels in the Low Countries. Whereas the Dutch paintings often bear a symbolic meaning, this is probably not the case with this work given Courbet's passionate love of nature and commitment to a realistic portrayal of his subjects. It is the naturalism of Courbet's painting that paves the way for the flower paintings of Manet, Degas, Bazille and Cézanne.

In *Baskets of Flowers* Courbet combines a great variety of flowers – peonies, roses, tulips, lilac, holly, bleeding hearts, a cyclamen, asters, a dahlia, snapdragon, love-in-a-mist and saxifrage – into a graceful design that describes a rhythmic arabesque across the canvas. In creating a near-abstract arrangement of colour, shape and pattern Courbet delights in the sensuous and varying textures of the blooms, playing the soft, full-blown, rounded petals of the peonies against the sharp edges of the dark green leaves that frame them.

As any gardener will know, these flowers, even in a conservatory, could not all be in bloom at the same time. The artist who resolutely declared that one must work from nature – 'show me an angel and I will paint one' – must, despite his declarations, have made use of artistic licence and painted from memory. The freshness, spontaneity and seeming authenticity of the blossoms might have been Courbet's way of proving that, as he was capable of repeating his work in the absence of the model, he was worthy of the term genius.

[1] Roger Bonniot, *Gustave Courbet en Saintonge*, Paris, 1973.

Gustave Courbet (Ornans, 1819–77, La Tour de Peilz, Switzerland)
Apple, Pear and Orange, c.1871–72
Oil on wooden panel
13.0 × 20.8cm

This is one of three fruit still-lifes by Courbet in the collection of Glasgow Museums painted during the artist's short period of confinement in the Sainte-Pélagie prison in Paris during the winter of 1871. Although Courbet always protested his innocence, he was imprisoned after being found guilty of assisting with the destruction of the Vendôme Column during the Paris Commune.

In letters to his family and friends Courbet railed against the prison authorities who would not allow him to work in the way he wanted: 'They just authorised me to paint in my cell without leaving it, without any kind of light or model. Their authorisation is useless for in that case I have no other motifs than God Almighty and the Holy Virgin.'[1] And again, 'they are preventing me from working . . . There are people who are put in prison because they do not want to work, whereas I am in prison to be deprived of my work. This is all the more frustrating as I have an idea . . . to paint bird's eye views of Paris'[2]

Denied the chance to work outside, Courbet executed still-lifes after the gifts of fruit and flowers brought to him by his sisters and friends. Paroled for health reasons on 30 December 1871, he was moved to Dr Duval's clinic in Neuilly where he continued to paint still-lifes.

Fruit was a subject Courbet had never before attempted, yet, in this small, masterly work, he conveys the sheer volume of the firm pear, the rounded orange and the dimpled apple with a realism that suggests a just-washed freshness. The warm tones of the pear and orange are strikingly contrasted with the green leaves, though various shades of green appear throughout – from the yellowy greens of the apple to the reflected notes of lime-green on the pear and orange. The rich colour and texture of the fruit are heightened by Courbet's having placed them against a simple dark background, and by having set them on a stark white cloth. In its perception of form and beauty of touch this painting surely anticipates Cézanne's still-lifes of the following decade.[3]

There were several Courbet still-lifes in Scottish collections by the 1880s. As early as 1874, the Aberdeen collector John Forbes White – who owned Corot's *Pastorale* – owned a small still-life of apples. *Apple, Pear and Orange* was sold by the Glasgow dealer Alex Reid to the Glasgow shipowner, Leonard Gow. The painting subsequently entered the collection of Gow's business partner, William McInnes.[4]

[1] Letter to Charles-Alexandre Lachaud, 25 October 1871 in ed. Petra ten-Doesschate Chu, *Letters of Gustave Courbet*, letter n.71–42, p.446.
[2] Letter to Jules Castagnary in *ibid.*, letter n.71–40, p.444.
[3] The painting in Glasgow was unknown to Fernier. For a related work, see Robert Fernier, *La vie et l'oeuvre de Gustave Courbet: Catalogue Raisonné, 1819–1865*, vol.1, 1977, n.798.
[4] In the museum archives a letter from A. J. McNeill Reid of 10 January 1966, records, 'Your 2384, our 2086 Courbet. The number is the one it bore when sold to Gow, and I have not traced the sale to McInnes. He may have taken it over direct from his partner. It was bought by us from Etienne Bignou but even in the London records it does not appear to have any history beyond that. . . .'

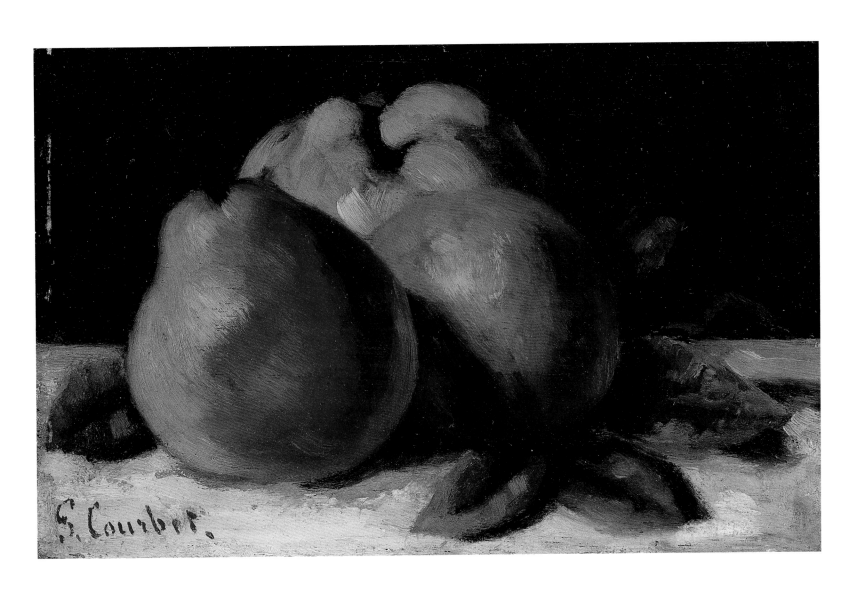

Catalogue 18

Charles-François Daubigny (Paris, 1817–78, Paris)

Lake with Ducks, 1873

Oil on wooden panel

37.9 × 67.3cm

Daubigny provided a vital link between the Barbizon artists and the young Impressionists. Like Millet, as a student at the Ecole des Beaux Arts he had competed unsuccessfully for the Prix de Rome in historical landscape, a prize that would have assured him a successful 'official' career. Daubigny chose instead to abandon the traditional academically accepted landscapes – with their historical, nostalgic or dramatic subjects – in preference for quiet river scenes that avoided all anecdote. Influenced by Corot, he learnt also to sacrifice topographical detail and to concentrate instead on capturing effects of light and atmosphere.

Although his large canvases were painted in the studio from oil sketches, Daubigny, like Boudin, often worked *en plein air.* As he strove to capture transient effects of light and atmosphere, his brushwork gradually became more direct, quick and free, and his palette lightened. Both his technique and his subject-matter – landscapes featuring rivers and lakes – inspired the Impressionists. As early as 1857 critics used the word 'impression' to describe and discuss his work, although some, like Gautier, complained about the sketchy quality: 'It is really too bad that this landscape painter who possesses such a true, such a just, and such a natural feeling, is satisfied by an impression and neglects details to this extent . . . his pictures are but rough drafts, and very slightly developed . . . and offer only juxtaposed spots of colour.'[1] The poet and critic Baudelaire, reviewing the Salon of 1859, praised Daubigny's landscapes for 'a grace and a freshness which fascinate the eye at once. They immediately convey to the spectator's soul the original feeling in which they are steeped', but complained that such effects were only achieved 'at the expense of finish and of perfection in detail. Many a picture of his, otherwise ingenious and charming, lacks solidity. It has the grace, but also the flabbiness and impermanence, of an improvisation.'[2]

Daubigny travelled widely in search of landscape motifs. One of his favourite spots was the river Oise, just north of Paris, which he often painted from his *botin* – the floating studio he launched in 1857. Although the locality of this painting is not known – and it is usually thought to be of a lake rather than a river – it may well be on or near the river Oise.[3] Daubigny's studio-boat allowed him to move freely, to choose original points of view, and to work from sunrise to sunset, while protecting him from the rain and from the sun. From contemporary accounts it seems that Daubigny sometimes forgot that he was on a boat, moving back to judge the effect of a painting and falling into the water! Inspired by Daubigny, Monet also worked from boats while painting at Argenteuil, Vétheuil and Giverny.

Despite his rejection of traditional landscape practice, Daubigny found official success and used his place on the Salon jury to argue – not always successfully – in favour of the works of the young Impressionists. This is one of eight works by Daubigny in Glasgow Museums' collection. Although we do not know when and where James Donald acquired it, we do know that it was already in his collection by 1888 when he lent it to the International Exhibition in Glasgow.

[1] Quoted in John Rewald, *The History of Impressionism,* 4th ed. rev. New York, 1973, p.101.
[2] Quoted in ed. Jonathan Mayne, *Art in Paris 1845–1862, Salons and Other Exhibitions, Reviewed by Charles Baudelaire,* Oxford, 1965, p.195.
[3] There are numerous paintings of similar subjects. See in particular *Alders,* 1872, National Gallery, London; *Scene on the River Oise,* 1873, Herbert L. Satterlee Sale, 22 April 1948 lot 13; and a related painting in the Calouste Gulbenkian collection, Lisbon.

Catalogue 19

André Derain (Chatou, 1880–1954, Garches, Seine-et-Oise)

Blackfriars Bridge, London, winter 1906

Oil on canvas

80.7 × 99.7cm

For a few short years Derain, a close friend of Matisse and Vlaminck, was one of the leading members of the Fauves. In 1905, and again in January 1906, Derain visited London at the request of the Parisian dealer Ambroise Vollard. Vollard probably hoped that the artist would return with paintings that would prove to be as commercially successful as those of Monet, whose views of the Thames had been shown at Vollard's gallery in 1904.

During the two visits Derain painted some 30 views of the city and its river. This painting dates from his second visit when Derain, intending a stay of some ten days, eventually remained for nearly two months. He explained in a letter to Matisse that he needed a change of setting and a concentrated period of work. This view has been painted from the Jamaica Wharf on the south bank, looking over to Blackfriars Bridge and the dome of St Paul's. An empty, anchored barge suggests the commercial activity of the now-still river. Derain commented on the eerie silence, 'I have seen a port with boats that arrived, a group of workers that finished their work, and I thought I was dreaming – in all this, not a sound.'[1] The area was home to rice mills, cement firms, mechanical engineers and, from the sign on the wooden wharf, to Wm. Lee, lime burners.

Blackfriars Bridge, London, with its simplified forms and strident blocks of strong, bright colour is one of the masterpieces of his Fauve period. Although Derain claimed he was not bound by academic rules of composition, a quick comparison with Boudin's *Venice: Santa Maria della Salute and the Dogana seen from across the Grand Canal* (cat.6) shows how classically this work is constructed. What is immediately striking is the sheer joy of Derain's brilliant and vibrant orchestration of pinks, yellows, blues, greens and oranges in startling juxtaposition. Derain's colours have nothing to do with reproducing the colours of nature; they are the colours of intuition. His object was 'to present happiness, a kind of happiness which must come from within us.' Although large clouds loom in the sky, Derain is less interested in capturing changing atmospheric effects than in the varied surfaces and reflections. His treatment of the water shows his knowledge of Signac's Neo-Impressionism and particularly of watercolour, areas of white primed canvas showing between the block-like brushstrokes and throwing the colours forward in a dazzling mosaic.

During his time with Reid & Lefèvre, Glasgow Museums' future director T. J. Honeyman met many of the Fauve artists. In an article recounting his experiences he describes the events that led to Glasgow's purchase of the Derain: 'Vollard, through our French colleague Etienne Bignou, was the source of some of the finest paintings we were able to acquire. We found, at Vollard's, eight of the Derain "Thames series" painted thirty years before. He parted with them at what we thought were bargain prices. But very few people in London were excited by them. "Oh yes! historically interesting but not great art!" . . . "Too much like posters!" . . . were among the milder criticisms. "That's not my idea of the Thames!" . . . "London doesn't look like that" . . . were among the more ignorant. Having had them for thirty years Vollard must have written them off as "not much value". He had become absorbed in other affairs. Each of these paintings could have been bought before the war for £150. Leeds and Glasgow were the only public collections to seize the chance . . . The Glasgow Derain . . . came to us through the good offices of A. J. McNeill Reid. It was, in a sense, my first effort to persuade the Art Gallery Committee to acquire a modern French painting. To help me do this I sought support from Sir John Richmond and Sir W. O. Hutchison (then Director of the School of Art). Neither of them was too sure, but they did help me. Sir John (whose generosity in the interests of the fine arts in Glasgow is remembered in the Richmond Chair at the University) said, "Well! All you say may be perfectly true and you can use my name, but I hope our students at the Art School don't waste their time looking at it!"'[2]

[1] Letter from Derain of 8 March 1906, London to Matisse, quoted in Judi Freeman's essay in the exhibition catalogue *The Fauves,* Sydney-Melbourne, 1995–96, p.29.
[2] T. J. Honeyman, 'Les Fauves – Some Personal Reminiscences', *Scottish Art Review,* 1969, vol. XII, n.1, p.19.

Catalogue 20

Narcisse Virgile Diaz de la Peña (Bordeaux, 1808–76, Menton)
*Roses and Other Flowers, c.*1845–50

Oil on canvas
63.2 × 51.0cm

Diaz was one of the most important artists of the Barbizon School, visiting the small village of Barbizon every year beginning in 1835. Although known primarily as a landscapist Diaz also painted still-lifes. Based on direct observation of nature these still-lifes are generally small, decorative works showing, as here, dense, rapidly painted bouquets looming out of a dark background. Although it is hard to tell whether this is an exterior or interior scene we can make out that the full-blown flowers are tumbling over the ledge on which they have been placed.

Delighting in the rough texture of thickly applied paint, Diaz uses small, scintillating flecks of pigment to capture the momentary effects of warm light. His love of texture is allied to a vibrant use of colour, dragging striking notes of green and blue over the canvas just above his signature. Unlike his artist friends Millet and Rousseau, Diaz was not interested in moralising, believing that art should be a *divertissement*, something to be enjoyed and not requiring deep thought.

The critic Jules Claretie described Diaz's paintings as 'prisms, peacock's tails, rainbows that force us to shut our dazzled eyes tightly; a sparkling flicker, a whirlwind of luminescent ornaments, golden atoms . . . Sometimes you might say he had a paint-laden palette that fell by accident on to the canvas, leaving the imprint of a figure, or a sinuous root, an agate with remarkable ramifications, all of this seemingly by chance.' Whilst critics like Claretie praised his daring style and exuberant use of colour, others – including the poet and critic Charles Baudelaire – despaired of his lack of drawing and accused him of setting out 'from the principle that a palette is a picture.'[1]

During the 1850s and 1860s Diaz's paintings became so popular that he no longer needed to exhibit, and it took him all his time just to keep up with the demands of his collectors. One of the first French paintings to enter the collection of Glasgow Art Gallery, *Roses and Other Flowers* was bequeathed by Mrs Isabella Elder in 1906.[2] The widow of the pioneering marine engineer John Elder, Isabella Elder was a great benefactress of the city of Glasgow. She fought to secure educational opportunities for women and helped establish a Medical School for Women.

[1] Quoted in ed. Jonathan Mayne, *Art in Paris 1845–1862, Salons and Other Exhibitions, Reviewed by Charles Baudelaire*, Oxford, 1965, p.77
[2] A companion picture of the same size belonged in 1886 to James Staats Forbes, London. It was lent to the Edinburgh International Exhibition in 1886, n.1139; see the Memorial Catalogue, n.49, p.32.

Catalogue 21

Raoul Dufy (Le Havre, 1877–1953, Forcalquier)
The Jetties of Trouville-Deauville, 1929

Oil on canvas

50.4 × 60.2cm

The popular seaside resorts of Trouville and Deauville have been attracting fashionable summer visitors since the early 1860s. One of the favourite pastimes of the visitors, when not sea-bathing, is promenading along the jetties and watching the return of the fishing fleet, the regular regattas, or simply each other. Eugène Boudin had delighted in capturing the distinctive costumes of the early visitors (ill.44). Here, nearly sixty years later, Dufy, another native of Normandy, does so too.

Dufy's style is original, distinctive and immediately recognisable. With brilliant economy of means, so suited to his subject, Dufy conveys the sense of exhilaration the elegant visitors experience as they take a bracing walk on this sunny but chilly, windy day. A master of line, he conveys the essence of the scene in a convincing visual shorthand, suggesting the freedom of movement and gesture that the elegant fashions then in vogue allowed. The fleeting nature of the experience is suggested by his expressive use of colour, a colour not bounded by line. Dufy later explained that a chance observation had made him realize that colour could exist independently of form, 'that a patch of colour of the dress of a little girl in red, running along the pier at Honfleur, had stayed longer on his retina than the outline of her silhouette.'[1]

While the sketch-like quality of this painting might suggest that Dufy had taken little time over it, it was born of much effort. After capturing the essence of the scene in drawings made in front of the motif, Dufy, in the quiet of his studio, would work up the drawings, the challenge being to retain the feeling of spontaneity of the passing moment and the changing quality of light. Deliberately simplifying the scene to its essentials, Dufy dispensed with wearying details, allowing the viewer to discover at a single glance everything that he the artist wanted to express. It is not surprising that Dufy's works sold easily, but Dufy himself was never fooled into thinking that his collectors understood the artistic qualities of his work. As he said, they 'bought subject and were forced to "swallow" the rest'!

Glasgow's brilliant museum director T. J. Honeyman recalled his own dealings with Dufy: 'In 1940, just before Germany compelled France to surrender, I received an urgent request. Could we accept the custody of several cases of pictures? [Dufy's entire collection of works, early and recent.] The cases arrived and throughout the war were hidden in the museum in Tollcross Park, Glasgow. Not until the fighting was over did I become aware of having broken the law by not declaring these paintings as "enemy property". They were eventually returned, having survived the risks of war and innumerable temptations! Dufy was very grateful and said so. Unfortunately he died before giving effect to a promise to repay Glasgow's generous hospitality by presenting an important work.'[2] *The Jetties of Trouville-Deauville* was purchased by Alex Reid's son, A. J. McNeill Reid, in July 1929 from Dufy's agent, Etienne Bignou, in Paris, and was gifted to the museum in 1960.

[1] Dora Perez-Tibi, *Dufy*, New York, 1989, p.134.
[2] T. J. Honeyman, 'Les Fauves – Some Personal Reminiscences', *Scottish Art Review*, vol. XII, n.1, 1969, pp.18–19.

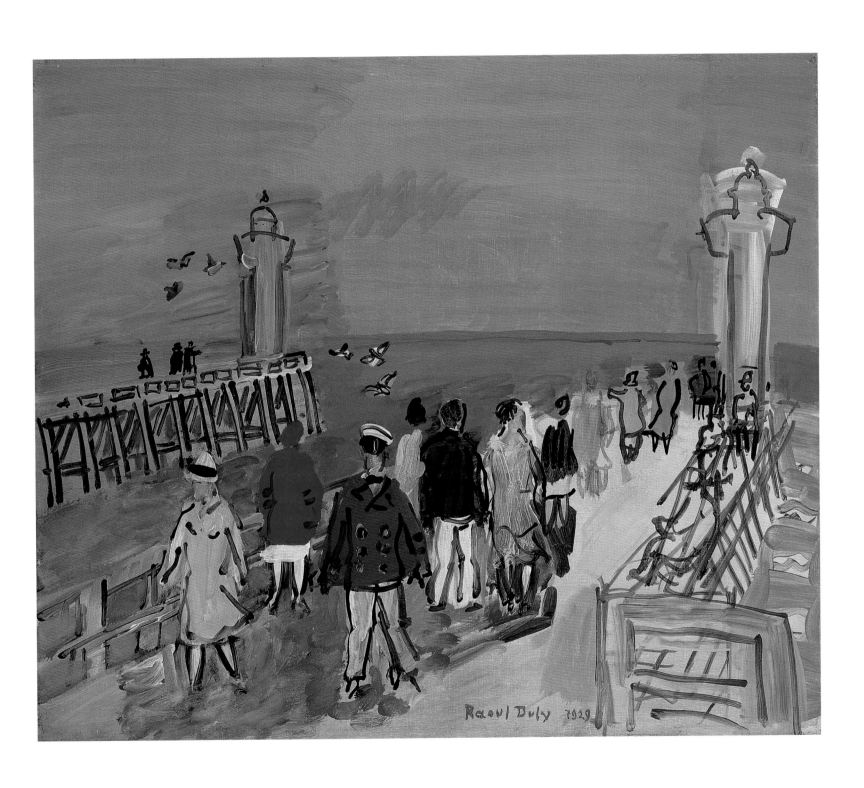

Raoul Dufy 1929

Catalogue 22

Henri Fantin-Latour (Grenoble, 1836–1904, Buré)

Yellow Chrysanthemums, 1879

Oil on canvas

61.6 × 48.6cm

During the eighteenth and nineteenth centuries the genre of still-life occupied a lowly position in the hierarchy of painting in France. Artists wishing to establish a reputation chose to concentrate instead on history painting – their works inspired by history, mythology, religion or literature – portraiture or landscape. Few major artists of the first part of the nineteenth century chose to tackle still-life. There was a gradual change in the 1860s when artists like Courbet, Manet, Cézanne and Fantin-Latour braved popular opinion and helped restore still-life to a position of respect.

Fantin's early still-lifes were somewhat complicated compositions featuring many types of fruit and flowers. It was only after 1875 that he chose to paint simple, small compositions focusing on one bouquet or on one bowl or basket of fruit, quite different from the tradition of composed still-lifes. This elegant and simple composition shows a group of yellow chrysanthemums in a cylindrical vase of blue-and-white porcelain at the base of which lies a sprig of yellow-and-orange wallflower. The vase stands on a grey table, angled into depth, against a neutral background which gives the flowers a monumentality and a presence they would have lacked had the viewer's eye been distracted by other details of the room in which they are placed. Fantin carefully studies the shape of each individual blossom, noting the numerous shades of yellow, moving from dark to light. Working from freshly cut flowers, Fantin needed to paint quickly before the blossoms wilted.

Fantin's remarkable abilities as a painter of still-life were celebrated by the American artist Whistler in his *Ten o' Clock Lecture*: 'He does not confine himself to purposeless copying, without thought, each blade of grass, as commended by the inconsequent, but, in the long curve of the narrow leaf, corrected by the straight tall stem, he learns how grace is wedded to dignity, how strength enhances sweetness, that elegance shall be the result.'[1]

Despite his friendship with the Impressionists, including Monet and Renoir, Fantin dismissed them as mere 'dilettantes who produce more noise than art' and denounced their efforts to organise a group exhibition in 1874, believing that it was best to win official recognition at the Paris Salon. In his choice of subject-matter, use of colour (darker and cooler in tone), his Realism, and in that he never worked outside directly from nature, he differs from them.

During the final decades of the nineteenth century Fantin-Latour achieved considerable fame in France and England as a painter of portraits and still-lifes. Works by Fantin-Latour were particularly popular with Scottish collectors and there are now twelve works by the artist in the collection of Glasgow Museums. *Yellow Chrysanthemums* was the first of these, and was acquired by the Trustees of the Hamilton Bequest in 1929, their first purchase of a French painting.

[1] Quoted in the exhibition catalogue *Fantin-Latour*, Paris-Ottawa-San Francisco, 1982–83, pp.259–60.

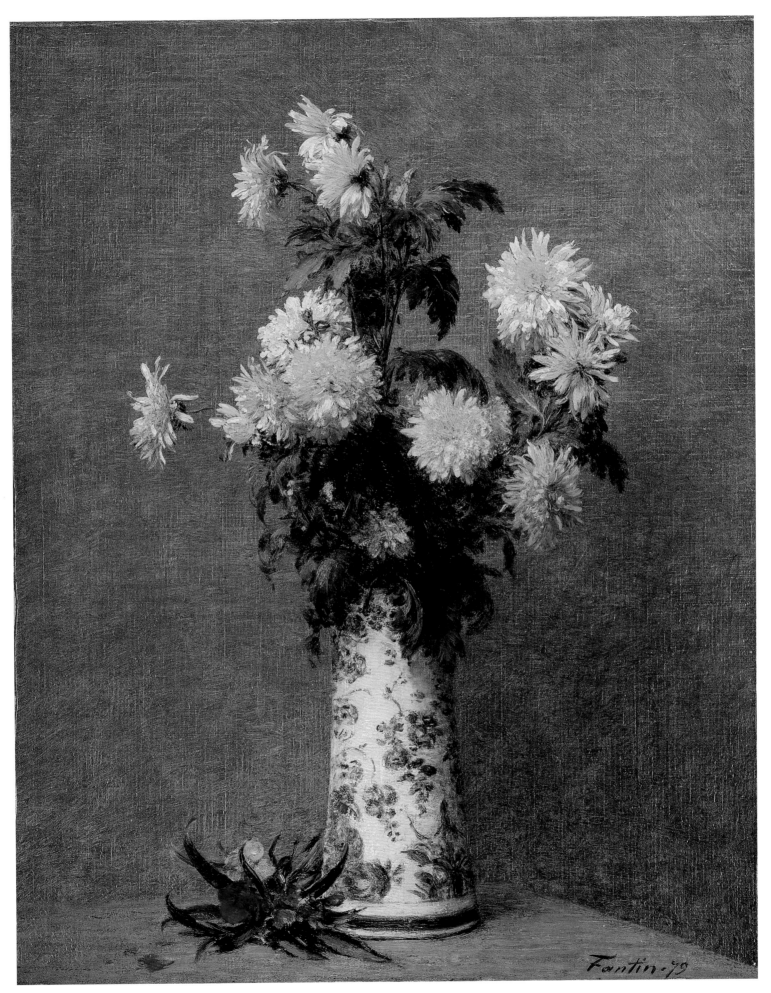

Catalogue 23

Henri Fantin-Latour (Grenoble, 1836–1904, Buré)

Larkspur, 1892

Oil on canvas

69.2 × 58.7cm

Fantin painted intimate and realistic still-lifes throughout his career, but after 1871 they became particularly numerous. *Larkspur* is typical of Fantin's finest still-lifes in the elegant simplicity of the composition, the beautifully observed form of each individual blossom and in the artist's marvellous ability to suggest the many shades of the flowers. These white, blue, pink and purple Double Larkspurs form one of Fantin's most austere flower-pieces. The artist has selected a brown glass vase with a conical bowl, the 'spiky' diagonals of which are echoed by the long diagonals of the blossoms themselves. Writing about this painting in the major Fantin retrospective which took place in 1982–83, Douglas Druick observed, 'despite the sombre quality of this picture – or perhaps because it is so relentlessly uningratiating – it exercises a peculiar fascination on the viewer and remains one of the most compelling of the artist's later works.'[1]

What is truly remarkable about his flower still-lifes is that Fantin can simultaneously be true to the subject and to his art, never lapsing into botanical illustration. He painted hundreds of flower still-lifes but each is very different. Fantin always took care to paint a wide variety of flowers in many different arrangements placed in a great variety of containers. His imaginative power and understanding of his subject is revealed in an amusing anecdote told by his British dealer, Mrs Edwards. She enjoyed relating how one woman had asked her if she would ask Fantin to give her lessons – not in painting but in flower arranging! When preparing a flower piece Fantin would first select and cut the flowers – from his own garden – then bring them into his studio, where he painted them immediately. His work was a race against time as he endeavoured to finish his painting before the flowers began to wither so he often painted wet-into-wet.

It is exciting to find labels on the reverse of a canvas or on a painting's frame. These labels help us trace the history of a work – where the canvas was purchased, which dealers have had it for sale, which exhibitions it has been displayed in and to whom the painting once belonged. One of the labels on the back of the frame of *Larkspur* has been handwritten. The first line gives the painting's title, *Pieds d'Alouette*, and then the artist's name. A London address follows – 26 Golden Square. The back of the canvas also bears a stamp – Hardy-Alan. What does this tell us? Before an artist begins to work on a canvas, it is usual practice to prepare a ground on which to paint. It is possible to buy canvases that have already been prepared with such a ground, and it seems that this is what Fantin did. From Fantin's many letters – to the artist Whistler, to his dealer Edwards and to his parents – we know that from 1861 Fantin purchased his painting materials from Hardy-Alan, a firm that manufactured canvases and fine colours.

From 1862 Fantin was a regular exhibitor at the Royal Academy in London, and *Larkspur* was exhibited there in 1900. His flower pieces won him fame and fortune partly because of his friendship with Edwin and Ruth Edwards who, acting as his dealers, made sure that each year his paintings could be seen in numerous exhibitions throughout Britain. *Larkspur* passed through their hands. This is one of ten pictures that constituted the bequest of William James Chrystal (1854–1921) to Glasgow Museums in 1939. Fantin's *Roses 'La France'* was also part of this bequest.

[1] Douglas Druick in the exhibition catalogue *Fantin-Latour*, Paris-Ottawa-San Francisco, 1982–83, p.341.

Catalogue 24

Henri Fantin-Latour (Grenoble, 1836–1904, Buré)
Roses 'La France', 1895

Oil on canvas
40.3 × 46.4cm

Though Fantin did not specialise in painting any particular flower, it was as a painter of roses that he became best known during the last quarter of the nineteenth century. Roses were very popular in Victorian England, which became the world leader in rose cultivation during the last two decades of the century. Fantin's skill in painting roses was appreciated equally in France and England.

The rose 'La France' is a hybrid tea rose of salmon pink suffused with primrose. The flowers are beautifully shaped, and for a long time it was considered to be 'the' rose. First appearing in 1867, it was popular until about 1930. It is rarely grown now. Here, Fantin has placed a large bunch of these roses in a rounded glass vase – the long green stems only just visible – against a neutral pale-brown background. We see various phases in the development of the cut flower – from the gently opening bud, through a blossom with its outer leaves open but its centre still tightly closed to the full-blown flower about to fall. Many of the flowers are overblown, and despite their beauty there is an almost tangible sense of decay.

In 1906 the artist and critic Jacques-Emile Blanche wrote that it is 'in his roses that Fantin has no equal. The rose – so complicated in its design, contours, and colour, in its rolls and curls, now fluted like the decoration of a fashionable hat, round and smooth, now like a button or a woman's breast – no one understood them better than Fantin. He confers a kind of nobility on the rose, which so many watercolourists have rendered insipid and insignificant by their bits of colouring on vellum, screens, and fans. He bathes it in light and air, uncovering with the point of his scraper the canvas . . . beneath layers of colour, so creating these interstices through which the painting breathes.'[1]

It is interesting to compare Fantin's work with Courbet's *Baskets of Flowers* (cat.16). Unlike Courbet, Fantin does not place together flowers that could not bloom at the same time. Nor would Fantin think of inventing a non-existent species of plant. For him these were not 'pale flowers without scent' but living, individual blossoms. Fantin's flower still-lifes reflect a common cultural heritage in which flowers are seen as fragile, ephemeral things of great beauty.

[1] Quoted in the exhibition catalogue *Fantin-Latour*, Paris-Ottawa-San Francisco, 1982–83, pp.265–6.

Catalogue 25

Othon Friesz (Le Havre, 1879–1949, Paris)
The Seine at Paris – Pont de Grenelle, c.1901–4

Oil on canvas
46.5 × 33.5cm

Friesz, like Dufy, was born in the Norman port of Le Havre. An important and early influence on the work of both young artists was that of the great colourist Eugène Delacroix, whose works they were taught to admire by their own first teacher, L. Lhullier. Continuing his studies at the Ecole des Beaux-Arts in Paris, where he met Matisse and Rouault, Friesz made time to study the work of the Impressionists whose paintings he could see in the gallery of the dealer Durand-Ruel. Until 1904, his paintings, both in their choice of subject – the contemporary urban landscape – and in their style show the continuing influence of Impressionist landscapes on the young artist.

For this small, early work, Friesz selected two motifs that had great meaning for him. In 1889 he and his mother had made a special trip to Paris to see the Eiffel Tower being built. Here the still-new structure is only partially glimpsed, emerging in the distance from a band of damp and heavy low-lying cloud. It is not surprising that the river Seine should be a favourite motif of an artist who, as the son of a successful shipowner, was brought up in the busy port through which the Seine flowed on its way out to the Channel. The high viewpoint and the weather conditions suggest that Friesz might have painted this work from the shelter of his studio window. The composition is built around the diagonal of the Seine, starting from the moored houseboats in the foreground on the north bank – with lights reminiscent of Chinese lanterns. We then move past another craft whose brilliant lights are reflected in the disturbed water to the Pont de Grenelle with its two red lights for the river traffic – to the bright lights of the city itself.

While his choice of a night scene is unusual, the broad, loose and free brushstrokes, and the extensive use of thick impasto and notes of heightened colour, are typical of Friesz's work.[1] The vibrant light and use of pure colour, while perfectly in accord with the scene, look forward to the drama of the Fauve canvases that he was to exhibit to critical derision in the Autumn Salon of 1905.

[1] A letter in the museum archives suggests that a pendant to this work, painted in daytime, was formerly in the collection of a Commander Corniouls.

Catalogue 26

Paul Gauguin (Paris, 1848–1903, Atuana, Marquesas Islands)
Ostre Anlaeg Park, Copenhagen, 1885

Oil on canvas

60.0 × 73.5cm

Until 1883 Paul Gauguin worked in the Paris stock exchange. In his spare time he enjoyed painting, working side by side with Pissarro from 1879 and with Cézanne in 1881. After losing his job in the stock market crash of 1882, he struggled to earn a living from his art.

His Danish wife Mette, dismayed at this sudden fall from comparative wealth to poverty, left Paris with their children and returned to live with her parents in Copenhagen. Gauguin joined his family during the winter of 1884 for a stay that was to last eight months. In an effort to make ends meet, Mette gave French lessons and Gauguin worked as an agent for a Paris-based tarpaulin wholesaler. Gauguin's despair at his situation is clear in a letter written to Pissarro in the spring of 1885: '. . . every day I wonder whether I shouldn't go to the attic and put a rope around my neck. It is only painting that prevents me from doing so and that's the real stumbling block. Anyway, in two months I shall either have departed this world or returned to Paris to live as a vagrant worker, anything rather than suffer in this wretched country.'[1]

During his time in Copenhagen Gauguin experimented with his own form of Impressionism, working on portraits, still-lifes and landscapes. This is one of at least two views of the nearby Oestre Anlaeg park which he painted in late April or May 1885, near the end of his stay.[2] In a letter to Pissarro he recorded how he felt his art was progressing, 'I have been working out of doors, and without any special effort or conscious desire to paint in a bright, luminous style the results are very different from those I produced in Rouen. I think I can say that this constitutes an enormous step forward; it's more flexible, lighter, more luminous, although I've not really changed my method: the colours are still laid on side by side with very little differentiation between them.'[3]

Although Gauguin is usually viewed as a Post-Impressionist, this early landscape is Impressionist both in its choice of subject and in its technique, with its broad, open brushwork and the use of blue in the shadows. Gauguin's own distinctive style did not develop until his first visit to Pont-Aven in 1886. From 1879 he had participated in the Impressionist group exhibitions, and it is possible that this work, exhibited as *Parc, Danemarck*, was included in the 8th and final Impressionist show held in Paris in 1886.[4]

While working as a stockbroker Gauguin had purchased paintings by his Impressionist friends. When he lost his job and moved to Copenhagen he took his collection with him. Reduced to near poverty, he grudgingly began to sell off some of the works. After his return to Paris, his wife sold off further paintings, works Gauguin had hoped to keep. One such work was Cézanne's *Château de Médan* (ill.56), today in The Burrell Collection in Glasgow. It is fascinating to compare the two paintings. The composition of *Ostre Anlaeg Park*, with the water of the lake running across the foreground and the successive layers of water, bank, trees and sky, is very similar to the composition of Cézanne's *Château de Médan*. Even Gauguin's brushstrokes share something of Cézanne's directional stroke – the water painted with horizontal dabs of paint while the trees are depicted using diagonal strokes.

[1] Quoted in John Rewald, *The History of Impressionism*, New York, 1973, p.500.
[2] It was Haavard Rostrup of the Ny Carlsberg Glyptotek in Copenhagen who first identified the site of this painting. A related work, *The Queen's Mill, Oestervold Park*, is in the collection of the Ny Carlsberg Glyptotek (Wildenstein, 141).
[3] Quoted in *op.cit.*, p.494.
[4] In the 1886 Impressionist exhibition Gauguin exhibited a work, n.56, *Parc, Danemarck*, that is usually thought to be either the work in Copenhagen or the painting in Glasgow. Given that the Copenhagen painting has a provenance consistently in that city it is likely that the Glasgow painting went with Gauguin to Paris when he returned.

Catalogue 27
Vincent van Gogh (Groot-Zundert, 1853–90, Auvers-sur-Oise)
The Blute-Fin Windmill, Montmartre, 1886
Oil on canvas
46.0 × 38.2cm

The son of a Dutch Protestant minister, Vincent van Gogh embarked on various careers – the art trade, teaching, the ministry and missionary work – before deciding around 1880 to become an artist. After brief periods of study in The Hague and later in Antwerp, despairing and poverty-stricken, he determined to travel to Paris to further his studies. He arrived in the French capital in early March 1886 where he stayed with his brother Theo, the manager of the boulevard Montmartre branch of the art-dealing firm Boussod & Valadon.

Encouraged and assisted by Theo, Vincent quickly set about learning all he could about contemporary art. He was particularly keen to learn about colour and figure painting. He was fortunate that two major exhibitions, the eighth and final Impressionist exhibition and Georges Petit's Fifth International, gave him the chance to study works by the Impressionists and the Post-Impressionists, Monet, Renoir, Sisley, Pissarro, Cézanne and Seurat. Vincent also visited dealers' galleries and artists' studios and, through the classes he attended at the *atelier* Cormon and through Theo met and became friendly with Gauguin, Bernard, Signac, Pissarro and Toulouse-Lautrec.

In June Vincent and Theo moved from the small room they had shared in the Rue Laval to larger lodgings in the Rue Lepic, in the heart of Montmartre. The *butte* Montmartre was a favourite spot for pleasure-seeking Parisians with its bars, pavement cafes, dance-hall and park. Vincent made many drawings and paintings of the area, often directly from nature. One of these oils, *The Blute-Fin Windmill, Montmartre*, shows how much the Dutch artist had absorbed, during his stay in Paris, in a short space of time. Vincent's earlier works, painted in Holland, had been dark and heavy, but here – influenced by the paintings of the Impressionists – he begins to use a lighter palette and freer brushstrokes, capturing fleeting effects of light and movement. With just a few strokes of paint he conjures up the small figures on the terrace and the strong notes of colour of the French flags, fluttering in the breeze. In the foreground the broad, powerful brushstrokes, heavily laden with paint, suggest the tangled growth of the small allotments with a dance of two straggling sunflowers, in shade on the right and caught in sunshine on the left.

The viewpoint selected by Vincent and the loose, thick brushwork suggest that he had seen *Rue Caulaincourt*, 1884 (cat.27.1) by his new friend Paul Signac. Vincent's view, however, was painted from a vacant plot beside the Rue Lepic and shows the Moulin de Blute-Fin, a seventeenth-century grain-mill which, of the three windmills that remained on the *butte*, was the one he would choose to paint most often.[1] A second windmill, the Moulin à Poivre, can just be made out on the horizon on the extreme left. The Moulin de Blute-Fin was a popular tourist attraction as both the terrace on its roof and the belvedere in front afforded magnificent views of the city below.

This painting was purchased by William McInnes from the Scottish art dealer Alex Reid, whose portrait by Van Gogh is also in the collection of Glasgow Museums (cat.28).

[1] Van Gogh painted at least four oils and several drawings of this mill all from different vantage points and at different times of the year. See *Moulin de Blute-Fin, Montmartre*, Carnegie Museum of Art, Pittsburgh and *Windmills on Montmartre*, 1886, Bridgestone Museum of Art. For the drawings see Marije Vellekoop and Sjraar van Heugten, *Vincent van Gogh Drawings, vol.3, Antwerp and Paris 1885–1888*, Van Gogh Museum, London, 2001.

27.1
Paul Signac
Rue Caulaincourt, 1884
Oil on canvas, 33.5 × 25.5cm
Musée Carnavalet, Paris

27.2
Vincent van Gogh
Gardens on Montmartre and the Blute-Fin Windmill, 1887
Pencil and chalk on laid paper, 39.8 × 53.8cm
Van Gogh Museum, Amsterdam

Vincent van Gogh (Groot-Zundert, 1853–90, Auvers-sur-Oise)
Portrait of Alexander Reid, 1887
Oil on board
41.0 × 32.9cm

During his stay in Paris, from 1886 to 1888, Van Gogh quickly absorbed the latest artistic styles. From the works he saw in the Eighth Impressionist exhibition, and from the example and support of his close friend Paul Signac, Van Gogh learnt about Pointillism, the technique used by the Neo-Impressionists. Developed by Seurat and Signac, this technique was based on the study of scientific colour theories and the laws of optics. Although the artists preferred the term Divisionism, Pointillism – derived from the French word for dot, *point* – describes how these artists applied paint in a calculated manner juxtaposing complementary and contrasting hues.

In this small portrait of the Glasgow art dealer Alex Reid, Van Gogh experiments with the Pointillist technique. Although he does not use the dot-like brushstrokes of Pointillism proper, he animates the picture surface with a mass of short directional brushstrokes. The fiery quality of the red, heightened by the notes of its complementary green, gives an enigmatic and expressive power to the portrait.

Alexander (Alex) Reid (1854–1928), the son of a Scottish businessman, had travelled to Paris to work as an apprentice to Boussod & Valadon, the firm of art dealers where Theo van Gogh was employed. For a short while, during the spring and summer of 1887, Reid shared the Van Gogh brothers' Montmartre apartment, and it was during this stay that he posed for two portraits by Vincent. At that time Vincent was hoping he could make a name for himself and earn some much-needed income from portraits. As he later wrote to his sister, Vincent wanted 'to make portraits that will be revelations, as it were, in a century's time for the people living then. So I am not trying to paint using a photographic likeness, but by expressing our passions, using our knowledge and modern taste in colour as a way to express and emphasise the character.'[1]

Until 1928 the painting was catalogued as a self-portrait. It was only a few months after Alex Reid's death that his son, A. J. McNeill Reid, saw the work reproduced in a catalogue of Vincent's work and recognised it as being a portrait of his father. Reid travelled to Laren to meet the painting's owner, Theo's son Vincent, and purchased the work 'for a nominal sum'. The artist A. S. Hartrick, a friend of both Alex Reid and Vincent, recorded in his autobiography the source of confusion: 'The likeness was so marked that they might have been twins. I have often hesitated, until I got close, as to which of them I was meeting. They even dressed somewhat similarly, though I doubt if Vincent ever possessed anything like the Harris tweeds Reid usually wore.'[2]

As Sir William Burrell recorded, Reid did more than anyone else 'to introduce fine pictures to Scotland and to create a love of art. He had a marvellous flair for [the works of the] French nineteenth century . . . and was looked up to by the Paris dealers with the greatest respect.'[3] Reid's Glasgow gallery, La Société des Beaux-Arts, established in 1889, had as clients some of the greatest collectors of French art of the nineteenth century, among them Sir William Burrell, Sir John Richmond, D. W. T. Cargill, Dr Leonard Gow and William Allen Coats.

[1] This translation is from the brochure accompanying the exhibition *Van Gogh Self-Portraits in Paris* held at the Van Gogh Museum, Amsterdam, from 10 June to 9 October 1994.
[2] A. S. Hartrick, *A Painter's Pilgrimage Through Fifty Years,* 1939, pp.50–1.
[3] Letter to A. J. McNeill Reid, 14 January 1946.

28.1
Vincent van Gogh
Portrait of Alexander Reid, 1887
Oil on board, 41 × 33cm
Fred Jones Jr. Museum of Art,
The University of Oklahoma

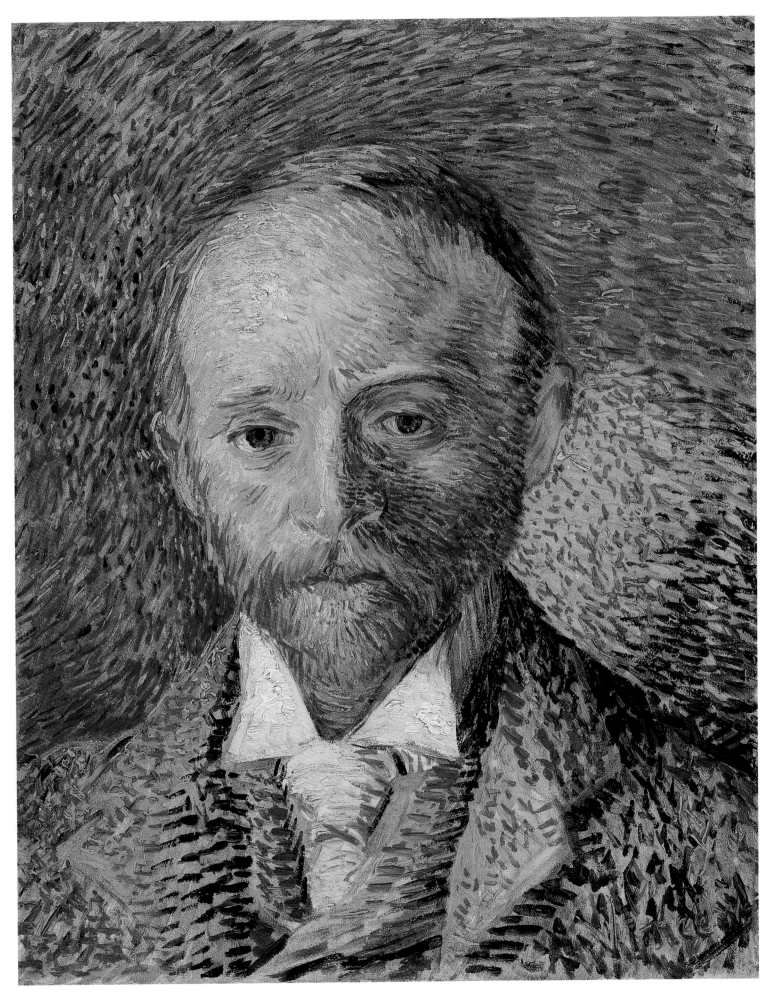

Catalogue 29

Armand Guillaumin (Paris, 1841–1927, Château de Grignon, near Orly)
*Riverbank, Autumn, c.*1910

Oil on canvas
65.0 × 81.0cm

Until 1891 Guillaumin earned his living working for various companies, including the Paris-Orléans railway and the Department of Roads and Bridges. By working nightshifts he left his days free for painting. His life changed dramatically when, in 1891, he won 100,000 French francs in a city lottery, allowing him to travel widely and devote himself to art.[1]

Guillaumin lived at Crozant on the river Creuse where *Riverbank, Autumn* was probably painted. This bright, autumnal scene is empty of incident, the barely flowing river clearly reflecting the trees on the distant bank. In subject and composition this work is strikingly close to Gauguin's Impressionist *Ostre Anlaeg Park* (cat.26), but here Guillaumin's simplified shapes, tapestry-like brushstrokes and heightened colours are truly Post-Impressionist. Although he was working outdoors directly from nature, Guillaumin does not use the comma-like brushstroke of his Impressionist friends to capture changing effects of light. Instead he uses bold and block-like strokes of vivid green, purple, orange and yellow. Combined with his deliberate simplification of form, this creates an overall decorative rather than realistic effect.

Guillaumin's use of intense colours and strident harmonies was commented on by the critic and novelist J. K. Huysmans, who writing in *L'Art Moderne* in 1883, observed that 'Guillaumin . . . is a colourist, and what is more, a ferocious one. At first sight his canvases are a confusion of battling tones and rough contours, a cluster of vermilion and Prussian blue zebra-stripes. Step back and blink and everything falls into place; the planes become steady, and the strident tones calm. The hostile colours reconcile themselves, and you are astonished by the unexpected delicacy of certain parts of these paintings.'

Guillaumin was one of the first members of what became known as the Impressionist group and was friendly with Cézanne and Pissarro, with whom he painted throughout the 1860s and 1870s. In the 1880s he met and encouraged Gauguin, Signac, Seurat and Van Gogh. Van Gogh often visited Guillaumin's studio and in his letters to his brother Theo mentions Guillaumin as 'a real friend'.

[1] Edouard des Courières, *Armand Guillaumin*, Paris, 1924, p.61.

Catalogue 30
Adolphe Hervier (Paris, 1818–79, Paris)
Village Scene, Barbizon, c.1850–60
Oil on wooden panel
12.9 × 31.0cm

During the early nineteenth century a group of artists chose to paint realistic landscapes rather than the traditional and more respected historical landscape. Many of these artists – among them Millet, Rousseau, Diaz and Daubigny – visited or stayed in the village of Barbizon, in the Forest of Fontainebleau. They shared a passion for nature and painted the surrounding landscape and various aspects of peasant life. It is possible that this tiny painting shows a street in Barbizon. This near-deserted view, giving the impression of a quiet rural retreat, belies that fact that by the 1850s Barbizon was a flourishing and busy resort for both tourists and artists.[1]

Hervier has abandoned the heavy dark tones favoured by many of his contemporaries, for a light and airy palette. He works from an artificially high angle and paints an unrealistically wide-angled, open and panoramic view – the cottages and houses to either side dramatically converging on the low horizon line. Hervier carefully observes details of light and atmosphere, capturing the feeling of a gentle wind blowing the white and grey clouds away, making way for a clear blue sky. Dappled sunlight hits the walls of the houses on the right, whilst the houses on the left and the horse and covered wagon are in shadow.

This tiny oil is painted on a wooden panel of a type traditionally used by landscape artists to make quick sketches from nature. These studies could then be used by the artist in the studio as 'notes' for a larger and more highly finished work. While the marvellous freshness of this painting would suggest that it has been painted directly from nature, it is possible that it was not. Hervier's small landscapes are often what he referred to as 'remembrances', works painted from memory in his studio.

Hervier's paintings were repeatedly rejected by the Salon jury, and despite the praise of critics like Gautier, Champfleury and Burty, he attracted little attention and was never able to escape poverty. He lived in a miserable hovel in the Rue des Martyrs in Montmartre and was sometimes reduced to painting landscape backgrounds for other artists to make ends meet. In 1856 the eminent critic Théophile Gautier wrote that he was 'surprised not to find M. Hervier better known than he is; he has everything that one should have: lively colour, an original technique and the ability to observe nature in a particular way . . . he knows the favourable moment, the mysterious minute, the unusual angle, the particular light, and it is then that he paints.'[2]

This work was already in Glasgow at an early date. It was included in an important sale of works belonging to A. J. Kirkpatrick which took place in Glasgow on 1 April 1914.

[1] Reviewing the innovative exhibition *Lighting up the Landscape* in the *Burlington Magazine* in November 1986, p.847, Richard Thomson challenged the traditional title, saying that this 'pleasing little village street certainly does not represent the "Barbizon" it has always been wistfully titled.' This title, however, has been accepted elsewhere including in the catalogue for the exhibition *Barbizon au Temps de J. F. Millet* held in Barbizon in 1975.
[2] Théophile Gautier, *Les Beaux-Arts en Europe*, Paris, 1856, pp.158–9, quoted in Gabriel Weisberg, *The Realist Tradition*, 1980, p.296.

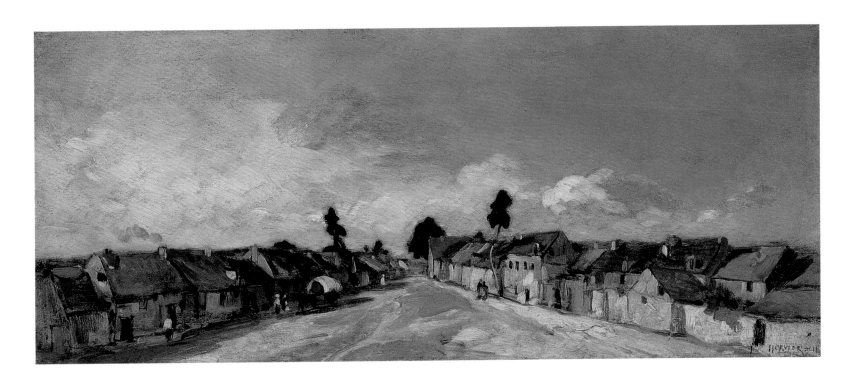

Catalogue 31

Stanislas Lépine (Caen, 1835–92, Paris)
The Rue de Norvins, Montmartre, c.1876–80

Oil on canvas

33.0 × 24.5cm

Lépine came to Paris in 1859 and settled in Montmartre, where he was to stay for the rest of his life. When this work was painted he was living at 40, Rue de Fontenelle – today Rue du Chevalier de la Barre – a road later partly demolished to make way for the Sacré-Coeur. It was apparently Corot who advised Lépine that 'a landscapist could make masterpieces on the *butte* Montmartre.'[1]

This is one of about fifty paintings – from a life output of some 800 works – which Lépine painted of views of the streets of Montmartre. Typical of these views, this small oil is a calm and tranquil scene. Lépine captures the aged walls of the house-lined streets using a few tiny figures as staffage. He suggests the warmth of a summer's day, clouds flitting across a blue sky, as a woman struggles up the sunlit hill, an infant in her arms and a toddler and a dog at her feet. Further figures are briefly indicated, Lépine using only a few quick strokes of paint to describe the stooping woman at a doorway and the group of people standing in the shade at the corner near the foot of the hill.

While in subject and composition this work is reminiscent of paintings of the 1870s by Pissarro and Sisley, it is the differences that are so telling. Lépine does not make use of the broken brushstroke or reflected light of the Impressionists, for he, like Boudin, is Pre-Impressionist. His tonalities are grey-blond enlivened by touches of red, green, nut brown and mustard, and with no strong contrasts. Although Lépine did study similar views in different light conditions – in the rain, in snow, in the evening – he does not share the Impressionists' or even Boudin's interest in capturing particular effects of light and atmosphere, making his works seem timid and conservative in comparison. His paintings have a quiet charm, his style changing only slightly throughout his career. Lépine never seemed to have felt the need to address new problems or find new solutions, his fundamental vision barely changing as he recorded the world he saw. In 1872 the critic Paul Mantz praised Lépine for finding inspiration in the suburbs of Paris, and for finding poetry where no-one else would think of looking.[2]

In many ways Lépine is like Boudin. Both artists were born in Normandy, of humble origins. Neither attracted high prices or much praise and both men were modest and reserved in nature and very hard-working. Both exhibited at the so-called First Impressionist exhibition in 1874 and then at no other. Unlike Boudin, it seems that Lépine chose to paint in the studio, slowly working from drawings and oil sketches done outside from nature. Unfortunately little is known about the relationship of the two artists.

The first known owner of this painting was Nicolas A. Hazard (1834–1913). Hazard's collection – much of it purchased from the Parisian dealer Père Martin – contained works by both Pre-Impressionist and Impressionist artists: Lépine (39), Corot (19), Boudin (3), Guillaumin (23), Cézanne, Gauguin, Manet, Pissarro and Renoir. *The Rue de Norvins, Montmartre* was included in an auction sale of Hazard's collection at Georges Petit's gallery in Paris in December 1919. The painting was purchased from this sale by the Glasgow dealer Alex Reid who then sold it to William McInnes.

[1] Quoted in John Couper, *Stanislas Lépine (1835–1892), sa vie, son oeuvre*, Paris, 1969, p.15.
[2] *Ibid.*, p.65.

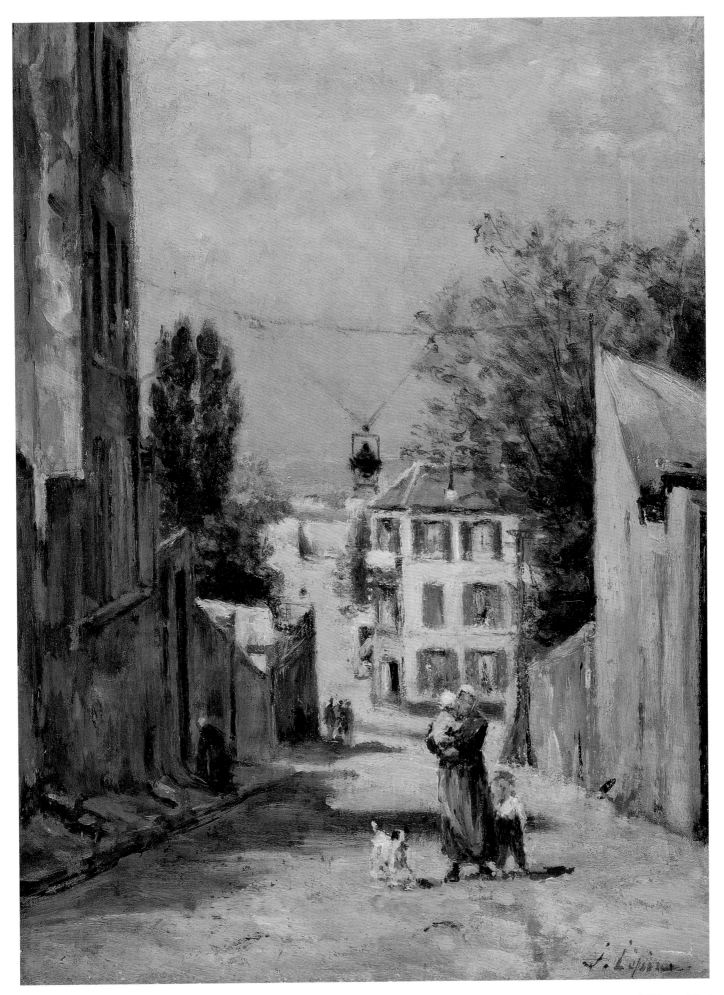

Henri Le Sidaner (Port-Louis, Mauritius, 1862–1939, Paris)

A Beauvais Square by Moonlight, 1900

Oil on canvas

70.2 × 92.4cm

Influenced by the poetry of Mallarmé and Verlaine and by the music of Wagner and Debussy, Henri Le Sidaner – like many of the artists and writers of his generation – dismissed the naturalistic novels of Emile Zola and the Realistic paintings of Manet and the Impressionists for what he perceived as their lack of spirituality. Although he was inspired by nature he chose not to transcribe what he saw. Instead he searched for an appropriate language with which to reveal what he felt was the essence of a scene, seeking something eternal and universal.

Beginning in 1900 Le Sidaner became what his biographer Camille Mauclair called 'le portraitiste des villes', painting the monuments of the historical towns of Beauvais, Chartres and Versailles. It was on the advice of the sculptor Auguste Rodin that in 1900 Le Sidaner rented a house in Beauvais, beside the great cathedral. The following year he moved to the nearby town of Gerberoy, where he was to live for almost the rest of his life. The artist's son, Louis Le Sidaner, recognized this painting as showing the Place Ernest Gérard in Beauvais, a square that was destroyed during the Second World War.

Across the moonlit cobbled square looms a tall slim statue, perched on a high plinth and surrounded by low railings. Although it is difficult to make out, the frontal view of the silhouetted form suggests the figure of a man, perhaps riding a horse. Our reading of the statue is hindered by the dusk and by the formless shadow it casts on the street below. The square is deserted, the many doors and the shuttered windows all closed, all in darkness, but it is not empty. It is bathed in silence. The poetic mood, one of calm rather than mystery, is partially created by Le Sidaner's subtle use of colour harmonies, his small blocky brushstrokes carefully describing the pale creamy browns and pinks of the cobbles, their tones echoed in the warm pink, cream and fawn of the facades of the houses. The colours are quiet, intimate, expressing what the artist feels rather than what he sees.

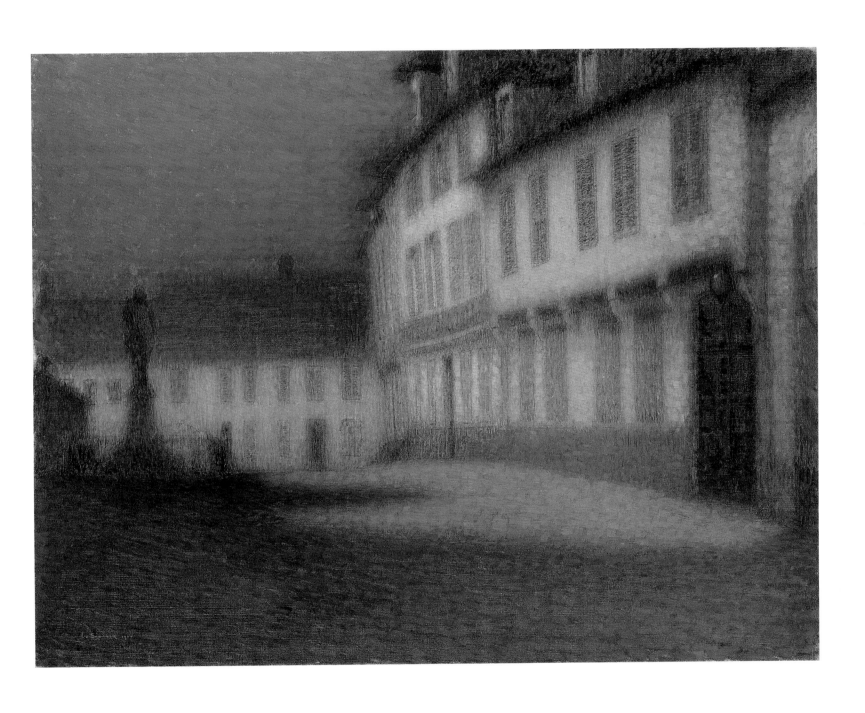

Catalogue 33

Léon Lhermitte (Mont-Saint-Père, Aisne, 1844–1925, Paris)
Ploughing with Oxen, c.1871

Oil on canvas
60.5 × 103.4cm

Like Millet, whom he greatly admired, Lhermitte painted scenes of rural life in which he conveyed the timeless quality of peasants working the land. Born in a picturesque village, overlooking the valley of Marne, it was Lhermitte's childhood experiences of neighbouring farms that provided the subjects for his early oils. Here against a stark landscape, two men are seen turning over the soil with a plough pulled by a pair of oxen. Tackling his subject objectively and realistically, Lhermitte records the scene in faithful detail, avoiding idealisation of the workers or exaggeration of the hardship of their lives. The lines of the furrows, the strip of grass and the plain beyond create a series of horizontals repeated in the clouds of the sky above. This horizontality is emphasised by the placement of the figures, the oxen and the plough. Seen in profile, almost in procession, they lend the scene a feeling of solemnity. As art historian Gabriel Weisberg has observed, Lhermitte manages to suggest the rich, humid quality of the newly turned earth, including telling detail such as the flank of the paler ox which is caked with soil.[1]

In early letters to his brother Theo, Vincent van Gogh mentions how he is fascinated by rural life and admires artists like Lhermitte who paint it, despite the views of the critics: 'Apparently nothing is more simple than to paint peasants, rag-pickers and labourers of all kinds, but no subjects in painting are as difficult as these everyday figures! As far as I know there is not a single academy where one learns to draw and paint a digger, a sower, a woman setting the kettle over the fire, or a seamstress.' In 1885, writing from the Netherlands, Vincent expresses his feeling that 'Millet and Lhermitte are the real artists, for the very reason that they do not paint things as they are, traced in a dry analytical way, but as they . . . feel them . . . my great longing is to learn to make those very incorrectnesses, those deviations, remodellings, changes of reality, so that they become, yes, untruth if you like – but more truth than the literal truth.'[2]

Lhermitte's works were regularly seen in Great Britain where this painting was exhibited at the Royal Academy in London in 1872. By 1907 Lhermitte had gained an international reputation. Part of the reason for his success is explained in an article by Frederic Henriet in the art magazine *The Studio*, of June 1909. While Lhermitte was considered to be 'allied with tradition through the clearness, the rhythm, the thoughtfulness' of his work, he was simultaneously considered modern 'in his love of sunlight, of movement, of life, and in the significance of his subjects. His work is sane and strong in its harmonious unity.'

[1] Gabriel Weisberg, *The Realist Tradition*, 1980, p.222.
[2] Mark Roskill (ed), *The Letters of Van Gogh*, Glasgow, 1963, p.236.

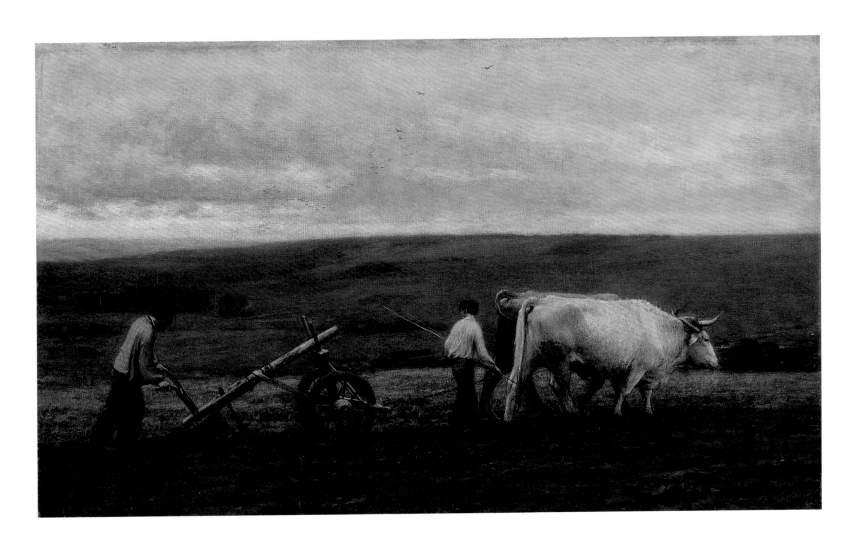

Catalogue 34

Louis Marcoussis (Warsaw, 1878–1941, Cussel, Allier)
Still-Life in Front of a Balcony, 1928

Oil on canvas

100.4 × 65.3cm

Marcoussis, a minor member of the School of Paris, painted only 270 oils. Of these, 140 date from his most prolific period, from 1927 to 1930 when he painted some three works a month. Rarely making preparatory studies, Marcoussis returned to the same painting over and over again until he achieved the desired degree of finish.[1]

Marcoussis had adopted a simplified form of analytical Cubism after meeting Braque and Picasso in 1910. The resulting works have a superficial and essentially decorative Cubist-like appearance, always more legible than the paintings of Braque and Picasso. Like these artists, Marcoussis used multiple viewpoints, painting both what he saw before him and what he 'knew' to be there. His still-lifes, in particular the theme of a still-life on a table in front of a balcony, even included the favoured objects of the two more famous artists – musical instruments and fish. Here, before the open doors of a balcony, stands a heavy circular-topped wooden table. On the table, which is partly in shadow, are a mandolin, a blue jug, a dead fish lying on a piece of white paper and, dropping from the table edge, a sheet of music. Given the musical theme the composition is – appropriately – ordered, measured and harmonious. Marcoussis creates a rhythm of echoing curves – the body of the mandolin and the curl of the paper, the rounded spout and handle of the jug and the sinuous lines of the balcony railings – and plays them off against the hard straight edges of the doors, the floor and the table legs. The cold white light picks out areas of brightness on the table, the papers and the reflected railings, making the tones of blue, pale green, brown and grey sing against the hasty note of terracotta that colours the fish. While many of Marcoussis's balcony paintings look out to an urban landscape, usually the Sacré Coéur or the Eiffel Tower, here the wide expanse of grey-blue and the pale sandy-lemon suggest that this oil may have been painted while Marcoussis was on holiday on the south coast of France.

Marcoussis had a strong poetic sense and was friendly with many of the writers of Montmartre and Montparnasse. He was particularly close to the poets Guillaume Apollinaire, Max Jacob and Paul Reverdy and found inspiration in many of their themes – unease, thirst for purity and formal perfection, mystery, lyricism and intimacy. The theme of the open door, which he had loved in the poetry of Reverdy, adds a note of mystery to the intimate character of his interiors and gives him the opportunity to play with shadows.

A brief note in the museum archives reveals something of the conflicting tastes and attitudes towards collecting in Glasgow: 'When this picture was submitted to the Art Galleries Committee, the Convener, Treasurer Kelly, who had seen it with me when we were in London, said "You will have to do your stuff on this." When the picture was brought before the Committee one of its members exploded thus, "What in God's name is that?" With the utmost goodwill and after some irrelevant observations the Committee unanimously agreed to its purchase.'[2]

[1] A photograph of this work at an earlier stage is illustrated in Jean Lafranchis, *Marcoussis, sa vie, son oeuvre*, Paris, 1961, p.260.
[2] This note was written by Glasgow's then Director of Art Galleries and Museums, T. J. Honeyman.

Albert Marquet (Bordeaux, 1875–1947, Paris)
*The Port of Algiers, c.*1922

Oil on canvas

54.2 × 65.3cm

Throughout his life Marquet travelled extensively in Europe and North Africa, delighting in visiting places where he was unknown and enjoying the sense of freedom this brought him. From 1910 water – particularly rivers and ports – was a major source of inspiration for him. He painted harbour scenes in Marseille, Paris, Hamburg, Stockholm, Rotterdam and Algiers, the subject in each essentially the same but transformed by differences in climate, national character and weather conditions – fog, haze, mist, rain, sunshine.

Of all these ports it was Algiers that had a special meaning for him. During his first visit in 1920, to recover from flu, the retiring artist met his future wife, and from then on their winters would be spent in Algeria. Preferring to paint from a window, working undisturbed by human contact, Marquet created works that often have, as here, a high viewpoint. This view, painted from the Boulevard Anatole-France, looks out over the port with its administrative buildings and the crescent-shaped north jetty marking the entrance to the commercial port for medium tonnage vessels and mail ships.[1]

For an artist with a love of order and clarity, the jetties, ships and warehouses provided him with a ready-made orderly composition with the horizontal lines of the roofs and quayside set against the verticals of masts and derricks. The artist's task, to translate a three-dimensional view on to a flat canvas, is made more difficult by his choice of viewpoint, as the high horizon line flattens the picture space. Yet Marquet skillfully suggests a recession into depth and to the distant hills, creating a wonderful sense of space. Like Dufy, Marquet reduces the scene to its essentials with great economy and expressiveness of line, and this, combined with the calm and quiet of the seemingly sleeping port, gives this painting a serenity, a silent poetry.

Marquet loved to observe and paint light on water. Constantly reflecting the changing mood of the sky, it is the water that unites the various areas of the composition. He suggests a slight breeze with the hasty zigzag reflections of the yacht's masts and funnel and by the slightly deeper shade of blue in the foreground. Marquet's remarkable sensitivity to colour – he preferred cool colours – allows him to capture nuances of light and subtleties of atmosphere in the most fugitive of moments.

As Daulte so tellingly wrote, Marquet may not have had the invention of a Picasso, the decorative skill of a Matisse, the mood of a Rouault or the tragedy of an Utrillo. His originality lay in his ability to go straight to the essentials of a scene – a subtle mix of poetry and truth.[2]

[1] For related views of the same period, see Jean-Claude Martinet and Guy Wildenstein, Marquet, *L'Afrique du Nord, Catalogue de l'oeuvre peint*, Paris, 2001, nos.I-68 and I-59. See also *The Port of Algiers*, in the Dixon Gallery, Memphis.
[2] François Daulte, *Marquet*, Lausanne, 1953, p.xxx.

Henri Matisse (Le Cateau-Cambresis, 1869–1954, Nice)

Woman in Oriental Dress, July 1919

Oil on canvas stretched over cardboard

40.9 × 32.9cm

Late in the spring of 1919 Matisse left Nice and returned to the family home at Issy-les-Moulineaux just outside Paris. It was here in July that he painted this portrait of the eighteen-year-old Antoinette Arnoux, a professional model he had first hired the previous December. Posed in Matisse's light and airy studio, Antoinette is seated on a green-painted steel garden armchair set in front of a patterned fabric screen. Her oriental costume is vaguely reminiscent of the Middle East or North Africa.

Since his visit to Morocco in 1912–13 Matisse had been interested in Near-Eastern culture. Antoinette, like Lorette before her, helped initiate the exotic odalisque fantasy that the artist would later develop with his next model, Henriette. Here, however, there is still a sense of individual portraiture, the strong frontal position lending the work a near-iconic aura. Unlike a traditional portrait, where the artist's task is to capture and convey the sitter's character and status, Matisse here delights in decorative arabesques, in the play of light from a source unseen falling on the pearly face, in the gauzy transparency of the blouse. The whole conveys a subtle eroticism.

There is a near abstraction in Matisse's deliberate play of pattern and decoration – the large organic curves of the background fabric against the harsh lines of the metallic chair. There are curves too in the edgings of Antoinette's bolero top, her striped scarf, in her narrowed eyes, in her pursed lips, in the curls of her chestnut brown hair, and her veiled breasts. Although we do not see her hands, her arms are briefly sketched in beneath the transparent sleeves. Her quiet, contemplative, somewhat challenging expression, the very mood of the painting is heightened by the harmonies of blues and greens set off by tones of yellows, mustard and terracotta.

This painting relates directly to the contemporaneous, but larger and more ambitious *The Black Table* (Private collection, Switzerland). Whether the Glasgow work is a study for, or a first and smaller version of the larger work is unclear. There is also a drawing in the Courtauld Institute, *Seated Woman*, with clear links to the Glasgow work, but closer still to *The Black Table*.

In the autumn of 1919 Matisse travelled to London for the first time. The main reason for his journey was a commission from Diaghilev for costumes and sets for a Ballet Russes production of Stravinsky and Massine's *Le chant du rossignol*. In addition, the Leicester Galleries were planning the first one-man show of Matisse's work to be held in Britain. The exhibition, in which this work was displayed, opened on 15 November and lasted for one month.

The paintings, small and recent works, were favourably received and sold easily, much to the surprise of Matisse. In a letter to Roger Fry, Vanessa Bell said, 'The Matisse's are lovely, but for the most part slight sketches . . . All are sold. He's evidently a great success nowadays. These are not important works and so attractive in colour I suppose no one can help liking them. I hope he's doing bigger things too.'[1]

The painting was acquired at the exhibition by the collector George Eumorfopolous (1862–1939). An important collector of oriental art, particularly Chinese ceramics, the *orientaliste* subject would have appealed to Eumorfopolous's eye for its beauty and quality. Today much of his collection is divided between the British Museum and the Victoria & Albert Museum, but some works were auctioned in May 1940. At one of these auctions this painting was purchased by A. J. McNeill Reid for the low price of £60 – the art world had not recovered from the outbreak of war. As Honeyman recounts, 'William McInnes heard of the bargain, acquired it and presented it to the Corporation to commemorate my appointment.'[2] Matisse was still living when this work was added to the collection – he was 70 years old.

[1] Quoted in Richard Shone, 'Matisse in England and two English Sitters', *The Burlington Magazine*, vol.CXXXV., n.1084, July 1993, p.481.
[2] T. J. Honeyman, 'Les Fauves – Some Personal Reminiscences', *Scottish Art Review*, vol.XII, n.1, pp.19–20.

36.1
Henri Matisse
Seated Woman, 1919
Pencil on paper, 35.1 × 25.2cm
Courtauld Institute Gallery,
London

Catalogue 37

Henri Matisse (Le Cateau-Cambresis, 1869–1954, Nice)
The Pink Tablecloth, c.1924–25

Oil on canvas

60.5 × 81.3cm

Where Braque and Picasso, intent on challenging our ability to look, expected an intellectual effort on the part of the viewer, Matisse cared only that the viewer relax and find comfort from the cares of daily life by looking at his work. Matisse wanted to communicate the joy and happiness that *he* experienced when looking. He strove to find a visual equivalent with which he could communicate these emotions. Although accused by some early critics of being a 'mere decorator', Matisse was revolutionary in that he successfully found a way of transcribing the three-dimensional world on to a two-dimensional canvas, replacing the plastic volume of 'realistic' forms with flat patches of colour.

From 1921 until 1926 Matisse rented an apartment on the third floor at 1, place Charles-Félix, in Nice, and it is likely that this still-life was painted here. The blue and white vase of anemones, the white fruit stand edged with gold and the pink tablecloth – sometimes without the decorative border – appear in several other still-lifes painted in Nice during the years 1924–25.[1] As in these other works, Matisse uses areas of pure bright, light-filled colour to create an all-over near two-dimensional design that still manages to suggest an air-filled space. By simplifying forms and heightening colours, and by playing shapes and colours off against each other, Matisse creates an *objet d'art* full of seductive harmonies and compelling disharmonies. The white-bordered grey image appears dull against the striped wallpaper, the broad straight lines of the panelled wood are bold against the curves of the petals on the patterned tablecloth, and the burgundy of the plums is warm against the acid yellow of the lemons.

By 1925 Matisse was one of Europe's most popular painters, and collectors were keen to own his works. It was the Scottish Colourist, Leslie Hunter, who seemingly encouraged William McInnes to collect modern French art. When the two visited Paris in 1925, they saw *The Pink Tablecloth* in the dealer Hessel's window. Despite Hunter's enthusiasm McInnes remained uncertain and sought A. J. McNeill Reid's advice. By the time McNeill Reid arrived in Paris the painting had already been purchased. But it was Reid & Lefèvre's French partner, Etienne Bignou, who had bought the work and, with Reid's reassurance of the painting's importance, McInnes acquired it. McInnes lent *The Pink Tablecloth* to the major Matisse exhibition held in Paris in the galleries of Georges Petit in June 1931.[2]

[1] Another version of this painting is in the collection of Mrs Sam A. Lewisohn, New York.

[2] An installation photograph of the exhibition, showing this painting, is reproduced in the exhibition catalogue *Henri Matisse, The Early Years in Nice, 1916–1930*, Washington, D.C., 1986–87, p.236, fig.4. McNeill Reid attended the banquet celebrating the opening of the exhibition. He can be seen, at the end of the table, in the photograph reproduced in the Washington catalogue on p.234 – there is a key to the photograph on p.270.

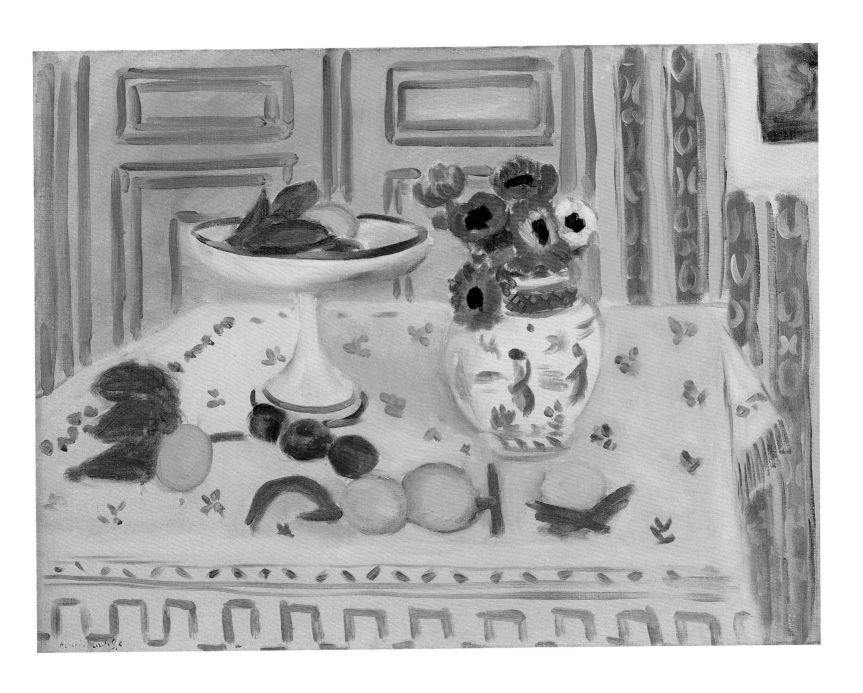

Catalogue 38

Georges Michel (Paris, 1763–1843, Paris)

Landscape with Cottages, after 1830

Oil on paper mounted on canvas

80.4 × 100.5cm

It is only relatively recently that Michel has been recognised as an important landscapist. Despite his training under a history painter, he, unlike his contemporaries, chose not to paint the then-expected imaginary classical or historical landscape but, instead, was inspired by the real landscape surrounding his home near Montmartre and Saint-Denis. In his attention to realistic detail and in his interest in drawing from nature, Michel provides an important link between the naturalistic landscapes of Dutch seventeenth-century artists like Ruisdael and Koninck and the realistic landscapes of the artists of the Barbizon School.

This landscape may be of Montmartre, an area Michel – often referred to as the 'Ruisdael of Montmartre' – explored endlessly. Then the nearest rural village to Paris, Montmartre – undeveloped and somewhat 'wild' – was just outside the confines of the city. There were no real roads, but there were some 30 working windmills, one of which can just be made out here as a dark silhouette to the left in the middle distance. Michel's biographer, Alfred Sensier, recorded that 'for those who know how to look' the area was superb, with its green slopes, pastures, vines, and extensive fields.[1] By the 1860s and 1870s Montmartre had been transformed. The population increased, it became popular with artists and writers, and it was absorbed gradually into the city.[2]

In this powerful late landscape, Michel retains the immediacy and freshness of the sensations he had experienced when sketching from nature. There is a passion in his handling; he uses thick brushstrokes loaded with paint, known as *impasto*, describing with great breadth and freedom the earth of the path and banks and the thatched roofs of the cottages. Michel also found a particular poetry in capturing dramatic effects of light on the landscape of Montmartre after a storm – in the foreground we see a road and cottages, suddenly lit after the passing of the dark clouds above.

Michel's composition, with its bold horizon line almost cutting the picture in half and with its magnificent panoramic depth, was certainly influenced by his study of the Dutch landscape tradition. As early as 1779 he had copied seventeenth-century Dutch paintings for the picture dealer Le Brun. From 1800, he worked as a conservator of paintings in the Louvre, where he could study at first hand the paintings of Flemish and Dutch masters, such as Jan van Goyen, Rembrandt and Ruisdael.

Although Michel died in obscurity his reputation was revived in the 1870s by an exhibition of his work at the Durand-Ruel Gallery in London in 1872, and by Alfred Sensier's 1873 monograph. Michel's paintings were widely collected in Britain in the later nineteenth century. We know little about the early history of this painting, purchased by the museum in London in 1959. The problems of dating Michel's work are well known.[3]

[1] Alfred Sensier, *Etude sur Georges Michel*, Paris, 1873, p.42.

[2] It is interesting to compare Michel's painting with Van Gogh's *Le Moulin de Blute-Fin, Montmartre* (cat.27).

[3] Michel's biographer Alfred Sensier discusses the difficulty of authenticating and dating Michel's works. In some thirty years of work on Michel he only found one painting with a signature. He never found one that was dated and could not find any documentary evidence that would help. The subject-matter and handling of *Landscape with Cottages* suggest that it is from his last period.

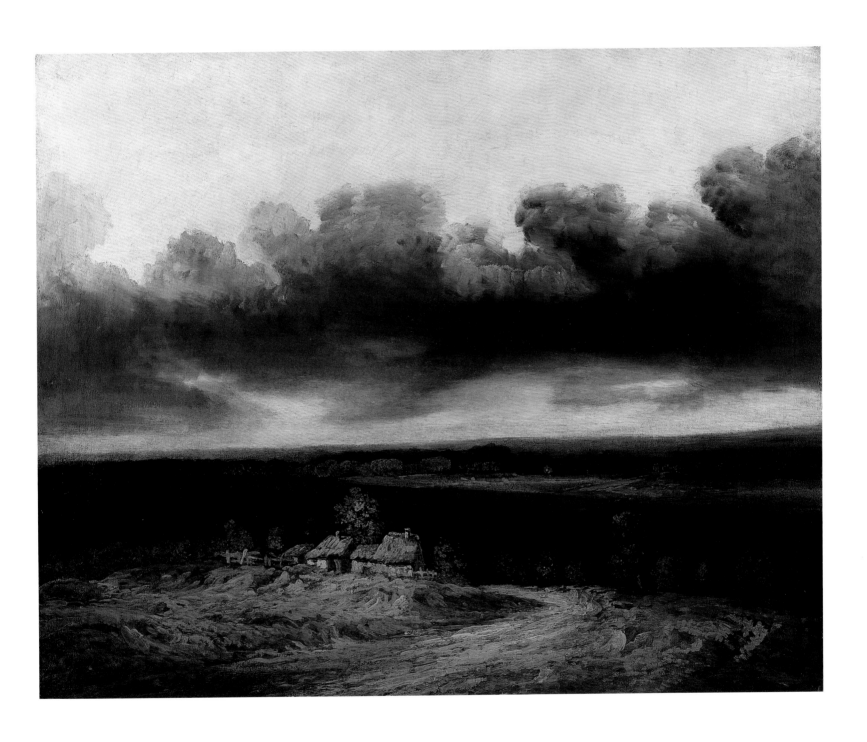

Catalogue 39

Jean-François Millet (Gruchy, 1814–75, Barbizon)
*Going to Work, c.*1850–51

Oil on canvas
55.9 × 46.4cm

Millet is universally acknowledged as the greatest painter of peasant scenes. His realistic works of peasants seen tied to the drudgery of the cultivation of the soil proclaim the dignity and nobility of labour. If his figures are not actually sowing, reaping or gleaning, they are shown with the tools for these tasks. One of Millet's most monumental studies of peasant life, *Going to Work* was painted shortly after he settled in Barbizon, the village at the edge of the Forest of Fontainebleau. The starkness and simplicity of this picture conveys the harshness of the peasant's existence. Silhouetted against the morning sky, the couple march silently to the fields, carrying their tools, their faces in deep shadow, the man with his cloth cap, the woman with the basket she wears as a hat. As Van Gogh said, they seem to have been painted with the very earth they are going to till.

Some critics complained that Millet was a poor colourist. Indeed, although there are strong notes of blue, yellow and green here, the predominant colour is brown. Millet is exaggerating and thus emphasising the very earthiness of the peasants' lives. His deliberate simplification of the human forms has a similar effect – the man is almost like a caricature, reduced to heavy, rounded shoulders, pointed elbows, thick, knobbly knees and large bulky clogs. Millet's vision has a universal impact because he creates a timeless and simple image of humanity. These peasant paintings were to be a powerful influence on the work of Bastien-Lepage, Pissarro, Van Gogh and Seurat.

Although political motives were often read into Millet's peasant paintings, the artist himself denied any such agenda. Reviewing the Salon of 1859, Charles Baudelaire explained his dislike for Millet's paintings, saying his 'peasants are pedants who have too high an opinion of themselves. They display a kind of dark and fatal boorishness which makes me want to hate them. Whether they are reaping or sowing, whether they are grazing or shearing their animals, they always seem to be saying, "We are the poor and disinherited of this earth – but it is we who make it fertile! We are accomplishing a mission, we are exercising a priestly function!" Instead of simply distilling the natural poetry of his subject, M. Millet wants to add something to it at any price. In their monotonous ugliness, all these little pariahs have a pretentiousness which is philosophic, melancholy and Raphaelesque. This disastrous element in M. Millet's painting spoils all the fine qualities by which one's glance is first of all attracted towards him.'[1]

As a student Millet had spent many hours studying in the Louvre, and he made copies after classical reliefs and of the work of Masaccio, Piero della Francesca and Poussin, amongst many others. We can find prototypes for his subject-matter in Pieter Brueghel and in late Gothic illuminated manuscripts. Many of Millet's paintings contain references to earlier works of art. Here the pose of the two young peasants echoes that of Adam and Eve in Masaccio's *Expulsion from Paradise*, in the Brancacci Chapel in Florence.

Between 1850 and 1870 Millet worked on several different versions of this painting as well as on numerous preparatory sketches and later, etchings. There is a near-identical oil in the Cincinnati Art Museum.[2] Glasgow's version of the painting was purchased directly from Millet in 1851 by the businessman Collot. We know that the painting was in Scotland, in the collection of James Donald, by 1882. Donald lent *Going to Work* to the International Exhibitions held in Edinburgh in 1886 and in Glasgow in 1888 and 1901.

[1] Quoted in ed. Jonathan Mayne, *Art in Paris 1845–1862, Salons and Other Exhibitions, Reviewed by Charles Baudelaire*, Oxford, 1965, p.195.
[2] The Cincinnati painting is a replica Millet made for his friend Alfred Sensier to sell. In 1863, Millet was persuaded by Sensier to produce an etching on the theme.

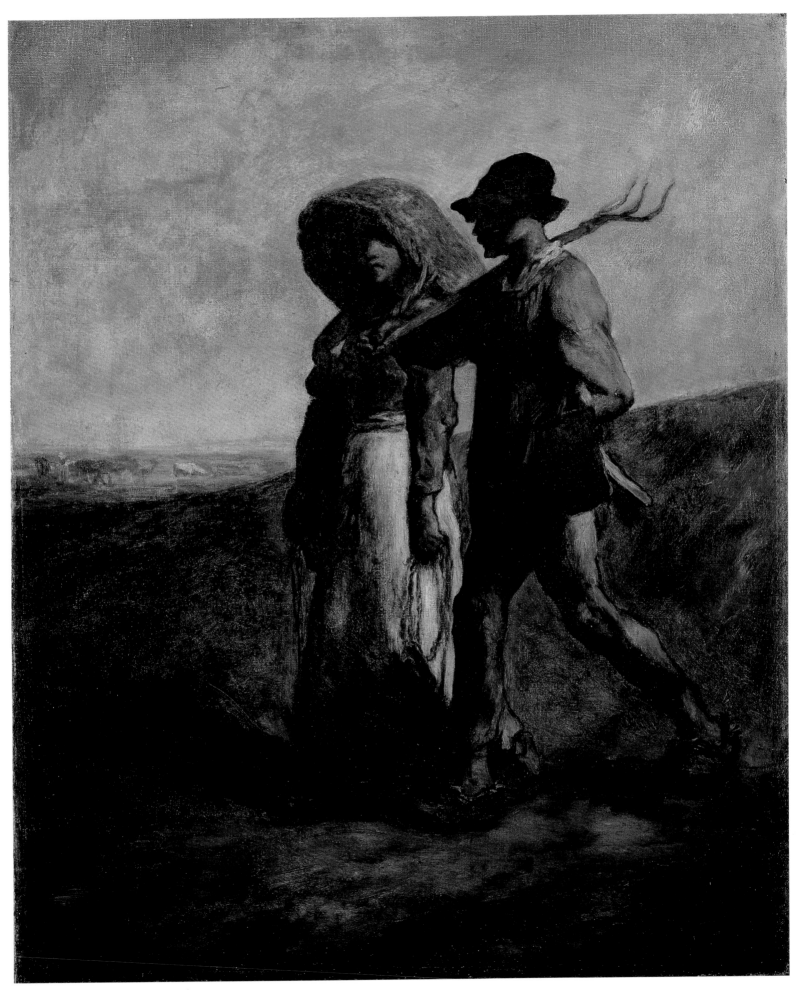

Catalogue 40

Claude Monet (Paris, 1840–1926, Giverny)
Vétheuil, 1880

Oil on canvas

60.0 × 80.6cm

In 1878 Monet moved to the small village of Vétheuil, on the river Seine, half-way between Paris and Rouen. Following the Franco-Prussian War, France had plunged into an economic depression and was only now recovering. Monet, who had enjoyed a degree of success in the early 1870s, was suffering severe financial difficulties and now joined forces with the family of the recently bankrupt Ernest Hoschedé, the two families living together in rented accommodation in Vétheuil.

Monet's stay at Vétheuil can, with hindsight, be seen as crucial in his development as a landscapist. Where previously he had celebrated modern life in his paintings of Parisian street scenes, of weekend pleasure-seekers at Argenteuil or of tourists on the beach at Trouville, he chose now to paint landscapes that were untouched by progress and that celebrated an unspoilt rural life in which the human figure rarely played a part.

This is one of several views Monet painted of the village from the Ile St Martin, a small island in the middle of the river Seine. Monet reached it using one of the boats he moored on the banks of the river near his home. Here the drifting soft clouds slowly crossing the blue sky hold his attention rather than the river itself, which he barely indicates with a swift splash of pale blue on the right. The village church, which was to inspire a series of paintings that prefigure his Rouen Cathedral series, is represented here by its distinctive tower, a triangle of white in the centre of the composition.[1]

Rather than working in a studio, Monet would have painted this work outside, working directly on to the canvas, probably returning day after day for subsequent sessions. Using small, hasty brushstrokes, he strives to capture the fleeting effects of light and movement on the ever-changing scene in front of him. His brushstrokes scarcely differentiate between the varying textures of sky, water and trees. They are all treated alike. Sometimes it is difficult to know what we are seeing – the lively strokes of red that dance in the foreground are poppies!

Monet often left areas of his canvas deliberately untouched. The distant hill on the left has only a few hasty strokes of yellow and green, for Monet allows the canvas support to show through. From a distance the colour of the canvas suggests the pale earth. When one realises how little of this canvas is actually covered with paint it is not surprising to learn that the critics and public of the time were outraged by what they believed to be the lack of 'finish' of Monet's paintings. The novelist and critic, Emile Zola, complained about Monet's sketchiness: 'When one is too easily satisfied, when one delivers a sketch which is scarcely dry, one loses the taste for pieces which are deeply studied; it is study which makes solid works. Today, because of his need to sell, Monet's work bears the signs of haste.'[2]

Although Monet was desperate to sell his canvases to pay off his many creditors, this painting remained with him until April 1918 when he sold it to the Parisian dealers Bernheim-Jeune. Like so many of the works in the collection of Glasgow Museums, this painting then passed through the hands of the Glasgow dealer Alex Reid. Reid had bought his first Monet as early as 1889 and had other works by the artist for sale in the 1890s, successfully selling three to Glasgow collectors by 1901.

[1] During the summer of 1880 Monet painted some 26 views of the area around the village, six of which were, like this, painted from the Ile St Martin, one of many nearby islands in the Seine. The Metropolitan Museum in New York has a portrait-format view quite similar to this, and as it is signed and dated 1880 we can be certain that it was done at the same time.
[2] Quoted in John House, *Monet, Nature into Art*, London, 1986, p.166.

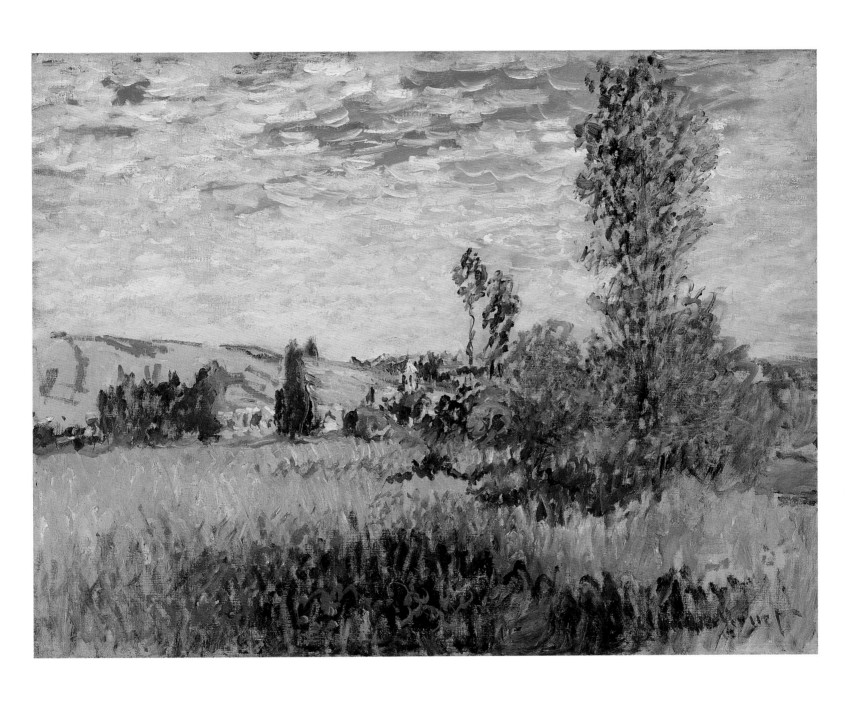

Catalogue 41

Claude Monet (Paris, 1840–1926, Giverny)
View of Ventimiglia, 1884

Oil on canvas
65.1 × 92.1cm

Inspired by his visits to North Africa, Italy and the south of France, Renoir, in 1883, persuaded Monet to accompany him on a painting expedition to the Mediterranean coast. Within a month Monet had returned exasperated, explaining in a letter to his dealer, 'I've always worked better in solitude and following my own impressions.'[1] Monet however had been inspired by what he had seen and returned alone to Bordighera in January 1884. Initially intended as a month-long visit, Monet's campaign lasted three months, with the artist returning home to Giverny in late March. This is one of forty-five canvases painted during his trip.

Ventimiglia, situated just inside the Italian border with France, is close to Bordighera, the picturesque Italian seaside resort town where Monet was staying. As was his custom Monet took time to explore the area, choosing motifs that inspired him and deliberately avoiding the views typically beloved by tourists and other artists. Monet's daily letters to Alice Hoschedé, his companion and future wife, are a marvellous record of the exhilaration and frustration he experienced, recounting his frantic search for motifs and his attempts to understand how to capture the heat, the brilliant light and the luxuriant vegetation. A note of growing desperation creeps into his letters as he realises that his first works no longer represent what he has learnt in the interim.

One letter conveys the frustration and torment he experienced when painting a work such as *View of Ventimiglia*: 'We're having marvellous weather and I wish I could send you a little of the sunshine. I am slaving away on six paintings a day. I'm giving myself a hard time over it as I haven't yet managed to capture the colour of this landscape; there are moments when I'm appalled at the colours I'm having to use. I'm afraid what I'm doing is just dreadful and yet I really am understating it; the light is simply terrifying. I have already spent six sessions on some studies, but it's all so new to me that I can't quite bring them off; however the joy of it here is that each day I can return to the same effect, so it's possible to track down and do battle with an effect. That's why I'm working so feverishly and I always look forward to the morrow to see if I can't do better next time.'[2]

Monet realised that the colours he needed – 'a palette of diamonds and jewels here because of the blues and pinks'[3] – would make people 'exclaim at their untruthfulness, at madness, but too bad . . . All that I do has the shimmering colours of a brandy flame or of a pigeon's breast, yet even now I do it only timidly. I begin to get it.'[4] That he worked quickly can be seen here in the brisk, free, flickering brushstrokes that describe the sky and the vegetation. Some of the sea-blues find a place among the warmer tones of the flowering shrubs and some leafy greens appear as gradations in the sea.

On his return to Giverny – working in his studio rather than directly from nature – Monet added the finishing touches to the canvases before sending them to his dealer in Paris, Durand-Ruel: 'At last I am sending you by express mail a chest containing eight pictures detailed on the opposite sheet. Their prices are somewhat higher, but you must take into account how difficult it is for me and how much it costs me. Well, let's hope that the buyers will fight for them and that you are somehow out of difficulties now: keep me informed on this.'[5] One of the works on the list, *Vue prise près de Vintimille*, priced at 900 francs, may well be this painting.

[1] Letter to Durand-Ruel, quoted in Virginia Spate, *The Colour of Time, Claude Monet*, London, 1992, p.165.
[2] Letter from Monet to Alice Hoschedé of 26 January, 1884, quoted in Richard Kendall (ed), *Monet by Himself*, London, 1989, p.109.
[3] Quoted in the exhibition catalogue, *Claude Monet, 1840–1926*, Chicago, 1995, p.210.
[4] Quoted in Spate, *op.cit.*, p.167.
[5] Quoted in the exhibition catalogue *Monet at the Time of Giverny*, Paris, 1983, p.32; and Wildenstein's description of the view: 'Prise d'une colline située à l'ouest de Bordighera, probablement Bellavista, cette vue panoramique montre de droite à gauche: Vintimille, le pic Baudon, le cap de la Mortola devant Menton, la double cime du mont Agel et la Tête de Chien au-dessus de Monaco.'

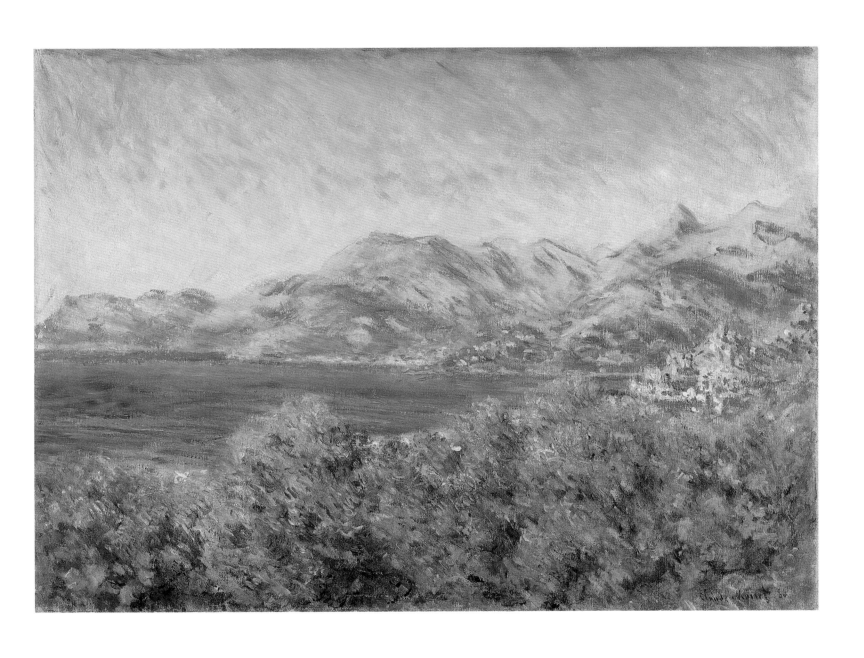

Catalogue 42

Henry Moret (Cherbourg, 1856–1913, Paris)

Cliffs at Port-Domois, Belle-Ile, c.1890

Oil on canvas

73.2 × 60.1cm

Although Norman by birth, Moret spent most of his working life in Brittany, painting the many faces and moods of the Breton countryside and the rugged Breton coast. This view was painted from the cliffs at Port-Domois on the island of Belle-Ile, off the south coast of Brittany. Often bleak and windswept, this area provided artists with distinctive and dramatic motifs – granite cliffs plunging into turbulent seas pierced by rocks.

As the public of the time would have recognised, Moret's view was inspired by a series of works Monet had painted at Belle-Ile in 1886 (ill.10). Like Monet, Moret has selected a high viewpoint looking down from the rich green cliffs on to the surging blue-green sea and the weather-twisted rocks that jut from its surface. Moret's broad, free and dynamic brushstrokes also show Monet's influence.

Between 1888 and 1892 Moret briefly experimented with the Synthetism of Gauguin and Bernard, and something of what he learned from their example can be seen here. Moret has deliberately selected a portrait format, a vertical canvas, rather than the more traditional horizontal used for landscapes. This format encourages the artist to show a narrow instead of a panoramic view – appropriate here to suggest the height of the cliffs – and to use a high horizon line which flattens the picture space rather than allowing the viewer to read back into depth and distance. This results in a decorative effect which is heightened here by Moret having simplified the landscape forms before him, carving out distinct patterns to suggest the shape of the cliffs and to describe the foreground vegetation with its meandering path.

But Moret's interest in capturing the strong vibration of light as it catches the crest of a wave, his ability to depict the depth and solidity of the rocks and the textural richness of his paint-loaded brushstrokes, are surely closer to Monet's Impressionism and have little to do with the patterned flatness of Synthetism. Perhaps unsurprisingly, he soon abandons the lessons he had learned from Bernard and Gauguin. In a later letter, Emile Bernard mentions Moret's change of heart: 'He was a quiet revolutionary, sincere; I lost sight of him after leaving Pont-Aven. He turned from our synthetic research to Monet's "*école de plein air*", which surprised me.'

In 1895 Moret was taken up by Monet's dealer, Durand-Ruel. Did Durand-Ruel promote Moret because his works were like those of Monet, or did Moret's work become more like Monet's under Durand-Ruel's influence? What we do know is that Moret's association with the dealer gave the solitary and modest artist the freedom to hunt, sail and paint throughout the region he loved.

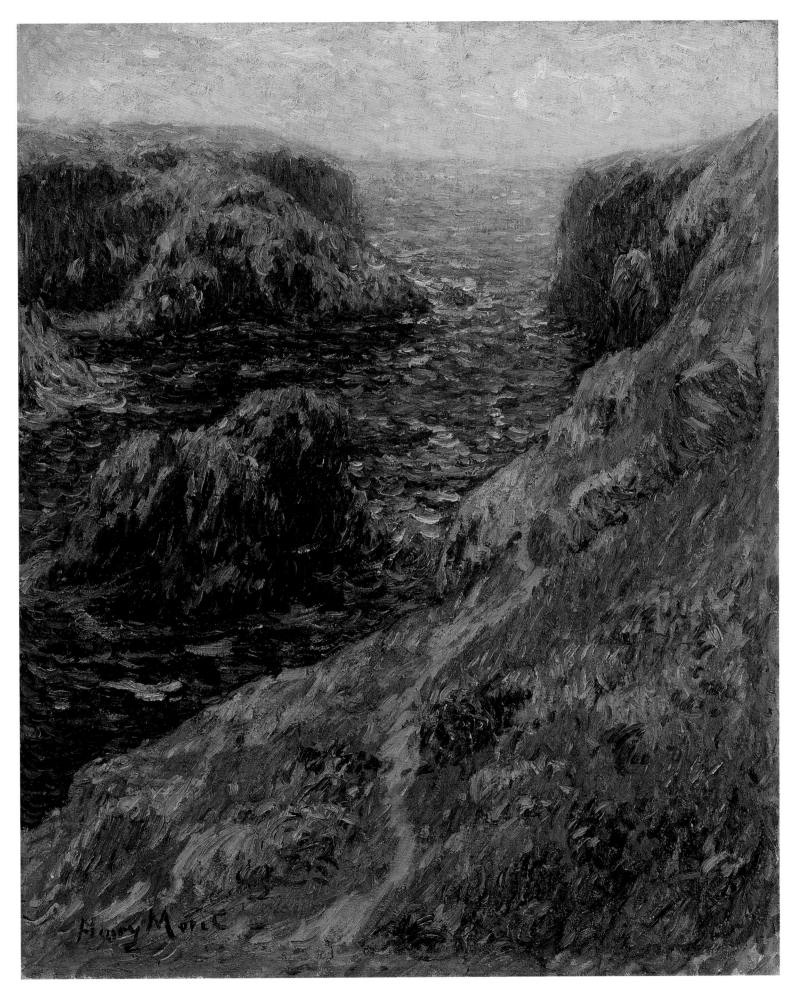

Pablo Picasso (Malaga, 1881–1973, Mougins)

The Flower Seller, 1901

Oil on millboard

33.7 × 52.0cm

Picasso painted children throughout his career. As his dealer Kahnweiler observed, 'If one were to make a ranking of the figures in Picasso's work, children would doubtless hold an outstanding place. There was no aesthetic reason for this. He painted and drew children . . . simply because he loved them passionately, especially the little ones.'[1]

The Flower Seller was painted in Paris in the spring of 1901 during the artist's second visit to the French capital. It is one of a small group of scenes of contemporary Parisian life in which Picasso has been inspired by the Impressionists in his choice of subject, and by the Nabi artists Bonnard and Vuillard in style. Facades of buildings stretch off into the distance, framing a square where mothers and governesses congregate, chatting as they watch over the children in their care.[2] On a double-sided park bench an elderly man and woman sit back-to-back, the gentleman, his shoulders stooped, staring off out of the picture space. The woman gazes down at the tiny, bundled baby she cradles, while at her feet Picasso describes the rounded form of the playing toddler with a few quick strokes of white, bare cardboard indicating the child's head. A young woman holding a huge basket of spring flowers looks on. The warm shades of pink, yellow, and orange in her flowers are picked up in the flowery bonnet of the other woman on the park bench, in the clothes of the group in the background and in the hair and dress of the running girls, who, full of the unbounded energy of youth, disappear in a flurry of frantic activity at the left.[3] Behind this group a straggly horse, pulling a heavy carriage, struggles up the hill. Is Picasso commenting on the universal theme of the 'Three Ages of Man'? Always inspired by something seen, Picasso worked in the studio using sketchbooks and memory, dispensing with detail and preferring to capture instead something timeless and generalised.

During June and July 1901 an exhibition of some 65 of Picasso's works was organised by Gustave Coquiot and held in the Rue Laffitte gallery of Ambroise Vollard. Picasso was only nineteen years old. The exhibition was a success, with 15 of the works selling before the exhibition even opened. Although *The Flower Seller* is not usually considered by scholars to have been included in this exhibition, a scribbled inscription on the back of the board, '*Appartient à Madame Besnard*', and the work's subject suggest that it was in fact included as n.22, known then as *The Square*. The inscription confirms that it is one of four works purchased prior to the exhibition by Mme Besnard, the wife of Picasso's art materials' supplier.

Coquiot, reviewing the exhibition, predicted: 'This very young Spanish painter, who has been here for only a short time, is wildly enamoured of modern life. It is easy to imagine him – wide awake, with a searching eye, keen to record everything happening in the street, all the adventures of life. He does not need to contemplate his subject-matter for long; so it is that we see him covering his canvas quickly, as if in a fury, impatient at the slowness of his hand, which holds long brushes laden with colour . . . From our own time he has taken prostitutes, country scenes, street scenes, interiors, workers and so on, and we can be sure that tomorrow he will offer us everything else that he has not been able to attain up to now because of his extreme youth.'[4]

[1] Daniel-Henry Kahnweiler, quoted in Werner Spies, *Picasso's World of Children*, Munich and New York, 1996, p.9.

[2] During Picasso's stay in Paris in 1901 his apartment was close to the Boulevard de Clichy.

[3] The two girls relate directly to *Three Little Girls Playing, The Blonde Tresses*, spring 1901, in C. Zervos, vol.XXI, n.302. For related works in general see the painting on loan to the Van Gogh Museum, Amsterdam, from a private collection, *Public Garden*, 1901, oil on cardboard, 32 × 47cm, in *Van Gogh Museum Journal*, 1996, p.202. The same child appears in *Child with Doll* in Zervos, vol.XXI, n.301.

[4] Review by Gustave Coquiot in *Le Journal*, 17 June 1901, quoted in J. Fabre, *Picasso, The Early Years 1881–1907*, Barcelona, 1985, p.514.

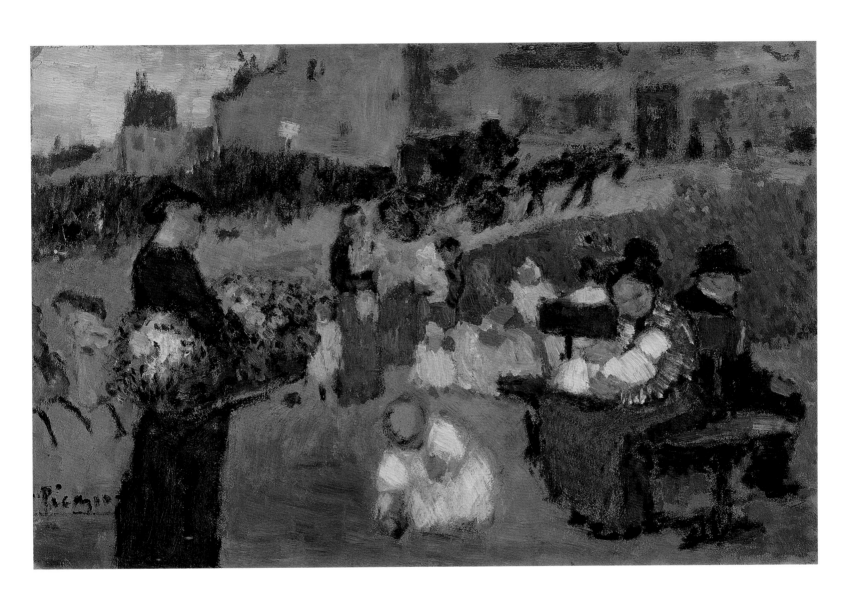

Catalogue 44

Camille Pissarro (Charlotte Amalie, St Thomas, 1830–1903, Paris)

The Banks of the Marne, 1864

Oil on canvas
84.0 × 110.2cm

Pissarro is revered as one of the major figures of Impressionism. As with the other Impressionists – Monet, Renoir and Sisley – his early paintings, such as *The Banks of the Marne*, reveal an artist who, although developing his own distinctive style, still clearly owes a debt both to the French academic tradition and to his older contemporaries, Corot, Daubigny and Courbet. While Corot's influence can be seen here in both the treatment of light and the rich tonalities, Pissarro's choice of subject – a quiet riverbank – owes much to Daubigny, in the timeless quality of a scene that could be nowhere and everywhere.

Pissarro, like Courbet, firmly believed that the artist's role was to paint subjects drawn from everyday life. Throughout his career Pissarro was devoted to landscape, and his rural scenes and portrayals of peasant life show his interest in an unsentimental observation of nature. Although the situation would eventually change, throughout the 1860s Pissarro was relatively successful in having his paintings accepted for exhibition at the Paris Salon. Despite the fact that his technique tended towards a lesser degree of finish than that expected by the academically biased jury, his compositions were largely conservative in their careful delineation of a dark foreground – with peasant figures as staffage, adding a touch of movement and suggesting scale – to a lighter middle ground and a calm horizon.

It is possible that this work was shown at the Salon of 1864 bearing the title *The Banks of the Marne*. Certainly the scale of the painting suggests that it was a work planned for the Salon. Pissarro went about preparing for this painting in the conventional way. First he made a small preparatory oil sketch directly from nature. This sketch was then used as the basis for the exhibition picture that was painted in the studio. It is one of the rare occasions when both the painting and the preparatory sketch survive.[1] The composition is close to the Neo-Classical landscapes that the Salon audiences expected, but Pissarro breaks with tradition in trying to retain the breadth and directness of the sketch in the finished painting. He abandons the meticulous finish expected in an exhibition picture and does not feel obliged to add in further topographical details.

Very few of Pissarro's paintings of the 1860s survive as many were destroyed in the Franco-Prussian War of 1870–71. This painting is said to have been looted during the war and was later discovered in Germany.

[1] Two paintings by Pissarro were accepted at the Salon that year: n.1558, *Bords de la Marne*, and n.1559, *La Route de Cachalas à La Roche-Guyon*. In the exhibition catalogue *Lighting up the Landscape*, Edinburgh, 1986, Michael Clark argues convincingly that Glasgow's painting may well be n.1558. The oil sketch is in the Fitzwilliam Museum, Cambridge.

Catalogue 45

Camille Pissarro (Charlotte Amalie, St Thomas, 1830–1903, Paris)
The Tuileries Gardens, 1900

Oil on canvas

74.0 × 92.6cm

During the last eight years of Pissarro's life, his subject-matter changed dramatically. Where previously his motifs were almost all drawn from rural life he now chose urban subjects, painting over three hundred views of Paris, Rouen, Le Havre and Dieppe. Many of these canvases were painted in series, Pissarro undoubtedly being inspired by the example of Monet's series paintings. Like Monet, Pissarro aimed to capture fleeting effects of light, but it is possible that the elderly artist also had more commercial reasons in mind, having witnessed the financial and critical success that Monet's series paintings had brought him.

In December 1898, Pissarro wrote to his son Lucien of his intention to paint a series of the Tuileries Gardens in Paris. He writes that he and his wife 'have engaged an apartment at 204 rue de Rivoli, facing the Tuileries, with a superb view of the Garden, the Louvre to the left, in the background the houses on the quais behind the trees, to the right the Dôme des Invalides, the steeples of Ste. Clothilde behind the solid mass of chestnut trees. It is very beautiful, I shall paint a fine series.'[1] Their choice meant the elderly artist and his wife could enjoy a degree of comfort superior to that of living in an hotel room. It also allowed Pissarro the chance to work on larger format canvases, as the apartment provided him with both the space and the time to contemplate the work at hand. His first series of fourteen views of the Tuileries Gardens was painted in 1899 and a second group – of which this is one, again of fourteen views – was painted in early 1900. These works were never exhibited as a series during Pissarro's lifetime.[2]

Pissarro's choice of a city park as his motif has allowed him to juxtapose and contrast architecture and nature. With the exception of the trees in the foreground, however, it is a controlled nature. Pissarro firmly believed that his paintings must have internal coherence, a strong composition. Here the patterns of the gardens – as originally designed by André Le Nôtre between 1664 and 1679 – provide him with verticals, horizontals and circles with which to construct his composition. The viewpoint is high – Pissarro was painting from his second-floor window – and half of this large-format canvas is devoted to the sky alone. Less interested in the motif itself, Pissarro is fascinated by atmospheric effects, contrasting the earthy tonalities of the trees in the foreground with the pale blues and mauves of the distant buildings. The Pavillon de Flore of the Palais du Louvre – with a flag flying in the breeze – can be seen on the left. Early in his career the young Pissarro, rebelling against officialdom, reportedly told Cézanne that it would be better if the Louvre burned down! Nevertheless from his letters we learn that he knew the contents of the museum well and, in the late 1890s, had been involved in a crusade against paid admission to the Louvre.

Pissarro's letters give us an invaluable insight into his method of painting. In a letter of advice to a young artist, Pissarro reveals how a work like *The Tuileries Gardens* would have been painted: 'Look for the kind of nature that suits your temperament . . . Do not define too closely the outlines of things; it is the brushstroke of the right value and colour that should produce the drawing . . . Use small brushstrokes and try to put down your perceptions immediately . . . Cover the canvas at the first go, then work at it until you can see nothing more to add . . . Do not proceed according to rules and principles, but paint what you observe and feel. Paint generously and unhesitatingly, for it is best not to lose the first impression. Do not be timid in front of nature: one must be bold, at the risk of being deceived and making mistakes. One must have only one master – nature; she is the one always to be consulted.'[3]

Alex Reid acquired his first Pissarro in 1889, continuing to handle his work until he retired in 1926. This painting is from Sir John Richmond's collection and was presented to Glasgow Art Gallery and Museum in 1948.

[1] Letter of 4 December 1898 quoted in John Rewald (ed), *Camille Pissarro, Letters to his Son Lucien*, Santa Barbara, rev.ed. 1981, p.431.
[2] See L. R. Pissarro and L. Venturi, *Camille Pissarro, son art, son oeuvre*, Paris, 1939, nos.1123–1136; a number of works from the two series are illustrated and discussed in the exhibition catalogue *The Impressionist and the City: Pissarro's Series Paintings*, Dallas-Philadelphia-London, 1992–93, pp.103–121.
[3] Quoted in John Rewald, *The History of Impressionism*, 4th ed. rev. 1973, pp.456–7.

Catalogue 46

Auguste Renoir (Limoges, 1841–1919, Cagnes)
Portrait of Madame Valentine Fray, 1901

Oil on canvas
65.2 × 54.3cm

On seeing the major Renoir exhibition held in Paris in 1892, the artist Maurice Denis praised the older artist's 'whole life of silent and unpretentious work, the beautiful and honest life of a true painter . . . with the joy of his eyes he has composed marvellous bouquets of women and flowers.'[1] It was with portraits that Renoir first found success, receiving commissions in the later 1880s and 1890s from the wealthy bourgeoisie of Paris. He later admitted that he disliked painting society beauties because 'their skins did not take the light' and their hands, too elegant and white, 'lacked the character which housework gives'. Indeed in the last thirty years of Renoir's life, family maids were his favoured models.

In this portrait Renoir celebrates the sensuous beauty of Valentine Fray (1870–1943). Posed in a standard bust-length, at a three-quarters angle, the sitter turns her head slightly to the left in a formal yet relaxed manner. Seen in near-profile, her face unsmiling, her eyes gaze beyond the picture space. Her pearly brocade dress is only suggested. Renoir luxuriates in the milky skin of her neck and shoulders, which the dress reveals, and which is highlighted by two large pink satin bows. Her golden red hair is swept up and back into a fashionable knot. She holds a closed fan. What is she thinking? As Götz Adriani has observed, 'Although Renoir's colours are radiant, the facial expressions of his subjects are seldom animated by a smile . . . From his male viewpoint, the artist glorified women as symbols of youthful beauty, yet he showed little interest in their physiological or psychological condition.'[2]

Born in Brussels in 1870, Valentine (née Micolaud) was a pupil of Renoir and of Eugène Carrière. She exhibited at the Paris Salon (under the name of 'Val'), specialising, as was typical for women artists of the time, in flower painting. Despite Renoir's known opinion that 'the woman artist is merely ridiculous', here he has treated his pupil sympathetically. Valentine had married Charles Fray some ten years before this portrait was painted, and they had three children – René, Georgette and Jacques. Renoir's portrait of Jacques is in the Sterling and Francine Clark Art Institute in Williamstown, Massachusetts. In 1911 Valentine divorced Charles Fray, later marrying Tancrede Synave, a painter of genre subjects.

When William McInnes purchased this painting it was known only as *Portrait of Madame X*. Later research suggested that it was a portrait of Mme Gaston Bernheim, the wife of Gaston Bernheim de Villers, a member of the well-known firm of Paris art dealers Bernheim-Jeune. With further research the true identity of the sitter was discovered – Valentine Fray, a distant cousin of Madame Bernheim.

[1] Quoted in Barbara Ehrlich White, *Renoir, His Life, Art, Letters*, New York, 1984, p.193.
[2] Götz Adriani, *Renoir: Gemälde 1860–1917*, Tubingen, 1996, p.202.

Catalogue 47

Auguste Renoir (Limoges, 1841–1919, Cagnes)
*The Painter's Garden, c.*1903

Oil on canvas
33.3 × 46.1cm

After Renoir's death some 700 paintings and studies were found in his studio. The Parisian dealers Josse and Gaston Bernheim-Jeune compiled an inventory of these works, cataloguing and dating each canvas prior to the paintings being sold. From the photographs in the published inventory we can identify this small landscape, which, when listed by the Bernheim-Jeunes, was part of a larger canvas with a portrait of a woman and another tiny landscape study. The title the brothers assigned this work was *Garden at Essoyes* and they dated it to 1903. Renoir often painted a number of works on one canvas, the Bernheim-Jeunes remarking that 'at times, a single panel will hold several studies done at different periods, spaces on the canvas having remained blank for years before their use.'[1]

We know little about when and from whom William McInnes acquired this work, but when he lent it to an exhibition in Norwich in 1925 it was known as *The Painter's Garden, Cagnes* and was believed to have been painted in about 1908. Although it is tempting to think that it shows one of Renoir's last homes, 'Les Collettes' in Cagnes in the south of France, it is more likely that it shows Renoir's country home at Essoyes, which he had bought in 1895 and where he used to spend his summers. Renoir's villa at Les Collettes was surrounded by ancient olive trees quite different from the standard roses and trees seen here.

Through a tree-lined alley we glimpse a large white building with a square tower abutting a red roof. Under the shade of a tree, a young woman, her head protected by a large yellow sun hat, reads. Renoir's hasty and expressive brushstrokes suggest the bright sunshine and joy of a warm summer's day, the complementary reds and greens heightened by notes of yellow, pink and white.

This small oil is typical of Renoir's late style as described by his friend Albert André. Renoir 'attacks his canvas, when the subject is simple, by tracing with a fine soft brush, usually with an earth red, a few very summary indications to see the proportions of the elements which will constitute his painting. Then immediately, with pure colours diluted with turpentine as if he were using watercolour, he would scumble the canvas rapidly and one could see something imprecise, iridescent appear, the colours merging into one another, something which one found ravishing even before understanding the sense of the image. Once the turpentine had evaporated a little, he would work over that preparation, proceeding in virtually the same manner, but with a mixture of oil and turpentine and a little more pigment.'[2] Renoir's fluid oil wash technique is clearly visible here, the multiple layers of glaze producing a transparent jewel-like colour.

Renoir's art was instinctive; it appeals to everyone's experience and demands no intellectual effort for its comprehension. In an interview given in the last years of his life, Renoir grumbled: 'Nowadays they want to explain everything. But if they could explain a picture it wouldn't be art. Shall I tell you what I think are the two qualities of a work of art? It must be indescribable, and it must be inimitable . . . The work of art must seize upon you, wrap you up in itself, carry you away. It is the means by which the artist conveys his passion.'[3]

[1] Messrs. Bernheim-Jeune, *Renoir's Studio*, Paris, 1931, p.xxxvi.
[2] Albert André, unpublished notes.
[3] Barbara Ehrlich White, *Renoir, His Life, Art and Letters*, New York, 1984, p.251.

Catalogue 48

Auguste Renoir (Limoges, 1841–1919, Cagnes)
Still-Life, c.1908

Oil on canvas

16.0 × 25.5cm

Still-life played a secondary role in Renoir's *oeuvre*, but it was a subject that he first tackled in the 1860s and regularly returned to throughout his life. At this late stage in his career it is unlikely that he painted it – as is so often the case with artists and still-life – as an experiment in arranging shape and volume and contrasting colour and texture. Renoir, now settled in Cagnes in the south of France, was badly afflicted by arthritis and would have found it easier to work on such small-scale canvases in the studio, knowing that they would find a ready market.

This tiny oil positively vibrates with warmth and light, the rich yellows and oranges of the fruit playing off against the deep green leaves, and the colder blue and white of the cup and saucer. Darker toned contours around the mandarin oranges distance them from the patterned background which also has touches of orange and green. The white tablecloth, with its blue shadows, also carries notes of reflected light. The work is thinly painted, each object described with quick, free, fluid strokes of paint. The canvas is primed with a light coating which shows through in many areas of the painting, helping to give luminosity to the picture.

Renoir's film director son, Jean Renoir, has left a moving description of his father in his last years, suggesting that although in evident pain he continued to paint: 'What struck outsiders coming into his presence for the first time were his eyes and hands. His eyes were light brown, verging on yellow . . . As for their expression, imagine a mixture of irony and tenderness, of joking and sensuality . . . Renoir was extremely modest and did not like to reveal the emotion that overwhelmed him while he was looking at flowers, women, or clouds in the sky, the way other men touch and caress. His hands were terribly deformed. Rheumatism had cracked the joints, bending the thumb toward the palm and the other fingers toward the wrist. Visitors who weren't used to it couldn't take their eyes off this mutilation. Their reaction, which they didn't dare express, was "It's not possible. With those hands, he can't paint these pictures." '[1]

This still-life once belonged to Maurice Gangnat (1856–1924). Gangnat, whom Renoir credited with an 'extraordinary eye', was a regular visitor at Renoir's home in Cagnes. It was Gangnat who purchased many of Renoir's late works, his collection eventually numbering some 180 paintings by the artist. Most of his Renoirs, including this still-life, were sold at auction in Paris in June 1925. The painting subsequently belonged to the Glasgow collector Leonard Gow, before being purchased by William McInnes.

[1] Quoted in Barbara Ehrlich White, *Renoir, His Life, Art, Letters*, New York, 1984, p.245.

Catalogue 49

Georges Rouault (Paris, 1871–1958, Paris)
*Circus Girl, c.*1939

Oil on paper, mounted on canvas
64.5 × 45.6cm

Guided by the example of his teacher, Gustave Moreau, Rouault chose to paint the inner world of his imagination and emotions, rather than the outer world of the art of the Impressionists. From Moreau, Rouault learnt a love of rich harmonies and bold effects with which to describe the wretchedness his difficult and poignant themes inspired in him – biblical scenes, prostitutes, judges and the circus. A disturbing and disquieting painter, the deeply religious Rouault sympathised with the plight of humanity, reflecting his compassion through his art.

Since childhood Rouault had been fascinated by the travelling circus and as a young art student regularly visited the Cirque Medrano. He tackled his first major series on the theme in 1904–6, returning to it once more in the 1930s. Rouault sympathised with the Clown, the solitary figure doomed to amuse. Through the Clown he brings home to us 'the drama of existence, to the everyday lives of the clowns we all are.'[1]

In *Circus Girl*, a young woman, her face serious and contemplative, stands out silent and withdrawn from the noise and movement suggested by the audacious shapes and shadows looming out of the background. Although we see only her head and shoulders, something of the glitter of the ringside is suggested by her large pearly necklace and by her headdress, a rounded concoction of subtly toned swirls of yellow, orange, blue, green and cream. The jewel-like colours are heightened by the sinuous velvet-black contours, a reminder of Rouault's early apprenticeship in stained glass. 'When we examine a Rouault, what strikes us first? Above all, the way the paint has been applied: very thickly and with passion . . . it gives the impression of a battlefield . . . The result is an agglomeration of tone upon tone, a thick, warm integument of the richest texture . . . No wonder when we look closely at these works, we find our imaginations oddly stirred . . . we are suddenly gripped by the visions they evoke, visions like those of a dying man. We are reminded of Degas' epigram that nothing so resembles a daub as a masterpiece.'[2]

How do we read the expression of her face? Her cold mask-like make-up and downcast eyes cannot hide the pain in the soul of this girl who, typically seen to be brilliant and sparkling, is here almost Madonna-like in her humility. There is an iconic quality to this powerful and resonant image, for although the actual theme may not be religious, the work has a definite spirituality.

The painting was bequeathed to the museum by Elizabeth Maud Macdonald in memory of her husband Duncan M. Macdonald, who had been a senior partner in the firm of Reid & Lefèvre in London. A. J. McNeill Reid recounted how it 'was one of quite a number of pictures I bought in Paris, when Mr. Macdonald was in the U.S. and he agreed that we would keep one Rouault each for ourselves. I had intended the lot to be for our 1940 Summer Exhibition and had the weird experience of flying to Paris and back in a blacked-out plane at the beginning of May that year. Alas! There was no exhibition, as the Germans invaded three days after my return, and the pictures did not arrive until 1946. I can remember that it cost £200, so it turned out to be a very good investment, and I thanked my lucky stars that I was not a few days later.'[3]

[1] Pierre Courthion, *Georges Rouault*, London, 1962, p.84.
[2] *Ibid.*, pp.234, 236.
[3] A. J. McNeill Reid, 'The French Room at Kelvingrove', *Scottish Art Review*, vol.VII, n.3, 1960, p.29.

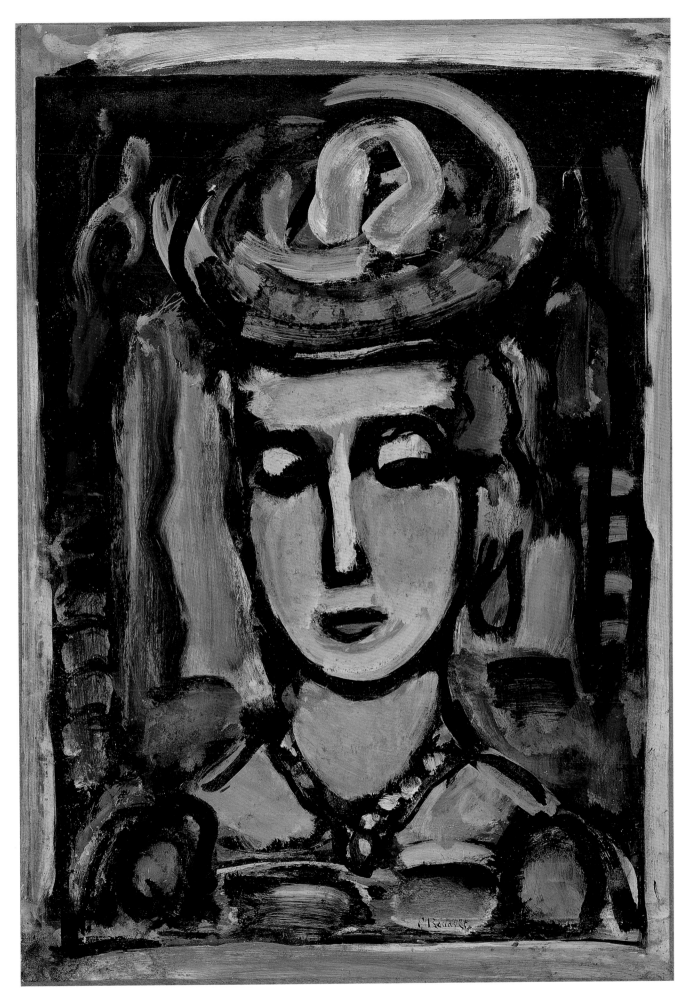

Catalogue 50

Théodore Rousseau (Paris, 1812–67, Barbizon)
The Forest of Clairbois, c. 1836–39

Oil on canvas
65.9 × 105.0cm

A controversial figure in his early career, Rousseau, notoriously known as '*le grand refusé*', suffered continual rejection by the Salon jury from 1836 until 1847. The work shown here may well be the painting entitled *The Edge of the Forest* that was rejected by the jury in 1839. Why should this work have been rejected? Rousseau's earthy, realistic landscapes clearly ignored the precepts of the French classical landscape tradition as practised by the academically trained jurists. The breadth and freedom of his handling and even his choice of subject, a rugged, unspoiled nature, rather than a tamed one, earned him the displeasure of the critics. Baudelaire, in his review of the Salon of 1859, complained that Rousseau 'falls into that famous modern fault which is born of a blind love of nature and nothing but nature; he takes a simple study for a composition . . . a rugged tree-trunk, a cottage with a flowery thatch, in short a little scrap of nature, becomes a sufficient and a perfect picture in his loving eyes. But even all the charm which he can put into this fragment torn from our planet is not always enough to make us forget the absence of construction in his pictures.'[1]

From 1826 Rousseau worked in the Forest of Fontainebleau making oil sketches from nature that would serve as 'notes' when he painted in the studio. He rented a studio in the village of Barbizon where he worked throughout the summer, returning to Paris in the winter. In *The Forest of Clairbois*, named after a part of the Forest of Fontainebleau, a dark tangle of trees and undergrowth barely allows us to penetrate the scene at all.[2] While our eye is easily drawn to the warm pink and reds of the figure of a woman walking towards us from the sunlit area on the right, it is only with difficulty that we make out a rocky incline with water trickling into a shallow pool in the left foreground. The painting is typical of Rousseau's forest scenes, with the rounded forms and varying textures of the curling branches and the rugged tree-trunks only broadly suggested. Rousseau's friends described how he used to spend long hours examining and memorising every twist of the tree branches in his attempt to depict 'the soul of the forest'. Something of the solemnity and drama of the forest is captured by Rousseau's use of strong tonal contrasts and by the varying effects of light and atmosphere. Unfortunately, the murky darkness of this painting makes it is difficult for us to appreciate it today. Rousseau experimented with a wide range of techniques, and as a result many of his paintings have deteriorated. Here his colours, originally rich and glorious, have darkened because of his use of bitumen.

Along with Corot, Daubigny and Millet, Rousseau's contribution to the development of realistic landscape painting was recognised by the critic Jules Castaganary who noted that their 'strong works, imbued with melancholy, elegance, and a gloomy grandeur, transformed landscape painting into the most important branch of contemporary art. And thus today the roles are reversed: landscape, once the lowest genre, now holds first place, and history painting, once at the top, exists in name only.'[3]

In the late nineteenth and early twentieth century many of Rousseau's works entered British public and private collections. After his death and until the First World War his works sold for large sums, rivalling the prices of works by Corot and Millet. *The Forest of Clairbois*, which remained unsold during Rousseau's lifetime fetched 13,600 francs in 1870, and 33,500 francs when it was sold again just three years later, in 1873.

[1] Charles Baudelaire, 'The Salon of 1959', quoted in Jonathan Mayne (ed), *Art in Paris 1845–1862, Salons and other Exhibitions, Reviewed by Charles Baudelaire*, Oxford, 1965, p.196.
[2] Rousseau's earliest etching, *Lisière de Clairbois* (L.Delteil, *Le peintre-graveur illustré*, vol.1, 1906, pl.1), shows the same motif. There is a preliminary drawing in the Cabinet des Dessins, Louvre (RF5362).
[3] Jules-Antoine Castagnary, *Salons (1857–1870)*, Paris, 1892.

Catalogue 51

Georges Seurat (Paris, 1859–91, Paris)
The Riverbanks, c.1882–83
Oil on wooden panel
15.8 × 25.1cm

This tiny painting shows what was to become the setting for Seurat's first large-scale composition, *Bathers at Asnières*, 1884 (cat.51.1). Working in a traditional, academic manner, Seurat made fourteen oil studies and numerous drawings before tackling the final composition. These studies probably lined the walls of his studio, allowing him to refer back to them as he worked on the large painting.

Asnières is a suburb of Paris on the river Seine. Here Seurat's view encompasses the Courbevoie bridge and behind it the factories of Clichy. To the right we can just make out the tree-lined tip of La Grande Jatte, the setting for Seurat's later painting *A Sunday Afternoon on the Island of La Grande Jatte, 1884*, 1884–86 (ill.4) with the keeper's cottage – small and round – indicated by a quick note of white.

This oil sketch was probably painted outside, directly in front of the motif, on a small wooden panel, using a hand-held painting box, *une boîte à pouce*. Previously thought to have been cigar-box lids, it is now known that these small mahogany or walnut panels were bought from an artists' supplier who would have had them available in various sizes and thicknesses. The thin panels would fit behind slats in the lid of the painting box, and many of Seurat's panels actually have marks or grooves at the edges. These boxes were a practical way of transporting materials to and from the motif and allowed the artist to make several 'impressions' in a day.

Seurat sometimes added a layer of white ground to his panels, but, more often, as can be seen here, he painted directly on to the wood. Small areas of the warm brown wood show through and become an active part of the colour scheme. Seurat exploits the natural grain of the wood for its textural effects, and manipulates the wet paint easily on the hard, slippery surface. The format of this small panel might seem restricting, but it allowed Seurat to work rapidly out-of-doors, working wet-into-wet to capture a motif in a single session. Sometimes he used the panels as a kind of notepad, quickly noting figures or details. At the Indépendants exhibition in 1884 he described his oil studies as *croquetons*, a word he seems to have invented and which probably derived from *croquis*, the academic term for a quick sketch.

The Riverbanks, usually dated to 1883, may have been painted earlier, in the autumn of 1882. The blue and white brushstrokes that suggest the surface of the water, and the movement of clouds in the sky, are still close to the broad and free brushwork of Impressionism. Although there is a suggestion of the more disciplined criss-cross brushstroke in the grass in the foreground, Seurat is not yet systematically using the *balayé* stroke which we see in *Boy Sitting in a Meadow* (cat.52) or in *House Among Trees* (cat.53).

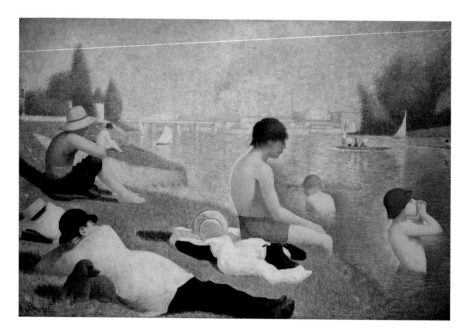

51.1
Georges Seurat
Bathers at Asnières, 1884
Oil on canvas, 201 × 300cm
National Gallery, London

Catalogue 52

Georges Seurat (Paris, 1859–91, Paris)
*Boy Sitting in a Meadow, c.*1882–83

Oil on canvas
65.0 × 81.2cm

In forging his own style, the innovative Seurat found much to learn from the artists of his own time. In the works of Millet, Pissarro, Puvis de Chavannes and Bastien-Lepage he found precedents for the subject, the composition and even the mood of his *Boy Sitting in a Meadow*, his first large-scale work. The young peasant, silent and immobile against a simple grass background, is seen in near-profile. The high horizon, the sheer depth of the pictorial space and the placing of the boy to the far right of the composition contribute to a feeling of awkwardness that emphasises the solitude of the boy. Gazing downwards, his hands idle, he ignores the scene before him, an island of dark and brooding in the midst of the glory of the strong sunshine that floods the landscape surrounding him. What could have been Seurat's purpose in painting such a scene?

Certainly this figure owes something to the simple, statuesque forms of Millet's peasants, but it shares none of the dignity of Millet's working figures. For Seurat's friend and mentor Pissarro the theme of the peasant seated in a landscape or meadows had been a frequent motif. However, unlike Seurat, Pissarro chose to show his figures integrated into their landscape. The expressive possibilities of a single figure must have been brought home to Seurat by the work of Puvis de Chavannes, and particularly his *Poor Fisherman* (Louvre, Paris), which Seurat copied when he saw it at the Paris Salon in 1881. Another important influence, however, may be that of Bastien-Lepage. While it is unlikely that Seurat could have seen Bastien-Lepage's *Poor Fauvette* (cat.1) in Paris, he may well have seen it on exhibition in England where he was a regular visitor. Might it be possible that Seurat's boy, like Bastien's girl, is a cowherd?[1]

From its size alone we know that this work would have been painted in the studio from studies made outside from nature. If we compare its technique with that of *The Riverbanks* (cat.51), we can see how much Seurat's technique has developed in just a short space of time. Influenced by his readings on colour theory in the books of Ogden Rood and Chevreuil, there is now a more deliberate application of colour – the grass may still be green, but now he uses touches of yellow and orange to suggest the sunlight and darker tones of blues and mauves to indicate the shadows. There is a deliberate use of contrasting tones, the bright yellow of the field against the purplish-green of the boy, and quick, flickering notes of mauve and orange bringing out subsidiary contrasts. Also the texture of the brushstrokes marks a new development. Here there is a more consistent use of the criss-cross pattern of brushstrokes, known as *balayé*, from the French verb *balayer*, meaning to sweep.

It was Seurat's friend, the writer and dealer Felix Fénéon who noted that it may be the same boy who appears in the *Young Peasant in Blue*, 1881–82 (cat.52.1). But the painting illustrated here is most closely related to the smaller and slightly later *Woman Seated on Grass*, 1883, (Guggenheim Museum, New York) in which a young girl again is placed to one side of a simple grass background. Both figures are remote, seated, impassive, without facial features or expression and their situations are unknown.

It has been suggested that both paintings, as they were never shown in the artist's lifetime, were experiments for his first major figure compositions, *Bathers at Asnières*, 1884 (cat 51.1) and *A Sunday Afternoon on the Island of La Grande Jatte, 1884*, 1884–86 (ill.4). Although it is difficult to be certain, the solitariness of this seated boy does seem to prefigure the main figure in *Bathers at Asnières* and similar figures in *A Sunday Afternoon on the Island of La Grande Jatte*.[2]

52.1
Georges Seurat
Young Peasant in Blue, 1881–82
Oil on canvas, 46 × 38cm
Musée d'Orsay, Paris

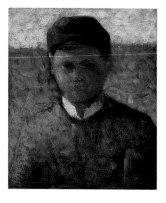

[1] This was first suggested by John House in his entry on the painting in the exhibition catalogue *Post-Impressionism, Cross-Currents in European Painting*, Royal Academy of Arts, London, 1974, n.195, p.131.
[2] As proposed by Richard Thomson in *Seurat*, Oxford, 1985, p.48.

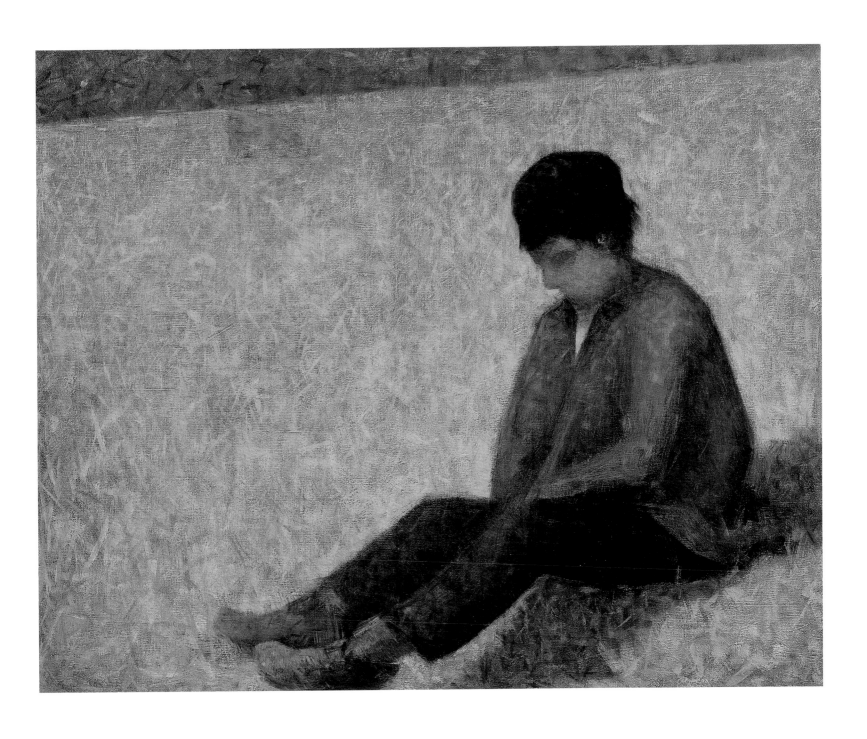

Catalogue 53

Georges Seurat (Paris, 1859–91, Paris)
*House Among Trees, c.*1883

Oil on wooden panel

15.7 × 25.1cm

Seurat's approach to nature was entirely unlike that of the Impressionists. Although he shared Monet's and Renoir's enthusiasm for colour, he was not interested in capturing ephemeral effects of nature, but rather in portraying something more permanent. Where Monet and Renoir chose to paint picturesque scenes on the banks of the river Seine and Pissarro painted the life of rural villages, Seurat's small suburban views, like this group of isolated houses, reveal his interest in the ordinary. He includes none of the anecdotal details, the human figures and animals, that animate Impressionist landscapes. Instead, he concentrates on using the forms in the landscape, the houses, walls and trees, to structure a strong composition made up of horizontals, verticals and right angles. The lessons he learnt from his many *conté* drawings about the massing of forms and how to balance light against deep shadow also find a place here.

The sense of discipline displayed in this tiny work is seen too in the artist's controlled handling of paint. Here Seurat's more consistent use of the criss-cross, *balayé*, brushstroke suggests that a date of 1883 is likely. These criss-crossing brushstrokes create a texture that helps unify the whole picture surface. Although less pronounced in the sky and on the white walls, they can be seen in the grass, the bushes and in the trees. The range of Seurat's palette is also greater than in the earlier *The Riverbanks* (cat.51). Here Seurat experiments with small, separate touches of colour, using violet in the shadows and playing complementary notes of orange and blue against each other.

Like *The Riverbanks*, this fresh and lively oil sketch was probably painted outside using *une boîte à pouce*. Although a considerable amount of warm-coloured wooden panel still shows through, the work has a more highly finished appearance. Painting outside on to small wooden panels like this was very much a part of the French landscape tradition. However, while artists like Diaz and Rousseau considered such paintings as sketches that could serve as 'notes' when working in the studio, an artist like Boudin was quite prepared – having applied some final touches to the work in the studio – to consider it as a work worthy of exhibition and sale (cat.5). Although we cannot know what Seurat thought of this particular work, it is unlikely he would have considered it fit for exhibition.

This small landscape is undoubtedly a record of one of Seurat's painting excursions – but where to? It is perhaps the village of Le Raincy, just south of Paris, where Seurat's father lived. Many aspects of the composition, however, in particular the low houses and the trees, are reminiscent of Seurat's *White House, Ville d'Avray* of 1882–83 (Walker Art Gallery, Liverpool). Indeed the very simplicity of the painting and its silence, the whole animated only by light, is reminiscent of Corot's atmospheric landscapes of Ville d'Avray.

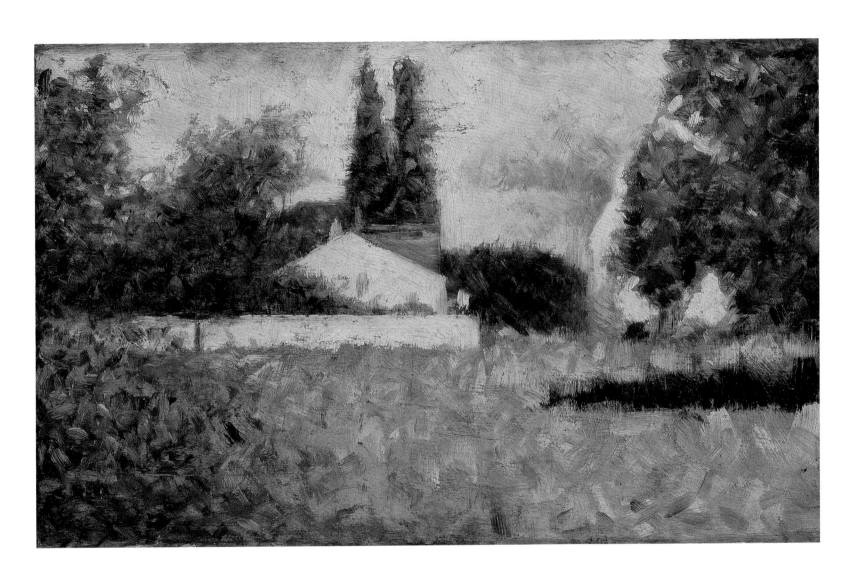

Catalogue 54
Paul Signac (Paris, 1863–1935, Paris)
Coal Crane, Clichy, 1884

Oil on canvas

59.3 × 91.8cm

Largely self-taught, Signac was initially inspired by the work of the Impressionists. It was his visit to an exhibition of the paintings of Monet, held in the offices of *La Vie Moderne* in June 1880, which had set him on a career as a painter. Until 1885, Signac's work was Impressionist both in choice of subject and in style, but under the influence of Guillaumin, Pissarro and, more importantly, Georges Seurat, his style changed.

In 1884, Signac participated in the first Salon des Artistes Indépendants, and it was here that he met Seurat. Seurat's recently completed *Bathers at Asnières* 1884 (cat.51.1) was a revelation to him. Realising that Seurat clearly understood the laws of colour contrast, Signac began to study colour theory for himself, even visiting the great theorist Chevreuil at the Gobelins tapestry factory in 1884. Colour theory and the laws of optics underpin the Neo-Impressionist style which Seurat and Signac developed. After his meeting with Seurat, Signac gradually moved away from Impressionism. *Coal Crane, Clichy* is a transitional work.

The banks of the river Seine were to inspire many of Signac's paintings, drawings and watercolours. The Signac family lived beside the Seine in Asnières, a new residential suburb of Paris. On the opposite side of the river lay Clichy with its factories, coal cranes and gastanks. Here Signac chooses an industrial motif, a steam-driven crane seen in operation, swinging round to lower a heavy load on to a wide, flat-bottomed barge. Tiny figures, barely visible, attend the machinery but they are insignificant, dwarfed by the gantry and the bridge behind. In the foreground, Signac uses short individual brushstrokes of bright colour carefully applied one beside the other. While the heightened colours of the resulting mosaic-like pattern show the influence of Guillaumin on the young Signac,[1] they also hint at the Divisionist or Pointillist technique that Seurat and Signac would later develop. These brush-strokes are quite different from the freer, loose strokes in the trees and sky.

Signac is not afraid to experiment with strong contrasts of colour. The strident yellowish-orange trees on the far bank are like burning bushes, their flames barely held in check by the deep green of the three central trees. The warm natural wood tones of the barges and gantry are picked up in notes of terracotta and pink on the quayside, making the cold grey-blue of the new bridge under construction in the background all the more of an intrusion.

[1] Guillaumin's influence on Signac during this period was strong. See, for example, Guillaumin's *Quai de Bercy, Paris c.*1885, in Ordrupsgaard, Copenhagen.

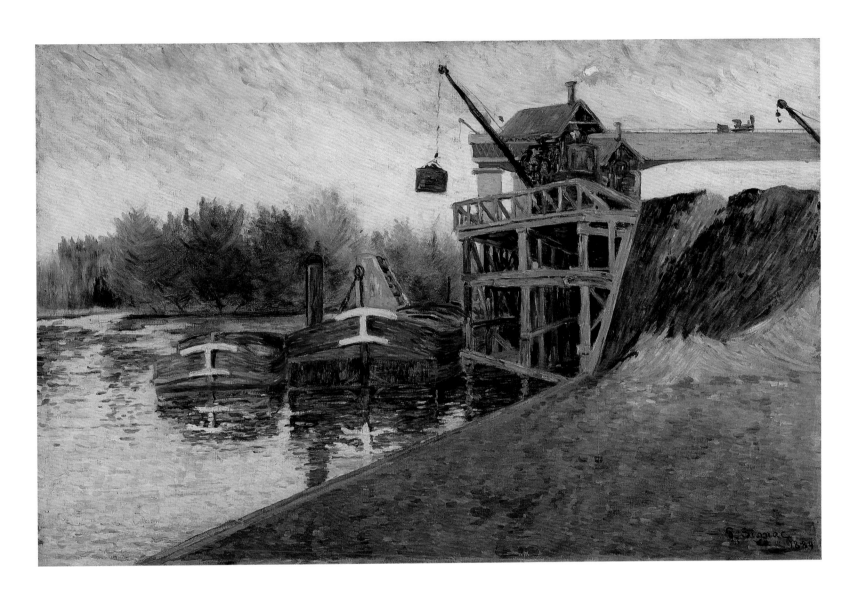

Catalogue 55

Paul Signac (Paris, 1863–1935, Paris)

Sunset, Herblay, Opus 206, 1889

Oil on canvas

57.7 × 90.3cm

It was Signac's friend, the dealer and critic Felix Fénéon, who in September 1886 coined the term Neo-Impressionism to describe the work of Seurat, Signac and their circle. These artists, through the use of a technique known as Divisionism (dubbed Pointillism by the critics), sought an art that was luminous, harmonious, and timeless.

Inspired by the ideas of Charles Blanc who believed that 'colour, which is controlled by fixed laws, can be taught like music', Seurat and Signac studied the theories of various scientific writers including Rude, Helmholtz, Charles Henry and Chevreuil. Chevreuil, the director of the dyeing department at the Gobelin tapestry factory in Paris, had demonstrated that the appearance of a colour is influenced and modified by those around it. If individual strokes of colour are juxtaposed with their complementary, the resulting colour will appear more intense than if it had been achieved by traditional mixing on the palette. The rich, atmospheric glow of *Sunset, Herblay, Opus 206,* is achieved by the carefully controlled contrast of the complementaries blue and orange. In a measured transition, Signac moves from the pale blue of the wide sky to the strident orange tones of the sunset on the long horizon, to the groups of green trees lit by notes of blue, to the reflected orange of the sunset pierced by the darker tones of the reflected trees, to the gentle blue ripples of the river in the immediate foreground. More interested in capturing a particular quality of light than in investigating the scientific properties of colour, Signac no longer applies the pointillist technique in a rigid way. He prefers instead to use a varied surface of dabs and patches.

Signac had been attracted to Herblay, a village on the river Seine some 20 kilometres north-west of Paris, by his love of sailing. *Sunset, Herblay, Opus 206,* was painted during his visit in September 1889 and may have been finished on a return visit the following year.[1] While Signac would doubtless have studied the sunset from a boat in midstream, it is likely that the painting was worked on in the studio. The composition is simple, with the wooded island in the centre balanced by the trees that line the riverbanks to either side. The horizon, which is almost in the middle of the canvas, and the trees and sky are reflected almost symmetrically in the water. Signac has inscribed *Opus 206* in the lower right-hand corner. For a period up to 1894 he numbered his paintings in the manner of musical compositions, believing that his method of painting, combining colours that were divided and then harmonized, was like musical composition.

When Signac exhibited *Sunset, Herblay, Opus 206* with three other Herblay paintings under the title *Le Fleuve* (*The River*) at both Les XX in Brussels and the Paris Indépendants in 1891, the critical reaction was mixed. While some critics complained that the pointillist technique subordinated the richness of the local tone for the sake of overall luminosity, others – acknowledging his 'cleverness' – accused him of lacking sensitivity. The critic of *La Revue Blanche* complained that Signac's views were of a frustrating uniformity and that 'at a certain distance these paintings look completely white.' Pissarro, who saw the exhibition at the Indépendants, wrote to Lucien that while Signac's landscapes were 'very correct, very well executed', they were 'cold and monotonous'.[2]

[1] There is a small oil sketch on wood that relates to our painting in the Cachin-Signac collection; a sketch is with the Schmit gallery in Paris; a fan painted in 1892 repeats the subject.

[2] In a letter to his son Lucien of 30 March 1891, in John Rewald (ed), *Camille Pissarro, Letters to His Son Lucien*, Santa Barbara, 1972, p.192.

Catalogue 56

Alfred Sisley (Paris, 1839–99, Moret-sur-Loing)
Boatyard at Saint-Mammès, c.1886

Oil on canvas
38.8 × 56.0cm

By 1880 the Impressionist painters had reached a crisis about how their art should develop. It was Sisley who remained true to the Impressionist ideals of recording light, colour and atmosphere, and of painting outside directly from the motif. Sisley left Paris and chose to paint in and around the barge-port of Saint-Mammès, situated at the confluence of the River Loing with the Seine. He painted more than one hundred pictures of the village, in all but one of which the river is included.

As far as is known Sisley never actually lived at Saint-Mammès. Throughout the 1880s, though, it would have been easy for him to work there, as he lived nearby, staying first at Veneux-Nadon, then at Moret and, from 1883 to 1889 at Les Sablons. As one of his favourite motifs was that of riverbanks, it is not surprising that boatyards appear regularly in his paintings. He painted several views of this timber- and boatyard in 1880, and three other paintings of the subject are dated 1885.[1] The view chosen in this undated picture differs from all of these, but the confident brushwork and the range of colour suggest that it probably dates from around 1886.

In the foreground we see a boatyard and can just make out a large brown barge making its way down the river. Sisley rarely makes the activity of work the subject of his landscapes. Instead – as here – he captures the homely quality of the scene, enlivening it by including some tiny figures. With just a few quick strokes of paint he manages to describe one figure, wearing a blue top, standing with his hands in his pockets and looking out over the river. Two other figures stand talking beside a shed. Another figure does indeed seem to be working – he is perched some four feet off the ground, on top of various planks of timber.

Sisley never intended his paintings to have any meaning beyond what they are – landscapes. Indeed, the influential English art critic Roger Fry described Sisley as an artist of 'pure sensibility'. Another critic, Adolphe Tavernier, speaking at Sisley's funeral, referred to him as 'a magician of light, a poet of the heavens, of the waters, of the trees – in a word one of the most remarkable landscapists of his day.'[2]

While his father was alive Sisley had few financial troubles, but after 1870 he was forced to make a living from his art and was never free of financial hardship. Unlike the works of his Impressionist friends Monet, Renoir, Degas and Pissarro, Sisley's paintings did not increase in value during his lifetime, although immediately after his death their prices rose dramatically. *Boatyard at Saint-Mammès* belonged previously to two important early collectors of Sisley's paintings. François Depeaux (1853–1920) formed the largest single collection, owning some fifty works by the artist. Monet, Sisley and Pissarro, amongst others, regularly visited Depeaux at his home in Rouen, Normandy. Included in the Depeaux sale at the Galerie Georges Petit in Paris from 31 May–1 June 1906 this work, lot 43, sold for 2,350 French francs. It then entered the collection of Léon Orosdi of Paris. Orosdi's collection included works by Monet, Boudin and Renoir. Twenty-two works by Sisley were sold from his collection after his death in 1923.

[1] As noted by Ronald Pickvance in the exhibition catalogue *Alfred Sisley (1839–99), Impressionist Landscapes*, n.9, p.28; see F. Daulte, *Alfred Sisley: catalogue raisonné de l'oeuvre peint*, Lausanne, 1959, nos.368–72 and Daulte nos.484, 577, 579.
[2] Quoted in B.Bibb, 'The Work of Alfred Sisley', *The Studio*, vol.XVIII, 1900, p.149.

Catalogue 57

Alfred Sisley (Paris, 1839–99, Moret-sur-Loing)
*Village Street, Moret-sur-Loing, c.*1894

Oil on canvas
38.4 × 46.1cm

Sisley settled in the picturesque medieval town of Moret-sur-Loing in 1889. Situated on the opposite bank of the river Loing from Saint-Mammès, Moret provided Sisley, throughout the 1890s, with a wealth of motifs – from its stone bridge, mill and Gothic church to its busy riverside. Sisley's thoughts on the town are recorded in a letter to Monet who was searching for somewhere outside Paris to settle, 'the countryside's not bad – a bit pretty pretty – as you no doubt remember. . . . Moret is two hours from Paris, with plenty of houses to rent from 600–1000 francs. There's a market, once a week, very pretty church, quite picturesque scenery . . .'.[1]

Very few of his paintings are of the streets in the town itself. Although it is not easy to identify the particular square in this quiet and unassuming work, it may be the Place de Samois with the Porte de Samois just out of the picture to the left. Like many of Sisley's late paintings, *Village Street* would have been painted rapidly in one sitting – *alla prima*. It is this that gives the painting its marvellous feeling of immediacy and vibrancy. Between the hasty broad brushstrokes in the sky there are many areas of bare canvas. His brush heavily loaded with paint, Sisley uses rapid, broad, free strokes and strong vibrant colours to indicate sky, buildings and vegetation. Typically, a few hasty strokes suggest the presence of villagers – under the trees and moving up the street to the right – added by the artist to suggest scale and to humanise the scene. Sisley builds up his composition by playing horizontals against verticals – here the trees and the line of roofs are set against the diagonal of the village street disappearing between the rows of buildings to the right. The predominant mauve and violet tones are set off by surprisingly strong notes of green, yellow and burgundy, and by the heavy brown brushstrokes Sisley uses to outline the forms of buildings and of the trees.

About the time this work was painted, the English critic and novelist George Moore compared the work of Sisley and Monet: 'Sisley is less decorative, less on the surface, and although he follows Monet in pursuit of colour, nature is, perhaps on account of his English origin, something more to him than a brilliant appearance. It has of course happened to Monet to set his easel before the suburban atmosphere that Sisley loves, but he has always treated it rather in the decorative spirit than in the meditative spirit. He has never been touched by the humility of a lane's end, and the sentiments of the humble life that collects there has never appeared on the canvas. Yet Sisley, being more in sympathy with such nature, has often been able to produce a much superior, though much less pretentious picture than the ordinary stereotyped Monet.'[2]

[1] Sisley's letter to Monet of September 1882 is quoted in the exhibition catalogue *Alfred Sisley*, Royal Academy of Arts, London, 1992, p.184.
[2] George Moore in 1893, quoted in Nicholas Wadley's essay on Sisley in the *Royal Academy Magazine*, summer 1992, n.35, p.29.

Catalogue 58

Maurice Utrillo (Paris, 1883–1955, Dax, Landes)

Village Street, Auvers-sur-Oise, c.1912

Oil on canvas

59.5 × 73.0cm

This early work, from what is known as Utrillo's *manière blanche* (white period), was painted when the artist was at the peak of his creativity. This wintry scene has a poetic and evocative power through which Utrillo expresses his feeling of loneliness and melancholy at the passing of time.

The focal point of the composition is the belfry of the Romanesque church rising above the narrow street. Throughout his long career, Utrillo painted several hundred views of churches, from the great thirteenth-century Gothic cathedrals to small modern village chapels. Although in early life religion was unimportant to him, in his last decades he divided his days between painting and prayer, even having a small chapel installed in his house in Le Vésinet. The local curate said of Utrillo that he had 'a beautiful soul, imprisoned in a weak body. His faith was that of a child.'[1]

From a viewpoint on street level we are led up past variously angled whitewashed houses that abut medieval fortifications – the ramparts in the foreground and the round watchtower further uphill. The warm red of the roof at the far corner of the street is played off against the cold whites of the light buildings, the greens and blues of the window shutters and against the pale blue of the cloudy sky. But it is the many-angled walls that give the painting its power and resonance. The mouldering quality of the varied whites suggests the decay of the ageing walls, their blistering and bleakness recording the passing of time. The dark wall surfaces in the foreground, built up by layers of paint applied variously by scumbling with a palette knife and etched with the point of his brush, have a patina that implies centuries of scratches, cracks and graffiti.

Village Street was included in Utrillo's first one-man exhibition at the Galerie Eugène Blot in Paris in 1913. It was one of thirty-one works on display, but the show attracted little attention, and only two paintings sold. In his introductory essay to the catalogue, Utrillo's friend and dealer Louis Libaude described how Utrillo 'plays with the whites of the plaster of the most humble houses as he might on a keyboard . . . Before a wall that leaves the passer-by indifferent, Utrillo stops, contemplates the play of colour in its splotches, notes them in his mind, and paints it. This wall interests him as much as the marvellous, barely perceptible clouds that he scatters in the soft sky . . .'.[2] Surely Utrillo's genius lies in having us see something we may not otherwise have noticed?

How and where did Utrillo work? Although this view is reasonably realistic in appearance, the artist has clearly spent hours layering the walls. This alerts us to the fact that this painting could not have been painted outside from nature. While Utrillo may well have made a quick sketch on the spot, he preferred to paint indoors, avoiding the stares of passers-by. He painted in the studio using a combination of picture postcards, photographs, sketches and memory. Sometimes the postcards were so old that the scene had changed, but this never bothered him!

Utrillo himself was infamous for his bohemian lifestyle; yet there was a great disparity between his life and work. 'The paintings, with their luminous quietude, their air of strength and sadness, their hushed serenity, are worlds removed from the disorderly existence – punctuated by periods in institutions and in jail – of the man who created them . . . The society folk who in the 1920s bought Utrillo's pictures for 50,000 francs or more would have been horrified had he himself appeared in their salons – a gaunt, unkempt, Don Quixote-like figure, carelessly dressed, with bloodshot eyes and with the unpleasant raucous voice of the dipsomaniac.'[3]

[1] Alfred Werner, *Maurice Utrillo*, New York, 1981, p.86.
[2] *Ibid.*, p.102 and p.124.
[3] *Ibid.*, p.11.

Catalogue 59

Maurice de Vlaminck (Paris, 1876–1958, Rueil-La-Gadelière)

Woody River Scene, after 1927

Oil on canvas

46.5 × 55.2cm

Vlaminck's rebellious temperament made him one of the most notorious of the Fauves. With Derain and Matisse he participated in the controversial show at the Salon d'Automne in 1905, when the term Fauve was first applied to their dynamic canvases of bold colour, applied in a spontaneous, even violent manner. Never interested in artistic conventions or theories, Vlaminck believed that painting should be instinctive, saying that for him it was a safety valve: 'I paint in order to clarify my thoughts, to assuage my desires, and above all to acquire a little purity.'

Vlaminck loved nature passionately and declared that he hated 'the scientific barbarity of the civilised human species.'[1] Attracted by the idea of living close to unspoilt nature, in 1925 he bought La Tourillière, a house in the country, situated near the village of Rueil-la-Gadalière, in the Eure-et-Loir district. It is possible that this landscape was painted in this area.

For all his purported defiance of convention, this painting is classically composed. The trees in the foreground frame the scene, a view over a river or lake to a cluster of buildings. Like Cézanne, whom he greatly admired, Vlaminck has built up a well-balanced and structured composition using the inherent geometry of the landscape elements. While the scene is quite realistically observed, it is Vlaminck's use of black and dark blues contrasted with the stark, cold white – as highlights on the tree trunks, as clouds in the wet and stormy sky and as reflections of cloud and of buildings in the flat calm of the river – and the expressive energy of his brushstrokes that combine to give this painting a simultaneous passion, energy and restraint.

As is typical of Vlaminck he uncovers the bold and dramatic aspect of the landscape, creating a feeling of movement and suggesting a poetic power. How is this achieved? The sheer energy of his creativeness is seen in the striations made with the end of his brush in the white highlights on the trees, in the thickly applied impasto, in the sheer slabs of paint that suggest the structure of the buildings and in the varied calligraphic strokes that represent the foliage. Vlaminck creates a mood – but what is it? Anguish? Brooding? The promise of the calm after a storm or the uneasy calm before a storm?

From Vlaminck's extensive writings it is clear that he could be a prickly person to deal with. Indeed, the curatorial staff of the museum were to learn this at first hand. After the painting's purchase in early 1958, the curator, in an effort to learn more about the work, wrote to Vlaminck asking for particular details about the painting: its date, title, the place it was painted, if it was painted in the studio or from nature, when it was first exhibited and who was the first owner. The letter was accompanied by a photograph of the work. The painting's authenticity was not in question. Vlaminck's hasty reply was that he could not do an authentication from a photograph. Avoiding answering any of the other questions, he said only that he did not know where the work had been painted. It seems that Vlaminck had doubts that the work was from his own hand and advised his Paris gallery that the painting should be sent over for his inspection. In May the museum sent the painting to the Galerie Charpentier in Paris 'for expert investigation of authenticity and location'. The museum then received a telegram from the director of the gallery, Raymond Nacenta, saying he had shown the work to Vlaminck who confirmed that it was 'a terrible fake'! Nacenta's telegram urged the museum to authorise that the police seize the work for investigation. The panicking curator hastily organised the immediate return of the work to Glasgow. As the museum authorities had never doubted the authenticity of the painting, the news must have come as a devastating shock and they sought the advice of the dealers through whom the work had been purchased. The dealer calmly pointed out that the 'fact that Vlaminck has disavowed the picture you have bought is no isolated case, in fact he is known to have done so in quite a number of cases without rhyme or reason.'[2] Today we have no reason to doubt that the painting is anything other than authentic.

[1] Jean Selz, *Vlaminck*, Bonfini Press, nd., p.59.
[2] From correspondence in the museum archives.

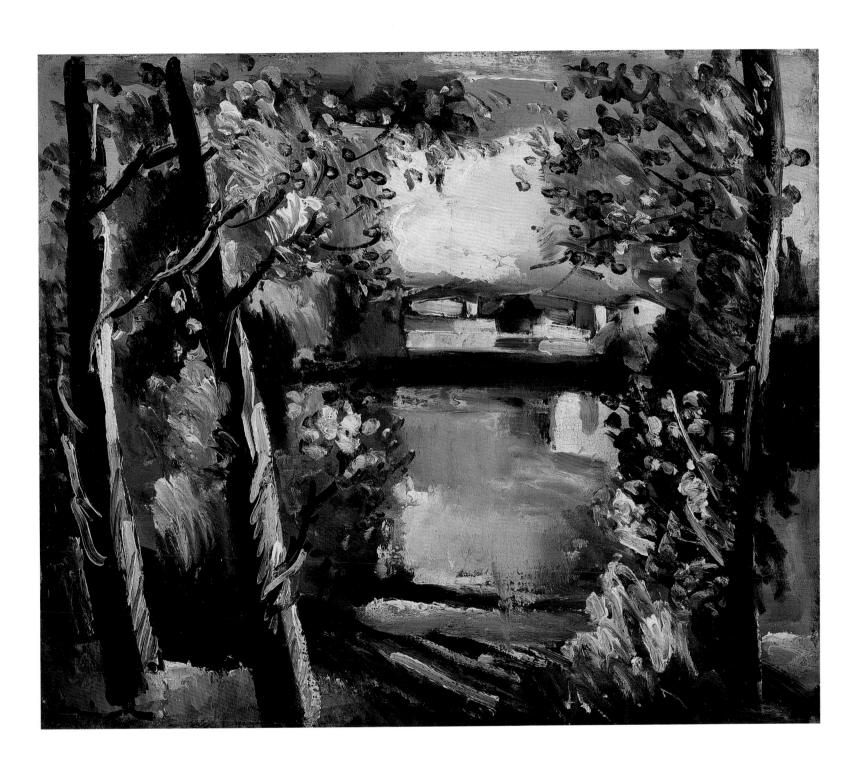

Catalogue 60

Antoine Vollon (Lyon, 1833–1900, Paris)
A Corner of the Louvre, c.1872–85

Oil on wooden panel

32.0 × 40.4cm

Although Vollon is famous as a painter of still-lifes, he also painted landscapes, seascapes and cityscapes. Many of these paintings, like *A Corner of the Louvre*, reflect his growing interest in the work of the Barbizon artists and in Impressionism.[1]

It is a grey, rainy day and crowds of hurrying pedestrians, umbrellas held high, bustle across the Pont Royal. Vollon suggests their gestures with hasty, fluid, strokes of paint. The solid, blond stone structure of the Pavillon de Flore of the Louvre is set against the deep dark green of a corner of the Tuileries Gardens. In the distance we see the apartments of the Rue de Rivoli but the river Seine, immediately below us, is hidden from view.

One of the most successful painters of his generation, Vollon is usually classed as a Pre-Impressionist. In common with his artist friends Daubigny and Boudin he worked through the innovations of Impressionism, but while adopting their brushstrokes and speed of observation he, like Daubigny and Boudin, never used reflected light, preferring colours that were darker and more dull. The spontaneity of Vollon's technique is seen here in his juicy handling of thick paint. While it is obvious that this painting was executed quickly, it is possible that it was done either outside from nature – it is a small oil on panel – or from a window on the left bank of the Seine.

When Vollon died in August 1900 numerous artists and critics attended his funeral at the Père Lachaise cemetery in Paris. The critic Arsène Alexandre, reviewing Vollon's career, wrote: 'M. Vollon was above all a popular painter. The public gathered in throngs before his paintings at the Salon, since the artist managed to achieve a successful composition solely through the vigour and the depth of his execution. As a "painter of objects", M. Vollon had few rivals among the Establishment artists. His talent, marked by a rare candour and much good humour, involved no ambiguity whatsoever . . .'.[2]

This painting was gifted to Glasgow Museums by Sir John Richmond who also gave Pissarro's *Tuileries Gardens* (cat.45) which shows the view from the other side of the Louvre.

[1] The author is grateful to Carol Forman Tabler for her advice on the dating of this work.
[2] Quoted in Gabriel P. Weisberg, 'A Still-Life by Antoine Vollon, Painter of Two Traditions', *Bulletin of The Detroit Institute of Arts*, vol.56, n.4, 1978, p.223.

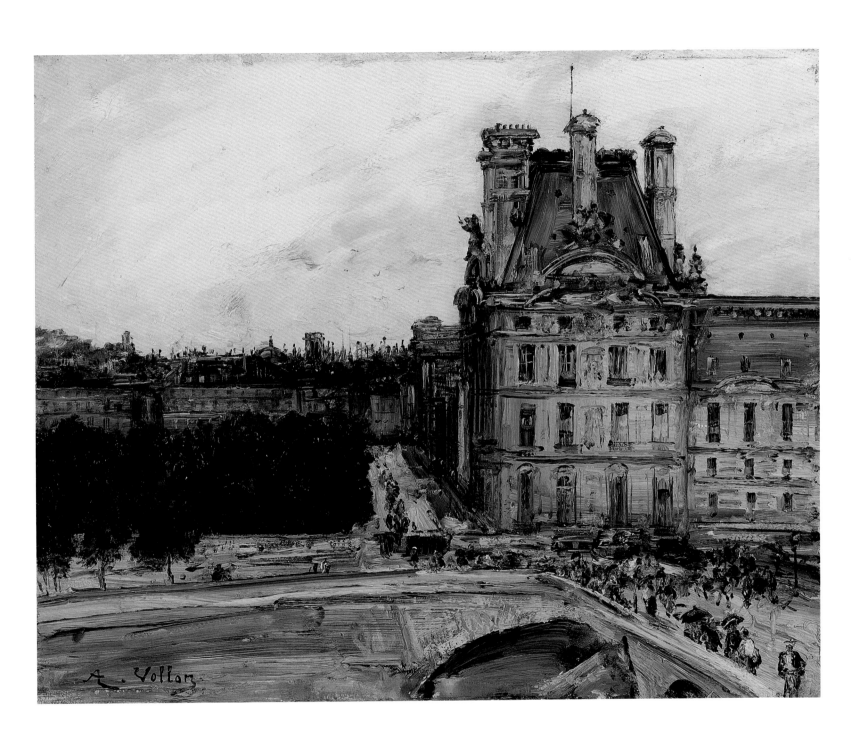

Catalogue 61

Edouard Vuillard (Cuiseaux, 1868–1940, La Baule)
*Woman in Blue with Child, c.*1899

Oil on cardboard, set in to a secondary wooden support and cradle
48.6 × 56.6cm

Until recently this painting was known as *Mother and Child*. It was originally believed to show Vuillard's sister Marie – the wife of his artist friend Ker-Xavier Roussel – and their baby daughter.[1] It was Antoine Salomon, Roussel's grandson, who pointed out that the woman in the painting is Vuillard's muse, the pianist, Misia Natanson (née Godebska). The baby she holds, at arms' length and so strangely aloft, is her half-brother Cipa's first child, Mimi Godebska, who was born in 1899. This claustrophobic room, a riot of floral patterns, was in the Natanson's Parisian apartment on the Rue Saint-Florentin.

We know from Vuillard's journal that he considered the 'subject of any work' to be 'an emotion simple and natural to the author.'[2] Did Vuillard intend that a viewer discover the identity of this woman who, seen from behind, wearing a large shapeless blue smock, we now know to have been thrice-married but never a mother herself? Does this information change our reading of the picture? Is it wrong to read it as a modern-day Madonna and Child? Is it just a homely family scene?[3]

Drawn into the painting by rich colour and by a profusion of surfaces and textures, the viewer is presented with a roomful of puzzles. There are numerous ambiguities of form and space: is that a dog, or a dog and a cat behind Misia on the *chaise longue*? Is that a standard lamp in the lower right foreground or is it part of the mantelpiece? Just as with a Renaissance Madonna and Child, while we are drawn into the painting something keeps us at a distance. Is it an emotional distance? This sense of detachment may partly be explained by Vuillard's use of photography. Having purchased his first Kodak box camera in 1897, Vuillard used it constantly, keeping it to hand and often hitting the button without even checking through the viewfinder.[4] This encouraged him to compose his works differently; as Edmond Duranty had written, if someone happens to be far over to one side of a room then why not paint them that way?

While Vuillard's use of photographs as *aides-mémoires* encouraged a sense of spontaneity, a seemingly haphazard use of asymmetry and cut-offs, Vuillard did rigorously compose his paintings, his photographs never being something he slavishly copied. *Woman in Blue with Child* relates directly to a photograph of Misia, in the same apartment, taken by Vuillard in 1898. She sits on the same *chaise longue* with the same folding screen behind her. There is the same riot of pattern and even the same tall plant-stand which, in the painting, is cropped at the extreme left edge. But the differences are many and the photograph is not a study for the painting – as Vuillard noted in his journal, unlike a photograph a painting has an expressive power. *Woman in Blue with Child* can also be seen in a photograph of the Natanson country home at Villeneuve-sur-Yonne, where it is part of the over-mantel.[3]

It was probably Thadée Natanson who wrote about *Woman in Blue* in the auction catalogue in 1908. He clearly considered it to be one of the gems of his collection: 'The frame holds in sufficient accentuated elements and enough invented relationships to enliven ten pictures or an important decoration. Only oriental carpets manage to weave together as many strident ideas and balance them in such a confined space. The reds are the only linking theme. The most strident chord is struck by a blue and a soft green which is set against a golden yellow, a dominant black and muted reds.'[5]

[1] The framed painting on the wall, above the woman's head, is by Roussel.
[2] Quoted in E. Easton's *Intimate Interiors of Vuillard*, 1989, p.19 from his journal, carnet 2, p.30 verso, March 1891.
[3] See Eik Kahng, 'Staged Moments in the Art of Edouard Vuillard', in *The Artist and the Camera, Degas to Picasso*, San Francisco-Dallas-Bilbao, 1999–2000, pp.253–63. When Thadée Natanson sold the painting in 1908 his former wife's name was not mentioned, the catalogue listing the painting as *Woman in Blue with Child*. Both photographs are illustrated in this essay.
[4] See J. Salomon and A. Vaillant, 'Vuillard et son Kodak', *L'Oeil*, 100, April 1963, p.2.
[5] Quoted in Belinda Thomson, *Vuillard*, Oxford,1988, p.68.

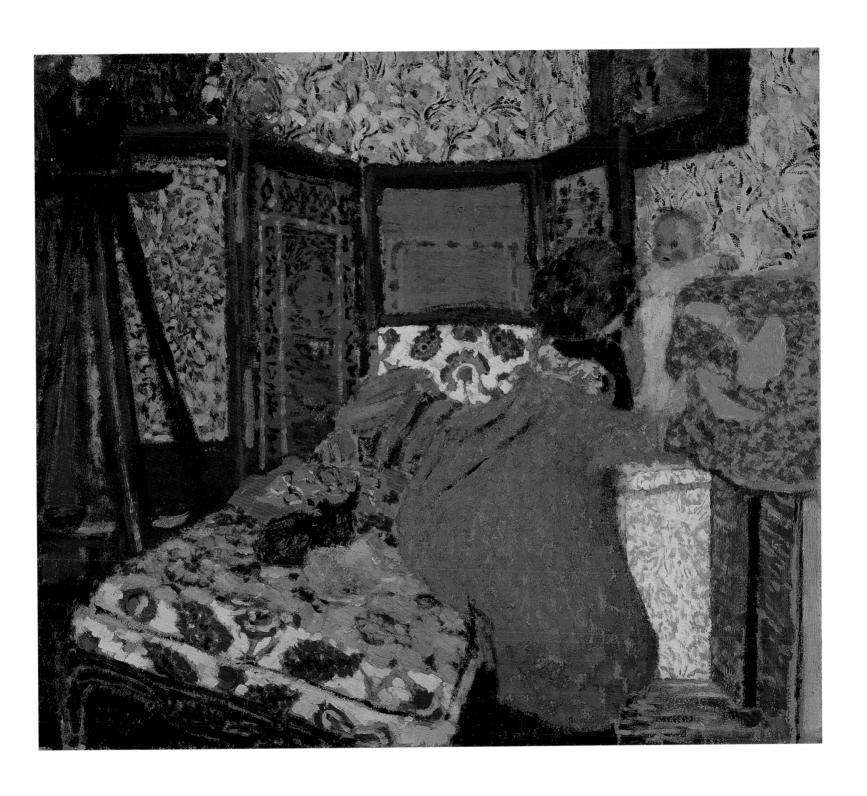

Edouard Vuillard (Cuiseaux, 1868–1940, La Baule)

Interior – The Drawing Room, 1901

Oil on cardboard, set in to a secondary wooden support and cradle

35.5 × 53.7cm

Vuillard's decorative domestic interiors tell us much about the lifestyles of his small circle of artist, dealer and writer friends and their families. In this enchanting oil, a symphony in warm pinks and soft greens, he shows the evident fascination of a crawling child discovering a luxurious Parisian drawing room, normally the domain of adults. Rather than sitting on the floor with the child and looking up, Vuillard looks down at the baby recording what it can see – a veritable forest of wooden legs of tables, chairs and sofas. The rich fabrics of the room nearly engulf the tiny child, whose small rounded form is echoed in the curvaceous arms of the plush, gold-trimmed velvet chairs. The luxuriously rich Aubusson rugs that run the entire length of the room mark the progress of the child past the formally arranged furniture.

Without a hint of sentimentality Vuillard captures the lively and natural movement of the child, who, stopping suddenly, is caught in a pool of light from a window off to the left. Carefully balancing on both hands, the child looks up open-mouthed at the artist who has disturbed his adventure and who now watches him intently with the composition of a painting in mind.

Antoine Salomon, the grandson of Vuillard's brother-in-law (the artist Ker-Xavier Roussel) and a great authority on Vuillard's life and work, has identified the child as Michel, the son of Georges Feydeau (1862–1921), the famous *farceur* and vaudeville celebrity. A great lover of art, Georges Feydeau was a regular client of the Bernheim-Jeune gallery and formed a collection which, when sold in February 1901, included works by Corot, Courbet, Daumier, Boudin, Cézanne, Monet, Pissarro, Renoir, and Sisley. After the sale he immediately began to form a new collection. Daily, in the late afternoon, he would pop in to the Bernheim-Jeune gallery in the Rue Laffitte for a chat with Félix Fénéon.

It was just at this time that Vuillard, who would have met Feydeau through his close friends the Hessels, painted an informal portrait of Feydeau and his wife in the same drawing room (Private collection).[1] While it is possible that Feydeau commissioned the present work, it is equally possible that the artist simply chose to record a scene that he had witnessed. It is perhaps this work Vuillard refers to when, in a letter requesting payment for a recently commissioned portrait, he suggests that Feydeau accept 'the little chap' – 'le petit bonhomme' – instead of 'the woman in red who doesn't much please you.'[2]

[1] There is a study for the Glasgow painting, *Child on a Carpet*, owned by Mrs John Wintersteen, of Villanova, Pennsylvania.
[2] From a letter to Georges Feydeau, 24 January 1902, in the archive of A. Salomon. Quoted in Belinda Thomson, *Edouard Vuillard*, 1991, p.58.

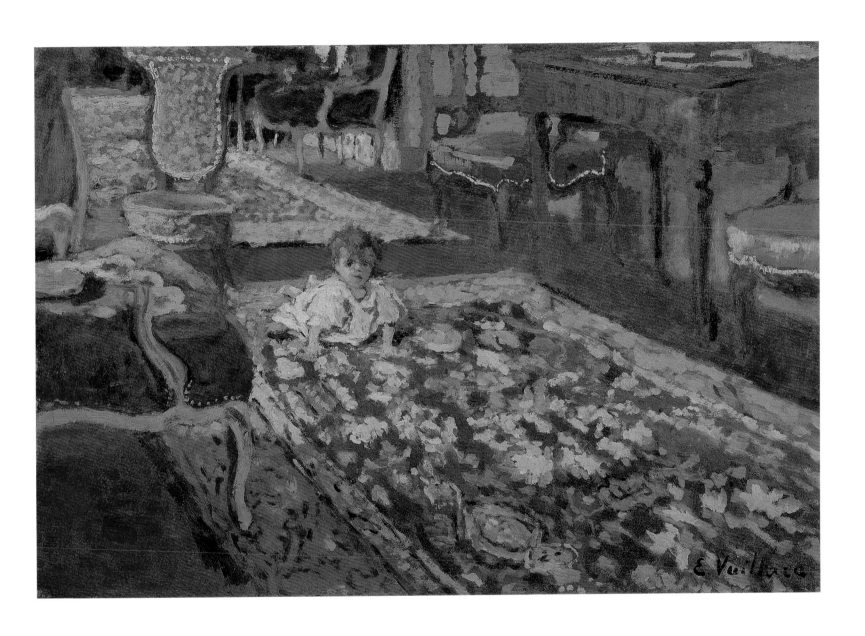

Catalogue 63

Edouard Vuillard (Cuiseaux, 1868–1940, La Baule)
The Table, 1902

Oil on cardboard

25.5 × 34.7cm

This tiny painting once formed part of the private collection of the art dealer Jos Hessel. Hessel worked for the Parisian dealers Bernheim-Jeune, and from a record in their stock-books we know that he sold the painting to them in March 1919. The Hessels were close friends of Vuillard and though it is possible that they commissioned or simply purchased the work, Vuillard may have given it to them as a token of his thanks for their ever-generous hospitality.[1]

The Hessel homes and their circle of family and friends were to feature in many of Vuillard's paintings after 1900 – Hessel's wife Lucy is the subject of *The Lady in Green* (cat.64). Although we do not know for certain where this work was painted, it may show the dining room in the Hessels's luxurious Parisian apartment on the Rue de Naples, where they lived from 1909.

Although the Hessels enjoyed a hectic social life, and their Salon was a venue for brilliant evenings with powerful and wealthy financiers and businessmen, this tiny painting records a quiet and unassuming scene of everyday life. Working from a high viewpoint the artist looks down on to the flat surface of a round dining room table over which a woman bends, quietly intent on setting the table or maybe preparing to clear things away. As with so many of Vuillard's intimate interiors, we have to work hard to make out what is in the room. On the table the quick, cream-coloured lines suggest cutlery while the undefined rounded shapes suggest glasses and plates. Just to the right a grey vase holds what seems to be a bouquet of cream and pink flowers. Are they peonies? The round shapes of the blooms are echoed in arabesques throughout the room, from the luscious curves of the plush chairs, through the exuberant detail of a carved buffet to the large lamp suspended above the table. The warm tones of pink and cream are complemented by the areas of buff-coloured card that Vuillard has deliberately allowed to show through. While some areas are thinly painted, the suggested light that floods the room in broad areas of cream is laid on quite thickly.

Of the five Vuillards in the collection of Kelvingrove Art Gallery, four are from the collection of William McInnes. The dealer A.J. McNeill Reid knew McInnes well and described him as having formed his collection over a period of thirty years out of 'a real love of the pictures themselves and of art in general.' McInnes purchased the works not as investments but for the pleasure they gave him. McInnes's home was not large and so on the whole the works he purchased, like these Vuillards, were small.

[1] The author is grateful to Mathias Chivot of the Wildenstein Institute – currently working on Antoine Salomon's forthcoming Vuillard catalogue raisonné – for suggesting the date of this painting.

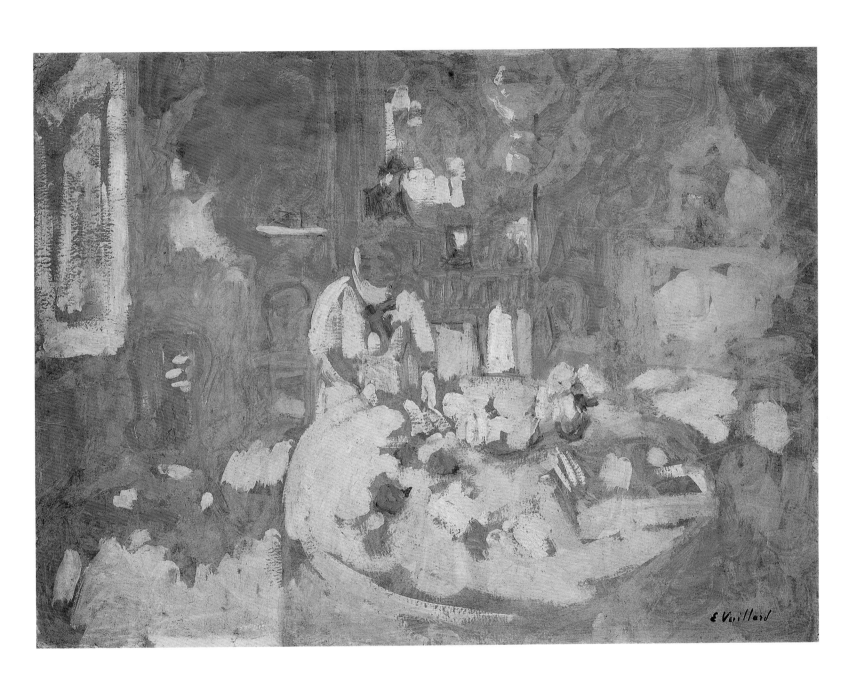

Edouard Vuillard (Cuiseaux, 1868–1940, La Baule)

*Lady in Green, c.*1905

Oil on cardboard

30.1 × 22.7cm

Although Vuillard never married, his close friendships with women were crucial to both his life and art. From his dutiful affection for his mother, to his intimate but platonic friendships first with Misia Natanson and then with Lucy Hessel, these women sustained the reserved artist, inspiring subjects for his paintings and, in the case of Misia and Lucy, providing him with a circle of friends, a busy social life and, importantly, with patronage.

In the corner of what seems to be a warm wooden-panelled room, the full figure of a dark-haired woman, her head supported by the thumb and index finger of her left hand, sits straight-backed, alert and silent. Although she leans slightly towards what may be a fireplace, she doesn't look into it. It seems unlikely that a fire is lit, as a strong bright light highlights the left side of her face and hand, seemingly coming from a window we assume to be out of sight to the right. In the immediate foreground we see the head and shoulders of the back of a seated man, who also seems to inhabit a world of his own.

Although the subject's theme is the quiet and calm of a companionable silence, Vuillard treats it in a lively way, with impastoed strokes of opaque colour, using his fingers and the pointed end of his brush to enliven the surface. As with so many of Vuillard's intimate interiors, this small work is painted on a piece of compressed cardboard. Vuillard has not prepared the board with a ground layer and allows the warm tones of the board to show through as part of the overall design. Although this work has the appearance of a hasty sketch, Vuillard has signed it, in blue, on the lower right edge. This signature, which was more recognizable when the work first entered the museum's collection, is now slowly disappearing.

From her distinctive features we know that this woman is Lucy Hessel. Lucy's friendship with Vuillard lasted some forty years from 1900 and it was she who was with him when he died. As Claude Roger-Marx explained, Lucy was the focus 'of innumerable interiors. Interested in life, greedy of confidences, devoted to her friends, and enterprising as Vuillard was not, she receives the painter every evening about six, does him the honours and keeps him to dinner.'[1]

Lucy was the wife of the Parisian art dealer Jos Hessel whom Vuillard had first met in 1895. Hessel worked for his uncle Alexandre Bernheim. By 1900, Alexandre's sons, Josse and Gaston, had taken over the running of the firm and the gallery, one of the most prominent and successful in Paris, was now known as Bernheim-Jeune. Vuillard was represented by the gallery, first showing his work there in a group exhibition in 1900. Vuillard accepted the Hessels's kindly hospitality in their Paris apartments, delighting at the ever-changing displays of contemporary art on their walls. He also joined them during their summer vacations, and accompanied Lucy – if not her philandering husband – to restaurants, concerts and the theatre.[2]

[1] Claude Roger Marx, *Vuillard, His Life and Work*, London, 1946, p.90
[2] The author is grateful to Mathias Chivot of the Wildenstein Institute – currently working on Antoine Salomon's forthcoming Vuillard catalogue raisonné – for suggesting the date of this painting.

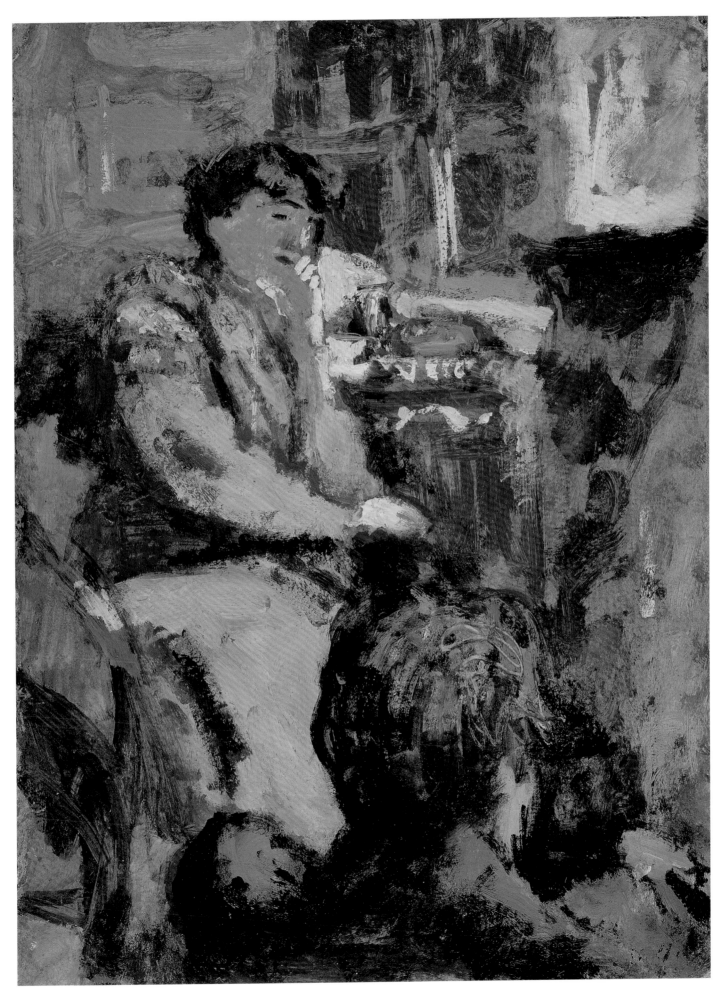

APPENDIX 1
CATALOGUE INFORMATION

The individual catalogue entries bring together what is known about the history of the paintings in the exhibition: from the collectors and dealers through whose hands a work has passed (**provenance**); to the exhibitions in which it has been displayed (**exhibitions**); and the major articles or books in which a work has been discussed and/or illustrated (**literature**).

As a result of recent research a number of the **titles** of the paintings have been revised. The new title is used here and a French title, if one is known, is given in parentheses. Earlier titles, where known, are listed in the provenance, exhibition and literature sections to facilitate future research. The **dating** of a number of the works is also open to discussion and details of earlier opinions are also given here.

Dimensions: height and then width.

Registration Number: the two, three or four digit number given before provenance is the unique identification number allocated to the painting by the museum. Any enquiries about a particular painting should include reference to this number.

Provenance: if a painting has passed directly from one owner to the next then this is indicated by the use of the phrase 'from whom'; the absence of this phrase indicates that there may be a gap in provenance. As far as possible further information on dealer's stock or photograph numbers is also given.

Exhibitions: only summary references for the exhibitions are given here – by place, year and catalogue or page number. A full list of the exhibitions cited, including details of exhibition title, venues and dates is given in **Appendix 2**.

Literature: only early articles or more recent books or articles that add something to our knowledge of the work or a collector are cited here. Early museum publications have not been included as, on the whole, they detail only title, date, dimensions and how the work entered the collection. These early museum publications are:

Catalogue (Illustrated) of the Old Masters, Dutch, Flemish, Italian, 1500–1700. Introduction by T. C. F. Brotchie. Corporation of Glasgow, Art Galleries and Museums, Kelvingrove, Glasgow, 1922

Catalogue Descriptive and Historical of the Pictures in the Glasgow Art Galleries and Museums, Glasgow, 1935

Catalogue of French Paintings, Glasgow Art Gallery, 1953

Interim Catalogue of French Paintings, Glasgow Art Gallery and Museum, nd. 1964?

French School Catalogue, Volume Two Illustrations, Glasgow Art Gallery and Museum, 1967 (the text volume was never published)

French Paintings and Drawings, Illustrated Summary Catalogue, Art Gallery and Museum, Glasgow, 1985 (with a good introductory essay by Anne Donald)

Glasgow Art Gallery and Museum, The Building and The Collections, Collins in association with Glasgow Museums, 1987 and revised edition 1994 (with an introductory essay on the French collection and featuring many colour illustrations)

Catalogue 1
Jules Bastien-Lepage 1848–84
Poor Fauvette
(*Pauvre Fauvette*)
Oil on canvas
162.5 × 125.7cm
64 × 49½ in
Signed, dated and inscribed, lower centre: J. BASTIEN-LEPAGE/DAMVILLERS 1881
1323

Provenance: James Staats Forbes, London; George McCulloch; his sale, Christie's, 23 May 1913, lot 9 (p.6 repr.); from which purchased by Glasgow Art Gallery and Museum, 1913.

Exhibitions: London, 1882, n.165; London, 1908; London, 1909–10, n.27; Glasgow, 1911, n.44, pl.36; Paisley, 1917; Liverpool, 1927; Glasgow, 1940, n.165; Greenock, 1958, n.1; Nottingham, 1972, n.123, p.46 repr.; London, 1979–80, n.10, p.164 repr.; Arts Council of Great Britain, 1980; Newcastle–Sheffield–Paisley–Aberdeen, 1981–82, n.39; London, 1983, n.4, repr.; Southampton–New York, 1986, fig.18.

Literature: Marie Bashkirsteff, *Journal*, Paris, 1890, pp.242–3 (entry for 21 January 1882); *The Academy*, 6 May 1882, p.328; *The Art Journal*, 1882, p.221; *The Magazine of Art*, vol.V, 1882, p.432; *The Magazine of Art*, vol.V, 1882; *Art Notes*, p.xxx; *The Builder*, 24 June 1882, p.762; *Journal des Arts*, 9 June 1882, p.30; W. C. Bronwell, *Bastien-Lepage; The Magazine of Art*, vol.VI, 1883, p.270, repr. p.268; Emmanuel Ducros, 'L'Exposition de l'Oeuvre de Bastien-Lepage', *L'Artiste*, vol.XXIII, 9e S, pp.393–4; A. Theuriot, *Bastien-Lepage, L'homme et L'artiste*, Paris, 1885; Wilfrid Meynell, *The Modern School of Art*, vol.3 , London, c.1887, p.32, repr. opp. p.31; Julia Cartwright, *Jules Bastien-Lepage*, 1894, p.57; *The Art Journal*, 1896, p.200; H. Arnic, *Jules Bastien-Lepage, letters et souvenirs*, Evreux, 1896; Richard Muther, *The History of Modern Painting*, 1896, pp.23–4; Mrs Arthur Bell, *Representative Painters of the 19th Century*, 1899, p.115; E. G. Halton, 'The Staats Forbes Collection', *The Studio*, vol.XXXVI, 1905, p.221; S. Reinach, *An Illustrated Manual of the History of Art Throughout the Ages*, 1907, pp.314, 319, 325, 335; *The Art Journal*, 1909, (special number on the McCulloch collection), repr. p.73; *The Graphic*, 18 April 1914, *Pictures from Glasgow Art Gallery* as *Little Fausatte* (sic); *Bibby's Annual*, 1916, p.160 repr.; W. S. Feldman, *The Life and Works of Jules Bastien-Lepage*, unpublished Ph.D., thesis, New York University, 1973, pp.171–5; Kenneth McConkey, 'The Bouguereau of the Naturalists', *Art History*, vol.1, 1978, p.374, pl.54; Kenneth McConkey, 'Bastien-Lepage and British Art', *Art History*, September 1978, p.377; The Royal Academy of Arts, *Post-Impressionism*, 1979, p.30, p.164 repr.; Bradford and Tyne and Wear Art Galleries, *Sir George Clausen RA*, 1980, p.46, fig.11; Kenneth McConkey, 'Pauvre Fauvette or petite folle; a study of Jules Bastien-Lepage's Pauvre Fauvette', *Arts Magazine*, 1981, pp.140–3, p.141 repr.; Gabriel P. Weisberg, *The European Realist Tradition*, Bloomington, Indiana University Press, 1982, fig.7.15; Marie-Madeleine Aubrun, *Jules Bastien-Lepage 1848–1884, Catalogue Raisonné de l'Oeuvre*, September 1985, p.212, fig.327; Kenneth McConkey, 'From Grez to Glasgow; French Naturalist Influence in Scottish Painting', *Scottish Art Review*, special number (*The Realist Tradition; An Exhibition of French Painting & Drawing 1830–1900*), vol.XV, n.4, pp.16–23, fig.9, p.21; Kenneth McConkey, *British Impressionism*, Phaidon, Oxford, 1989, p.28 and p.32, pl.23.

Catalogue 2
Emile Bernard 1868–1941
Landscape, Saint-Briac, c.1887–89
(*Paysage*)
Oil on canvas
53.8 × 65.0cm
21¼ × 25¼in
Signed and dated, lower right: EB'89
3401

Provenance: (?) Durand-Ruel; Ambroise Vollard, Paris; private collection; sale, Sotheby's, London, 5 December 1984, lot 128 (as *Paysage*); from which purchased by Crane Kalman Gallery, 178 Brompton Road, London; from whom purchased with the aid of the Government's Local Museums Purchase Fund, by Glasgow Art Gallery and Museum, 1985.

Exhibitions: Tokyo–Nagoya–Osaka–Kumamoto, 1994, n.51, pp.130–1, repr. p.206.

Literature: W. Jaworska, *Gauguin et l'école de Pont-Aven*, Neuchâtel, 1971, p.40 repr.; Jean-Jacques Luthi, *Emile Bernard, catalogue raisonné de l'oeuvre peint*, Paris 1982, pp.32–3, n.192, repr. (as *Paysage, 1889*).

Catalogue 3

Pierre Bonnard 1867–1947
The Edge of the Forest, c.1918
(*Lisière de Forêt or Entrée de village*)
Oil on wooden panel
37.3 × 45.9cm
14⁵/₈ × 18¹/₁₆in
Signed, lower right: Bonnard
2376

Provenance: Jos. Hessel, Paris, 1919; from whom purchased by Bernheim-Jeune, Paris, 18 October 1919, (n.21.731, neg.2749); by whom sold to Dr Soubies, 20 July 1920; collection Dr Soubies; collection Georges Bernheim; from whom purchased by Bernheim-Jeune, Paris, 7 January 1925, (n.24.140, neg.5284); by whom sold to Lord Thomas or Matthew? Justice, Dundee, 20 October 1925; William McInnes; by whom bequeathed to Glasgow Art Gallery and Museum, 1944.

Exhibitions: ? Paris, 1924, n.19 (as *A L'orée du bois*, 1919); London, 1935; Glasgow, 1943, n.58; Edinburgh, 1943, n.203, (as *Lisière de Forêt*, lent by William McInnes); Edinburgh, 1944, n.206, p.23 (lent by William McInnes); Glasgow, 1945, n.34; Scottish Tour, 1946, n.26; Edinburgh, 1948, n.28, p.10 (as *The Edge of the Forest c.1922*); Edinburgh, 1955 n.I; London, 1962, n.241, p.82 (as *The Edge of the Wood, c.1919*); London, 1966, n.139, p.53 (as *The Edge of the Forest, c.1919*); Edinburgh, 1968, p.33 repr.

Literature: *Le Bulletin de la Vie Artistique*, Edition Bernheim-Jeune, VIe année, n.23 (1 December 1925), p.516 repr.; Claude Roger-Marx, 'Reflections on Landscape', *Scottish Art Review*, vol.II, n.2, 1948, pp.7–11 repr. (as *Lisière de Forêt*); Jean and Henry Dauberville, *Bonnard, Catalogue raisonné de l'oeuvre peint*, vol.2 (1906–19), Bernheim-Jeune, Paris, 1968, n.935, p.430, p.431 repr. (as *Entrée de Village* ou *Lisière de Forêt*, 1918).

Catalogue 4

François Bonvin 1817–87
Still-Life with Apples and Silver Goblet
(*Nature morte aux pommes et au gobelet d'argent*)
Oil on canvas
33.0 × 41.1cm
12⁵/₈ × 15⁷/₈in
Signed and dated, lower left: F. Bonvin, 1876
2377

Provenance: sale M. S. Seure, Hôtel Drouot, Paris, 9 March 1888; from which purchased by M. Foinard; sale, M. Foinard, 7 December 1918; from which purchased by Alex Reid, Glasgow (n.1128); from whom purchased by William McInnes, April 1919; by whom bequeathed to Glasgow Art Gallery and Museum, 1944.

Exhibitions: Paris, 1886 (B); Glasgow, 1945, n.11; Scottish Tour, 1946, n.9; Glasgow, 1967 (Reid), n.13, p.26; Tokyo–Nagoya–Osaka–Kumamoto, 1994, n.4, pp.44–5, repr. pp.194–5.

Literature: Gabriel P. Weisberg, *Bonvin, La Vie et L'Oeuvre*, Paris, 1979, n.152, p.227 repr. (as *Nature morte aux pêches et au gobelet d'argent*).

Catalogue 5

Eugène Boudin 1824–98
A Street in Dordrecht
(*Dordrecht. Une rue*)
Oil on wooden panel
41 × 32.7cm
16¹/₈ × 12⁷/₈in
Signed and dated, lower left: 84/Boudin
2378

Provenance: Van der Velde and Rosenberg, Paris; from whom purchased by Durand-Ruel, Paris, 9 March 1900; from whom purchased by Alex Reid (L5724), Glasgow, on 6 May 1912 for 3,000 FF; Alex Reid, Glasgow; from whom purchased by William McInnes; by whom bequeathed to Glasgow Art Gallery and Museum, 1944.

Exhibitions: London, 1905, n.23; ? Glasgow, 1912, n.11; Scottish Tour, 1946; Edinburgh, 1968, p.12, repr.; Honfleur, 1992, n.100, p.229, p.152 repr.

Literature: G. Jean-Aubry, *Eugène Boudin d'après les lettres et les documents inédits*, Neuchâtel, 1968, p.216, repr.; Robert Schmit, *Eugène Boudin 1824–1898, Catalogue raisonné de l'oeuvre peint*, vol.II, Paris, 1973, n.1851, p.214, repr. (as *Dordrecht. Une rue*).

Catalogue 6

Eugène Boudin 1824–98
Venice: S. Maria della Salute and the Dogana seen from across the Grand Canal
(*Venice: Le mole à l'entrée du grand canal et la Salute*)
Oil on canvas
36 × 53.5cm
14¹/₈ × 21⁵/₈in
Signed, dated and inscribed, lower right: Venise/95. E Boudin/20 juin
3605

Provenance: Mme Juliette Cabaud, Paris; Tempelaere, Paris; Alex Reid, Glasgow; from whom purchased by William Francis Robertson, Glasgow on 17 March 1920 for £250; presented by the family of W. F. Robertson of Glasgow to Glasgow Museums in 1996.

Exhibitions: Paris, 1899, n.117; Glasgow, 1920, n.1 or n.75 or n.79; Glasgow, 1943, n.8.

Literature: Robert Schmit, *Eugène Boudin 1824–1898, Catalogue raisonné de l'oeuvre peint*, vol.3, Paris, 1973, n.3448, p.318, repr.

Catalogue 7

Georges Braque 1882–1963
Dish of Fruit, Glass and Bottle
(*Nature morte* or *Le compotier* or *Plat de fruits, verre et bouteille*)
Oil on wooden panel
44 × 54.8cm
17⁵/₁₆ × 21¹/₂in
Signed and dated, lower right: G. Braque/26
2380

Provenance: purchased from the artist by Paul Rosenberg, Paris; from whom purchased by A. J. McNeill Reid, c.1928 (Reid label 2448); from whom

purchased by William McInnes, 1933; by whom bequeathed to Glasgow Art Gallery and Museum, 1944.

Exhibitions: Glasgow, 1943, n.74 (as *Nature morte*, lent by William McInnes); Edinburgh, 1944, n.207, p.23 (lent by William McInnes); Glasgow, 1945, n.76; Edinburgh, 1949, n.268; Edinburgh, 1955, n.2; Edinburgh–London, 1956, n.57, pl.22i, p.42; London, 1956, p.42, pl.47; Belfast, 1958–59, n.1 (as *Still-Life*); London, 1962, n.255, p.86, pl.53, (as *Peaches on a Dish*); Munich, 1963, p.45, pl.73; Edinburgh, 1964, n.135; Edinburgh, 1968, p.39, repr.; Leeds, 1985, n.35, p.31 repr.; Liverpool-Bristol, 1990, n.17, p.42 repr. and pp.16, 70 (as *Peaches in a Dish*, 1926).

Literature: G. Isarlov, *Catalogue des oeuvres de Georges Braque*, Paris, 1932, n.419 repr.; 'The McInnes Collection', *Scottish Art Review*, vol.1, n.1, 1946, p.23 repr.; James Bridie, 'Leaves from a Gallery Rat's Primer', *Scottish Art Review*, vol.1, n.4, 1947, p.8 repr.; *Scottish Art Review*, vol.III, n.4, 1951, p.20 repr.; A. J. McNeill Reid, 'The French Room at Kelvingrove', *Scottish Art Review*, vol.VII, n.3, 1960, p.17 repr., p.19; Susan Jacobsen, 'Georges Braque and Paul Klee', *Art Quarterly*, January 1964; Maeght éditeur, *Catalogue de l'oeuvre de Georges Braque, Peintures 1924–27*, vol.5, 1968, n.82 repr. (as *Plat de Fruits, Verre et Bouteille*).

Catalogue 8

Jules Breton 1827–1906
The Reapers
(*Les glaneuses*)
Oil on canvas
77.2 × 115.3cm
29¹/₂ × 44in
Signed and dated, lower right: Jules Breton/1860
3396

Provenance: Ernest Gambart; Gambart sale, Christie's, 4 May 1861, lot 296; from which purchased by Earl Grosvenor; given by the Marquis of Westminster to his wife n.d., thence by descent; sale Sotheby's, 15 June 1982; from where purchased by Pym's Gallery, London; from whom purchased by Glasgow Art Gallery & Museum, 1984, with the aid of the Government's Local Museums Purchase Fund, the National Art Collections Fund, The Pilgrim Trust, Glasgow Art Gallery and Museum Association and public subscription.

Exhibitions: London, 1860; London, 1873, n.1024; Wrexham, 1876, n.597; London, 1898, n.210; Omaha–Memphis–Williamstown, 1982–83, n.12 p.21 and p.73 repr.; London, 1983, n.3, repr.; Tokyo–Nagoya–Osaka–Kumamoto, 1994, n.18, pp.72–3, repr. p.198; Tobu, 1996, n.31, p.68 repr.; Glasgow, 1997, p.28.

Literature: *The Art Journal*, 1860, p.125; *The Times*, 6 May 1861, p.9; *The Architect*, 26 April 1873, p.217; exhibition catalogue, *Rural and Urban Images, An exhibition of French and British Paintings 1870–1920*, Pyms Gallery, London, 1984, fig.1, p.8.

Catalogue 9

Charles Camoin 1879–1965
The Place de Clichy, Paris, 1910
(*La Place de Clichy, Paris*)
Oil on canvas
65.3 × 81.5cm
25³/₈ × 32in
Signed, lower left: Ch. Camoin
3063

Provenance: ? Ludovic Schames, dealer, Frankfurt; Streit Collection, Berlin; purchased by the Matthiesen Gallery, 142 New Bond Street, London, 1954, (as *The Monument*); from whom purchased (as *The Square*) by the Hamilton Trustees and presented to Glasgow Art Gallery and Museum, 1957.

Exhibitions: Glasgow, 1967 (H), p.49 n.9 repr.; Edinburgh, 1968, p.36 repr. (as *Place de Clichy, Paris*, c.1907); Glasgow, 1977, p.39 n.60 repr.; Glasgow, 1977(J), p.23 n.30; Glasgow–Dundee–Edinburgh–Aberdeen, 1985–86, n.14, p.30 repr.; Tokyo–Nagoya–Osaka–Kumamoto, 1994, n.68, pp.164–5, repr. p.211; Lausanne–Marseille, 1997–98, n.42, p.115, repr. p.230 (as *La Place de Clichy*, 1910).

Literature: T. Mullaly, 'The Fauves', *Apollo*, vol.64, 1956, p.189, fig.IX, repr. (as *The Monument*, and as belonging to the Matthiesen Gallery).

Catalogue 10

Mary Cassatt 1844–1926
The Young Girls, c.1885
(*Les jeunes filles*)
Oil on canvas
46.53 × 56.0cm
18¹/₄ × 21¹³/₁₆in
Signed, lower right: Mary Cassatt
2980

Provenance: Ambroise Vollard, Paris; private collection, France; French dealer; Roland, Browse & Delbanco, London; from whom purchased by the Hamilton Trustees and presented to Glasgow Art Gallery and Museum, Hamilton Bequest, 1953.

Exhibitions: Belfast, 1958–59, n.2; Glasgow, 1967 (H), p.48 n.10 repr.; Edinburgh, 1968, p.25 repr. (as *The Sisters*, c.1885); Washington, 1970, p.25 n.35 pl.35 (as *The Little Sisters*, c.1885); Liverpool, 1976–77, p.15 n.25 pl.61; Glasgow, 1977, p.37 n.56 repr.; Glasgow, 1977 (J), p.15 n.14; Tokyo–Nagoya–Osaka–Kumamoto, 1994, n.34, pp.104–5 repr. p.203; Atlanta–Seattle–Denver, 1999, n.7, p.116, repr. p.117, p.240.

Literature: Alec Sturrock, 'Impressionist Paintings in Glasgow', *Apollo*, vol.57, August 1953, p.40 repr.; *The Scottish Art Review*, vol.4, n.4, 1953, p.18, p.16 repr.; Bernard Denvir, 'Masterpieces Explained', *The Artist*, vol.47, n.4, June 1954, pp.80–2 repr.; Adelyn Dohme Breeskin, *Mary Cassatt, A Catalogue Raisonné of the Oils, Pastels, Watercolours, and Drawings*, Washington, 1970, p.82, n.142 repr. (as *The Little Sisters*, c.1885); Griselda Pollok, *Mary Cassatt*, London, 1980, pp.69–70 pl.XVIII.

Catalogue 11

Paul Cézanne 1839–1906
Overturned Basket of Fruit, c.1877
(*La corbeille renversée* or *Panier de fruit renversée*)
Oil on canvas
17.0 × 33.3cm
6⁵/₁₆ × 12³/₄in
Unsigned
2382

Provenance: Ambroise Vollard, Paris; Cornelis Hoogendijk, Amsterdam; Paul Rosenberg, Paris; Charles Ruloz, Paris; Alex Reid, Glasgow; from whom purchased on 14 October 1925 by William McInnes; by whom bequeathed to Glasgow Art Gallery and Museum, 1944.

Exhibitions: New York, 1921, n.31 (as *Basket of Fruit Overturned*); Glasgow, 1923, nn.; London, 1924, nn.; Glasgow, 1925, nn.; Glasgow, 1943, n.52, (lent by William McInnes); Edinburgh, 1944, n.234A, p.25, (lent by William McInnes); Glasgow, 1945, n.80; London, 1954, n.17; Oslo, 1954, n.7; Edinburgh, 1954, n.17 (as c.1877); Helsinki, 1954–55; Edinburgh, 1955, n.3; Tokyo–Kyoto–Fukoka, 1974, n.18, repr.; London, 1980, n.4, p.9, p.27 repr. (as *Overturned Basket of Fruit*, c.1873–7); Amsterdam, 1992–93, n.2, p.38, repr.

Literature: Lionello Venturi, *Cézanne, Son Art, Son Oeuvre*, Paris, 1936, vol.I, p.112, n.211 and vol.II, p.58 repr. (as c.1873–77); Alec Sturrock, 'Impressionist Paintings in Glasgow', *Apollo*, vol.57, 1953, p.40; L. Gowing 'Notes on the Development of Cézanne', *The Burlington Magazine*, vol.XCVIII, June 1956, p.188; A. J. McNeill Reid, 'The French Room at Kelvingrove', *Scottish Art Review*, vol.VII, n.3, 1960, p.16 repr.; Alfonso Gatto, *L'opera completa di Cézanne*, Milan, Rizzoli, Classici dell'arte n.39, 1970, n.192, p.94, p.95 repr.; John Rewald, *The Paintings of Paul Cézanne: A Catalogue Raisonné*, London, 1996, vol.I, n.303, p.209, vol.II, p.99, repr. (as *La corbeille renversée*, c.1877).

Catalogue 12

Paul Cézanne 1839–1906
The Star Ridge with the King's Peak, c.1878–79
(*La Chaîne de l'étoile avec le Pilon du Roi*)
Oil on canvas
50.4 × 60.2cm
19³/₈ × 23¹/₄in
Unsigned
2932

Provenance: Ambroise Vollard, Paris, (Vollard archives, photo n.515, annotated by Cézanne's son: *Aix 1885*. Vollard Stockbook n.3534[A] *Au premier plan une bande verte apres qq. Vallonements de terain – ciel gris bleu 50 × 60; 7142[C] Paysage. Collines bleus as fond. Midi. 50 × 60*); purchased by Etienne Bignou, Paris, 1934; purchased by Alex Reid; David Eccles, London; purchased by Alex Reid & Lefèvre, London, 1942; from whom purchased by William McInnes, 1942; Mrs Jessie McInnes; presented by Mrs Jessie McInnes to Glasgow Art Gallery and Museum, 1952.

Exhibitions: New York–Detroit, 1933, n.6 (as *Environs de Gardanne*); London, 1934, n.5; Glasgow, 1934, n.9; London, 1939, n.31; London, 1942, n.4; Glasgow, 1943, n.55 (lent by William McInnes);

Edinburgh, 1955, n.4; Belfast, 1958–59, n.3; Wolfsburg, 1961, n.18, pl.12; Edinburgh, 1968, p.20, repr. (as *Near Gardanne*, c.1885); Tokyo–Kyoto–Fukuoka, 1974, n.22, repr. (as *La Chaîne de l'Étoile avec le Pilon du Roi*, c.1878–79); Tokyo–Nagoya–Osaka–Kumamoto, 1994, n.39, pp.114–15, repr. pp.204–5; London–Boston, 1995–96, n.88, pp.240–1 repr.

Literature: Lionello Venturi, *Cézanne, Son Art, Son Oeuvre*, Paris, 1936, vol.I, n.418, p.155, pl.116 (as 1884–85; revised dates 1883–85); A. Barnes and V. de Mazia, *The Art of Cézanne*, New York, 1939, n.93; *Scottish Art Review*, vol.4, n.1, 1952, p.16, repr.; *Scottish Art Review*, vol.4, n.3, 1953, p.14, p.18, repr.; A. J. McNeill Reid, *Scottish Art Review*, vol.7, n.3, 1960, pp.18–19; Alfonso Gatto, *L'opera completa di Cézanne*, Milan, 1970, n.346, p.102, repr. (as 1884–85); T. J. Honeyman, *Art and Audacity*, London, 1971, pp.104–5, repr.; J. J. Rischel, *Cézanne in Philadelphia Collections*, Philadelphia, 1983, p.62, fig.29b; John Rewald, *The Paintings of Paul Cézanne, A Catalogue Raisonné*, Thames and Hudson, London, 1996, vol.1, n.399, p.266, vol.II, p.126, repr.

Catalogue 13

Camille Corot 1796–1875
The Woodcutter, c.1865–70
(*Le bûcheron*)
Oil on canvas
49.7 × 65.0cm
19⁹/₁₆ × 25 9/₁₆in
Signed, lower right: COROT
1115

Provenance: James Donald; by whom bequeathed to Glasgow Art Gallery and Museum, 1905.

Exhibitions: Edinburgh, 1886, n.1137 (lent by James Donald); Glasgow, 1888, n.706 (lent by James Donald); Cardiff, 1926; Edinburgh, 1951; Greenock, 1958, n.4, repr.; Belfast, 1958–59, n.4; Chicago, 1960, n.106, p.24 (as *The Woodcutter*, c.1865–70); Newcastle–Sheffield–Paisley–Aberdeen, 1981–82, n.1, repr.; Amsterdam, 1992–93, fig.1.3 p.11, n.3 p.39, repr.; Tokyo–Nagoya–Osaka–Kumamoto, 1994, n.1, pp.38–9, repr., p.194; Glasgow, 1997, p.28.

Literature: *International Exhibition, Memorial Catalogue, French and Dutch Loan Collection*, 1888, p.7, n.13, repr.

Catalogue 14

Camille Corot 1796–1875
Mademoiselle de Foudras, 1872
Oil on canvas
88.5 × 59.8cm
35 × 23³/₈in
Signed, lower right: COROT
2858

Provenance: M. Emile Dekens, Brussels, by 1895; purchased from him by Durand-Ruel & Cie., Paris, 7 January 1897; sold to H. O. Havemeyer, New York, along with two other pictures by Corot, for Colonel Oliver H. Payne (1839–1917), New York, 7 January 1897; returned by Payne to Durand-Ruel, New York, February 8, 1897; kept by them until purchased joint-

ly by Durand-Ruel & Cie., Paris, and Bernheim-Jeune & Cie., Paris, February 21, 1910; Durand-Ruel & Cie., Paris, sold their half share to Bernheim-Jeune & Cie., Paris, April 1, 1910; Galerie Georges Petit, Paris, by 1930; M. Knoedler and Co., New York, in November 1930; David William Traill Cargill (1872–1939), Glasgow, until his death; placed on consignment by his estate with the Bignou Galleries, New York, and Alex Reid & Lefèvre, London; presented to Glasgow Art Gallery and Museum by the Trustees of David W. T. Cargill, 1950.

Exhibitions: Paris, 1895, n.59 (lent by Emile Dekens, as *Portrait de jeune fille)*; Glasgow, 1920; Paris, 1930, n.3, repr; Paris, 1930 (C), n.3, repr. (as *Portrait de Mlle de Foudras*); New York, 1930, n.3, repr.; London, 1936 (C), n.10; Dallas, 1942, (lent by the Bignou Gallery); Portland, 1944; New York, 1945, n.3; Philadelphia, 1946, n.68 (lent by the Bignou Gallery); Chicago, 1960, n.133, p.26 repr.; London, 1962, n.216, p.75; Paris, 1962, n.79, p.182, p.183, repr.; London, 1963, n.45, p.39, p.82, repr.; Edinburgh, 1965, n.98, pl.44; London, 1980, n.5, p.9, p.27, repr.; Manchester–Norwich, 1991, n.37, p.61, p.45, repr.; Paris–Ottawa–New York, 1996–97, n.152, pp.354–6, p.355, repr.; Glasgow, 1997, p.29.

Literature: E. Heilbut, *Figurenbilder von Corot, Kunst und Kunstler*, December 1904, vol.III, repr. facing p.96; Alfred Robaut, *L'Oeuvre de Corot, Catalogue raisonné et illustré*, Paris, 1905, vol.3, n.2133, p.292, p.293, repr. and vol.IV, p.290; P. Korb, 'Corot, Delacroix und Courbet', *Der Cicerone*, March 1911, pp.161–9; Bernheim de Villers, *Corot, peinture de figures*, Paris, 1930, n.306; J. Meier-Graefe, *Corot*, Berlin, 1930, p.143 (as belonging to private collector, North America); G. Bazin, 1942, p.108; 'D. W. T. Cargill Collection', *The Glasgow Art Review*, vol.I, n.4, 1947, p.24, repr.; H. Uhde-Bernays, *Corot*, Berne, 1948, pl.47; 'D. W. T. Cargill Collection', *Scottish Art Review*, vol.III, n.1, 1950, p.30, repr.; G. Bazin, *Corot*, Paris, 1951, p.114; A. J. McNeill Reid, 'The French Room at Kelvingrove', *Scottish Art Review*, vol.VII, n.3, pp.19, 29; Keith Roberts, *Corot*, London, 1965, pl.48; Madeleine Hours, *Jean-Baptiste-Camille Corot*, New York, n.d. p.156, p.157, repr.; Anthony F. Janson, 'Corot: Tradition and the Muse', *Art Quarterly*, n.s.I, 1978, p.313; Jean Leymarie, *Corot*, Geneva and New York, 1979, (English edition translated by Stuart Gilbert), 1979, p.155, repr.; Antje Zimmermann, *Studien zum Figurenbild bei Corot*, Cologne, 1986, pp.170–1, p.377, fig.162; Michael Clarke, *Corot and the Art of Landscape*, London, 1991, p.143, fig.129; Jean Leymarie, Corot, Geneva, 1992, p.180; exhibition catalogue, *Splendid Legacy: The Havemeyer Collection*, The Metropolitan Museum of Art, New York, 1993, p.220; Iain Gale, *Corot*, London, 1994, pp.128–9, repr.

Catalogue 15
Camille Corot 1796–1875
Pastorale, 1873
(*Pastorale-Souvenir d'Italie*)
Oil on canvas
173.0 × 144.0cm
68 × 56⁷/₈in
Signed, lower left: COROT
732

Provenance: acquired from the artist by Cléophas, Paris; from whom acquired by Melhote, Paris; John Forbes White, Aberdeen, 1874; from whom purchased by James Reid, 26 February 1892; presented to Glasgow Art Gallery and Museum by the sons of James Reid of Auchterarder (1823–94), 1896.

Exhibitions: Paris, 1873, n.359 (as *Pastorale*, lent by Cléophas); Edinburgh, 1878, n.33; ? Edinburgh, 1886; Glasgow, 1888, n.651; Paris, 1889, n.161 (lent by Cléophas); Glasgow, 1943, n.4; Edinburgh, 1944, n.160, p.19; Edinburgh, 1965, n.96; London, 1974 (RA), n.29, p.69, pl.IXa; Manchester–Norwich, 1991, n.38, p.62, pl.51, repr.; Edinburgh, 1994, n.116, pp.77–8; Paris–Ottawa–New York, 1996–97, n.150, pp.350–2, repr.; Glasgow, 1997, p.15, repr. p.29.

Literature: David Croal Thomson, *The Barbizon School of Painters*, London, 1891 and 1902, p.54, repr. facing p.56; Maurice Hamel, *Corot and His Work*, vol.2, Glasgow and Paris, 1905, n.86 (as *Danse de nymphes*); A. Robaut, *L'Oeuvre de Corot*, vol.3, Paris, 1905, p.280, n.2107, p.281, repr.; Claude Roger-Marx, 'Reflections of Landscape', *Scottish Art Review*, vol.II, n.2, 1948, pp.7–11, p.8, repr.; Charles Carter, 'Art Patronage in Scotland: John Forbes White 1831–1904', *Scottish Art Review*, vol.VI, n.2, 1957, pp.27–30, p.29, repr.; Alfred Robaut, *L'Oeuvre de Corot*, Paris, 1965, n.2107, p.281, repr.; Michael Clarke, *Corot and the Art of Landscape*, London, 1991, pp.131, 135, fig.123; Jean Leymarie, *Corot*, Geneva, 1992, pp.172–3, 197.

Catalogue 16
Gustave Courbet 1819–77
Baskets of Flowers
(*Corbeilles de fleurs*)
Oil on canvas
76.9 × 101.7cm
29⁷/₈ × 39⁵/₈in
Signed and dated, lower left: ..63/Gustave Courbet
2859

Provenance: Etienne Bignou; from whom purchased by Alex Reid, Glasgow, March 1924 (n.3794); from whom purchased on same day by D. W. T. Cargill, Lanark, March 1924 (as *Fleurs Melée*, for £4,500); presented by the Trustees of D. W. T. Cargill to Glasgow Art Gallery and Museum, 1950.

Exhibitions: Glasgow, 1927, n.9; Paris, 1930, n.5, repr.; London–Manchester, 1932, n.351, p.169 (lent by D. W. T. Cargill); Venice, 1954, n.20, repr.; Lyon, 1954, n.25 (as *La corbeille de fleurs*); Paris, 1955, n.46, pl.35; Philadelphia-Boston, 1959–60, n.41, p.133, p.72 repr. (as *Fleurs dans un panier*); Glasgow, 1977(R), n.13; Paris-London, 1977–78, n.66, pp.143–4, repr. (as *Basket of Flowers*); London, 1980, Wildenstein, n.6, p.9, repr.; Brooklyn-Minneapolis, 1988–89, n.43, pp.148–9, repr.; Tokyo–Nagoya–Osaka–Kumamoto, 1994, n.3, pp.42–3, repr. p.194; Glasgow, 1997, p.29; Lausanne-Stockholm, 1998–99, n.23, pp.135–6, repr., n.21, p.29 repr.

Literature: *L'Amour de l'Art*, September 1930, p.375, repr.; *French Art 1200–1900, Commemorative Catalogue 1933*, London, 1932, n.318, pl.112; 'D. W. T. Cargill Collection', *The Glasgow Art Review*, vol.I, n.4, 1947, p.25, repr.; C. Leger, *Courbet et son temps*,

Paris, 1948, fig.29; 'Three Notable Paintings', *Scottish Art Review*, vol.III, n.1, 1950, p.31; *Scottish Art Review*, vol.IV, n.4, 1953, p.9, repr.; *Scottish Art Review*, vol.VII, n.3, 1960, p.29; *Scottish Art Review*, vol.VIII, n.3, 1962, p.33; André Fermigier, *Courbet*, Geneva, 1971, p.89, repr.; Roger Bonniot, *Gustave Courbet en Saintonge*, Paris, 1973; Robert Fernier, *La vie et l'oeuvre de Gustave Courbet: Catalogue raisonné, 1819–65*, vol.I, 1977, n.366, p.208, p.209 repr. (as *Corbeilles de Fleurs*); Pierre Courthion, *Tout l'oeuvre peint de Courbet*, Paris, 1987, pp.92–3, n.343, repr.; Michael Fried, *Courbet's Realism*, Chicago and London, 1990, p.252, fig.106, p.252 repr.

Catalogue 17
Gustave Courbet 1819–77
Apple, Pear and Orange, c.1871–72
(*Pomme, poire et orange*)
Oil on wooden panel
13.0 × 20.8cm
5¹/₈ × 8¹/₈in
Signed, lower left: G. Courbet.
2384

Provenance: Etienne Bignou, Paris; Alex Reid, Glasgow (n.2086); Leonard Gow; William McInnes; by whom bequeathed to Glasgow Art Gallery and Museum, 1944.

Exhibitions: Glasgow, 1945, n.82; Scottish Tour, 1946, n.33; Edinburgh, 1955; Montpellier, 1985.

Literature: Mentioned in Delestre's unpublished catalogue; I. M. Harrower, *Apollo*, vol.50, 1950, p.96, repr.; *Scottish Art Review*, vol.VIII, n.3, 1962, p.2; Pierre Courthion, *Tout l'oeuvre peint de Courbet*, Paris, 1987, n.762, p.116, repr. (as 1871).

Catalogue 18
Charles-François Daubigny 1817–78
Lake with Ducks
(*Mare aux Canards*)
Oil on wooden panel
37.9 × 67.3cm
14¹⁵/₁₆ × 26¹/₂in
Signed and dated, lower right: Daubigny 1873
1141

Provenance: James Donald; by whom bequeathed to Glasgow Art Gallery and Museum, 1905.

Exhibitions: Edinburgh, 1886, n.1089, (as *Landscape*, lent by James Donald); Glasgow, 1888, n.768, (lent by James Donald); Glasgow, 1901, n.1297, p.92 (as *River Scene*, lent by James Donald); Leeds, 1910; Greenock, 1958, n.6, p.3, p.7, repr. (as *Lake with Ducks*); Belfast, 1958–59, n.6, p.3; Paris, 1964, n.30; Glasgow, 1997, p.28.

Literature: *Memorial Catalogue of the French and Dutch Loan Collection*, 1888, n.34, pl.18; Percy Bate, *Art at the Glasgow Exhibition 1901*, London, 1901, p.76; Martin Davies, *French School Catalogue, The National Gallery*, London, 1957, p.65 and 1970, p.43; Robert Hellebranth, *L'oeuvre complet de Charles-François Daubigny 1817–1878*, Paris, 1964; Galerie André Watteau, *The Life and Work of Charles-François Daubigny*, Paris, 1975; Madeline Fidell-Beaufort and

Janine Bailly-Herzberg, *La vie et l'oeuvre de Charles-François Daubigny*, Paris, 1975, n.133, p.186, repr. (as *La Mare aux Canards*); Robert Hellebranth, *Charles-François Daubigny 1817–1878*, 1976, n.703, p.231, repr.

Catalogue 19

André Derain 1880–1954
Blackfriars Bridge, London, 1906
(*Londres: Le Pont de Blackfriars*)
Oil on canvas
80.7 × 99.7cm
31³/₄ × 39¹/₈in
Unsigned
2283

Provenance: purchased from the artist by Ambroise Vollard, Paris; from whom purchased by Alex Reid & Lefèvre, London, 1938; from whom purchased by Glasgow Art Gallery and Museum in May 1942.

Exhibitions: Moscow, 1908, n.35–8 (possibly one of 4 views of London exhibited by Derain); New York, 1933, n.21 (as *St. Paul's Cathedral* – letter 23 September 1953 from Bignou to T. J. Honeyman); New York, 1936; London, 1937, n.8; Montreal, 1938, n.12; London, 1942, n.12; Glasgow, 1943, n.75 (as *Blackfriars*, 1907); Edinburgh, 1950, nn.; London, 1951, n.3; London, 1951(RBD), n.8; Edinburgh, 1955, n.5; London, 1957, p.7; Belfast, 1958–59, n.8; Wolfsburg, 1961, n.53, pl.37 (as *Blackfriars*, c.1906–7); Edinburgh, 1968, p.28, repr.; London, 1971, n.38; Glasgow, 1972–73, n.82, p.44, repr.; London, 1977; Paris, 1979, p.77, repr., p.524; London, 1980, n.8, p.10, p.32, repr.; Los Angeles–New York–London, 1990–91, pl.202, p.196 repr. p.197, p.277 (as *Le Pont de Blackfriars, Londres*, winter 1906), (exhibited in New York and London only); Tokyo–Nagoya–Osaka–Kumamoto, 1994, n.66, pp.160–1, repr. pp.210–1; Paris, 1994–95, n.49, p.145 repr.; Sydney-Melbourne, 1995–96, n.29, p.94, p.95, repr. (as *Blackfriars Bridge, London*, winter 1906); Barcelona, 1997, n.19, p.60 repr. p.117.

Literature: 'Some War-Time Acquisitions', *The Art Review*, vol.I, n.1, 1946, p.28, repr.; A. D. B. Sylvester, 'Modern French Painting at the Royal Academy', *Burlington Magazine*, vol.XCIII, March 1951, pp.86–7, fig.25; *Scottish Art Review*, vol.III, n.3, 1951, p.24, repr.; Terence Mullaly, 'The Fauves', *Apollo*, vol.64, 1956, pp.187–8, fig.5; Ronald Alley, *Foreign Paintings, Drawings and Sculptures*, London, Tate Gallery, 1959, p.64; Denys Sutton, *André Derain*, London, 1959, pp.17–18; *Scottish Art Review*, vol.VII, n.3, 1960, p.30; Gaston Diehl, *Les Fauves*, Paris, 1943, p.55, repr.; Joseph-Emile Muller, *L'art au XXe siecle*, Paris, Larousse, 1967, p.48, repr.; T. J. Honeyman, 'Les Fauves – Some Personal Reminiscences', *Scottish Art Review*, vol.XII, n.1, 1969, pp.17–20, p.18, repr.; Jane Lee, *Derain*, Phaidon, Oxford, 1990, fig.12, repr.; Michel Kellerman, *André Derain (1880–1954), Catalogue Raisonné de l'oeuvre peint*, Paris, 1992, vol.I (1895–1914), n.86, p.55, repr. (as *Londres: Le Pont de Blackfriars*).

Catalogue 20

Narcisse Virgile Diaz de la Pena 1808–76
Roses and other Flowers, c.1845–50
(*Fleurs*)
Oil on canvas (oval)
63.2 × 51.0cm
24³/₈ × 19¹/₂in
Signed, lower left: N. Diaz
1159

Provenance: (?) Craibe Angus, Glasgow (printed label on frame); Mrs Isabella Elder; by whom bequeathed to Glasgow Art Gallery and Museum, 1906.

Exhibitions: Edinburgh, 1886, n.1128 (lent by Mrs Elder); Glasgow, 1888, n.649 (lent by Mrs Elder); Greenock, 1958, n.8; Tokyo–Nagoya–Osaka–Kumamoto, 1994, n.12, pp.60–1, repr. p.196; Glasgow, 1997, p.29.

Literature: *Memorial Catalogue of the French and Dutch Loan Collection*, Edinburgh International Exhibition, 1886, p.32, n.49.

Catalogue 21

Raoul Dufy 1877–1953
The Jetties of Trouville-Deauville
(*Les jetées de Trouville-Deauville*)
Oil on canvas
50.4 × 60.2cm
18³/₁₆ × 21⁵/₈in
Signed and dated, lower right: Raoul Dufy 1929
3120

Provenance: purchased from the artist by Etienne Bignou, 8, rue de la Boétie, Paris, 1929 (Dufy's agent); from whom purchased by A. J. McNeill Reid, July 1929; presented by Mr and Mrs A. J. McNeill Reid to Glasgow Art Gallery and Museum, 1st February 1960.

Exhibitions: Edinburgh, 1949–50, n.8; Edinburgh, 1968, p.41, repr. (as *Pier at Deauville*); Tokyo–Nagoya–Osaka–Kumamoto, 1994, n.69, pp.166–7, repr. pp.211–2.

Literature: *Scottish Art Review*, vol.V, n.3, 1955, p.2, repr.; *Scottish Art Review*, vol.VIII, n.2, 1961, pp.7–8, repr.; T. J. Honeyman, 'Les Fauves – Some Personal Reminiscences', *Scottish Art Review*, vol.XII, n.1, 1969, pp.18–19; Maurice Laffaille, *Raoul Dufy, Catalogue Raisonné de l'Oeuvre Peint*, vol.II, Geneva, 1973, n.638, p.190, repr. (as *Les Jetées de Trouville-Deauville*).

Catalogue 22

Henri Fantin-Latour 1836–1904
Yellow Chrysanthemums
(*Chrysanthèmes jaunes*)
Oil on canvas
61.6 × 48.6cm
24 × 19in
Signed and dated, lower right: Fantin. 79
1795

Provenance: Miss F. Douglas, 5 Vernon Chambers, Southampton Row, London; Douglas sale, Christie's 17 May 1912, lot 96; from which purchased by F. and

J. Tempelaere, Paris for 360 guineas (£376); Paul Eugène Cremetti, London; (?) Mr George Clark; James Connell & Sons, Glasgow; from whom purchased by the Hamilton Trustees and presented to Glasgow Art Gallery and Museum, Hamilton Bequest, 1929.

Exhibitions: ? London, 1885, n.854; Glasgow, 1951, n.16, repr.; Glasgow, 1977, n.13, p.18, repr.; London, 1980, n.9, p.10, p.27, repr.; Edinburgh, 1981; Paris–Ottawa–San Francisco, 1982–83, n.100, pp.267–8, repr. n.37, pp.110–11, repr. p.204; Bielefeld, 1995–96, p.83; Glasgow, 1997, p.29.

Literature: Mme Victoria Fantin-Latour, *Catalogue de l'oeuvre complet de Fantin-Latour*, Paris, 1911, n.953, p.98; *Scottish Art Review*, vol.V, n.2, 1955, p.19, repr.; Michelle Verrier, *Fantin-Latour*, London, 1977, p.41, repr.; Edward Lucie-Smith, *Fantin-Latour*, London, 1977, p.158.

Catalogue 23

Henri Fantin-Latour 1836–1904
Larkspur
(*Pieds d'Alouette*)
Oil on canvas
69.2 × 58.7cm
27 × 22⁷/₈in
Signed and dated, lower right: Fantin. 92
2139

Provenance: Mrs Ruth Edwards, London; ? Christie's sale 17 May 1912, lot 96; from which purchased by Gustave Tempelaere, Paris; Mrs Davidson, Hertfordshire; Christie's sale 30 April 1915, lot 100; from which purchased by James Connell & Sons, London; from whom purchased by William James Chrystal, Dunbartonshire (as *Delphiniums in a Glass Vase* for £441); by whom bequeathed to Glasgow Art Gallery and Museum, 1939.

Exhibitions: London, 1900, n.135; Glasgow, 1943, n.7 (as *Pieds d'Alouette*); Edinburgh, 1944, n.131 (as *Flowers*); Belfast, 1958–59, n.9; Paris–Ottawa–San Francisco, 1982–83, n.145, p.340, repr.; London, 1984, n.46, fig.44.

Literature: *The Athenaeum*, 1900, p.758; Madame Fantin-Latour, *Catalogue de l'oeuvre complet de Fantin-Latour*, Paris, 1911, n.1478, p.156; Edward Lucie-Smith, *Fantin-Latour*, London, 1977, p.158; Paul de Roux, *Fantin-Latour: Figures et Fleurs*, Paris, 1995, p.62, p.63 repr.

Catalogue 24

Henri Fantin-Latour 1836–1904
Roses 'La France', 1895
Oil on canvas
40.3 × 46.4cm
15⁷/₈ × 18¹/₈in
Signed, upper right: Fantin
2138

Provenance: Gustave Tempelaere, Paris; Allard et Noel, Paris; F. and J. Tempelaere, Paris; Bonjean, Paris; Cremetti, London; Thomas McLean, London; from whom purchased by W. J. Chrystal,

Dunbartonshire, 3 June 1912 (as *Roses in a Bowl* for £900); by whom bequeathed to Glasgow Art Gallery and Museum, 1939.

Exhibitions: Greenock, 1958, n.10; Bournemouth, 1960, n.17; London, 1984, n.49, pl.45; Tokyo–Nagoya–Osaka–Kumamoto, 1994, n.38, pp.112–3, repr. p.204.

Literature:
Madame Fantin-Latour, *Catalogue de l'oeuvre complet de Fantin-Latour*, Paris, 1911, n.1592, p.168 (as *Roses 'La France'*, 1895).

Catalogue 25
Othon Friesz 1879–1949
The Seine at Paris – Pont de Grenelle, c.1901–4
(*La Seine à Paris* or *Le Quai de Grenelle* or *La Tour Eiffel*)
Oil on canvas
46.5 × 33.5cm
18¹/₈ × 13¹/₁₃in
Signed, lower left: E. Othon Friesz
3110

Provenance: ? Brottet-Friesz, Paris; purchased by Galerie Raymonde Cazenave, 12 rue de Berri, Paris, April 1957; purchased by the Tib Lane Gallery, 14 Tib Lane, Manchester, 1959; from whom purchased by Glasgow Art Gallery and Museum, on 10 September 1959.

Exhibitions: Edinburgh, 1968, p.21 repr.; Glasgow–Dundee–Edinburgh–Aberdeen, 1985–86, n.4, p.27, repr.; Tokyo–Nagoya–Osaka–Kumamoto, 1994, n.70, pp.168–9 repr. p.212.

Literature: Maximilien Gauthier, *Othon Friesz*, Geneva, 1957, n.30 repr.

Catalogue 26
Paul Gauguin 1848–1903
Ostre Anlaeg Park, Copenhagen
Oil on canvas
60.0 × 73.5cm
23¹/₄ × 28⁵/₈in
Signed and dated, lower left: P. Gauguin 85
2465

Provenance: Miss Diana Watson; from whom purchased through an agent on half-share between Matthieson Gallery and Alex Reid & Lefèvre, London; Reid & Lefèvre; from whom purchased by the Hamilton Trustees, and presented to Glasgow Art Gallery and Museum, Hamilton Bequest, 1944.

Exhibitions: Copenhagen, 1885; ? Paris, 1886, n.56, p.9 (as *Parc, Danemarck*); Glasgow, 1944; Glasgow, 1951, n.19. p.11 (as *Landscape*); Scottish Tour, 1951–52, n.10, p.8; Glasgow, 1967, *The Hamilton Bequest*, Art Gallery and Museum, n.24, p.45, repr.; Edinburgh, 1968, p.18, repr. (as *Oestervold Park, Copenhagen*); Glasgow, 1977, n.44, p.31, repr.; Tokyo–Nagoya–Osaka–Kumamoto, 1994, n.40, pp.116–7 repr. p.205; Martigny, 1998, n.15, pp.216, 261–2, p.65 repr. (as *Park, Denmark*).

Literature: Alec Sturrock, 'Impressionist Paintings in Glasgow', *Apollo*, vol.57, 1953, pp.40–3; Georges Wildenstein, *Gauguin*, Paris, 1964, vol.1, n.142, p.54, repr. (as *La rivière*, and as 'disparu'); Lesley Stevenson, *Gauguin*, London, 1990, p.48, repr.; exhibition catalogue, *The New Painting, Impressionism 1874–1886*, Washington, 1986, pp.443–4.

Catalogue 27
Vincent van Gogh 1853–90
The Blute-Fin Windmill, Montmartre, 1886
(*Le Moulin de Blute-Fin, Montmartre*)
Oil on canvas
46.0 × 38.2cm
17⁷/₈ × 14³/₄in
Signed, lower right: Vincent
2425

Provenance: J. van Gogh-Bonger, Amsterdam; Tedesco, Paris; from whom purchased by Bernheim-Jeune, Paris, 9 May 1921 (n.22,629, reg.n.3.767); purchased by Alex Reid, Glasgow, 13 July 1921; purchased by William McInnes, Glasgow; by whom bequeathed to Glasgow Art Gallery and Museum, 1944.

Exhibitions: Glasgow, 1943, n.53; Glasgow, 1945, n.81; London, 1962, n.238, p.81, p.49 repr. (as *Le Moulin de la Galette, Montmartre*, 1886); Edinburgh, 1968, p.10, repr.; Auckland, 1975, n.3, repr.; Glasgow, 1990–91, n.25, pp.134–5, repr.; Tokyo–Nagoya–Osaka–Kumamoto, 1994, n.52; Copenhagen, 1995–96.

Literature: J. B. de la Faille, *The Works of Vincent Van Gogh*, 1928, vol.I, n.274 and 1970, p.138, F.274; 'The McInnes Collection', *The Glasgow Art Review*, vol.I, n.1, 1946, p.23, repr.; T. J. Honeyman, 'Van Gogh: A Link with Glasgow', *Scottish Art Review*, vol.II, n.2, 1948, p.18, repr.; Alex Sturrock, 'Impressionist Paintings in Glasgow', *Apollo*, vol.57, 1953, p.40; Phoebe Pool, *Impressionism*, London, 1967, p.209, repr.; Mark Roskill, *Van Gogh, Gauguin and the Impressionist Circle*, London, 1971, p.42, pl.12 (as *Moulin de la Galette, c.1887*); Jan Hulsker, *The Complete Van Gogh*, 1980, p.242 and p.244, n.1115, repr.; Nathaniel Harris, *The Art of Van Gogh*, London, 1982, p.35, repr.; Bruce Bernard, *Vincent by Himself*, London, 1985, p.148, repr.; Pierre Richard, 'Vincent van Gogh's Montmarte', *Jong Holland 4*, 1988, I, pp.161–21; exhibition catalogue, *Vincent van Gogh*, Rijksmuseum Vincent van Gogh, Amsterdam, 1990, p.72; Frances Fowle, 'Alexander Reid', *National Art Collection Fund Quarterly*, autumn, 1999, p.45 repr.

Catalogue 28
Vincent van Gogh 1853–90
Portrait of Alexander Reid (1854–1928), 1887
Oil on board
41.0 × 32.9cm
16¹/₂ × 13in
Signed, lower right: Vincent
3315

Provenance: Mme J. van Gogh-Bonger, Amsterdam; V. W. van Gogh, Laren; purchased in 1929 by A. J. McNeill Reid; Graham Reid, Guildford; purchased by Glasgow Art Gallery and Museum, 1974, with the aid of a special Government grant, the National Art

Collections Fund, an anonymous donor and public subscription.

Exhibitions: Berlin, 1914, n.36; London, 1930, n.14; Glasgow, 1930, n.20; Manchester, 1932, n.16; Edinburgh, 1934, n.352; Melbourne-Adelaide-Sydney, 1939–40; London, 1947(R-L), n.46, repr.; London-Birmingham-Glasgow, 1947–48, n.26, repr.; London, 1951(R-L), n.36, repr.; Edinburgh, 1958; Glasgow, 1963; London, 1963(W), n.70, repr. (as *Portrait of Alexander Reid*, 1886–87, lent by Graham Reid); Glasgow, 1964, n.144, repr.; Glasgow, 1967 (Reid), n.41, p.41 (lent by Graham H. Reid); London, 1974, n.17, pp.36–7 repr.; Glasgow, 1977 (J), n.113, p.58, p.46 repr.; London, 1980, n.13, pp.11–12, p.30, repr.; Glasgow, 1983; Paris, 1988, n.38; Amsterdam, 1990, n.26, p.83, p.84 repr.; Glasgow, 1990–91, n.29, p.139, repr.; Edinburgh, 1991, n.41; Amsterdam, 1992–93, n.8, p.44, n.8, repr.; Tokyo–Nagoya–Osaka–Kumamoto, 1994, n.53; Detroit-Boston-Philadelphia, 2000–2001, n.93, p.106 repr.

Literature: J. B. de la Faille, Vincent van Gogh, Paris, vol.I, nd., n.343 repr. (as *Portrait de Van Gogh par lui-même*); T. J. Honeyman, 'Van Gogh: A Link with Glasgow', *Scottish Art Review*, vol.II, n.2, 1948, pp.16–20, p.21 repr.; *The Studio*, vol.CXLI, n.699, June 1951, pp.161–7, p.165, repr.; J. B. de la Faille, *The Works of Vincent van Gogh: His Paintings and Drawings*, rev.ed. 1970, F.343, p.624, p.165 repr.; Jan Hulsker, *The Complete Van Gogh*, 1980, p.278, n.1250, repr.; Richard Marks, *Burrell – Portrait of a Collector*, 1983, pp.62–4, repr; Martin Baillie, *Young Vincent*, 1990, p.140, pl.II; exhibition catalogue, *Vincent van Gogh*, Amsterdam, 1990, pp.83–4, n.26, repr; Frances Fowle, 'Impressionism in Scotland, An acquired taste', *Apollo*, vol.CXXXVI, n.370, December 1992, pp.374–8, p.374, repr.; Frances Fowle, 'Van Gogh's Scottish "twin"', *Art Quarterly (NACF)*, autumn 1997, pp.42–5, p.42 repr.

Catalogue 29
Armand Guillaumin 1841–1927
Riverbank, Autumn, c.1910
(*Bord de la Creuse* or *Bord de la rivière à l'automne*)
Oil on canvas
65.0 × 81.0cm
25¹/₈ × 31¹/₂in
Signed, lower right, in red: Guillaumin
2897

Provenance: (?) R. Lucius, Paris; G. Mitchell, London; Alex Reid & Lefèvre, London; from whom purchased by the Hamilton Trustees, 1951 and presented to Glasgow Art Gallery and Museum, Hamilton Bequest, 1951.

Exhibitions: Glasgow, 1951, n.23; Glasgow, 1967 (H), n.29, p.46, repr.; Edinburgh, 1968, p.40, repr. (as *Beside the Creuse, Autumn*); Glasgow, 1977, n.53, p.36, repr. (as *Riverbank, Autumn*); Tokyo-Nagoya-Osaka-Kumamoto, 1994, n.31, pp.98–9, repr. p.202.

Literature: Scottish Art Review, vol.IV, n.1, 1952, p.14, repr.; Anne Donald, 'Armand Guillaumin', Scottish Art Review, vol.XIII, n.2, 1971, pp.15–16, repr. p.30.

Catalogue 30
Adolphe Hervier 1818–79
*Village Scene, Barbizon, c.*1850–60
Oil on wooden panel
12.9 × 31.0cm
5¹/₁₆ × 12¹/₈in
Signed, lower right: HERVIER
2389

Provenance: A. J. Kirkpatrick, Glasgow; Kirkpatrick sale, 1 April 1914, n.315 or n.319; from which purchased by Alex Reid, Glasgow, (stock n.1452); from whom purchased by William McInnes, Glasgow, April 1914 for £26.5/-; by whom bequeathed to Glasgow Art Gallery and Museum, 1944.

Exhibitions: Glasgow, 1945, n.14; London, 1950, n.38, p.17; Glasgow, 1967 (Reid), n.27, p.34; Barbizon, 1975, n.200, p.229; Cleveland–Brooklyn–St Louis–Glasgow, 1980–82, n.157, p.185 and p.184 repr.; Edinburgh, 1986, n.51, p.55, p.54 repr.; Glasgow, 1997, p.28.

Literature: *Illustrated London News*, 'The School of 1830 in France', 15 April 1950, p.595, repr.; 'Louis Adolphe Hervier', *Scottish Art Review*, vol.VIII, no.3, 1962, p.25, repr.; Jean Bouret, *The Barbizon School and 19th Century French Landscape Painting*, London, 1973, p.86, repr.; Richard Thomson, review, 'Edinburgh National Gallery, Lighting up the Landscape', *The Burlington Magazine*, November 1986, p.847; André Parinaud, *Artists and Their Schools: Barbizon, The Origins of Impressionism*, 1994, p.20 repr.

Catalogue 31
Stanislas Lépine 1835–92
*The Rue de Norvins, Montmartre, c.*1876–80
(*La rue de Norvins, Montmartre*)
Oil on canvas
33.0 × 24.5cm
12⁵/₈ × 9¹/₄in
Signed, lower right: S. Lépine
2401

Provenance: Hazard Collection, Paris; Hazard sale, Paris, 1–3 December, 1919, lot 163; from which purchased by Alex Reid; from whom purchased by William McInnes; by whom bequeathed to Glasgow Art Gallery and Museum, 1944.

Exhibitions: Glasgow, 1945, n.4; London, 1950, n.48, repr.; Tokyo–Nagoya–Osaka–Kumamoto, 1994, n.21, pp.78–9, repr. p.199; Glasgow, 1997, p.31.

Literature: *The Illustrated London News*, 15 April 1950, p.595, repr.; John Couper, *Lépine*, Paris, 1970, nn.; K. Adler, *Unknown Impressionists*, London, 1988, pl.33, repr.; Robert and Manuel Schmit, *Catalogue Raisonné of the Paintings of Stanislas Lépine 1835–1892*, Paris, 1993, n.239, p.102 repr.

Catalogue 32
Henri Le Sidaner 1862–1939
A Beauvais Square by Moonlight
(*Place de Beauvais au Clair de Lune*)
Oil on canvas
70.2 × 92.4cm
27⁵/₈ × 36³/₈in

Signed and dated, lower left: LE SIDANER 1900
2193

Provenance: Dr David Perry; by whom bequeathed to Glasgow Art Gallery and Museum, 1940.

Exhibitions: ? Glasgow, 1903; Glasgow, 1906, n.356, (as *A Quiet Square*, lent by D. Perry); Tokyo–Nagoya–Osaka–Kumamoto, 1994, n.62, pp.152–3, repr. p.209.

Literature: *Glasgow Herald*, 1 August, 1940; Yann Farinaux–Le Sidaner, *Le Sidaner. Catalogue raisonné de l'Oeuvre peint et gravé*, Paris, 1989, n.99, p.73 repr.

Catalogue 33
Léon Lhermitte 1844–1925
Ploughing with Oxen, 1872
(*Le labourage*)
Oil on canvas
60.5 × 103.4cm
23³/₈ × 40¹/₂in
Signed, lower right: Léon Lhermitte
2229

Provenance: Durand-Ruel, Paris, 1872; Holloway; Deschamps, London, 1874; Forbes, London; J. J. Carnaud; his sale, Hôtel Drouot, Paris, 31 March 1911, lot 28 (as *Le Labour*, for 12,500FF); sale, Galerie Georges Petit, Paris, 4–5 December 1918, lot 85; Eugène Cremetti, London; purchased by Rev. H. G. Roberts Hay-Boyd; by whom bequeathed to Glasgow Art Gallery and Museum, 1941.

Exhibitions: London, 1872, n.27, (as *Oxen Ploughing*); ? London, 1901, n.73; Cleveland–Brooklyn–St Louis–Glasgow, 1980–82, n.194, p.223 repr.; Tokyo–Nagoya–Osaka–Kumamoto, 1994, n.19, pp.74–5, repr. pp.198–9; Glasgow, 1997, p.30.

Literature: Pierre Dubois, *Journal des Arts*, 25 March 1911; *Journal*, 1 April 1911; R. de Pezannes, 'Carnet de la curiosité', *Indépendance belge*, 5 April 1911; Mary Michele Hamel, *A French Artist: Léon Lhermitte, 1844–1925* (Ph.D. diss., Washington University, St Louis, 1974), n.20, p.23, n.43, p.34; exhibition catalogue, *Rural and Urban Images, an Exhibition of British and French Painting, 1870–1920*, Pyms Gallery, London, 24 October–30 November 1984, p.30; Monique Le Pelley Fonteny, *Léon Augustin Lhermitte (1844–1925), Catalogue Raisonné.* Paris, 1991, n.3, p.89 repr.

Catalogue 34
Louis Marcoussis 1878–1941
Still-Life in Front of a Balcony
(*Table devant le balcon* or *Nature morte devant le balcon*)
Oil on canvas
100.4 × 65.3cm
39³/₈ × 25⁵/₈in
Signed and dated, upper left: Marcoussis 28
2902

Provenance: ? Galerie Jeanne Bucher (rue de Seine), Paris; Roland, Browse and Delbanco, London; from whom purchased by Glasgow Art Gallery & Museum, 1951.

Exhibitions: Brussels, 1928, n.13 (as *Table devant le balcon*); Paris, 1929, n.6; Paris, 1948, n.2, repr. (as *Le Balcon*); London, 1951, n.37, p.6; Edinburgh, 1968, p.35, repr.

Literature: *Scottish Art Review*, vol.IV, n.1, 1952, repr. p.21; Jean Lafranchis, *Marcoussis, sa vie, son oeuvre: catalogue complet des peintures, fixés sur verre, aquarelles, dessins, gravures*, Paris, 1961, n.132, p.260 repr. and pp.221, 225; *Scottish Art Review*, vol.IX, n.2, 1963, p.11.

Catalogue 35
Albert Marquet 1875–1947
*The Port of Algiers, c.*1922
(*Le Port d'Alger*)
Oil on canvas
54.2 × 65.3cm
21¹/₄ × 25⁵/₈in
Signed, lower left: marquet
3030

Provenance: purchased from the artist by Bernheim-Jeune, Paris, 22 June 1922 (n.23.069 as *Alger*); from whom purchased by Alex Reid, 18 November 1922 (n.184/26 and 2428); purchased by F. J. Conway in 1926; by whom bequeathed to George Campbell; purchased by Ian MacNicol; from whom purchased by the Hamilton Trustees and presented to Glasgow Art Gallery and Museum, Hamilton Bequest, August 1955.

Exhibitions: ? Paris, 1922, n.153; Glasgsow, 1923; ? Glasgow, 1925; Glasgow, 1967 (H), n.44, repr.; Edinburgh,1968, p.30, repr. (as *Harbour at Bougie, Algeria*, 1944); Glasgow, 1977 (J), n.7, p.14 (as *Harbour at Bougie, Algeria, c.*1922); Glasgow, 1977 (H) n.59, p.38, repr.; Tokyo–Nagoya–Osaka–Kumamoto, 1994, n.71, pp.170–1, repr. p.212.

Literature: *Scottish Art Review*, vol.V, n.4, p.21, repr.; Jean-Claude Martinet and Guy Wildenstein, *Marquet, L'Afrique du Nord, Catalogue de l'oeuvre peint*, Wildenstein Institute, Paris, 2001, 1-60, p.113 and 114 repr. (as *Le Port et La Santé Maritime*).

Catalogue 36
Henri Matisse 1869–1954
Woman in Oriental Dress, July 1919
(*Tête de jeune fille* or *Femme vêtue à l'orientale*)
Oil on canvas stretched over cardboard
40.9 × 32.9cm
16¹/₁₆ × 12⁷/₈in
Signed, lower left: Henri Matisse
2197

Provenance: purchased from Leicester Galleries exhibition by George Eumorfopoulus, November 1919; Eumorfopoulus sale, Sotheby's, London, 12 June 1940, lot 30; from where purchased by A. J. McNeill Reid of Alex Reid & Lefèvre, London for £60; from whom purchased by William McInnes, Glasgow, 1940; by whom presented to Glasgow Art Gallery and Museum to commemorate the appointment of T. J. Honeyman as Director, 1940.

Exhibitions: London, 1919; London, 1940, lot 30;

Glasgow, 1943, n.69 (as *Tête de Jeune Fille*); Edinburgh, 1944, n.214, p.24; Glasgow, 1945, n.75; Knocke-le-Zoute, Belgium, 1952, n.21; Edinburgh, 1955, n.9; London, 1962, n.240, p.82, repr.; Washington, 1986–87, n.71, p.298, p82, pl.28 repr. (as *Femme vêtue à l'orientale*, July 1919); Rome, 1997–98, n.61, p.182, p.183 repr.; Paris, 1999–2000, n.50, p.126, p.127 repr.

Literature: Elie Faure, Jules Romains, Charles Vildrac and Léon Werth, *Henri Matisse*, Paris, 1920, pl.36; Alfred H. Barr Jr, *Matisse, His Art and Public*, New York, The Museum of Modern Art, 1951, p.557; A. J. McNeill Reid, 'The French Room at Kelvingrove', *Scottish Art Review*, vol.VII, n.3, 1960, pp.15–19, 29–30, p.18 repr.; T. J. Honeyman, 'Les Fauves – Some Personal Reminiscences', *Scottish Art Review*, vol.XII, n.1, 1969, pp.17–20, repr.; Richard Shone 'Matisse in England and two English Sitters', *The Burlington Magazine*, vol.CXXXV, n.1084, July 1993, pp.479–84, see footnote 11, p.480.

Catalogue 37
Henri Matisse 1869–1954
*The Pink Tablecloth, c.*1924–25
(*Anemones sur une table* or *La nappe rose*)
Oil on canvas
60.5 × 81.3cm
23³/₄ × 31¹⁵/₁₆in
Signed, lower left: Henri Matisse
2402

Provenance: Jos. Hessel; from whom purchased by Etienne Bignou in 1925; from whom purchased by A. J. McNeill Reid for William McInnes, July 1925 (stock n.3970); William McInnes; by whom bequeathed to Glasgow Art Gallery and Museum, 1944.

Exhibitions: Paris, 1931, n.121 (as *La Nappe rose*); Glasgow, 1943, n.68; Edinburgh, 1944, n.234B, p.25 (lent by William McInnes); Glasgow, 1945, n.67; Edinburgh, 1968, p.32, repr. (as *Pink Tablecloth*, 1925); London, 1980, n.17, p.13, p.32, repr.; Leeds, 1985, n.26, p.24, p.25, repr.; Tokyo–Nagoya–Osaka–Kumamoto, 1994, n.63, pp.209–210, pp.154– 5, repr.

Literature: *Die Kunst*, Berlin, October 1929; A. C. Barnes and Violette de Mazia, *The Art of Henri Matisse*, New York, 1933, p.445, n.159 and pp.106, 115; T. J. Honeyman, *Introducing Leslie Hunter*, London, 1937, pp.174–5; *The Art Review*, vol.1, n.1, 1946, p.19, repr. (as *La Nappe Rose*); Alfred H. Barr, *Matisse: His Art and Public*, New York, 1951, pp.212, 557; Clive Bell, 'Henri Matisse', *Apollo*, vol.57, December 1953, p.155, repr.; exhibition catalogue, *Henri Matisse: The Early Years in Nice 1916–1930*, National Gallery of Art, Washington, 1986, p.236, fig.4.

Catalogue 38
Georges Michel 1763–1843
Landscape with Cottages, after 1830
(*Nuages orageux*)
Oil on paper mounted on canvas
80.4 × 100.5cm
30⁷/₈ × 39in
Unsigned
3111

Provenance: private collection America; Weitzner Gallery (Julius H. Weitzner, 10 Fern Street, London); New York dealer; from whom purchased by Hazlitt Gallery, London in 1955; from whom purchased by a French dealer in 1955; Messrs G. M. Lotinga Ltd, London; from whom purchased by Glasgow Museum and Art Galleries, 1959.

Exhibitions: ? London, 1955, n.33 (as *Nuages orageux*); Glasgow, 1977, n.28, p.23 (as *Landscape with Cottages*); Glasgow, 1997, p.10, repr. p.28.

Literature: Griselda Pollock, 'Vincent van Gogh in zijn Hollandse jaren', Van Gogh Museum, Amsterdam 1980, p.158, n.116, p.79, repr.; Hamish Miles, 'Some French Eighteenth Century Pictures at Kelvingrove', *Scottish Art Review*, vol.IX, n.4, p.25.

Catalogue 39
Jean-François Millet 1814–75
*Going to Work, c.*1850–51
(*Le départ pour le travail*)
Oil on canvas
55.9 × 46.4cm
21⁷/₈ × 18¹/₈in
Unsigned
1111

Provenance: said to have been bought from the artist by Millet's dealer Collot in 1851; Collot sale, Paris, 25, 26, 29 May 1852; Justice C. Day; from whom purchased by Boussod, Valadon et Cie, Paris, 24 March 1882 (n.15983); from whom purchased by James Donald, Glasgow, 24 March 1882; by whom bequeathed to Glasgow Art Gallery and Museum, 1905.

Exhibitions: Glasgow, 1883, n.38; Edinburgh, 1886, n.1138; Glasgow, 1888, n.667; London, 1889, n.81; London, 1898, n.115; Glasgow, 1901, n.1300; Kirkcaldy, 1925, n.16; Norwich, 1925, n.34; London–Manchester, 1932, n.347, p.167 (as *Partant pour le travail*); Glasgow, 1943, n.24; Edinburgh, 1944, n.141; London, 1950, n.51, p.19; London, 1962, n.214, p.74; London, 1969, n.26, repr.; London, 1974, n.46; London, 1980, n.18, p.13, p.26, repr.; Vatican City State, 1991–92, n.6, p.118, repr.; Amsterdam, 1992–93, n.5, p.41, repr. and p.11; Tokyo–Nagoya–Osaka–Kumamoto, 1994, n.5, pp.46–7, repr. and p.195; Glasgow, 1997, p.11, repr. p.28.

Literature: A. Sensier, *La vie et l'oeuvre de J. F. Millet*, Paris, 1881, p.376, and London, 1881, p.90; *Memorial Catalogue of French and Dutch Loan Collections*, Edinburgh, 1888, p.54, p.78; W. L. Henley, *A Century of Artists*, Glasgow, 1889, p.125; Beraldi, *Les Graveurs du 19th siècle*, 1890, n.10; D. Croal Thomson, *The Barbizon School of Painters*, London, 1891, p.227, repr.; L. Soullié, *Catalogue descriptif . . . Millet sale records 1849–1900*; Percy Bate, *Art at the Glasgow Exhibition 1901*, London, 1901, p.74, p.80, repr.; D. S. MacColl, *Nineteenth Century Art*, Glasgow, 1902, p.88, repr.; 'The Donald Bequest', *Art Journal*, 1905, p.190, repr.; L. Delteil, *Peintre-Graveur*, 1906, vol.1, n.19; T. J. Honeyman, 'Art Masterpieces', *Art Journal*, 1906, p.70, repr.; *The Studio*, vol.39, 1907, p.198; T he *Print Collectors Quarterly*, Boston, 1912, vol.2, p.225; *The Print Collectors Quarterly*, Boston, 1914, vol.4, p.3; E.

Moreau-Nelaton, *Millet raconté par lui-même*, Paris, 1921, p.92; Robert Herbert, *Millet Reconsidered, Museum Studies*, Art Institute of Chicago, 1966, vol.1, p.60; T. J. Clark, *The Absolute Bourgeois, Artists and Politics in France 1848–1851*, London, 1973, pp.96–7, pl.VI, p.78, repr.; exhibition catalogue, Gabriel P. Weisberg, *Social Concern and the Worker: French Prints from 1830–1910*, University of Utah, 1973, fig.7, p.16; exhibition catalogue, *J. F. Millet*, Hayward Gallery, London, 1976, p.96; Griselda Pollock, *Millet*, London, 1977, n.22, p.45, repr.; ed. Gabriel P. Weisberg, *The European Realist Tradition*, Indiana, 1982, p.223, p.229, repr.; Roger Billcliffe, *The Glasgow Boys*, London, 1985, p.32, n.20, repr.; Laura Wortley, *British Impressionism*, London, 1988, p.81 repr.

Catalogue 40
Claude Monet 1840–1926
*Vétheuil, c.*1880
(*Paysage à Vétheuil*)
Oil on canvas
60.0 × 80.6cm
23¹/₂ × 31¹/₂in
Signed, lower right: Claude Monet
2403

Provenance: purchased from the artist on 3 April 1918 by Bernheim-Jeune and Durand-Ruel, Paris; from whom purchased by Léon Marseille in 1918; resold to Bernheim-Jeune; from whom purchased by Alex Reid, Glasgow in 1919 (n.2840); from whom purchased by William McInnes in 1920; by whom bequeathed to Glasgow Art Galleries and Museums, 1944.

Exhibitions: Glasgow, 1920, n.150; Glasgow, 1943, n.35 (lent by William McInnes as *Vétheuil*); Glasgow, 1945, n.41; Belfast, 1958–59, n.12; Cardiff, 1960, n.43, p.xiii, p.35, repr. (as *c.*1878–80); Wolfsburg, 1961, n.106; Glasgow, 1967 (Reid), n.31, p.36, pl.11, repr. (as 1880); Edinburgh, 1968, p.16, repr.; London, 1969 (R-L), n.18, p.53 repr.; London, 1980, n.19, p.13, p.28, repr.; Glasgow, 1997, p.13, repr. p.31.

Literature: *The Art Review*, vol.I, n.1, 1946, p.18 repr.; Alex Sturrock, 'Impressionist Paintings in Glasgow', *Apollo*, vol.57, 1953, p.42, repr.; *Scottish Art Review*, vol.VI, n.3, 1957, p.5, repr.; Daniel Wildenstein, *Claude Monet: biographie et catalogue raisonné – vol I, 1840–1881 peintures*, Lausanne, 1974, n.595, p.368 (as *Paysage à Vétheuil*); John House, *Monet: Nature into Art*, New Haven and London, Yale University Press, 1986, p.167, fig.204, p.168 repr.; Richard Kendall (ed.), *Monet by Himself*, London, 1989, p.92.

Catalogue 41
Claude Monet 1840–1926
View of Ventimiglia
(*Vue de Vintimille*)
Oil on canvas
65.1 × 92.1cm
25⁵/₈ × 36¹/₈in
Signed and dated, lower right: Claude Monet 84
2336

Provenance: Durand-Ruel, Paris, September 1888; Marietton, 1890; sale, Mrs James F. Sutton, Chickering Hall (The American Art Galleries), New

York, 30 May 1895 or 25–30 April, n.97, lot 97; from where purchased by Durand-Ruel, Paris (stock n.3323, ph.D.R. 749); from whom purchased by Arthur Tooth and Sons, London, 1943; from whom purchased by the Hamilton Trustees and presented to Glasgow Art Gallery and Museum, Hamilton Bequest, 1943.

Exhibitions: Venice, 1897, n.51 (lent by Durand-Ruel); Paris, 1899, n.21; Stuttgart, 1901; London, 1905, n.137; London, 1939 (M), n.32; Glasgow, 1951, n.35; Scottish Tour, 1951–52, n.21, p.10 (as *Vue de Ventimille*); Edinburgh–London, 1957, n.72, p.52, pl.20i, repr. (as *View Towards Ventimiglia*, 1884); Glasgow, 1967 (H), p.42, n.45, repr.; Edinburgh, 1968, p.19, repr.; Glasgow, 1977, n.42 p.30, repr. (as *View of Ventimiglia*); Paris, 1983, n.6, p.32, fig.5, p.19 repr.; Tokyo–Nagoya–Osaka–Kumamoto, 1994, n.29, pp.94–5, repr. p.201; Fort Worth–New York, 1997–98, n.24, p.98, repr.; Bordighera, 1998, p.99, repr.

Literature: *Letters* vol.III, 1357, 1361; pièce justificative n.95; L. Venturi, *Archives*, 1939, vol.I, p.364; Alec Sturrock, 'Impressionist Paintings in Glasgow', *Apollo*, vol.57, 1953, p.42; *Scottish Art Review*, vol.VI, n.3, 1957, p.19, repr.; Brian Petrie, *Claude Monet, The First of the Impressionists*, Oxford, 1979, p.60–3, repr.; Daniel Wildenstein, *Claude Monet: Biographie et catalogue raisonné*, vol.II, Peintures, 1882–1886, Lausanne, 1979, n.878, p.122, p.123, repr. (as *Vue de Vintimille*); Horst Keller, *Claude Monet Der Impressionist*, Zurich and Munich, 1990, p.57, n.8, repr.; Berndt Kuster, *Monet, Seine Reisen in den Suiden*, Hensurg, 1992, p.16, repr.

Catalogue 42
Henry Moret 1856–1913
Cliffs at Port Domois, Belle-Ile, c.1890
Oil on canvas
73.2 × 60.1cm
28⅝ × 23½in
Signed, lower left: Henry Moret
3168

Provenance: ? R. N. Ketterer, Stuttgart; private collection, Paris; Rheims & Laurin, 1, rue de Lille, Paris; from whom purchased by Roland, Browse & Delbanco, London; Tib Lane Gallery, Manchester; from whom purchased by the Hamilton Trustees and presented to Glasgow Art Gallery, Hamilton Bequest, 1962.

Exhibitions: Glasgow, 1967 (H), n.46, repr. p.47; Edinburgh, 1968, p.23, repr.; Stirling, 1973.

Literature: Museum catalogues only.

Catalogue 43
Pablo Picasso 1881–1973
The Flower Seller, 1901
(*La marchande de fleurs dans la rue*)
Oil on millboard
33.7 × 52.0cm
13¼ × 20½in
Signed, lower left: Picasso
2417

Provenance: Mme Besnard, Paris; Tanner, Zurich; from whom purchased by Alex Reid & Lefèvre in October 1934; from whom purchased by William McInnes for £550; by whom bequeathed to Glasgow Art Gallery and Museum, 1944.

Exhibitions: ? Paris, 1901, n.22 (as *Le Square*, lent by Mme. Besnard); ? Paris, 1904, n.31 (as *Marchande des quatre saisons*); Glasgow, 1943, n.62 (lent by William McInnes); Edinburgh, 1944, n.225, p.25 (as *La Marchande de Fleurs*, lent by William McInnes); Edinburgh, 1955, n.11; Belfast, 1958–9, n.13, p.6 (as *The Flower Seller*, 1901); London, 1962, n.256, p.86; Edinburgh, 1968, p.42, repr.; London, 1980, n.22, p.14, p.31, repr.; Barcelona, 1994–95, n.160, p.215 repr.; Düsseldorf-Stuttgart, 1995–96, n.13 repr.; Tokyo, 2000, n.16, p.53 repr.

Literature: *The Glasgow Art Review*, vol.I, n.4, 1947, summer, p.18, repr.; *The Studio*, vol.CXLI, n.699, June 1951, p.161 repr.; E. Newton, *Apollo*, vol.57, December 1953, p.169, repr.; Christian Zervos, *Pablo Picasso*, 33 vols, Paris, 1932–78, vol.XXI, 207; Gaston Diehl, *Picasso, 1960*, p.5, repr.; Pierre Daix & Georges Boudaille, *Picasso, the Blue and Rose Periods, A Catalogue Raisonné 1900–1906*, London,1967, p.45, V65, p.183 and p.185 repr.; Timothy Hilton, *Picasso*, London, 1975, p.19, p.20, pl.8 repr.; Josep Palau i Fabre, *Picasso, The Early Years 1881–1907*, Barcelona, 1985, ill.581, p.231 repr., p.250 and n.581, p.534 (as *Spring 1901*); ed. Werner Spies, *Picasso's World of Children*, Munich and New York, 1996, pp.20–1, pl.13.

Catalogue 44
Camille Pissarro 1830–1903
The Banks of the Marne
(*Chemin de Halage* or *Bords de la Marne*)
Oil on canvas
84.0 × 110.2cm
32¼ × 42½in
Signed and dated, lower right: C. Pissarro 1864
2934

Provenance: said to have been looted during the Franco-Prussian War and later found in Germany (according to A. J. McNeill Reid of Alex Reid & Lefèvre); Goldschmidt Collection, Berlin; Herbert Einstein (dealer), London; from whom purchased by Alex Reid & Lefèvre; from whom purchased by the Hamilton Trustees and presented to Glasgow Art Gallery and Museum, Hamilton Bequest, 1951.

Exhibitions: ? Paris, 1864, Salon, as n.1558 *Bords de la Marne* or n.1559 *La Route de Cachalas à La Roche-Guyon*; Edinburgh, 1944, n.259; Belfast, 1958–59, n.14; Sheffield, 1960; Cardiff, 1960, n.29, p.x (as *The Tow Path*); London, 1962, n.247, p.84; Glasgow, 1977, n.54, p.36, repr.; London–Paris–Boston, 1980–81, n.3L, p.71 repr. (as *Le Chemin de Halage*, shown in London only); Edinburgh, 1986, n.9, p.33, repr.; Birmingham–Glasgow, 1992, n.2, pl.1, repr., pp.12–13 repr. (as *Bords de la Marne*); Paris–New York, 1994–95, n.154, pp.443–4, repr. fig.116, p.88 (as *Banks of the Marne*); London-Boston, 1995–96, n.8, pp.80–1, repr.; Tobu, 1996, n.124, p.165, repr.; Glasgow, 1997, p.30, repr.; Tokyo–Osaka–Fukuoka-Mie, 1998, n.17, p.47.

Literature: A. Tabarant, *Pissarro*, Paris, 1924, p.17; *Scottish Art Review*, vol.IV, n.1, 1952, pl.6, repr.; *Scottish Art Review*, vol IV, n.3, 1953, p.14; Alex Sturrock, 'Impressionist Paintings in Glasgow', *Apollo*, vol.57, 1953, p.42; Cambridge, Fitzwilliam Museum, *Annual Report*, 1964, p.8; Kermit Swiler Champa, *Studies in Early Impressionism*, New Haven and London, Yale University Press, 1973, pp.70–3, fig.99, repr.; John Rewald, *The History of Impressionism*, New York, 4th ed. rev.1973, n.22, p.136; R. Brettell, *Pissarro and Pontoise: the Painter in a Landscape*, unpublished Ph.D., 1977, pp.245–7; Christopher Lloyd, *Pissarro*, Oxford, 1979, p.4, pl.1 repr. (as *The Banks of the Seine at Bougival*); Christopher Lloyd, *Camille Pissarro*, New York, 1981, p.28; David Bomford, Jo Kirby, John Leighton and Ashok Roy, *Art in the Making: Impressionism*, New Haven and London, 1990, p.17, pl.5, repr.

Catalogue 45
Camille Pissarro 1830–1903
The Tuileries Gardens, Paris
(*Le Jardin des Tuileries*)
Oil on canvas
74.0 × 92.6cm
29 × 37¼in
Signed and dated, lower right: C Pissarro. 1900.
2811

Provenance: ? Durand-Ruel, Paris; Alex Reid, Glasgow; from whom purchased by Sir John Richmond CBE, March 1911 for £220; by whom presented to Glasgow Art Gallery and Museum, 1948.

Exhibitions: Glasgow, 1943, n.26 (lent by Sir John Richmond); Edinburgh, 1944, n.187, p.22 (lent by Sir John Richmond); Edinburgh, 1949, n.276; London, 1949–50, n.279; Paisley, 1952; Glasgow, 1967 (Reid), n.36, p.38, pl.13; Edinburgh, 1968, p.15, repr.; London–Paris–Boston, 1980–81, n.85, pp.146–7, repr.; Amsterdam, 1992–93, n.6, p.42, repr.; Dallas–Philadelphia–London, 1992–93, n.84, p.116, repr.; Tokyo–Nagoya–Osaka–Kumamoto, 1994, n.25, pp.86–7, repr. p.200 (exhibited in London only); Copenhagen, 1995–96; Ferrara, 1998, pl.52, p.87.

Literature: L. R. Pissarro and L. Venturi, *Camille Pissarro, son art, son oeuvre*, Paris, 1939, n.1133; W. J. Macaulay 'Some Additions to the Glasgow Art Collection', *Scottish Art Review*, vol.IV, n.3, 1953, p.15, repr.; Alec Sturrock, 'Impressionist Paintings in Glasgow', *Apollo*, vol.57, 1953, p.42; *Scottish Art Review*, vol.VI, n.3, 1957, p.2, repr.; exhibition catalogue, *A Day in the Country, Impressionism and the French Landscape*, New York, 1984, p.214, repr.

Catalogue 46
Auguste Renoir 1841–1919
Portrait of Madame Valentine Fray (1870–1943)
Oil on canvas
65.2 × 54.3cm
25½ × 21¼in
Signed and dated, lower right: Renoir. 01.
2419

Provenance: William McInnes; by whom bequeathed to Glasgow Art Gallery and Museum, 1944.

Exhibitions: Glasgow, 1943, n.47; Edinburgh, 1944, n.176 (as *Portrait de Madame 'X'*, lent by William McInnes); Glasgow, 1945, n.49; London, 1956 (M), p.29, n.22 (as of *Madame Gaston Bernheim*); Tokyo–Nagoya–Osaka–Kumamoto, 1994, n.33, pp.102–3, repr. pp.202–3.

Literature: 'The McInnes Collection', *The Art Review*, vol.I, n.1, 1946, p.21, repr.; *Scottish Art Review*, vol.IV, n.3, 1953, p.19, repr.; Alec Sturrock, 'Impressionist Paintings in Glasgow', *Apollo*, vol.57, 1953, p.42, repr.; Anne Donald, 'Renoir's "Madame X" in Glasgow', *Scottish Art Review*, vol.X, n.4, 1966, pp.22–3, repr.; Barbara Ehrlich White, *Renoir, His Life, Art and Letters*, New York, 1984, pp.218–19, p.221, repr.

Catalogue 47
Auguste Renoir 1841–1919
The Painter's Garden, c.1903
(*Jardin à Essoyes*)
Oil on canvas
33.23 × 46.1cm
13 1/16 × 18 1/8in
Lower right: atelier stamp, Renoir
2418

Provenance: Renoir studio, n.224 as part of a canvas size 10, with another landscape and a head; Bernheim-Jeune; ? Justice, Dundee; with William McInnes by 1925; by whom bequeathed to Glasgow Art Gallery and Museum, 1944.

Exhibitions: Norwich, 1925, n.61, (as *The Painter's Garden, Cagnes*, lent by William McInnes); Glasgow, 1943; Edinburgh, 1955, n.14; Belfast, 1958–59, n.15; London, 1962, n.235, pp.80–1; Edinburgh, 1968, p.31, repr. (as c.1908–10); Tokyo–Nagoya–Osaka–Kumamoto, 1994, n.32, pp.100–1, repr. p.202.

Literature: Messrs Bernheim-Jeune, *Renoir's Studio*, Paris, 1931, n.224, pl.72 repr. (as *Jardin à Essoyes*, 1903), reprint, San Francisco, 1989; Alec Sturrock, 'Impressionist Paintings in Glasgow', *Apollo*, vol.57, 1953, p.42; Anthea Callen, *Renoir*, London, 1978, p.93, n.77 repr. (as c.1905).

Catalogue 48
Auguste Renoir 1841–1919
Still-Life, c.1908
(*Tasse et mandarins* or *Nature morte à la tasse*)
Oil on canvas
16.0 × 25.5cm
6 1/4 × 10in
Signed, lower right: Renoir
Inscribed, on reverse in pencil: Cagnes, 1908 (in Renoir's own hand?)
2420

Provenance: Maurice Gangnat; his sale, Hôtel Drouot, Paris, 24–25 June 1925, lot 82; from which purchased by Etienne Bignou, Paris (letter from A. J. McNeill Reid, 8 February 1966); Alex Reid; sold to Leonard Gow; sold to William McInnes; by whom bequeathed to Glasgow Art Gallery and Museum, 1944.

Exhibitions: Glasgow, 1943, n.48 (lent by William McInnes); Glasgow, 1945, n.50; Glasgow, 1986–87, (no cat.).

Literature: Glasgow Museum catalogues.

Catalogue 49
Georges Rouault 1871–1958
Circus Girl, 1939
(*Fille de cirque*)
Oil on paper, mounted on canvas
64.5 × 45.6cm
25 5/16 × 17 13/16in
Signed, lower right: G Rouault
3103

Provenance: (?) E. Bignou (8, rue la Boetie), Paris; from whom purchased by Alex Reid & Lefèvre, London in 1940 (n.21/40); from whom purchased in 1946 by Mrs E. M. Macdonald; by whom presented to Glasgow Art Gallery in memory of her husband Duncan M. Macdonald, 1959.

Exhibitions: London, 1946, n.29, p.15, repr. (as lent by Read [sic] & Lefèvre in large catalogue and Bignou Collection in small catalogue); London, 1947, n.48; Edinburgh, 1958 (FI), n.2 (as collection Mme E. M. Macdonald, lent by Glasgow Art Gallery); London, 1962, n.254, p.86; Edinburgh, 1968, p.38, repr. (as c.1930–35); Glasgow, 1977, n.32, pp.23–4 repr. p.18 (as c.1925–30).

Literature: 'Loan Painting in Glasgow Art Gallery', *Glasgow Herald*, 2 November 1957; A. Humbert, *Scottish Art Review*, vol.IV, 1958, p.3, repr.; *Scottish Art Review*, vol.VI, n.4, 1958, p.3; 'Did You Hear That?', *The Listener*, 15 October 1959, p.609; A. J. McNeill Reid, 'The French Room at Kelvingrove', *Scottish Art Review*, vol.VII, n.3, 1960, p.29, p.19 repr.; Bernard Dorival and Isabelle Rouault, *Rouault, l'Oeuvre Peint*, Monte-Carlo, 1988, n.1962, p.166 repr.

Catalogue 50
Théodore Rousseau 1812–67
The Edge of the Forest of Clairbois, Fontainebleau, c.1836–39
(*Lisière de Clairbois* or *La forêt de Clairbois*)
Oil on canvas
65.9 × 105.0cm
25 3/4 × 41in
Signed, lower left: TH. Rousseau
1124

Provenance: collection Théophile Thoré; Edwards sale, Paris, 7 March 1870, lot 34 (for 13,600FF); Laurent-Richard; Laurent-Richard sale, Paris, 7 April 1873, lot 47 (for 33,500FF); James Donald; by whom bequeathed to Glasgow Art Gallery and Museum, July 1905.

Exhibitions: ? Paris, 1850–51, n.2708; Edinburgh, 1886, n.1146; Glasgow, 1888, n.755 (lent by J. Donald); London, 1898; Glasgow, 1901, (lent by J. Donald); Kirkcaldy, 1925; London–Manchester, 1932, n.87 and n.369, p.176; Paris, 1937, n.406, p.197; London, 1949–50, n.200; London, 1959, n.308, pp.203–4; London, 1974 (RA), n.50 (as *La Forêt de Clairbois*, c.1850s); Norwich-London, 1982, n.27, pl.20 (as *Forest of Clairbois*, 1836–39); Edinburgh, 1986, n.13, pp.62–3, repr., p.197; Glasgow, 1997, p.29.

Literature: Archives Braun, n.83; Archives Moreau-Nélaton, Louvre; J. Ravenal (alias A. Sensier), 'Vente de la Collection Edwards' in *Revue universelle de l'art et de la curiosité*, vol.III, 1870, p.112; A Silvestre, *Vente Laurent-Richard*, Paris, 1873, p.49; *Edinburgh International Exhibition 1886, Memorial Catalogue of the French and Dutch Loan Collection*, 1888, n.95, p.72, repr.; Percy Bate, *Art at the Glasgow Exhibition 1901*, London, 1901, p.75; H. Focillon *La Peinture au XIXème siècle – Le Retour à l'antique, le Romantisme*, Paris, 1927, p.348; *Commemorative Catalogue of the Exhibition of French Art, 1200–1900*, Royal Academy, London, 1932, n.502, p.113; Michel Schulman and Maria Bataillès, *Théodore Rousseau 1812–1867, Catalogue raisonné de l'oeuvre peint*, Paris, 1999, n.644, p.327 repr. (as *Lisière de Clairbois en forêt de Fontainebleau*, 1839–65).

Catalogue 51
Georges Seurat 1859–91
The Riverbanks: Study for 'Bathers at Asnières,' c.1882–83
(*Les deux rives (étude pour Une Baignade)*)
Oil on wooden panel
15.8 × 25.1cm
6 1/4 × 9 7/8in
Unsigned
2422

Provenance: the artist until 1891; included in the posthumous inventory but not numbered; inherited by Madeleine Knoblock, Paris, in 1891, until 1892; sold to Jean de Greef, Auderghem, Belgium, in February 1892, until no later than 1894; Félix Fénéon, Paris by at least 1908, until at least 1920; Étienne Bignou, Paris (?); Percy Moore Turner (Independent Gallery), London by 1930; from whom purchased by William McInnes; by whom bequeathed to Glasgow Art Gallery and Museum, 1944.

Exhibitions: New York, 1886, n.133 (n.3 in a frame of '12 studies'); Paris, 1887, n.447 (one of *douze croquis*); Brussels, 1892, n.I (one of *douze esquisses*); Paris, 1908–9, n.21 (as *Les Deux Rives, Etude pour Une Baignade*); Paris, 1919–20, n.53; Glasgow, 1943, n.34 (as 1883, lent by William McInnes); Edinburgh, 1944, n.220, p.24 (lent by William McInnes); Glasgow, 1945, n.66; Amsterdam, 1953, n.58; Glasgow, 1972–73, n.114; London, 1978, n.14, p.38 repr.; London, 1980, n.28, p.16, p.28 repr.; Glasgow, 1986–87, (no cat); Paris–New York, 1991–92, n.103, pp.152–3 repr. (as 1882–83, exhibited in Paris only); London, 1997, n.2, pl.48, pp.52–3.

Literature: L. Cousturier, *Georges Seurat*, Paris, 1921, pl.7; Gustave Coquiot, *Georges Seurat*, Paris, 1924, p.199, p.246; L. Cousturier, *Georges Seurat*, Paris, 1926, pl.9 repr.; B. Nicholson, 'Seurat's La Baignade', *Burlington Magazine*, 1941, vol.LXXIX, p.140; Douglas Cooper, *Georges Seurat, Une Baignade à Asnieres*, London, 1946, p.12; John Rewald, *Georges Seurat*, New York, 1946, pl.52, p.86; John Rewald, *Georges Seurat*, Paris, 1948, p.40; John Rewald and H. Dorra, *Seurat*, Paris, 1959, n.84, p.82, repr.; Cesar de Hauke and Paul Brame, *Seurat et son oeuvre*, Paris, 1962, vol.I, p.46, n.79, repr.; John Russell, *Seurat*, London, 1965, ill.114, repr. p.118; Andre Chastel, *L'opera completa di Seurat*, Milano, 1972, n.83, repr.; Richard Thomson, *Seurat*, Oxford, 1985, p.79 (as *The Two Banks*); John Rewald, *Seurat*, New York, 1990, p.59,

repr.; Paul Smith, 'Painter who sought the point of things', *The Glasgow Herald*, 27 April 1991, p.30, repr.; Michael F. Zimmermann, *Seurat and the Art Theory of his Time*, 1991, ill.286, p.152 repr, p.155; Sarah Carr-Gomm, *Seurat*, London, 1993, pp.64–5, repr.

Catalogue 52

Georges Seurat 1859–91
Boy Sitting in a Meadow, c.1882–83
(*Petit paysan assis dans un pré*)
Oil on canvas
65.0 × 81.2cm
25 × 31³/₈in
Unsigned
2857

Provenance: Léon Appert; M. Mignon; from whom purchased by Bernheim-Jeune on 17 December 1906 (n.15.298); from whom purchased by Bernhard Koehler, Berlin, 1908; Alex Reid & Lefèvre, 1936; Lady Huntington; Bignou, New York; David W. T. Cargill (lent to Gallery in 1947); presented by the Trustees of David W. T. Cargill to Glasgow Art Gallery and Museum, 1950.

Exhibitions: Paris, 1900, n.3; London, 1936, n.32 repr.; London, 1936 (C), n.44; Belfast, 1958–59; London, 1962, n.251, p.85 (as 1882); Edinburgh, 1968, p.26, repr.; London–Washington, 1979–80, p.131, n.195, repr. (as c.1883); Tokyo–Nagoya–Osaka–Kumamoto, 1994, n.59, pp.146–7 repr. p.208; London, 1997, n.49, pl.41, p.44, p.46 (as *Seated Boy in a Meadow*, c.1882–83).

Literature: J. Meier-Graefe, *Entwickelungsgeschichte der Modern Kunst*, 1904, p.232, vol.1; John Rewald, *Georges Seurat*, New York, 1946, fig.10 (det.); 'D. W. T. Cargill', *The Glasgow Art Review*, n.4, 1947, p.24, repr.; John Rewald, *Georges Seurat*, Paris, 1948, p.34 repr.; 'Three Notable Paintings', *Scottish Art Review*, vol.III, n.1, 1950, p.31 repr.; Jacques de Laprade, *Seurat*, Paris, 1951, repr.12; H. Dorra and J. Rewald, *Seurat*, Paris, 1959, p.29, n.30, repr.; C. de Hauke and P. Brame, *Seurat et son oeuvre*, Paris, 1962, n.15; John Russell, *Seurat*, London, 1965, pp.72–5, p.112, n.111, repr.; André Chastel, *L'Opera completa di Seurat*, Milan, 1972, pp.92–3, n.25, repr. (as 1882 and painted at Yonne); A. Z. Rudenstine, *The Guggenheim Museum Collection II*, New York, 1976, pp.644–6; Richard Thomson, *Seurat*, Oxford, 1985, pp.45–8, n.44, repr. (as 1883); Robert L. Herbert et al., *Georges Seurat 1859–1891*, The Metropolitan Museum of Art, New York, 1991, p.115–16 repr. (as *Young Peasant Sitting in a Meadow*, c.1881–82); Richard Tilston, *Seurat*, 1991, pp.50–1 repr. (as c.1883); Michael F. Zimmermann, *Seurat and the Art Theory of his Time*, Antwerp, 1991, ill.283, p.150 and pp.152–3 (as c.1882).

Catalogue 53

Georges Seurat 1859–91
House Among Trees, c.1883
(*Maison dans les arbres*)
Oil on wooden panel
15.67 × 25.1cm
6¹/₈ × 9⁷/₈in
Unsigned
2421

Provenance: the artist's brother, Emile Seurat; from whom acquired by Félix Fénéon, Paris; Percy Moore Turner, Independent Gallery, London; from whom purchased by William McInnes; by whom bequeathed to Glasgow Art Gallery and Museum, 1944.

Exhibitions: Glasgow, 1943, n.42 (as *Maison dans les Arbres*, lent by William McInnes); Glasgow, 1945, n.68; Hamburg, 1963, n.98, p.22 repr. (as c.1882); Glasgow, 1972–73, n.113, p.24, repr.; London, 1978, n.9, pp.28–9 repr.; London, 1980, n.29, p.16, p.28, repr. (as *House Among Trees* c.1883); London, 1997, n.47, pl.24, pp.29–31, p.157.

Literature: Claude Roger-Marx, 'Reflections on Landscape', *Scottish Art Review*, vol.II, n.2, 1948, pp.7–11, p.11, repr.; *Scottish Art Review*, vol.III, n.4, 1951, p.19, repr.; John Rewald and H. Dorra, *Seurat*, Paris, 1959, p.64, n.67, repr. (as c.1883); Cesar de Hauke and Paul Brame, *Seurat et son oeuvre*, Paris, 1962, vol.I, p.30, n.56, repr.; Sir Anthony Blunt and Roger Fry, *Seurat*, London, 1965, p.79, pl.12, repr.; John Russell, *Seurat*, London, 1965, n.104, p.108, repr.; Pierre Courthion, *Seurat*, New York, 1968, p.81, repr.; Andre Chastel, *L'opera completa di Seurat*, Milan, 1972, n.65, p.94–5, repr.; S. Alexandrian, *Seurat*, 1980, p.16, repr.; Richard Thomson, *Seurat*, Oxford, 1985, p.39, pl.36, repr., p.41; Alain Madeleine-Perdrillat, *Seurat*, New York, 1990, p.42, repr.; Richard Tilston, *Seurat*, 1991, p.54 repr.; Michel F. Zimmermann, *Seurat and the Art Theory of his Time*, 1991, ill.210, pp.116–17.

Catalogue 54

Paul Signac 1863–1935
Coal Crane, Clichy
(*Grue au charbon. Clichy*)
Oil on canvas
59.3 × 91.8cm
23¹/₄ × 36in
Signed and dated, lower right: P. Signac/1884
2574

Provenance: Goldschmidt, Frankfurt, 1921; Flechtheim, Berlin; Bernheim-Jeune, Paris, 1928 (in draft catalogue); Alex Reid & Lefèvre and Matthiesen Galleries, London, 1943 (R&L n.116/43); T. & R. Annan & Sons, Glasgow; from whom purchased by the Trustees of the Hamilton Bequest, and presented to Glasgow Museum and Art Gallery, Hamilton Bequest, 1946.

Exhibitions: Paris, 1884, n.250 (as *La Grue du Charbon et gazomètre de Clichy*); New York, 1886, n.129 (as *La Grue de Charbon Clichy*); Edinburgh, 1944, n.213, p.24 (as *Le Quai de Clichy*, lent by Reid & Lefèvre); Glasgow, 1946; London, 1946 (D), n.51; Glasgow, 1951, n.48; Scottish Tour, 1951–52, n.31; Belfast, 1958–59, n.18, p.8; Glasgow, 1967 (H), n.61, p.44, repr.; Edinburgh, 1968, p.29, repr.; Glasgow, n.45, p.32 repr.; London, 1980, n.30, p.17, p.29, repr.; Swansea, 1980, n.3, repr.; London, 1997, n.76, pl.136, p.115, repr.

Literature: Cahier d'opus, n.88: *Grue du charbon*; Cahier manuscript: *Grue au charbon. Clichy*, repr. p.84 'avec la mention que le tableau a été rehaussé au pastel'; A. Leroy, *La Presse*, 10 December 1884, p.2; Du Croisy, *La Ligue*, 11 December 1884, p.3; C. Fremine, *Le*

Rappel, 11 December 1884, p.3; G. Parthenay, *L'Opinion*, 12 December 1884; Marcello, *Le Télégraphe*, 17 December 1884, p.3; Anon, *Le Petit Quotidien*, 19 December 1884; A Pinard, *Le Radical*, 19 December 1884; *The Illustrated London News*, 13 July 1946, p.51, repr.; Alex Sturrock, 'Impressionist Paintings in Glasgow', *Apollo*, vol.57, 1953, p.42; Françoise Cachin, *Signac, Catalogue raisonné de l'oeuvre peint*, Gallimard, Paris, 2000, n.79, p.163.

Catalogue 55

Paul Signac 1863–1935
Sunset, Herblay, Opus 206, 1889
(*Herblay. Coucher de Soleil*)
Oil on canvas
57.7 × 90.3cm
22¹/₂ × 35¹/₂in
Signed and dated, lower right: P. Signac 90
Inscribed, lower left: Op.206
3324

Provenance: Comte Antoine de la Rochefoucauld, Paris, 1890; private collection, USA; sale, Parke-Bernet, California, 25 January 1956, lot 89, repr. (as *The Seine at Argenteuil*); Knoedler, New York; Frank Perls Gallery; private collection, London sale Sotheby's, London, 28 June 1972, lot 25b, repr.; C. H. Cintz; private collection, USA; accepted by H. M. Government in lieu of estate duty and presented to Glasgow Art Gallery and Museum, 1976.

Exhibitions: Brussels, 1891, (as *Op.206, Herblay (Seine-et-Oise)*, September 1889), lent by M. le Comte Antoine de la Rochefoucauld); Paris, 1891, n.1109 (lent by M. le Comte de la Rochefoucauld); Paris, 1964, n.32, pp.35–7, p.36 repr. (as *Coucher de Soleil à Herblay*, lent by a private collector, London); London, 1966 (T), n.8; Glasgow, 1977 (J), n.82, p.52; London–Washington, 1979–80, n.210, p.138 repr.; Tokyo–Nagoya–Osaka–Kumamoto, 1994, n.60, pp.148–9, repr. pp.208–9; Edinburgh, 1994, n.175, p.195, p.114 repr., p.115; Paris-Amsterdam-New York, 2001–2002, n.38, p.147 repr.

Literature: F. Fénéon, *Paul Signac*, Vanier, 1890 (as *La Seine au d'Herblay*); F. Fénéon, *Les Hommes d'aujourd'hui*, n.373, n.d. (1890); M. F. (Fouquier), *Le XIXth Siècle*, 20 March 1891, p.2; O. M. (Maus), *L'Art dans les Deux Mondes*, 21 March 1891, p.216; J. Krexpel, *La Revue Blanche* (Série belge), March 1891, p.381; A. Germain, *Le Moniteur des arts*, 27 March 1891, p.543; A. Ernst, *La Paix*, 27 March 1891; William B., *La Revue Blanche* (série belge), April 1891, n.ed. 1972, p.19; P. M. Olin, *Mercure de France*, April 1891, p.237; Saint-Rémy, (G. Lecomte). *L'Art dans les deux mondes*, 4 April 1891, p.324; G. Geffroy, 10 April 1891, in *La Vie artistique*, 1892, p.308; J. Christophe, *Journal des artistes*, 12 April 1891, p.100; J. Antoine, *La Plume*, 1 March 1891, n.ed. 1968, p.157; A. Retté, *L'Ermitage*, May 1891, new ed. 1968, p.295; J. Leclerq, *Mercure de France*, May 1891, p.298; A. de La Rochefoucauld 'Paul Signac', *Le Cœur*, May 1893, p.5; G. Charensol, *La Revue des Deux Mondes*, 1 January 1964, pp.130–5; 'La chronique des arts', *Gazette des Beaux-Arts*, March 1978, supplement, p.78, repr. n.323; F. Cachin, *Japonisme in Art. An International Symposium*, 1980, p.230; Belinda Thomson and Michael Howard, *Impressionism*, London, 1988,

pp.172–3; Françoise Cachin, *Signac, Catalogue raisonné de l'oeuvre peint*, Paris, 2000, n.192, p.195 repr.

Catalogue 56

Alfred Sisley 1839–99
Boatyard at Saint-Mammès, c.1886
(*Le chantier à Saint Mammès*)
Oil on canvas
38.8 × 56.0cm
15 × 22in
Signed, lower right: Sisley
2464

Provenance: François Depeaux, Rouen; Depeaux sale, Galeries Georges Petit, Paris, 31 May and 1 June 1906, lot 43; from which purchased by Léon Orosdi (for 2,350FF); Léon Orosdi, Paris; Alfred Daber, Paris; (?) Lockett Thomson, London; (?) Alex Reid & Lefèvre (n.221/42); (?) Mrs S. Kaye, London; Alex Reid & Lefèvre, London (n.274/43); from whom purchased through Annan by the Hamilton Trustees and presented to Glasgow Art Gallery and Museum, Hamilton Bequest, 1944.

Exhibitions: Glasgow, 1944; Glasgow, 1951, n.49; Scottish Tour, 1951–52, n.32; Bournemouth, 1960, n.47 (as *Boatyard on the Loing, Moret*, 1879); Glasgow, 1967(H), p.43, n.62, repr.; Edinburgh, 1968, p.22, repr. (as c.1880–6); Nottingham, 1971, pp.28–9, n.9, repr. (as *Le Chantier à Saint-Mammès*); Glasgow, 1977, p.31, n.43, repr.; London, 1980, p.17, n.32, p.29, repr.; Tokyo–Nagoya–Osaka–Kumamoto, 1994, n.28, pp.92–3, repr. p.201.

Literature: *Art News*, London, 1938, p.9, repr.; *The Art Review*, vol.I, n.1, 1946, p.31, repr. (as *Boatyard on the Loing, Moret*); *Scottish Art Review*, vol.III, n.3, 1951, p.22, repr.; Alec Sturrock, 'Impressionist Paintings in Glasgow', *Apollo*, vol.57, 1953, p.42, repr.; François Daulte, *Alfred Sisley: catalogue raisonné de l'oeuvre peint*, Lausanne, 1959, n.640, repr. (as *Le Chantier à Saint-Mammès*, 1886).

Catalogue 57

Alfred Sisley 1839–99
Village Street, Moret-sur-Loing, c.1894
(*Rue à Moret-sur-Loing*)
Oil on canvas
38.4 × 46.1cm
15 × 18^1/$_8$in
Signed, lower right, in pencil: Sisley
2424

Provenance: Alex Reid & Lefèvre, London; from whom purchased by William McInnes; by whom bequeathed to Glasgow Art Gallery and Museum, 1944.

Exhibitions: Glasgow, 1920, n.156; ? Glasgow, 1929 (as *Rue de Village*, lent by Andrew Clarke); Glasgow, 1945, n.44; Greenock, 1958, n.25, repr.; Belfast, 1958–59, n.19.

Literature: *Scottish Art Review*, vol.VI, n.3, 1957, p.6, repr.; François Daulte, *Alfred Sisley: catalogue raisonné de l'oeuvre peint*, Paris, 1959, n.833, repr. (as *Rue à Moret-sur-Loing*, 1894).

Catalogue 58

Maurice Utrillo 1883–1955
Village Street, Auvers-sur-Oise, c.1912
(*Eglise et village, Auvers-sur-Oise*)
Oil on canvas
59.5 × 73.0cm
23^3/$_8$ × 28^3/$_4$in
Signed, lower right: Maurice Utrillo. V.
2217

Provenance: Louis Libaude, 17 avenue Trudaine, Paris; sale, Etienne Vautheret, Hôtel Drouot, Paris, 16 June 1933, lot 32 (as *Rue de Village* c.1912, for 29,888FF); Montague Shearman, London; Alex Reid & Lefèvre, 1939; from whom purchased by the Hamilton Trustees and presented to Glasgow Art Gallery and Museum, Hamilton Bequest, 1941.

Exhibitions: Paris, 1913; Paris, 1925; London, 1939 (R–L), n.31; Glasgow, 1940 (RGI), n.421; Glasgow, 1943, n.73; Edinburgh, 1943, n.20; Edinburgh, 1949, n.258; Glasgow, 1951, n.51; Scottish Tour, 1951–52, n.34; London, 1962, n.257, p.87; Glasgow, 1967 (H), p.50, n.64, repr.; Edinburgh, 1968, p.34, repr.; Glasgow, p.29, n.40, repr.; Tokyo–Nagoya–Osaka–Kumamoto, 1994, n.75, pp.178–9, repr. p.213; Oita–Kyoto–Saga–Chiba, 1998–99, n.16, p.47 repr. p.177 (as *Eglise et village, Auvers-sur-Oise*, c.1913).

Literature: *Illustrated London News*, 15 July 1939, p.118, repr.; *The Studio*, vol.CXVIII, September 1939, n.559, p.144, repr.; *The Studio*, vol.CXX, 1940, n.569, p.44 repr.; *The Art Review*, vol.I, n.1, 1946, p.30, repr. (as *Rue de Village*); *The Glasgow Art Review*, vol.I, n.3, 1946, p.18 repr.; Paul Pétridès, *L'Oeuvre Complet de Maurice Utrillo*, Paris, 1959, vol.I, n.399, pp.464–5 repr. (as *Petite Eglise et Maisons Blanches*, c.1913); Alfred Werner, *Maurice Utrillo*, New York, 1981, p.102, pl.24, repr. (as *Village Street*, c.1912).

Catalogue 59

Maurice de Vlaminck 1876–1958
Woody River Scene, after 1927
Oil on canvas
46.5 × 55.2cm
18^1/$_8$ × 21^{11}/$_{16}$in
Signed, lower left: Vlaminck
3086

Provenance: Redfern Gallery, London; from whom purchased by Leslie Howard; Mrs Leslie Howard sale, Christie, Manson & Woods, 28 March 1958, lot 89; from where purchased by Crane Kalman; from whom purchased by Roland, Browse & Delbanco; from whom purchased by Glasgow Art Gallery and Museum, 1958.

Exhibitions: Glasgow, 1977 (J), n.33, p.24; Tokyo–Nagoya–Osaka–Kumamoto, 1994, n.67, pp.162–3, repr., p.211.

Literature: Editorial, *La Chronique des Arts*, supplement to *Gazette des Beaux-Arts*, n.1092, January 1960, p.23, pl.74.

Catalogue 60

Antoine Vollon 1833–1900
A Corner of the Louvre, after c.1872–75
(*Les Tuileries* or *Le Pavillon de Flore*)
Oil on wooden panel
32.0 × 40.4cm
12^1/$_2$ × 15^3/$_4$in
Signed, lower left: A. Vollon
2813

Provenance: Probably Moreau-Chaslon collection; Moreau-Chaslon sale, Hôtel Drouot, Paris, 6 February, 1882, lot 84 (as *Le Pavillon de Flore et le Pont Royal*); probably M. Clemenso de Lyon; M. Clemenso de Lyon sale, Hôtel Drouot, Paris, 19 May, 1888, lot 52 (as *Pavillon de Flore*); M. Millet, Marseilles; M. Millet Sale, Hôtel Drouot, Paris, 9 May 1898, lot 23, repr. (as *Pavillon de Flore*); F. and J. Tempelaere; from whom purchased by Alex Reid, November 1919; from whom purchased by John P. Kinghorn, January 1920; Sir John Richmond; by whom presented to Glasgow Art Gallery and Museum, 1948.

Exhibitions: Glasgow, 1920, n.35 (as *Les Tuileries*); Kirkcaldy, 1928, n.131 (lent by John P. Kinghorn); Tokyo–Nagoya–Osaka–Kumamoto, 1994, n.20, pp.76–7, repr. p.199.

Literature: Carol Forman Tabler, *The Landscape Paintings of Antoine Vollon (1833–1900): A Catalogue and an Analysis*. Ph.D., dissertation, Institute of Fine Arts, New York University, 1995, n.82.

Catalogue 61

Edouard Vuillard 1868–1940
Woman in Blue with Child, c.1899
(*La dame en bleu à l'enfant*)
Oil on cardboard laid down on to wooden cradle
48.6 × 56.6cm
19^1/$_8$ × 22^1/$_4$in
Signed, lower left: E. Vuillard
2814

Provenance: Thadée Natanson, Paris; Natanson sale, Paris, 13 June 1908, lot 50 (as *La dame bleue à l'enfant*); from which purchased by Bernheim-Jeune (16.703); from whom purchased by Octave Mirbeau, Paris, 24 June 1908; Mirbeau sale, 24 February 1919, lot 58; from which purchased by Bernheim-Jeune (21.449); purchased by Alex Reid, 1919; from whom purchased by Sir John Richmond, 31 Jan 1920 for £600; by whom presented to Glasgow Art Gallery and Museum, 1948.

Exhibitions: Glasgow, 1919; Glasgow, 1920, n.127; Glasgow, 1943, n.12; Edinburgh, 1944, n.229, p.25 (as *La mère et l'enfant*, lent by Sir John Richmond, C. B. E.); Edinburgh, 1949, n.265; Cleveland-New York, 1954, n.49; Belfast, 1958–59, n.20; Wolfsburg, 1961, n.172; Paris, 1960–61, p.246, n.741; London, 1962, n.237, p.81; Mannheim, 1963–64, n.313, repr.; Edinburgh, 1968, p.37, repr.; Toronto–California–Chicago, 1971–72, p.94, pl.VIII, p.227 (exhibited in Toronto only); London, 1980, n.34, p.18 repr.; Houston, 1989–90, n.86, pp.114; Glasgow-Sheffield-Amsterdam, 1991–92, p.44, n.35, repr. (as *Woman in Blue with Child*, c.1899, exhibited in Glasgow and

Amsterdam only); Zurich–Paris, 1993–94, pp.347–8 repr. (exhibited in Zurich only); Tokyo–Nagoya–Osaka–Kumamoto, 1994, n.57, pp.142–3 repr. pp.207–8; Frankfurt-am-Main, 1998, n.83, pp.272–3 repr.; Florence, 1998; San Francisco-Dallas-Bilbao, 1999–2000, n.414, pp.257–9, repr.

Literature: *Scottish Art Review*, vol.II, n.3, 1949, p.24, repr. (as *La mère et l'enfant*); John Russell, *Vuillard*, New York, 1971, p.227 and p.95, pl.VII; Denys Sutton, 'A Don Juan of Idealism', *Apollo*, January 1978, p.53, repr.; Klaus Berger, *Japonismus in der westlichen Malerie 1860–1920*, Munich, 1980, pp.224–6, pl.XI; Belinda Thomson, *Vuillard*, Oxford, 1988, pp.64–8, repr. pl.50; Michel Makarius, *Vuillard*, Paris, 1989, pp.7–9, repr. p.105; ed. Martha Kapos, *The Post-Impressionists: A Retrospective*, New York, 1993, p.115, repr., pl.34.

Catalogue 62

Edouard Vuillard 1869–1940
Interior – The Drawing Room, 1901
(*L'enfant sur un tapis* or *L'Intérieur de Salon – Portrait de l'Enfant*)
Oil on compressed cardboard, set in to a secondary wooden support and cradle
35.5 × 52.7cm
14 × 20³/₄in
Signed, lower left: E. Vuillard
2428

Provenance: William McInnes; by whom bequeathed to Glasgow Art Gallery and Museum, 1944.

Exhibitions: Glasgow, 1943, n.10 (as *L'Intérieur de Salon – Portrait de L'Enfant*, lent by William McInnes); Glasgow, 1945, n.36; Glasgow–Sheffield–Amsterdam, 1991–92, n.63, p.59 repr. (as *Interior of the Drawing Room*, exhibited in Glasgow and Amsterdam only); Florence, 1998, n.68, p.108 repr.

Literature: Claude Roger Marx, *Vuillard, His Life and Work*, London, 1946, p.58, repr. (as *Child on Carpet*, c.1905); Claude Roger Marx, *Vuillard*, Paris, 1948, p.64 repr.; Belinda Thomson, *Vuillard*, Oxford, 1988, p.96; Guy Cogeval, *Vuillard le temps détourné*, Paris, 1993, pp.91 and 112 (det.) repr.

Catalogue 63

Edouard Vuillard 1868–1940
Lady in Green, c.1905
(*La dame en vert*)
Oil on compressed cardboard
30.1 × 22.7cm
11⁷/₈ × 8⁷/₈in
Signed, lower right, in blue: Vuillard (remains of)
2426

Provenance: purchased from the artist on 26 May 1919 by Bernheim-Jeune, Paris (21.599. neg. BJZ563);? Alex Reid; sold on 11 October 1919 to ? Matthew L. or Th. Justice, Dundee; William McInnes; by whom bequeathed to Glasgow Art Gallery and Museum, 1944.

Exhibitions: Glasgow, 1945, n.2; Glasgow, 1967 (Reid), n.47.

Literature: Glasgow Museum catalogues.

Catalogue 64

Edouard Vuillard 1868–1940
The Table, 1902
(*La table*)
Oil on compressed cardboard
25.5 × 34.7cm
10 × 13¹/₂in
Signed lower right: E. Vuillard
2427

Provenance: Jos. Hessel; purchased by Bernheim-Jeune, 11 March 1919 (21.454); ? Alex Reid, May 1919; purchased by Thomas Justice, or ? Matthew L. Justice, Dundee, 11 October 1919; William McInnes; by whom bequeathed to Glasgow Art Gallery and Museum, 1944.

Exhibitions: Glasgow, 1945, n.5; Glasgow, 1990, n.31; Tokyo–Nagoya–Osaka–Kumamoto, 1994, n.56, pp.140–1, repr. p.207.

Literature: Glasgow Museum catalogues.

APPENDIX 2
EXHIBITIONS CITED

Summary references for the exhibitions in which each painting has appeared are given in **Appendix 1**. This list, organised chronologically, complements the summary references by giving details, where known, of the exhibition venues and dates. Titles of exhibitions are given as they appear in sources.

Paris, 1850–51
Salon

London, 1860
Flemish and French Gallery

Paris, 1864
Salon

London, 1872
114th Annual Exhibition, Royal Academy of Arts

London, 1873
International Exhibition

Paris, 1873
Salon

Wrexham, 1876
North Wales Art Treasures Exhibition

Edinburgh, 1878
52nd Annual Exhibition, Royal Scottish Academy

London, 1882
United Arts Gallery, May

Glasgow, 1883
22nd Exhibition, Glasgow Institute of the Fine Arts, February–April

Paris, 1884
1er Exposition de la Société des artistes indépendants, Pavillon de la Ville de Paris aux Champs-Elysées, 10 December

Copenhagen, 1885
Society of the Friends of Gauguin, 1 May

London, 1885
117th Annual Exhibition, Royal Academy of Arts, May

Edinburgh, 1886
International Exhibition, French and Dutch Loan Collection

New York, 1886
Works in Oil and Pastel by the Impressionists of Paris, (organised by Durand-Ruel under the auspices of the American Art Association), American Art Galleries, National Academy of Design, 10–28 April

Paris, 1886
Eighth Impressionist Exhibition, 1 rue Laffitte, 15 May–15 June

Paris, 1886 (B)
Exposition de tableaux et de dessins par François Bonvin, Galerie D. Rothschild, 10–31 May

Paris, 1887
Société des Artistes Indépendants, 3ème exposition, Pavillon de la Ville de Paris (Champs-Elysées), 26 March–3 May

Glasgow, 1888
International Exhibition, 8 May–10 November

London, 1889
The French and Dutch Romanticists, Dowdeswell Galleries, April–May

Paris, 1889
Exposition Centenalle de l'Art Français, Collection Cléophas, May

Brussels, 1891
8th Annual Exhibition of Les XX, February–March

Paris, 1891
7th Exhibition of La Société des Artistes Indépendants, 20 March–27 April

Brussels, 1892
Neuvième exposition annuelle des XX, Musée d'Art Moderne, 6 February–6 March

Paris, 1895
Exposition d'oeuvres de Corot a l'occasion de son centenaire, Palais Galliera, May–June

Venice, 1897
2nd Exposition Internationale des Beaux-Arts, 13 March–20 December

London, 1898
Free Pictures Exhibition, West Ham

London, 1898 (G)
Guildhall, June

Paris, 1899
Exposition des oeuvres d'Eugène Boudin, Ecole Nationale des Beaux-Arts, 9–13 January

Paris, 1899 (D-R)
Monet, Pissaro, Renoir and Sisley, Durand-Ruel, April

London, 1900
132nd Annual Exhibition, Royal Academy of Arts, May

Paris, 1900
Seurat, La Revue Blanche, 19 March–5 April

Glasgow, 1901
International Exhibition, Art Gallery and Museum, Kelvingrove, 2 May–9 November

London, 1901
Lhermitte, Goupil Gallery, May

Paris, 1901
Exhibition of Paintings by F. Itturino and P. R. Picasso, Galeries Vollard, 25 June–14 July

Stuttgart, 1901
Art Français Contemporain, Kunstverein

Glasgow, 1903
Le Sidaner

Paris, 1904
Galerie Berthe Weill, 2 October–20 November

London, 1905
Pictures by Boudin, Cézanne, Degas, Manet... Grafton Gallery (organized by Durand-Ruel)

Glasgow, 1906
45th Annual Exhibition, Royal Glasgow Institute of the Fine Arts, February–May

London, 1908
Winter Exhibition, Royal Academy of Arts

Moscow, 1908
Exposition de la Toison d'Or

Paris, 1908–09
Exposition Georges Seurat (1859–1891), Galerie Bernheim-Jeune et Cie, 15 rue Richepane, 14 December 1908–9 January 1909

London, 1909–10
The Collection of the Late George McCulloch, Royal Academy of Arts

Leeds, 1910
Spring Exhibition, Leeds City Art Gallery

Glasgow, 1911
51st Annual Exhibition, Royal Glasgow Institute of the Fine Arts, February–May

Glasgow, 1912
Fifth Exhibition of Pictures by the Distinguished French Artist Boudin, Alex Reid, La Société des Beaux-Arts, December

Paris, 1913
Utrillo, Galerie Eugène Blot, May

Berlin, 1914
Galerie Paul Cassirer, May–June

Paisley, 1917
Paisley Art Institute

Glasgow, 1919
Edouard Vuillard, Alex Reid, La Société des Beaux-Arts, May

London, 1919
Leicester Galleries, November

Paris, 1919–20
Indépendants: Oeuvres d'artistes ayant exposé à La Société des Artistes Indépendants de 1884–1904, Galerie d'Art des Editions, Galerie Crès et Cie, 21 rue Hautefeuille, 18 December 1919–20 January 1920

Glasgow, 1920
An Exhibition of French Painting, Alex Reid, McLellan Galleries, January

New York, 1921
Paintings by the Great French Impressionists from the Collection of Paul Rosenberg of Paris, Wildenstein Galleries

Paris, 1922
Peinture moderne: Groupe II, Galerie Bernheim-Jeune

Glasgow, 1923
Masterpieces of French Art, Alex Reid, McLellan Galleries, August

London, 1924
Important Pictures by 19th Century French Masters, arranged jointly by Alex Reid and the Lefèvre Galleries, 1a King Street, May–June

Paris, 1924
Tableaux de Pierre Bonnard de 1891 à 1922, Galerie Druet, 7–18 April

Glasgow, 1925
Important Pictures by XIX Century Masters, Alex Reid (with Lefèvre Galleries), January

Kirkcaldy, 1925
Inaugural Fine Art Loan Exhibition, Kirkcaldy Art Gallery, 27 June–20 September

Norwich, 1925
Centenary Exhibition, Castle Museum, 24 October–21 November

Paris, 1925
Exposition Maurice Utrillo, Galerie Barbazanges, March

Cardiff, 1926
Swansea Art Gallery

Glasgow, 1927
A Century of French Paintings, Alex Reid, McLellan Galleries, May

Liverpool, 1927
Walker Art Gallery

Brussels, 1928
Marcoussis, Galerie le Centaure, 10–20 March

Kirkcaldy, 1928
Second Inaugural Loan Exhibition of Pictures by Scottish and Foreign Artists, Museum and Art Gallery, July–August

Glasgow, 1929
68th Annual Exhibition, Royal Glasgow Institute of the Fine Arts

Paris, 1929
Marcoussis, Galerie Georges Bernheim, 15–28 February

Amsterdam, 1930
Vincent van Gogh et ses contemporains, Stedelijk Museum, 6 September–2 November

Glasgow, 1930
XIXth and XXth century French Paintings, Alex Reid & Lefèvre

London, 1930
Renoir and the Post-Impressionists, Alex Reid & Lefèvre, June–July

New York, 1930
Masterpieces by Nineteenth Century French Painters, October–November

New York, 1930 (C)
Corot, Daumier: Eighth Loan Exhibition, The Museum of Modern Art, 16 October–23 November

Paris, 1930
Cent ans de peinture française, Galerie Georges Petit, June

Paris, 1930 (C)
Corot, paysages de France et figures, Paul Rosenberg

Paris, 1931
Henri Matisse, Galerie Georges Petit, 16 June–25 July

London-Manchester, 1932
Exhibition of French Art 1200–1900, Royal Academy of Arts, 4 January–5 March; City Art Gallery, 22 March–1 May

Manchester, 1932
Vincent Van Gogh, Loan Exhibition of Paintings and Drawings, City Art Gallery, October–November

New York, 1933
Paintings from the Ambroise Vollard Collection, Knoedler Galleries, Arts and Crafts Club, November–December

Edinburgh, 1934
108th Annual Exhibition, Royal Scottish Academy

Glasgow, 1934
French Painting of the 19th Century, McLellan Galleries

London, 1934
Renoir, Cézanne and their Contemporaries, Alex Reid &

Lefèvre, June

London, 1935
Pierre Bonnard, Alex Reid & Lefèvre, (organized by MM. Bernheim-Jeune), May

London, 1936
Eugène Boudin and some Contemporaries, Alex Reid & Lefèvre

London, 1936 (C)
Corot to Cézanne, Alex Reid & Lefèvre, June

New York, 1936
London Visualised by Derain, Bignou Gallery, May

London, 1937
Derain. The Thames, 1907, Alex Reid & Lefèvre, December

Paris, 1937
Chefs d'Oeuvre de l'Art Français, Palais National des Arts

Montreal, 1938
Delacroix to Dufy, W. Scott & Son, October

London, 1939
Homage to Paul Cézanne, Wildenstein, July

London, 1939 (M)
Monet, Tooth's

London, 1939 (R-L)
L'Entente Cordiale, Alex Reid & Lefèvre, July

Glasgow, 1940
Narrative Paintings, Art Gallery and Museum, Glasgow

Glasgow, 1940 (RGI)
79th Annual Exhibition, Royal Glasgow Institute of the Fine Arts

London, 1940
The Eumorfopoulos and Harcourt Johnstone Collections, Catalogue of Old and Modern Oil Paintings, etc., Sotheby's 10–12 June (Exhibition and sale of the collection of paintings formed by George Eumorfopoulos)

Dallas, 1942
Exhibition of the Pendulum Swing from Classic to Romantic in French Painting, Museum of Fine Arts, 25 January–22 February

London, 1942
French Paintings of the 19th and 20th Centuries, Alex Reid & Lefèvre

London, 1942 (R-L)
British and French Paintings, Alex Reid & Lefèvre, March–April

Edinburgh, 1943
49th Exhibition, Society of Scottish Artists

Glasgow, 1943
The Spirit of France, French Paintings of the

Nineteenth and Twentieth Centuries, Art Gallery and Museum, 1 June–4 July

Glasgow, 1944
T. & R. Annan

Edinburgh, 1944
A Century of French Art 1840–1940, National Gallery of Scotland

Portland, 1944
Eight Masterpieces of Painting, Art Museum, December

Glasgow, 1945
Exhibition of Paintings, Drawings and Etchings, The McInnes Collection, Art Gallery and Museum, 30 March–29 April

New York, 1945
A Selection of Nineteenth-Century French Paintings, Bignou Galleries, 22 October–17 November

Glasgow, 1946
A. J. McNeill Reid Exhibition, T. & R. Annan

London, 1946
Braque and Rouault, (The British Council), Tate Gallery, April

London, 1946 (D)
Delacroix to Dufy, Alex Reid & Lefèvre, June–July

Philadelphia, 1946
Corot 1796–1875, Museum of Art, 11 May–16 June

Scottish Tour, 1946
Paintings and Drawings from the McInnes Collection, Scottish Arts Council

London, 1947
Bonnard and his French Contemporaries, Alex Reid & Lefèvre, June–July

London, 1947 (R-L)
The Nineteenth-Century French Masters, Alex Reid & Lefèvre, July

London-Birmingham-Glasgow, 1947–48
Vincent van Gogh 1853–1890, Tate Gallery, 9 December 1947–14 January 1948; Museum and Art Gallery, 24 January–14 February 1948; Art Gallery and Museum, 20 February–14 March 1948

Edinburgh, 1948
Exhibition of Paintings by Pierre Bonnard & Edouard Vuillard, Royal Scottish Academy (Arts Council of Great Britain), 17 August–18 September

Paris, 1948
Marcoussis, Galerie d'Art du Faubourg, 15 October–10 November

Edinburgh, 1949
123rd Annual Exhibition, Royal Scottish Academy

Edinburgh, 1949–50
Modern Pictures from a Private Collection, Arts Council Scottish Tour

London, 1949–50
Landscape in French Art, Royal Academy of Arts, 10 December 1949–45 March 1950

Edinburgh, 1950
Paintings and Drawings by Modern French Masters, Edinburgh University Art Society, 2–17 May

London, 1950
A Loan Exhibition of the School of 1830 in France, Wildenstein Galleries, 30 March–29 April

Edinburgh, 1951
United Nations Association, Messrs. Whyttock & Reid, August–September

Glasgow, 1951
The Hamilton Bequest, Art Gallery and Museum, 19 April–30 September

London, 1951
L'Ecole de Paris 1900–1950, Royal Academy of Arts

London, 1951 (RBD)
Fauve Painting in France and Abroad, Roland, Browse & Delbanco

London, 1951 (R-L)
Géricault to Renoir, Alex Reid & Lefèvre, May

London, 1951 (M)
Paintings by Marcoussis, Roland, Browse & Delbanco

Scottish Tour, 1951–52
A Selection from the Hamilton Bequest, Scottish Arts Council Touring Exhibition

Paisley, 1952
Art Institute

Knocke-le-Zoute, Belgium, 1952
Ve Festival Belge d'Eté, Matisse, Casino Communal

Cleveland-New York, 1954
Vuillard, Museum of Art, 27 January–14 March; Museum of Modern Art, 6 April–6 June

Edinburgh-London, 1954
Paintings by Cézanne, (Arts Council of Great Britain), Royal Scottish Academy, 20 August–18 September; Tate Gallery, 29 September–27 October

Lyon, 1954
Courbet, Musée de Lyon

Oslo, 1954
Nasjonalgalleriet, Kunstnerforbundet

Venice, 1954
Courbet, 27th Venice Biennale

Helsinki, 1954–55
Art Gallery of Ateneum

Edinburgh, 1955
French Paintings of the 19th and 20th Centuries, Scottish Arts Council Gallery, touring exhibition

London, 1955
Some Paintings of The Barbizon School, Hazlitt Gallery, May

Paris, 1955
Courbet, Petit Palais, January–February

Edinburgh-London, 1956
Georges Braque, Royal Scottish Academy, Tate Gallery

London, 1956
The Barbizon Painters and Their Contemporaries, Lotinga, October

London, 1956 (R)
Renoir, An Exhibition of Paintings from European Collections, In Aid of the Renoir Foundation, Malborough Fine Art Ltd, 9 May–23 June

Edinburgh-London, 1957
Claude Monet, Edinburgh Festival, Tate Gallery

London, 1957
André Derain 1880–1954, Wildenstein, April–May

Edinburgh, 1958
National Gallery of Scotland

Edinburgh, 1958 (R)
Hommage à Georges Rouault, French Institute

Greenock, 1958
Opening Exhibition, Art Gallery and Museum, 4–21 June

Belfast, 1958–59
XIXth and XXth Century French Paintings, Museum and Art Gallery, 2 December 1958–31 January 1959

London, 1959
The Romantic Movement, The Tate Gallery, (Arts Council), 10 July–27 September

Philadelphia-Boston, 1959–60
Gustave Courbet 1819–1877, Philadelphia Museum of Art, 17 December 1959–14 February 1960; Boston Museum of Fine Arts, 26 February–14 April 1960

Bournemouth, 1960
125th Loan Exhibition: Nineteenth-Century French Pictures, Russell-Cotes Art Gallery, 9 April–11 June

Cardiff, 1960
How Impressionism Began, National Museums and Galleries of Wales (The Arts Council of Great Britain Welsh Committee), 16 July–21 August

Chicago, 1960
Corot 1796–1875, An Exhibition of his Paintings and Graphic Works, The Art Institute, 6 October–13 November

Sheffield, 1960
Picture of the Month, Graves Art Gallery, February

Paris, 1960–1961
Les sources du XXe siecle, Les Arts en Europe de 1884 à 1914, Musée National d'Art Moderne

Wolfsburg, 1961
Französische Malerei von Delacroix bis Picasso, Stadthalle, 8 April–31 May

London, 1962
Primitives to Picasso: An Exhibition from Municipal and University Collections in Great Britain, Royal Academy of Arts, winter exhibition

Paris, 1962
Figures de Corot, Musée du Louvre, 19 June–November

Hamburg, 1963
Cézanne, Gauguin, Van Gogh, Seurat, Kunstverein, 4 May–14 July

London, 1963
Corot, Loan exhibition in aid of the Royal Opera House Benevolent Fund, Marlborough Fine Art Ltd, 29 October–6 December

London, 1963 (W)
The French Impressionists and some of their contemporaries, Wildenstein

Munich, 1963
Georges Braque, Haus der Kunst

Glasgow, 1963–64
Pictures to live with, Art Gallery and Museum, 28 December–16 February

Mannheim, 1963–64
Die Nabis und ihre Freunde, Stadtische Kunsthalle, 23 October 1963–66 January 1964

Paris, 1963–64
Signac, Musée du Louvre, December–February

Edinburgh, 1964
138th Annual Exhibition, Royal Scottish Academy, 18 April–13 September

Edinburgh, 1965
Corot, (Edinburgh Festival, The Arts Council), Royal Scottish Academy

London, 1966
Pierre Bonnard, 1867–1947, Royal Academy of Arts, 6 January–6 March

London, 1966 (T)
Pointillisme, Arthur Tooth & Sons, 7–25 June

Glasgow, 1967 (H)
The Hamilton Bequest, Art Gallery and Museum, 9 August–1 October

Glasgow, 1967 (Reid)
A Man of Influence: Alex Reid 1854–1928, Scottish Arts Council, 21 October–11 November

Edinburgh, 1968
Boudin to Picasso, Masterpieces from Kelvingrove, Royal Scottish Academy, 17 August–8 September

London, 1968
19th and 20th Century French Paintings, Alex Reid &

Lefèvre, 7 November–21 December

London, 1969 (MI)
J. F. Millet (1814–1875), Wildenstein

London, 1969 (MO)
Claude Monet, The Early Years, Alex Reid & Lefèvre

Washington, 1970
Mary Cassatt 1844–1926, National Gallery of Art, 27 September–8 November

London, 1971
London and the Greater Painters, Guildhall Art Gallery

Nottingham, 1971
Alfred Sisley (1839–99), Impressionist Landscapes, University Art Gallery, 6–27 February

Toronto-California-Chicago, 1971–72
Edouard Vuillard 1868–1940, Art Gallery of Ontario, 11 September–24 October; California Palace of the Legion of Honor, 18 November 1971–2 January 1972; Art Institute of Chicago, 29 January–12 March 1972

Nottingham, 1972
Young Bert, Castle Museums, July–August

Glasgow, 1972–73
Glasgow's European Treasures, Art Gallery and Museum, 21 December 1972–31 January 1973

Stirling, 1973
Illusion in 20th Century Art, MacRobert Arts Centre, Stirling University

London, 1974
Important XIX and XX century Paintings and Drawings, Alex Reid & Lefèvre, 21 November–20 December

London, 1974 (RA)
Impressionism, Its Masters, Its Precursors, and its Influence in Britain, Royal Academy of Arts, 9 February–28 April

Tokyo-Kyoto-Fukuoka, 1974
Exposition Cézanne, Musée National d'Art Occidental, 30 March–19 May; Musée de la Ville de Kyoto, 1 June–17 July; Centre Culturel de Fukuoka, 24 July–18 August

Auckland, 1975
Van Gogh in Auckland, City Art Gallery

Barbizon, 1975
Barbizon au temps de J. F. Millet (1849–1875), Salle des Fêtes, 3 May–2 June

Liverpool, 1976–77
American Artists in Europe 1800–1900, Walker Art Gallery, 14 November 1976–2 January 1977

Glasgow, 1977
The Hamilton Bequest, Paintings presented to the Glasgow Art Gallery 1927–1977, Art Gallery and Museum, 14 September–30 October

Glasgow, 1977 (J)
25 Glorious Years, An Exhibition of outstanding acquisitions to mark the Queen's Silver Jubilee, 1977, Art Gallery and Museum, 2 October–11 November

Glasgow, 1977 (R)
Roses and other Flowers, Art Gallery and Museum, 6 May–12 June

London, 1977
London and the Thames, Somerset House

Paris-London, 1977–78
Gustave Courbet 1819–1877, Galeries Nationales du Grand Palais, 1 October 1977–2 January 1978; Royal Academy of Arts, 19 January–19 March

London, 1978
Seurat Paintings and Drawings, David Carritt Ltd, 15 November–15 December

Paris, 1979
Paris-Moscou, Centre Georges Pompidou

London-Washington, 1979–80
Post-Impressionism, Cross-Currents in European Painting, Royal Academy of Arts, 17 November 1979–16 March 1980; National Gallery, 25 May–1 September 1980

Arts Council of Great Britain, 1980
The National Gallery Lends French Nineteenth-Century Paintings of Town and Country, touring exhibition

London, 1980
Paintings from Glasgow Art Gallery, A Loan Exhibition in Aid of the NACF, Wildenstein, 28 February–29 March

Swansea, 1980
Ship-Shape 1880–1980, Glynn Vivian Art Gallery and Museum, (Festival Exhibition), 4 October–25 October

London–Paris–Boston, 1980–81
Camille Pissarro 1830–1903, Hayward Gallery, 30 October 1980–11 January 1981; Galeries Nationales du Grand Palais, 30 January–27 April 1981; Museum of Fine Arts, 19 May–9 August 1981

Cleveland–Brooklyn–St Louis–Glasgow, 1980–82
The Realist Tradition, French Painting and Drawing 1830–1900, Cleveland Museum of Art, 12 November 1980–18 January 1981; Brooklyn Museum, 7 March–10 May 1981; St Louis Art Museum, 23 July–20 September 1981; Glasgow Art Gallery and Museum, 5 November 1981–4 January 1982

Edinburgh, 1981
French Flower Paintings, National Gallery of Scotland

Newcastle–Sheffield–Paisley–Aberdeen, 1981–82
Peasantries – Nineteenth-Century French and British Pictures of Peasants and Field Workers, Polytechnic Art Gallery, 12 October–6 November 1981; Mappin Art Gallery, 5 December 1981–3 January 1982; Paisley Art Gallery, 16 January–13 February 1982; Aberdeen Art

Gallery, 27 February–27 March 1982

Norwich–London, 1982
Théodore Rousseau 1812–1867, Loan Exhibition of Paintings, Drawings and Prints from English and Scottish Collections, University of East Anglia, Sainsbury Centre for Visual Arts 12 January–21 February; Hazlitt, Gooden & Fox, 10 March–8 April

Omaha-Memphis-Williamstown, 1982–83
Jules Breton and the French Rural Tradition, Joslyn Art Museum; Dixon Gallery; Sterling and Francine Clark Art Institute, 6 November 1982–5 June 1983

Paris-Ottawa-San Francisco, 1982–83
Fantin-Latour, Grand Palais, 9 November 1982–7 February 1983; National Gallery of Canada, 17 March–22 May 1983; California Palace of the Legion of Honor, 18 June–6 September 1983

Glasgow, 1983
80th Birthday: National Art Collections Fund, Art Gallery and Museum, 19 May–26 June

London, 1983
Autumn Anthology, An Exhibition of British, French and Irish Paintings, Pyms Gallery, 26 October–25 November

Paris, 1983
Claude Monet at the Time of Giverny, Centre Cultural du Marais, 6 April–31 July

London, 1984
Fantin-Latour, Wildenstein, 10 October–21 November

Leeds, 1985
The Irresistible Object: Still-Life 1600–1985, City Art Galleries, 18 October–8 December

Montpellier, 1985
Courbet in Montpellier, Musée Fabre, November–December

Glasgow–Dundee–Edinburgh–Aberdeen, 1985–86
Colour, Rhythm and Dance, J. D. Fergusson and his circle, (Scottish Arts Council), Art Gallery and Museum, 6 September–13 October 1985; Art Gallery and Museum, 26 October–23 November 1985; City Art Centre, 18 December 1985–1 February 1986; Art Gallery, 15 February–15 March 1986

Edinburgh, 1986
Lighting up the Landscape, French Impressionism and its Origins, National Gallery of Scotland, 1 August–19 October

Southampton, New York, 1986
In Support of Liberty – European Paintings at the 1883 Pedestal Fund Art Loan Exhibition, The Parish Art Museum, 29 June–1 September; National Academy of Design, 18 September–7 December

Glasgow, 1986–87
Academics and Revolutionaries, Art Gallery and Museum, 6 November 1986–18 January (no cat.)

Washington, 1986–87
Henri Matisse, The Early Years in Nice 1916–1930, National Gallery of Art, 2 November 1986–29 March 1987

Paris, 1988
Van Gogh à Paris, Musée d'Orsay, 2 February–15 May

Brooklyn-Minneapolis, 1988–89
Courbet Reconsidered, Brooklyn Museum, 4 November 1988–16 January 1989; Institute of Fine Arts, 18 February–30 April 1989

Amsterdam, 1990
Vincent van Gogh, Rijksmuseum Vincent van Gogh, 30 March–29 July

Birmingham-Glasgow, 1990
Camille Pissarro: Impressionism, Landscape and Rural Labour, City Museum and Art Gallery, 8 March–22 April; The Burrell Collection, 4 May–7 June

Glasgow, 1990
Edouard Vuillard 1868–1940, A Small Tribute to a Great Master, William Hardie Gallery, 14–24 November

Liverpool-Bristol, 1990
Braque, Still-Lifes and Interiors, Walker Art Gallery, 7 September–21 October; Bristol Museum and Art Gallery, 27 October–9 December

Glasgow, 1990–91
The Age of Van Gogh, Dutch Painting 1880–1895, The Burrell Collection, 10 November 1990–10 February 1991

Los Angeles-New York-London, 1990–91
The Fauve Landscape, County Museum of Art, 4 October–30 December 1990; The Metropolitan Museum of Art, 19 February–5 May 1991; Royal Academy of Art, 10 June–1 September 1991

Edinburgh, 1991
Saved for Scotland, Works of Art Acquired with the Aid of the National Art Collections Fund, National Gallery of Scotland, 8 August–29 September

Manchester-Norwich, 1991
Corot, (A National Touring Exhibition from the South Bank Centre), Manchester City Art Gallery, 18 May–30 June; Norwich Castle Museum, 6 July 1991–18 August

Glasgow–Sheffield–Amsterdam, 1991–92
Vuillard (A National Touring Exhibition from the South Bank Centre), Art Gallery and Museum, 7 September–20 October 1991; Graves Art Gallery, 26 October–18 December 1991; Van Gogh Museum, 9 January–8 March 1992

Paris-New York, 1991–92
Georges Seurat 1859–1891, Galeries Nationales du Grand Palais, 9 April–12 August 1991; The Metropolitan Museum of Art, 24 September 1991–12 January 1992

Vatican City State, 1991–92
The Work of Man in Painting from Goya to Kandinsky, Braccio di Carlo Magno

Honfleur, 1992
Eugène Boudin 1824–1898, Musée Eugène Boudin, 11 April–12 July

Amsterdam, 1992–93
Glasgow 1900, Art and Design, Van Gogh Museum, 20 November 1992–7 February 1993

Dallas-Philadelphia-London, 1992–93
The Impressionist and the City: Pissarro's Series Paintings, Museum of Art, 15 November 1992–31 January 1993; Philadelphia Museum of Art, 7 March–6 June 1993; Royal Academy of Arts, 2 July–10 October 1993

Zurich-Paris, 1993–94
Nabis 1888–1900, Kunsthaus, 28 May–15 August 1993; Galeries Nationales du Grand Palais, 21 September 1993–3 January 1994

Edinburgh, 1994
Monet to Matisse: Landscape Painting in France 1874–1914, National Gallery of Scotland, 11 August–23 October

Tokyo–Nagoya–Osaka–Kumamoto, 1994
Masterpieces of French 19th Century Art from the Collections of Glasgow Museums, Isetan Museum of Art, 13 January–14 February; Matsuzakaya Art Museum, 3 March–10 April; Daimaru Museum, Umeda, 20 April–16 May; Kumamoto Prefectural Museum of Art, 20 May–26 June

Barcelona, 1994–95
Picasso, Paisatges 1890–1912, Museu Picasso, 8 November 1994–12 February 1995

Paris, 1994–95
André Derain (1880–1954): 'Le peintre du "trouble moderne"', Musée d'Art Moderne de la Ville de Paris, 18 November 1994–19 March 1995

Paris-New York, 1994–95
Origins of Impressionism, Galeries Nationales du Grand Palais, 19 April–8 August 1994; The Metropolitan Museum of Art, 27 September 1994–8 January 1995

Bielefeld, 1995–96
Blumenstücke Kumstücke vom 17. Jahrhundert bis in die Gegenwart, Kunsthalle, 10 December 1995–25 February 1996

Copenhagen, 1995–96
Impressionism, The City and Modern Life, Ordrupgaardsamlingen, 6 September–1 December

Düsseldorf-Stuttgart, 1995–96
Picassos: Welt der Kinder, Kunstsammlungen Nordrhein-Westfalen, 9 September–3 December 1995; Staatsgalerie Stuttgart, 16 December 1995–17 March 1996

London–Boston, 1995–96
Landscapes of France: Impressionism and Its Rivals,

Hayward Gallery, 18 May–28 August 1995; Museum of Fine Arts, 4 October 1995–14 January 1996

Sydney-Melbourne, 1995–96
The Fauves, Art Gallery of New South Wales, 8 December 1995–18 February 1996; National Gallery of Victoria, 29 February–13 May 1996

Tobu, 1996
The Birth of Impressionism, Museum of Art, 30 March–30 June

Paris-Ottawa-New York, 1996–97
Corot, Galeries du Grand Palais, 27 February–27 May 1996; National Gallery of Canada, 21 June–22 September 1996; Metropolitan Museum of Art, 29 October 1996–19 January 1997

Barcelona, 1997
André Derain, Museu Picasso, 18 March–29 June

Glasgow, 1997
The Birth of Impressionism from Constable to Monet, McLellan Galleries, 23 May–7 September

London, 1997
Seurat and the Bathers, National Gallery, 2 July–28 September

Fort Worth–New York, 1997–98
Monet and the Mediterranean, Kimbell Art Museum, 8 June–7 September 1997; Brooklyn Museum of Art, 10 October 1997–4 January 1998

Lausanne-Marseille, 1997–98
Charles Camoin, Rétrospective 1879–1965, Fondation de l'Hermitage, 26 June–5 October 1997; Musée Cantini, 25 October 1997–18 January 1998

Rome, 1997–98
Matisse: La révélation m'est venue de l'Orient, Musei Capitolini, 20 September 1997–20 January 1998

Bordighera, 1998
Monet a Bordhigera, Chiesa Anglicana, June–September

Ferrara, 1998
Camille Pissaro, Palazzo dei Diamanti, 15 February–10 May

Florence, 1998
Il tempo dei Nabis, Palazzo Corsini, 28 March–28 June

Martigny, 1998
Gauguin, Fondation Pierre Giannada, 10 June–22 November

Tokyo–Osaka–Fukuoka–Mie, 1998
Camille Pissarro and the Pissarro Family, Isetan Museum of Art, 5 March–7 April; Daimaru Museum, Umeda, 29 April–11 May; Mitsukoshi Gallery, 20 May–10 June; Mie Prefectural Art Museum, 23 June–26 July

Frankfurt-am-Main, 1998–99
Innenleben: The History of the Interior, Vermeer to Kabakov, Städelsches Kunstinstitut und Städtische Galerie, 24 September 1998–10 January 1999

Lausanne-Stockholm, 1998–99
Gustave Courbet, Artiste et promoteur de son oeuvre, Musée Cantonal des Beaux-Arts de Lausanne, 21 November 1998–21 February 1999; National Museum, Stockholm, 25 March–30 May 1999

Oita-Kyoto-Saga-Chiba, 1998–99
Exposition Maurice Utrillo, Prefectural Hall of Art, 5 August–6 September 1998; Eki Kyoto Museum, 11 September–19 October 1998; Prefectural Museum, 28 October–29 November 1998; Art Museum, 13 January–14 February 1999

Atlanta-Seattle-Denver, 1999
Impressionism, Paintings Collected by European Museums, High Museum of Art, 23 February–16 May; Seattle Art Museum, 12 June–29 August; Denver Art Museum, 2 October–12 December

San Francisco–Dallas–Bilbao, 1999–2000
The Artist and the Camera, Degas to Picasso, Museum of Modern Art, 1 October 1999–4 January 2000; Museum of Art, 1 February–7 May 2000; Guggenheim Museum, 12 June–10 September 2000

Paris, 1999–2000
Le Maroc de Matisse, Institut du Monde Arabe, 19 October 1999–30 January 2000

Tokyo, 2000
Picasso's World of Children, The National Museum of Western Art, 14 March–18 June

Detroit-Boston-Philadelphia, 2000–2001
Van Gogh: Face to Face, Institute of Arts, 12 March–4 June 2000; Museum of Fine Arts, 2 July–24 September 2000; Museum of Art, 22 October 2000–14 January 2001

Paris–Amsterdam–New York, 2001–2002
Signac, Galeries Nationales du Grand Palais, 27 February–28 May 2001; Van Gogh Museum, 18 June–9 September 2001; The Metropolitan Museum of Art, 1 October–31 December 2001

APPENDIX 3
BIOGRAPHIES: COLLECTORS

The following is a list of collectors from the west coast of Scotland who were buying nineteenth-century French art during the period 1860–1925. Where possible the collector's dates, place of residence, details of collection and how it was dispersed, as well as information on the dealers are given. Cross-references to other collectors in this appendix or to dealers listed in **Appendix 4** are given in bold.

Bibliographical note
The information in this appendix has been gathered from various sources, including descendants of collectors, newspaper obituaries and articles in contemporary periodicals such as *The Bailie* and *The Scots Pictorial*. Information on individual collections has been taken from Christie's and Sotheby's sale catalogues and from the catalogues of the annual exhibitions of the Glasgow Institute. The Elizabeth Bird files in Glasgow University Library, Special Collections have been consulted as has T. J. Honeyman's *Art and Audacity*, Glasgow 1971, pp.120–34. Any further biographical sources are included in a separate bibliography after each entry. For information on major English collectors of this period, see the appendix in Dianne Sachko Macleod, *Art and the Victorian Middle Class: Money and the Making of Cultural Identity*, Cambridge, 1996.

Thomas Glen Arthur (1857–1907)
Lived at 78 Queen Street, Glasgow (1888) and later at Carrick House, Ayr.
Second son of James Arthur of Barshaw, Paisley. James Arthur founded the Glasgow drapery firm of Arthur & Co. (previously Arthur & Fraser) in about 1856. Thomas Glen Arthur became director in 1885 and in September 1888 he married Elizabeth Winthrop Coats, a daughter of Sir James Coats of Auchendrane, who was first cousin of the Paisley collector, **W. A. Coats**. Arthur was a keen huntsman and kept stables at Carrick House.

Arthur was the leading collector of Dutch and French nineteenth-century art in the late 1880s and early 1890s. He collected works by Degas, Whistler, Courbet, Daumier, Monticelli, Bonvin, Vollon and Matthijs Maris. He also owned an important collection of Legros etchings, which was formed under A. W. Thibaudeau, and a number of Japanese prints. He was one of the earliest collectors of Joseph Crawhall and also owned works by E. A. Hornel, Alexander Roche, Grosvenor Thomas and George Henry, as well as a number of Old Masters, including Cranach, Cuyp and Frans Hals. He was the first Scottish collector to acquire an Impressionist painting, Degas's *At The Milliners*, 1882 (Metropolitan Museum of Art, New York), which he bought from **Alexander Reid** (hereafter **Alex Reid**) in January 1892. He also bought from **Craibe Angus** and **Thomas Lawrie**.

Arthur ceased collecting by the mid-1890s, due to ill-health, and from 1897 onwards he spent the winters in Tangiers. He lived in an old Moorish palace, where on one occasion he entertained Edward VII.

58. *Thomas Glen Arthur at the dinner to celebrate the opening of the exhibition of the Institute of the Fine Arts* 1883. *The Bailie.* Mitchell Library, Glasgow

He died in Tangiers on 2 February 1907. Part of his collection was sold at Sotheby's on 3 July 1888, the rest was sold at Christie's on 20 March 1914.

Andrew Bain (1844–1926)
Lived at 17 Athole Gardens, Glasgow (1901) and later at Glen Tower, Hunter's Quay (by 1911).
Andrew Bain entered his father's printing business, Bell & Bain, and later joined the shipping firm of J. & R. Young. He was a member of the Clydesdale Iron Company, which made a fortune from manufacturing steel in the 1880s. He was a cultured man and had an important collection of rare books. He was also a keen yachtsman – he owned four racing yachts and was commodore of the Royal Western Yacht Club in 1888.

His love of sailing was probably the motivating factor behind his purchase of Monet's *A Freshening Breeze*, 1867 (Sterling and Francine Clark Institute, Williamstown, Mass.) which he loaned to the International Exhibition in Glasgow in 1901. He probably bought this work from **Alex Reid** who held an exhibition of French pictures, including works by Monet, in December 1898.

Bibliography: 'Men You Know' n.820, *The Bailie*, 4 July 1888.

George Burrell (1857–1927)
Lived at Glenifer Lodge, Paisley (1901).
George Burrell was the older brother of **William Burrell** and partner in the shipowning firm of

59. *Sir William Burrell.* Glasgow Museums: The Burrell Collection

Burrell & Son. He was a client of **Alex Reid** and owned pictures by Degas, Crawhall and Melville.

William Burrell (1861–1958)
Lived at 4 Devonshire Gardens, Glasgow, and later at Hutton Castle, Berwick-on-Tweed.
William Burrell worked for the family shipping firm of Burrell & Son on the Clyde. Together with his brother **George** he made his fortune from a series of shrewd shipping deals, buying during a slump and selling during a boom period. By the age of 39 he had made enough money to go into semi-retirement. He married Constance Mitchell in 1901.

Like **Arthur Kay** Burrell began collecting in his teens, and was reputedly only 15 years of age when he bought his first painting. In its entirety The Burrell Collection is one of the largest belonging to one man, and certainly one of the largest of its kind in Europe. In addition to an important collection of French nineteenth-century pictures, the collection includes major holdings of stained glass, tapestries, furniture, metalwork, Chinese ceramics and bronzes and Persian and Indian carpets and rugs.

In 1927 Burrell was knighted for his services to art, and in the same year he and Lady Burrell moved to Hutton Castle near Berwick-on-Tweed. In 1944 he donated 6000 items to the city of Glasgow, and a further 2000 objects at his death in 1958.

One of the most important features of Burrell's collection is the nineteenth-century French pictures. The strength of this part of the collection can be attributed

in the main to **Alex Reid**, on whose advice Burrell relied. In particular Reid persuaded Burrell to invest in works by Daumier, Courbet, Boudin, Degas and Manet from an early date. He also introduced him to Joseph Crawhall, for whose work Burrell developed a passion.

During the 1890s Burrell bought from Alex Reid, **Craibe Angus** and the Dutch dealer **Elbert van Wisselingh**. After the turn of the century he was also buying from **W. B. Paterson**; and during the 1920s, when he developed a real passion for Impressionist art, he frequently bought from French dealers, including J. Allard, Georges Bernheim, Paul Rosenberg and Gerard Frères, as well as Knoedler's and Reid & Lefèvre in London. He also bought Barbizon works from Bernheim-Jeune and F. & J. Tempelaere in Paris, and **David Croal Thomson** in London.

Bibliography: *Catalogue of Important Modern pictures and drawings of the English and Continental Schools; also Fine Early English pictures and a few works by Old Masters the property of William Burrell Esq., Robert Ryrie Esq. (deceased), Miss Squire (deceased) and heirlooms of the 3rd Earl of Onslow*, Christie's, London, 14 June 1902.
R. Marks, *Burrell – A Portrait of a Collector*, Glasgow, 1983.

D. W. T. Cargill (1872–1939)
Lived at Stanmore, Lanark.
David William Trail Cargill was the third son of David S. Cargill and a director of the Burmah Oil Company, founded by his father. He also had business interests in India.

Cargill formed one of the finest collections of Impressionist and later French paintings ever assembled in Scotland. Between 1918 and 1927 he acquired works by Daumier, Boudin, Fantin-Latour, Le Sidaner, Degas, Manet, Monet, Sisley, Renoir and many others from **Alex Reid**. After Reid retired he continued to buy from A. J. McNeill Reid at Reid & Lefèvre in London, adding to his collection works by Redon, Seurat, Pissarro, Toulouse-Lautrec, Van

60. *D. W. T. Cargill*. Private collection

Gogh, Gauguin, Cézanne, Utrillo, Derain and even Ingres and Delacroix.

His collection also included a large number of Scottish paintings, including 14 works by Crawhall, seven McTaggarts and works by D. Y. Cameron, Wingate, Hornel, Peploe and Hunter.

Most of Cargill's pictures were sold at Christie's in London on 2 May 1947 and at the Parke Bernet Galleries in New York on 6 January 1949. The proceeds were used to form the Cargill Fund, a trust which gives assistance to Scottish charities and artistic organisations.

Bibliography: Obituary in *The Glasgow Herald*, 7 September 1939, p.11.
Christie's, *Ancient & Modern Paintings & Drawings*, London, 2 May 1947.
Parke Bernet Galleries, *Modern Paintings; American Paintings*, New York, 6 January 1949.
T. J. Honeyman, *Patronage and Prejudice*, W. A. Cargill Memorial Lecture in Fine Art, Glasgow 1968, p.4.
T. J. Honeyman, *Art and Audacity*, London 1971, pp.128–9.

William Cargill d.1962
Lived at Carruth, Bridge of Weir.
William Alexander Cargill was the half-brother of **D. W. T. Cargill** and, like him, made his fortune from the Burmah Oil Company. He lived with his mother in Bridge of Weir and after her death became an eccentric recluse, devoting himself to gardening and collecting. He amassed an important collection of nineteenth-century French art, some of which he bought from **Alex Reid**. After a difference of opinion he turned to the French dealer Etienne Bignou, from whom he bought most of his important Impressionist and Post-Impressionist works.

Bibliography: *Catalogue of the Highly Important Collection of French Impressionist Paintings formed by the late William A. Cargill*, Sotheby's, London, 11 June 1963.
T. J. Honeyman, *Patronage and Prejudice*, W. A. Cargill Memorial Lecture in Fine Art, Glasgow 1968, p.5.
T. J. Honeyman, *Art and Audacity*, London 1971, pp.128–9.

William J. Chrystal (1854–1921)
Lived at Calderwood Castle, High Blantyre and later at Auchendennan House, Arden, near Balloch.

61. *Auchendennan*. Private collection, courtesy of Mrs F. Henderson

62. *William Chrystal*. Private collection, courtesy of Mrs F. Henderson

Married Marion Lennox Alexander and had two sons (the younger, Ian, killed in France in 1917) and a daughter. His hobbies included sailing (he was a member of numerous yacht clubs), rearing Highland cattle and shooting.

William Chrystal was the son of Robert Chrystal, a Glasgow insurance broker. He was educated at Glasgow Academy, Glasgow High School and Loretto School, Musselburgh, and read chemistry at Glasgow University. He then joined the Glasgow chemical manufacturing firm John & James White Ltd and later became chairman. A scientist by training, he introduced many improvements into the firm's processes of manufacture and was elected a Fellow of the Institute of Chemistry. He also held other positions, including directorships of the Burmah Oil Co., the Caledonian Railway Co. and the Clydesdale Investment Co.

The bulk of his collection was formed between 1882 and 1915 and included Barbizon and Hague School paintings, as well as nineteenth-century Scottish art. His French collection included works by Courbet, Fantin-Latour, Monticelli, Lépine, Lhermitte, Diaz, Daubigny and Troyon. He also owned John Pettie's *Ho, Ho, Ho, Old Noll* (Art Gallery and Museum, Kelvingrove). Ten works from his collection were bequeathed to the Art Gallery and Museum, Kelvingrove after his death in 1921.

Chrystal bought from a number of Glasgow dealers, including **Thomas Anderson, James Connell & Sons, Thomas Lawrie, E. & E. Silva White, W. B. Paterson, Alex Reid** and the **Van Baerle brothers**. He also bought from Hollender & Cremetti and Arthur Tooth & Sons in London.

Bibliography: *Glasgow Contemporaries* (no author or date), p.173.
Obituary in *The Glasgow Herald*, 22 April 1921.

63. *W. A. Coats*. Private collection, courtesy of Sir William Coats

William Allen Coats (1853–1926)

Lived at Skelmorlie Castle, Ayrshire, until 1913, and thereafter at Dalskairth, Dumfriesshire, and 30 Buckingham Terrace, Edinburgh. Married Agnes Muir in 1888 and had two sons, Thomas and Jack. His hobbies included yachting and 'cultivating his artistic tastes'.

William Allen Coats was the fourth son of Thomas Coats of Ferguslie and a director of J. & P. Coats, a thread manufacturing company based in Paisley. The firm was founded by W. A. Coats's grandfather, James Coats, and handed down to James's three sons, James (1803–45), Peter (1808–90) and Thomas (1809–83). Thomas Coats had eleven children, three of whom, Thomas (Glen-Coats), George (later Baron Glentanar) and William all became enthusiastic collectors of fine art.

W. A. Coats was particularly interested in nineteenth-century French and Dutch art, especially artists of the Barbizon and Hague Schools. His collection included about twenty Corots, thirty-one works by Monticelli and the same number of works by Bosboom. He owned six works by Géricault. He also collected English portraiture and owned a number of landscapes by Constable and Bonington. His most important acquisition, of which he was particularly proud, was Vermeer's *Christ in the House of Mary and Martha*, now in the National Gallery of Scotland. In addition to the Vermeer, his Dutch collection included works by Rembrandt, Hals, Ruysdael, Kalf and Saenredam. He also owned works by Rubens, Velasquez and Fragonard.

Coats bought from a number of dealers, including **Alex Reid**, **W. B. Paterson**, **Thomas Lawrie**, **Craibe Angus** and **E. & E. Silva White** in Glasgow and Hollender & Cremetti in London.

Bibliography: *Catalogue of the Collection of Pictures of the French, Dutch, British and Other Schools belonging to W. A. Coats*, Wm. B. Paterson, Glasgow 1904.

Catalogue of Pictures and Drawings being the entire collection of the late W. A. Coats, Esq., Exhibited at the Galleries of the Royal Society of British Artists, Suffolk Street, London, Wm. B. Paterson, London, January 1927.
Catalogue of Ancient and Modern Pictures and Drawings of the British and Continental Schools, the Property of W. A. Coats Esq., Deceased, Christie, Manson & Woods, London, 10 June 1927.

William Connal (1819–98)

Lived at 19 Park Circus, Glasgow and Solsgirth, near Dollar, Perthshire. Also 23 Berkeley Square, London. William Connal was born in Stirling and was the son of Patrick Connal, a banker. As a young man he was apprenticed to his uncle William's Glasgow firm, Connal & Co., which imported tea and sugar. After his uncle's death in 1856 he took over the business and focused on warehousing pig-iron, expanding the business to Middlesborough by 1877. He married Emilia Jessie Cambell and had nine children.

Connal was an early collector of Monticelli but in general his collection reflected a taste for the Aesthetic movement, especially the work of Albert Moore and Burne-Jones. He also owned works by Poynter, Sandys, Stanhope, Watts and Rossetti, a Whistler Nocturne and three pictures by the Belgian Symbolist Fernand Khnopff.

His collection was sold at Christie's on 14 March 1908. Burne-Jones's *Danae, or the Tower of Brass* was bequeathed to Kelvingrove Art Gallery.

Bibliography: *Dianne S. Macleod, Art and the Victorian Middle Class*, Cambridge 1996, pp.403–4.

James Donald (1830–1905)

Lived at 5 Queen's Terrace, Glasgow and later at Anerly Park, London. He married Emily Mary Lang (?) and had one daughter, also Emily, who married Harry Busby of London.
James Donald was born in Bothwell, where his father, John Donald, ran a grocery business. Donald became a partner in the Glasgow chemical manufacturing firm of George Miller & Co.

Donald was one of the first important collectors of French art in Glasgow. His collection included works by artists of the Barbizon School, including Corot, Daubigny, Millet and Rousseau, many of which he exhibited at the Glasgow International Exhibition of 1888. He also collected Dutch Old Masters, including Kalf and Cuyp, and nineteenth-century British landscapes by Turner and Constable, as well as a great number of works by artists of The Hague School. The bulk of his collection was acquired through **Craibe Angus**.

Donald left forty-two pictures and other works of art to Kelvingrove Art Gallery after his death in 1905. Two of the most outstanding pictures in the collection are Millet's *Going to Work* and *The Sheepfold* (both Art Gallery and Museum, Kelvingrove).

Bibliography: Obituary in *The Glasgow Herald*, 25 March 1905.
Corporation of Glasgow Museums and Art Galleries, *Catalogue of the Pictures and Other Works of Art forming the Donald Bequest*, Glasgow 1905.

James Duncan

Lived at Benmore, near Dunoon, Argyllshire.
Duncan was an important early collector of the

Barbizon School. He exhibited Corot's *Landscape with Figures* (Private Collection, Paris) at the Glasgow Institute in 1876 and was also an early collector of Courbet and Millet.

Some of Duncan's collection was sold at Christie's in London in July 1887. His collection of Barbizon paintings (including thirty-three lots) was sold in Paris on 15 April 1889 and the remaining portion of his collection was sold at Christie's in February 1895.

Bibliography: *Catalogue of Ancient and Modern Pictures and Sculpture, being the remaining portion of the collection of James Duncan Esq. of Benmore*, Christie, Manson & Woods, 8 King Street, St James's Square, 9 February 1895.

Leonard Gow (1859–1936)

Lived at Camis Eskan, Helensburgh, Dunbartonshire. Gow was a senior partner in the firm of Gow, Harrison & Co., shipowners, brokers, insurance agents and coal exporters. He began collecting in the 1890s and continued to buy pictures and other works of art until the end of his life. He owned a fine collection of Impressionist paintings and had a particular liking for the work of Fantin-Latour. He also owned an important collection of etchings and drypoints by Muirhead Bone, which was presented to the University of Glasgow by the Leonard Gow Trust in 1965. In addition to his collection of modern paintings he owned a number of Old Masters, including works by Holbein, Terborch, Memlinc, Rubens, Hobbema and de Hooch. He also had a fine collection of Chinese porcelain.

Gow bought from **Alex Reid** (and later Reid & Lefèvre) on a regular basis from 1911 onwards, including a large number of nineteenth-century French works by artists such as Corot, Monticelli, Boudin, Fantin, Manet, Monet, Degas, Renoir, Vuillard and Seurat.

His collection was sold at Christie's, London, on 28 May 1937.

Arthur Kay (c.1862–1939)

Lived at 21 Winton Drive, Kelvinside.
Arthur Tregortha Kay was the son of John R. Kay who had a small textile warehouse business in London's Cheapside and who, in the early 1860s, joined James Arthur as a partner of Arthur & Co. At first he managed the London branch of the company, but when this closed in about 1870 he moved north to Glasgow. Arthur Kay joined **T. G. Arthur** on the board of Arthur & Co. in 1887. He was highly educated and studied art in Paris, Hanover, Leipzig and Berlin. He married the painter Katharine Cameron and was a great admirer of her brother, D. Y. Cameron.

Kay was one of the first Scottish collectors to buy Impressionist paintings and bought two pictures by Degas from **Alex Reid** in 1892 and Manet's *A Café, Place du Théâtre Français*, (Glasgow Museums, The Burrell Collection) from Vollard by 1901. He also owned a number of works by artists of the Barbizon and Hague Schools (especially Matthijs Maris). Kay specialised in early Dutch paintings and had a fine collection of Old Masters, including works by Rembrandt, Van Dyck and Saenredam, over 100 drawings by Tiepolo, a Goya and a number of British portraits.

Kay's collection also included more than 2,000 pieces of English glass, a fine collection of Chinese bronzes and a collection of Japanese lacquer work.

64. *Arthur Kay*, *The Bailie*, 20 March 1901. Mitchell Library, Glasgow

65. *A. J. Kirkpatrick*, *The Bailie*, 9 March 1892. Mitchell Library, Glasgow

Some of Kay's collection was sold through Martin et Camentron, Paris, in April 1893. The rest was dispersed at various Christie's sales: Old Masters in May 1901, May 1911 and March 1929; Gainsborough drawings in May 1930; and Chinese bronzes in July 1930. He died in 1939 and there was a further sale of pictures at Christie's in April 1943.

Bibliography: 'Men You Know,' n.1483, *The Bailie*, 20 March 1901.
A. Kay, *Treasure Trove in Art*, Edinburgh & London, 1939.
Colin Clark, 'Arthur Kay', *Scottish Arts Review*, vol.XIII, n.1, 1971, pp.25–8.
See also Dianne S. Macleod, *Art and the Victorian Middle Class*, Cambridge 1996, pp.437–8.

Andrew J. Kirkpatrick (d.1900)
Lived at 5 Park Terrace, Glasgow and also at Lugbuie, Shandon, Dunbartonshire.

Kirkpatrick's family came from Galloway, but he was brought up in Glasgow. He was chief partner of Middleton & Kirkpatrick, an old Glasgow firm of chemical merchants, and was Chairman of the Glasgow Institute from 1889–98.

Kirkpatrick was collecting throughout the 1880s and 1890s and had a fine collection of nineteenth-century pictures, including examples from The Hague School and French works by artists such as Courbet, Daumier, Diaz, Monet and Sisley. He also owned pictures by Whistler and Jongkind and was an early collector of Joseph Crawhall's work.

In the late 1890s Kirkpatrick began buying Impressionist works, almost certainly from **Alex Reid** at **La Société des Beaux-Arts**. He was also a client of **Thomas Lawrie**. He died in 1900 and some of his collection was sold in Glasgow on 5 February 1901 by Walter J. & R. Buchanan. A further sale was held on 1 April 1914 by Waring & Gillow, Glasgow. Alex Reid bought a number of works from this second sale for **William Burrell**, including Hague School

paintings and French nineteenth-century works by Monticelli, Courbet, Ricard, Bonvin, Hervier.

Bibliography: 'Men You Know' n.1012, *The Bailie*, 9 March 1892.
Robert Walker, 'Private Picture Collections in Glasgow and West of Scotland – Mr A. J. Kirkpatrick's Collection', *The Magazine of Art*, 1895, pp.41–7.
Catalogue of 'Very Choice Pictures', Walter J. & R. Buchanan, 5 February 1901.
Catalogue of the Very Valuable Collection of Pictures at No.5 Park Terrace, Glasgow, 1 April 1914, Christie's, London.

66. Leslie Hunter (1877–1931), *William McInnes*, Oil on canvas, 45.7 × 38.1cm. Glasgow Museums: Art Gallery and Museum, Kelvingrove

John McGavin d.1882
Glasgow.
McGavin was an important early collector of the Barbizon School. His collection included works by Corot, Diaz, Troyon and Millet (including *The Goose Girl, Gruchy*, National Museum and Gallery of Wales) and he loaned three works by Corot to the Glasgow Institute between 1879 and 1881. He also owned a number of paintings by artists of the Hague School, including Josef Israëls's *The Frugal Meal* (Art Gallery and Museum, Kelvingrove) and works by Jacob Maris. He was strongly influenced in his tastes by the Scots artist G. P. Chalmers.

William McInnes (1868–1944)
Lived at 8 Gordon Street, Glasgow.
William McInnes was a partner, along with **Leonard Gow**, in the Glasgow shipping firm of Gow, Harrison & Co. He was fond of music and art and amassed an important collection of French Impressionist and Post-Impressionist works, including paintings by Boudin, Monet, Sisley, Degas, Renoir, Seurat, Van Gogh, Cézanne, Matisse, Vuillard, Braque and Picasso. He was also G. Leslie Hunter's most important patron and bought numerous works by the Glasgow Boys and the Scottish Colourists. Between 1910 and 1925 he acquired many nineteenth-century French paintings from **Alex Reid**, including Degas's *Dancers on a Bench*, c.1898, Cézanne's *Overturned Basket of Fruit*, c.1877, Matisse's *Pink Tablecloth*, 1925, and works by Boudin, Jongkind, Fantin-Latour and Daumier.

His entire collection of over seventy French and Scottish paintings, along with prints, drawings, porcelain, silver and glass was left to Glasgow Corporation (Art Gallery and Museum, Kelvingrove) at his death in 1944.

Bibliography: Glasgow Art Gallery and Museums Association, 'The McInnes Collection', *The Art Review*, vol.1 n.1, 1946, pp.21–3.
T. J. Honeyman, *Art and Audacity*, London, 1971, pp.124–6.

Andrew Maxwell (1828–1909)
Lived at 8 St James Terrace, Glasgow.
Eldest son of Andrew Maxwell senior and brother of the painter Harrington ('Harry') Maxwell, who exhibited with Kay & Reid as early as 1878. He also had two sisters, Isabella and Mary Anne Cunningham Maxwell.

Andrew Maxwell was an iron and steel merchant who founded the firm of Nelson & Maxwell in Glasgow. He was collecting during the 1880s and 1890s and served as honorary secretary of the Glasgow Institute for five years in the 1880s. His collection comprised works by Scottish, Dutch and French nineteenth-century artists, including Corot and Monticelli and he was probably the first Scottish collector to acquire a work by Monet. He owned Monet's *View of Vétheuil in Winter*, which was exhibited by **Alex Reid** at **La Société des Beaux-Arts** in 1892 and was in Maxwell's collection by 1894.

Maxwell died in December 1909 and his collection was sold at Christie's on 3 June 1910.

Bibliography: 'Men You Know' n.602, *The Bailie*, 20 April 1884.
Robert Walker, 'Private Collections in Glasgow and

67 *Leonard Gow, Jean Tempelaere and Alex Reid at Gow's home, Camis Eskan*. Private collection

West of Scotland – Mr Andrew Maxwell's Collection', *The Magazine of Art*, 1894, pp.221–7.

James Reid of Auchterarder (1823–94)
Lived at Auchterarder House, Perthshire.
James Reid founded the Hyde Park Locomotive Works at Springburn in Glasgow. He was an early collector of Barbizon and Hague School paintings, but also owned some important old masters, including Turner's *Modern Italy – the Pifferani* of 1838 (Art Gallery and Museum, Kelvingrove) and a Virgin and Child (*La Vierge de Novar*) believed to be by Raphael, now catalogued as Giulio Romano (National Gallery of Scotland). In 1896 his five surviving sons gifted ten pictures from his collection to Glasgow Corporation (Art Gallery and Museum, Kelvingrove). These included Corot's *Pastorale* (previously owned by John Forbes White), Israëls's *The Frugal Meal* (previously in the collection of John McGavin) and works by Troyon, Constable, Nasmyth, Linnell, Alma-Tadema and Orchardson.

Bibliography: Robert Walker, 'Private Picture Collections in Glasgow and West of Scotland: Mr James Reid's Collection', *Magazine of Art*, 1894, pp.153–9.

John Reid (1861–1933)
Lived at 7 Park Terrace, Glasgow.
Sir John Reid was the fourth son of **James Reid of Auchterarder** and a partner in the Hyde Park Locomotive Works in Glasgow. In 1908 he became director of the North British Locomotive Company and he was knighted in 1918. He was strongly influenced in his tastes by his father but he appears to have bought, rather than inherited, the bulk of his collection between 1908 and 1910. He was particularly fond of the Hague School and by 1913 owned as many as forty-three Dutch pictures, including eleven works by Israëls, five by Jacob Maris, four by Willem Maris, three by Mauve and eight by Blommers. However, he owned nothing by Matthijs Maris or Bosboom. He was also fond of French nineteenth-century art, owning a number of Barbizon paintings, including seven works by Corot and two by Millet. He favoured British landscapes, appreciating particularly the work of Turner, Constable, Nasmyth and Sam Bough. He also admired the work of G. F. Watts and bought three pictures directly from the artist. Watts's *Charity* (1898) was gifted to the Art Gallery and Museum, Kelvingrove in 1988.

Bibliography: *Catalogue of the Collection of Pictures of the British, French & Dutch Schools belonging to John Reid, with notes by James L. Caw, Director of the NGS*, Glasgow 1913.

Andrew T. Reid (1863–1940)
Lived at 10 Woodside Terrace, Glasgow and later at Auchterarder House, Perthshire
Andrew Thomson Reid was the fifth son of **James Reid of Auchterarder** who founded the Hyde Park Locomotive Works in Glasgow. Andrew Reid shared his father's and brother John's taste for Barbizon and Hague School painters. His collection included fine examples of Corot, Diaz, Lhermitte, Jacque and Harpignies. He owned a series of fourteen works by Boudin, representing the whole course of the artist's career. He also owned seven flower pieces by Fantin-Latour, Sisley's *Edge of the River* of 1885 and an Utrillo street scene.

In addition to his French and Dutch works, Reid owned a number of eighteenth-century portraits and early nineteenth-century British landscapes. He also had a fine collection of prints, including works by Rembrandt, Whistler, D. Y. Cameron, James McBey and Muirhead Bone.

Bibliography: *The Collection of Pictures formed by Andrew T. Reid of Auchterarder*, with notes by Sir James L. Caw, Glasgow, printed for private circulation, 1933.

Sir John Richmond (1869–1963)
Lived at Westpark, 14 Hamilton Drive, Pollokshields, Glasgow (1911); later at 23 Sherbrooke Avenue, Pollokshields (1936) and at Blanefield, Kirkoswald, Ayrshire.
John R. Richmond worked for the Glasgow engineering firm of G. & J. Weir. The firm was founded by his stepfather, James Weir, and Richmond started as an apprentice in 1889, eventually rising to the position of senior Deputy Chairman. He was also Chairman of Glasgow School of Art from 1936 to 1947, and Chairman of the Glasgow Institute, where he once exhibited a painting under the pseudonym of R. H. Maund.

The strength of Richmond's collection lay in his nineteenth-century French paintings, although he also owned works by the Glasgow Boys and the Scottish Colourists. He began collecting in the 1900s and, with the guidance of **Alex Reid**, acquired works by Fantin-Latour, Boudin, Monticelli, Monet, Pissarro and Vuillard. His first purchase of an Impressionist work was Pissarro's *The Tuileries Gardens*, 1900, which he bought in 1911. He also owned works by Vollon, Monticelli and Lucien Simon.

Some of Richmond's collection was presented to the Art Gallery and Museum, Kelvingrove, in 1948, and the remainder was left to the National Gallery of Scotland by his niece Mrs Isabel Traill.

Bibliography: H. Brigstoke, *French and Scottish Painting – The Richmond-Traill Collection*, National Gallery of Scotland, 1980.

John G. Ure (fl.)1906
Lived in Glasgow.
John Ure was senior partner of John Ure & Sons, flour millers. His father was Lord Provost Ure of Cairndhu, Helensburgh, and it was from him that Ure developed a taste for art.

Ure's collection included works by Whistler, Fantin-Latour, Daumier, Monticelli, Corot and Mettling, as well as some Hague School paintings. He also owned a number of eighteenth-century portraits.

His collection of modern pictures and drawings was sold at Christie's, London, on 29 April 1911. A further sale of portraits was held on 19 May 1916.

Bibliography: 'Men You Know' n.1771, *The Bailie*, 26 September 1906, p.2.

APPENDIX 4
BIOGRAPHIES: DEALERS

68. T. & R. Annan, *Craibe Angus*, *The Scots Pictorial*, 15 January 1900. Mitchell Library, Glasgow

Craibe Angus & Son

Gallery opened at 159 Queen Street in 1874. Moved to 81 Renfield Street in 1898 and to 106 Hope Street in 1904.

Craibe Angus (1830–99) was born in Aberdeen where he worked for a time as a shoemaker. He was self-educated and became an authority on the poet Robert Burns. He opened an art gallery at 159 Queen Street, Glasgow, in 1874, as a dealer in pictures, china, bronzes, weapons and antiques. He specialised in Hague School works but also stocked nineteenth-century French art – especially Monticelli – and the work of the Glasgow Boys. His clients included **T. G. Arthur**, **James Donald**, **William Burrell** and **W. A. Coats**.

Craibe Angus was the agent for **Daniel Cottier**, who apparently set him up in business. In 1887 Angus married Isabella van Wisselingh, the daughter of Cottier's London agent, Elbert van Wisselingh. After Angus's death his son took over the running of the gallery.

Bibliography: 'The Late Mr Craibe Angus, by One Who Knew Him', *The Scots Pictorial*, 15 January 1900, pp.17–18.

T. & R. Annan

Photography business founded at 116 Sauchiehall Street in 1857. Dealing at 153 Sauchiehall Street by 1890 and at 230 Sauchiehall Street by 1892. Moved to 518 Sauchiehall Street by 1906. Business still in existence.

The company originated as a small photography business, founded by Thomas Annan (1829–87) in 1857. The firm moved into dealing in the 1890s, producing and selling mainly etchings, and did not deal seriously in paintings until the late 1930s. However, in November 1890 the London dealers **Dowdeswell & Dowdeswell** exhibited works by Manet, Degas and Whistler at Annan's gallery. This is the only Glasgow gallery from this period which is still in existence today.

Bibliography: Sara Stevenson, *Thomas Annan 1829–1887*, Edinburgh 1990.

Van Baerle Brothers

Gallery in existence by 1891 at 203 Hope Street. Moved to 117 West George Street by 1894 (later **Alex Reid's** gallery) and to 109 West George Street by 1896. Still in existence in 1901.

Edward and Charles van Baerle specialised in Flemish art, but also sold nineteenth-century French art. They were associated with Hollender & Cremetti of the Hanover Gallery in London and through them were able to hold regular exhibitions of modern French paintings in the 1890s, including works by Corot, Daubigny, Courbet, Diaz, Troyon, Monticelli, Jacque, Meissonnier and Isabey. They also supported the Glasgow School. In addition to art dealing and printselling they were involved in picture restoration and fine art publishing. Their clients included **William Chrystal** and **W. A. Coats**.

J. B. Bennett & Sons

Business founded in 1856 at 50 Gordon Street. Dealing at same address by 1889 and at 36 Newmarket Street, Ayr by 1890. Glasgow branch moved to 50 West George Street in the 1920s and to 156 Buchanan Street by 1932. The Ayr branch was managed by Colonel Robert Bennett.

J. B. Bennett set up business in 1856 as 'painter, paperhanger, gilder, glass embosser and interior decorator to the Queen'. By 1889 he was selling modern French and Dutch works, including the French Symbolist Gustave Moreau. By the 1890s Bennett's two sons, Charles and Robert, had taken over the business, and they began to specialise in Hague School pictures. The gallery also patronised some of the Glasgow School and held exhibitions of Japanese and Chinese ceramics and Japanese carved ivories in the early 1890s.

James Connell & Sons

Business founded at 117 Stockwell Street in 1863. Dealing by 1889 at 88–90 Stockwell Street. Moved to 31 Renfield Street by 1890. London branch opened at 1a Old Bond Street in March 1903 and moved to 43 Old Bond Street in 1906 and to 47 Old Bond Street by 1911. Glasgow firm moved to 75 St Vincent Street in the 1920s. Thomas and David Connell joined the firm by 1922.

The business was founded originally to sell glass and mouldings and to manufacture and gild picture frames. By 1889 James D. Connell described himself as a 'dealer in paintings, chromos, oleographs and lithographs'. He had a permanent exhibition of etchings and engravings on view and specialised in the work of D. Y. Cameron as early as 1890. The gallery became more active in the 1900s, selling mainly contemporary Scottish, Dutch and some English paintings and also furniture and antiques. By 1910 Connell was showing work by Le Sidaner and by 1913 he was including Boudin and Fantin-Latour in his exhibitions of European art. In 1923 Connell held an exhibition of nineteenth-century French art, including works by Monet, Sisley and Pissarro.

Connell's clients included **William Chrystal** who made purchases from the gallery between 1906 and 1922.

Bibliography: There is a small file on James Connell & Sons in the National Library of Scotland, Edinburgh, Acc.7797.

R. Ashton Irvine

Gallery at 33 Renfield Street from November 1904.

R. Ashton Irvine was the manager of **W. B. Paterson & Co** at 33 Renfield Street from 1892 onwards. Paterson moved to London in 1900 and Irvine took over the business in November 1904, when he held an exhibition of nineteenth-century French art, including Manet.

Kay & Reid

Business founded in 1865 at 50 Wellington Street. Moved to 84 Wellington Street in 1865 and to 83 Gordon Street in 1871. Separate workshop at 97 Dumbarton Road, 1870 onwards. Dealing by 1877 at 103 St Vincent Street. Moved to 128 St Vincent Street in 1886 (workshops at 222 and 224 West George Street Lane) and to 9 St Vincent Place in 1887. Partnership dissolved in 1889.

Founded in 1857 by James Gardiner Reid (1828–1907) and Thomas Kay. The firm specialised in furnishing ships and making figure heads, and were also plate glass merchants. In 1870 they acquired a separate workshop at 97 Dumbarton Road and from this date onwards they became involved in the manufacture of mirrors and picture frames. In 1872 the firm began selling prints and by 1877 they had moved into picture dealing and James Reid was employing a staff of 80.

By 1879 they were showing works by the Hague School and nineteenth-century Scottish artists. In 1880 the gallery showed their first French paintings, and James Reid's son, **Alex Reid** was taking an interest in Corot.

From 1889 James Reid became director of **La Société des Beaux-Arts** at 232 West George Street. He retired from the business in about 1899 after suffering a severe cerebral haemorrhage.

Thomas Lawrie & Son

Business founded at 126 Union Street before 1850. Moved to 85 St Vincent Street in 1872. London gallery (Lawrie & Co.) opened at St James' Mansions, 54/55 Piccadilly in 1892 and moved to 15 Old Bond Street in 1893. Both businesses closed down late 1904.

Thomas Lawrie started out as a painter and paper-hanger and by 1854 was involved with glass painting and interior decoration. In 1872 the business began dealing in 'high class pictures and objects of vertu' and Thomas Lawrie was joined by his son, W. D. Lawrie. When Thomas Lawrie died, J. M. Brown took over as the second director. The firm sold Hague School paintings as well as nineteenth-century French paintings by Millet, Daubigny, Corot, Troyon, Dupré, Diaz and Monticelli. They were showing Whistler's work as early as 1879 and also supported the Glasgow Boys and other Scottish artists. In addition to pictures they dealt in furniture, silver and bronzes, stained glass and embroidery.

W. D. Lawrie appears to have been in partnership with a London dealer, A. J. Sulley, as early as October 1888, when Theo van Gogh sent a Corot and a Van Gogh self-portrait to 'Sulley & Lori' from Boussod & Valadon in Paris. Towards the end of 1892, Lawrie set up his own gallery (Lawrie & Co) in London. The inaugural exhibition in February 1893 included work by Corot, Rousseau, Daubigny, Millet and Diaz.

A sale of Lawrie's collection was held at Christie's, London, on 28 January 1905.

Lawrie's clients included **James Donald, T. G. Arthur, A. J. Kirkpatrick** and **W. A. Coats**.

Charles Moody

Gallery at 61 Renfield Street by 1891. Moved to The New Gallery, 4 West Regent Street in 1899.

Charles Moody sold work by Hague School and Barbizon artists, and he was showing Fantin-Latour as early as 1891. He also sold Scottish nineteenth-century art, but was fairly conservative in his tastes. His clients included **William Chrystal**.

North British Galleries (Edward Fox White)

Opened at 44 Gordon Street in 1878. Second gallery at 13 King Street, St James's London. The Glasgow gallery closed down in 1886. (The stock was sold off on 5 May 1886.)

This gallery was run jointly by Edward Fox White and **Edward Silva White** until the winter of 1880 when Silva White opened his own gallery in West George Street. In January 1879 they showed two Whistler paintings including *Nocturne in Snow and Silver* (MY205) which they sold to the Edinburgh collector A. B. Stewart.

Edward Fox White sold works by Tissot, Meissonier and Munkacsy, as well as a number of English and Scottish nineteenth-century works.

William B. Paterson

Gallery opened in 1892 at 33 Renfield Street. London branch opened at 5 Old Bond Street in 1900. Glasgow business taken over by R. Ashton Irvine in 1904. London business closed 1932.

William Bell Paterson (1859–1952) was the younger brother of the artist James Paterson. He worked for five or six years in the family textiles business (his father manufactured muslin in Glasgow), but his inclinations were towards art. He opened the

69. *Alex Reid and the Glasgow Boys*. Private collection

gallery at 33 Renfield Street in September 1892, where he worked in partnership with the artist George Grosvenor Thomas (1856–1923). They specialised in Barbizon and Hague School paintings, and also sold Japanese prints, antique bronzes, carved ivories, furniture and rugs.

By November 1893 Grosvenor Thomas had left the partnership. W. B. Paterson continued to sell French and Dutch nineteenth-century works, and also began to focus on the work of the Glasgow School, including James Paterson, E. A. Walton, Grosvenor Thomas and later Joseph Crawhall.

Paterson's London partner was Norman Forbes, brother of the actor Forbes-Robertson. The partnership did not last long, and in November 1904 Paterson sold his Glasgow business (to **R. Ashton Irvine**, who had been manager of the gallery for over 12 years) and moved permanently to London.

In 1913 Paterson and Herbert K. Wood organised an important exhibition of sixty-three works at the Grand Hotel in Glasgow, where they showed works by Monet, Degas, Pissarro and Gauguin, as well as works by the Glasgow Boys and the Barbizon School.

Paterson built up a strong core of clients, including **William Chrystal**, James Smith of Blunden Sands, **William Burrell** and **W. A. Coats**.

Edward Silva White, later E. & E. Silva White or The French Gallery

Edward Silva White's gallery opened at 161 West George Street in 1880 and closed in 1885. E. & E. Silva White opened at 104 West George Street in 1885.

Edward Silva White specialised in etchings and engravings, but also sold modern paintings, including works by Alma-Tadema. In June 1882 Silva White announced his intention to move to London due to the failure of his George Street gallery, but he continued to run his Glasgow gallery until 1885 when he went into partnership with Eugene G. White and opened a new gallery, known as The French Gallery, at 104 West George Street. The French Gallery was part of a franchise run by Wallis & Son in London, Glasgow, Edinburgh and Dundee, with T. Wallis, Edward Silva White and W. L. Peacock as the principal directors.

E. & E. Silva White specialised in modern French art, but also gave exhibitions to young Scottish painters such as James Paterson. Their clients included **W. A. Coats** and **William Chrystal**, who in 1890 alone bought works by Courbet, Diaz, Daubigny, Rousseau and Troyon from the gallery.

70. *Alex Reid*. Private collection

After his death Edward Silva White's collection was sold at Christie's on 8 December 1888.

Alex Reid – La Société des Beaux Arts

Opened in 1889 at 227 West George Street and 232 West George Street. First gallery moved to 124 St Vincent Street in April 1894. Second gallery closed down 1899. Moved to 117–121 West George Street in May 1904. Merged with Lefèvre Gallery in London in 1926. Glasgow business closed down in 1932.

Alex Reid set up his own gallery in Glasgow some time before October 1889. His father became director of the gallery at 232 West George Street, while he himself managed some small rooms at 227 West George Street. It seems likely that the 227 gallery was devoted to the sale of contemporary art and Impressionism, while the other gallery specialised in more established artists.

In December 1891 Reid held an exhibition of nineteenth-century French art, including works by Degas, Monet, Pissarro and Sisley, at the rooms of his London associate, Arthur Collie, at 13b Old Bond Street. The exhibition moved north to Glasgow and Reid sold his first Degas, *At the Milliners*, 1882 (Metropolitan Museum of Art, New York) to **Thomas Glen Arthur**. Reid sold works by Degas, Manet, Monet and Sisley to Scottish collectors during the 1890s, and also promoted the work of Whistler. He took a special interest in Monticelli and from about 1897 onwards he promoted the work of Boudin, Fantin-Latour and Daumier.

In 1913 Reid's son, A. J. McNeill Reid, joined the business and later took over from his father as director. After the war Reid began taking an interest in Vuillard and during the 1920s he held a whole series of exhibitions of French art in Glasgow. In 1923 he included Cézanne in a major exhibition entitled *Masterpieces of French Art* at Agnew's in London and the McLellan Galleries in Glasgow. In about 1924, Reid retired and

Picasso. In January 1925 he was joined by Duncan Macdonald, formerly a director of the Edinburgh firm Aitken Dott. The following year Reid's gallery amalgamated with the Lefèvre Gallery in London and the business became known as Alex Reid & Lefèvre.

Bibliography: R. Pickvance, *A Man of Influence: Alex Reid 1854–1928*, exhibition catalogue, Edinburgh 1967.
R. Pickvance, 'A Man of Influence: Alex Reid 1854–1928', *Scottish Art Review*, vol.II, 1968, pp.5–9.
T. J. Honeyman, 'Van Gogh – a link with Glasgow', *Scottish Art Review*, vol.II, no.2, 1948, pp.16–21.
D. Cooper, *Alex Reid & Lefèvre 1926–1976*, London 1976.
F. Fowle, *Alexander Reid in Context: Collecting and Dealing in Scotland in the late 19th and early 20th Centuries*, PhD thesis, University of Edinburgh, 1994.
F. Fowle, 'Alexander Reid: The Influential Dealer', *Journal of the Scottish Society for Art History*, vol.2, 1997, pp.24–35.
F. Fowle, 'Van Gogh's Scottish Twin', *Art Quarterly*, autumn 1999, pp.42–5.
F. Fowle, 'Vincent's Scottish Twin: The Scottish Art Dealer Alexander Reid', *Van Gogh Museum Journal*, Amsterdam 2000, pp.90–9.

1. List of the museums and galleries managed by Glasgow City Council, Cultural and Leisure Services (Art Galleries and Museums)

Art Gallery and Museum, Kelvingrove

The Burrell Collection

Fossil Grove, Victoria Park (summer only)

Gallery of Modern Art, former Royal Exchange

Martyrs' School, housed in a building designed by Charles Rennie Mackintosh. Currently home of the outreach service – the Open Museum

Museum of Transport, Kelvin Hall (transferred from Albert Drive in 1988)

People's Palace, Glasgow Green, local history collections

Pollok House, eighteenth- and early twentieth-century historic house. Home of the Stirling Maxwell collection which comprises an important collection of Spanish art and works by William Blake (managed by the National Trust for Scotland)

Provand's Lordship (Glasgow's oldest house)

Scotland Street School Museum, housed in a building designed by Charles Rennie Mackintosh. Home of the Museum of Education

St Mungo Museum of Religious Life and Art, alongside Glasgow Cathedral

2. List of Chief Officials

Over the years Glasgow's Museums and Galleries have been administered and funded by the local authority, which has been known variously as Town Council, Corporation, District Council and now City Council. The affairs of the department have been under the control of a committee or sub-committee of elected councillors, led by a Chairman, or Convener. Changes in the local authority's committee structures have lead to a variety of larger committees having Museums and Galleries as part of their remit: Parks, Civic Amenities, Arts and Culture, Cultural and Leisure Services. The day-to-day running of the buildings and services has been in the hands of a paid chief official known as Superintendent or Director. Staff are employed by the local authority.

1876–1913	Superintendent James Paton
1914–15	Superintendent Gilbert A Ramsay
1915–18	Acting Superintendent Thomas Rennie
1919–30	Superintendent Theodore C. F. Brotchie
1930–38	Director James Eggleton
1939–48	Director Dr. Tom J. Honeyman
1948–54	Director of Art Gallery Dr. Tom J. Honeyman
1948–54	Director of Museums Dr. Stuart M. K. Henderson
1954–72	Director Dr. Stuart M. K. Henderson
1972–79	Director Trevor A. Walden
1979–88	Director Alasdair A. Auld
1989–98	Director Julian Spalding
1998–	Director of Cultural and Leisure Services Bridget McConnell
	Head of Museums and Galleries Mark O'Neill

Select Bibliography

The authors have each provided a brief bibliography. To assist the reader interested in pursuing a particular topic these bibliographies are listed below under essay title. The author of the catalogue entries has consulted many of the publications listed in the bibliographies for essays one and four, but to avoid unnecessary duplication has not repeated a mention of these publications in the bibliography for the catalogue.

1. French Painting 1830–1930: An Historical Context – Belinda Thomson

This is a selected reading list of works that provide useful introductions to French art of the period. Further suggestions for reading, including studies on individual artists, can be found within the bibliographies of these general works.

S. Adams, *The Barbizon School and the Origins of Impressionism*, London, 1994

R. and C. Brettell, *Painters and Peasants in the Nineteenth Century*, Geneva, 1983 (deals with the burgeoning of rural painting in nineteenth-century France)

A. Callen, *The Art of Impressionism: Painting Technique and the Making of Modernity*, New Haven and London, 2001

D. Cottington, *Cubism*, London, 1998

C. Green, *Cubism and its Enemies: Modern Movements and Reaction in French Art, 1916–1928*, New Haven and London, 1987

R. L. Herbert, *Impressionism. Art, Leisure and Parisian Society*, New Haven and London, 1988

M. Jacobs, *The Good and Simple Life: Artists' Colonies in Europe and America*, London, 1985

P. Mainardi, *The End of the Salon: Art and State in the Early Third Republic*, Cambridge and New York, 1993

J. Rewald, *The History of Impressionism*, New York, 1973

J. Rewald, *Post-Impressionism: From Van Gogh to Gauguin*, New York, 1956, revised ed. 1978 (these remain the classic and detailed accounts of Impressionism and Post-Impressionism)

R. Rosenblum and H. Janson, *Art of the Nineteenth Century, Painting and Sculpture*, London, 1984 (on styles and themes in the art of the nineteenth century as a whole)

B. Thomson, *Impressionism, Origins, Practice, Reception*, London and New York, 2000

B. Thomson, *The Post-Impressionists*, Oxford and New York, 1990 (first published 1983)

J. and L. Whiteley, 'The Institutions of French Art, 1648–1900' in *Tradition and Revolution in French Art 1700–1880, Paintings and Drawings from Lille*, The National Gallery, London, 1993 (a useful overview of the changing patterns of patronage in France during this period)

See also the following exhibition catalogues:

J. Freeman et al. *The Fauve Landscape*, Los Angeles, New York and London, 1990–91

J. House, *Impressionism for England: Samuel Courtauld as Patron and Collector*, Courtauld Institute Galleries, 1994 (deals with patterns in the collecting of French painting in Britain)

J. House, *Landscapes of France: Impressionism and its Rivals*, London and Boston, 1995

J. Leighton and R. Thomson, *Seurat and the Bathers*, London, 1997

H. Loyrette and G. Tinterow, *Origins of Impressionism*, Paris and New York, 1994

H. Sturges, et al. *Jules Breton and the French Rural Tradition*, Nebraska, 1983

C. S. Moffett, et al. *The New Painting: Impressionism, 1874–1886*, San Francisco and Washington D. C. 1986

R. Thomson, *From Monet to Matisse: Landscape Painting in France 1874–1914*, Edinburgh, 1994

S. and W. Johnston, *The Triumph of French Painting: Masterpieces from Ingres to Matisse*, Baltimore and London, 2001 (deals with patterns of collecting French art in America)

2. Glasgow, 1860–1914: Portrait of a City – Irene Maver

Pre-1914

Sir J. Bell and J. Paton, *Glasgow, Its Municipal Organisation and Administration*, Glasgow, 1896

J. Blackie, jnr. *The City Improvement Act: A Letter to the Lord Provost of Glasgow*, 1866

D. Defoe, *A Tour Through the Whole Island of Great Britain*, London, 1724–26 and 1971

J. Denholm, *The History of the City of Glasgow and Suburbs*, Glasgow, 1804

R. Gillespie, *Glasgow and the Clyde*, Glasgow, 1876

Glasgow City Archives DTC 14.2.2, *Notes on Personal Observations and Inquiries in June, 1866, on the City Improvements of Paris, etc: with Appendix*, (privately printed municipal report)

Glasgow Corporation, *Municipal Glasgow: Its Evolution and Enterprises*, Glasgow, 1914

J. A. Hammerton, *Sketches from Glasgow*, Glasgow and Edinburgh, 1893

G. Macgregor, *The History of Glasgow: From the Earliest Period to the Present Time*, Glasgow, 1881

J. McUre, *A View of the City of Glasgow*, Glasgow, 1736 and 1830

J. Hamilton Muir, *Glasgow in 1901*, Glasgow and Edinburgh, 1901

J. Paton, 'An art museum: its structural requirements', in *Proceedings of the Philosophical Society of Glasgow*, vol.XXII (1890–91), pp.128–38

A. Shaw, *Municipal Government in Great Britain*, New York, 1895

Sir J. Sinclair, *The Statistical Account of Scotland, 1791–1799: Volume VII, Lanarkshire and Renfrewshire*, Wakefield, 1799 and 1973

Stratten and Stratten, *Glasgow and its Environs: A Literary, Commercial and Social Review Past and Present, with a Description of its Leading Mercantile Houses and Commercial Enterprises*, London, 1891

W. West Watson, *Report Upon the Vital, Social and Economic Statistics of Glasgow for 1878*, Glasgow, 1879

Post-1914

B. Aspinwall, *Portable Utopia: Glasgow and the United States, 1820–1920*, Aberdeen, 1984

J. J. Bell, *I Remember*, Edinburgh, 1932

M. Burgess, *Imagine a City: Glasgow in Fiction*, Glendaruel, 1998

J. Burkhauser et al. *Glasgow Girls: Women in Art and Design, 1880–1920*, Edinburgh, 1990

S. G. Checkland, *The Upas Tree: Glasgow, 1875–1975*, Glasgow, 1976

T. M. Devine, *The Tobacco Lords: A Study of the Tobacco Merchants of Glasgow and their Trading Activities, c.1740–1790*, Edinburgh, 1975 and 1990

T. M. Devine and G. Jackson, (eds), *Glasgow, Volume I: Beginnings to 1830*, Manchester, 1995

J. Fisher, *The Glasgow Encyclopedia*, Edinburgh and London, 1994

W. Fraser and I. Maver, (eds), *Glasgow, Volume II: 1830 to 1912*, Manchester, 1996

A. Gibb, *Glasgow, The Making of a City*, London, 1983

W. Kaplan (ed.), *Charles Rennie Mackintosh*, New York, 1996

P. and J. Kinchin, *Glasgow's Great Exhibitions*,

1888, 1901, 1938, 1988, Wendlebury, 1988

P. Kinchin, *Tea and Taste: the Glasgow Tea Rooms, 1875–1975*, Wendlebury, 1991

E. King, *Scotland Sober and Free: the Temperance Movement, 1829–1979*, Glasgow, 1979

E. King, *The Hidden History of Glasgow's Women: the Thenew Factor*, Edinburgh and London, 1993

Sir T. Lipton, *Leaves from the Lipton Logs*, London, 1931

J. F. McCaffrey, *Scotland in the Nineteenth Century*, Basingstoke, 1998

G. McCrone, *Wax Fruit*, London, 1947

I. Maver, *Glasgow*, Edinburgh, 2000

N. Munro, *The Brave Days: A Chronicle from the North*, Edinburgh, 1931

B. Peter, *100 Years of Glasgow's Amazing Cinemas*, Edinburgh, 1996

P. Reed (ed), *Glasgow, the Forming of the City*, Edinburgh, 1993 and 1999

J. Riddell, *The Clyde: the Making of a River*, Edinburgh, 2000

E. Robertson, *Glasgow's Doctor: James Burn Russell, 1837–1904*, East Linton, 1998

G. Stamp and S. McKinstry (eds), *'Greek' Thomson*, Edinburgh, 1994 and 1999

G. Urquhart, *Along Great Western Road: An Illustrated History of Glasgow's West End*, Ochiltree, 2000

E. Williams, A. Riches and M. Higgs, *The Buildings of Scotland*, Glasgow and London, 1990

3. A Short History of Kelvingrove and Its Collection of French Art – Hugh Stevenson

Annual Reports of City Industrial Museum, Corporation Galleries of Art, Museums and Galleries of Glasgow 1876–1917, 1925, 1942/3–1971

J. C. Robinson, *Report on the Art Collections*, Glasgow, 1882

Glasgow Corporation Galleries of Art *Registers* (2 volumes, 1855 to present). *Sculpture Register* (1855 to present)

J. Hunter Dickson and J. Paton, *The Present Position of the Museum and Art Galleries of Glasgow*, read before the Philosophical Society, Glasgow, 1886

J. Paton, *An Art Museum, its Structural Requirements*, read before the Philosophical Society, Glasgow, 1891

Glasgow Art Galleries and Museums *Press Cuttings Books*, 1901 to date

Glasgow Art Gallery and Museums Association, Friends of Glasgow Art Galleries and Museums, *Calendar of Events and Friends Preview*, (bi-monthly/quarterly, 1944 to present)

T. J. Honeyman, *Art and Audacity*, Glasgow, 1971

Jack Webster, *From Dali to Burrell: the Tom Honeyman Story*, Edinburgh, 1997

4. West of Scotland Collectors of Nineteenth-Century French Art – Frances Fowle

For further reading on individual collectors and dealers, see bibliographies in Appendices 3 and 4.

Atelier Eugène Boudin. Catalogue des tableaux, pastels, aquarelles et dessins, dont la vente après aura lieu . . . les 20 et 21 mars 1899, Hôtel Drouot, Paris. Preface by Arsène Alexandre

C. Carter, 'Alexander Macdonald 1837–1884 – Aberdeen Art Collector', *Scottish Art Review*, vol.V, n.3, 1955, pp.23–8

C. Carter, 'Art Patronage in Scotland: John Forbes White', *Scottish Art Review*, vol.VI, n.2, 1957, pp.27–30

Catalogue of the Collection of Pictures of the British, French & Dutch Schools Belonging to John Reid, with Notes by James L. Caw, Glasgow, 1913

Catalogue of Pictures and Drawings being the entire collection of the late W.A. Coats Esq., Wm B. Paterson, 5 Old Bond Street, London W1, January 1927

D. Cooper, *Alex Reid & Lefèvre 1926–1976*, London, 1976

F. Fowle, 'The Hague School and the Scots – A Taste for Dutch pictures', *Apollo*, August 1991, pp.108–11

F. Fowle, 'Impressionism in Scotland: an acquired taste', *Apollo*, December 1992

F. Fowle, 'Alexander Reid in Context: Collecting and Dealing in Scotland in the late nineteenth and early twentieth centuries', unpublished PhD thesis, University of Edinburgh, 1994

F. Fowle, 'Alexander Reid: the Influential Dealer', *Journal of the Scottish Society for Art History*, vol.2, 1997, pp.24–35

F. Fowle, 'Vincent's Scottish Twin – The Glasgow Art Dealer Alexander Reid', *Van Gogh Museum Journal 2000*, pp.91–9

E. Gallie, 'Archibald McLellan', *Scottish Art Review*, vol.V, n.1, 1954, pp.7–12

B. Gould, *Two Van Gogh Contacts – E.J. van Wisselingh, art dealer; Daniel Cottier, glass painter and decorator*, Bedford Park, 1969

E. G. Halton, 'The Collection of James Staats Forbes', *The Studio*, vol.36, n.153, December 15, 1905, pp.30–47 ('The Barbizon Pictures') and pp.218–32 ('Third and Concluding Article')

E. G. Halton, 'The Collection of Mr Alexander Young', *The Studio*, vol.39, I – The Corots, pp.2–21; II – The Daubignys, pp.99–118; III – Some Barbizon Pictures, pp.192–210; IV – Modern Dutch Pictures, pp.288–306

V. Hamilton, *Boudin at Trouville*, London, 1992

I. M. Harrower, *John Forbes White*, Edinburgh and London, 1918

I. M. Harrower, 'Joseph Israëls and his Aberdeen Friend', *Aberdeen University Review*, vol.XIV, 1927, pp.108–22

W. E. Henley, 'Daniel Cottier 1838–1891' in *Catalogue of ancient and modern Pictures . . . (Sale of Pictures of the late Mr. Cottier of London)*, Paris (Galleries Durand-Ruel) 27–8 May 1892, pp.IX–XIII

Sarah Herring, 'The National Gallery and the collecting of Barbizon paintings in the early twentieth century', *Journal of the History of Collections*, vol.13, n.1, 2001, pp.77–89

T. J. Honeyman, *Patronage and Prejudice*, W.A. Cargill Memorial Lecture in Fine Art, University of Glasgow, 1968

Arthur Kay, *Treasure Trove in Art*, Edinburgh, 1939

D. S. Macleod, *Art and the Victorian Middle Class: Money and the making of cultural identity*, Cambridge, 1996

Jennifer Melville, 'Art and Patronage in Aberdeen, 1860–1920', *Journal of the Scottish Society for Art History*, vol.3, 1998, pp.16–23

Jennifer Melville, 'John Forbes White and George Reid: Artists and Patrons in North-East Scotland', unpublished PhD thesis, University of Edinburgh, 2001

Memoirs and Portraits of One Hundred Glasgow Men, vol.II, Glasgow, 1886

R. Pickvance, 'L'Absinthe in England', *Apollo*, vol.LXXVII, n.15, May 1963, pp.395–8

R. Pickvance, *A Man of Influence: Alex Reid (1854–1928)*, Scottish Arts Council Exhibition, Edinburgh, 1967

R. Pickvance, 'Daumier in Scotland', *Scottish Art Review*, vol.XII, n.1, 1969

G. Reitlinger, *The Economics of Taste: The Rise and Fall of Picture Prices 1760–1960*, vol.III, London, 1970

D. C. Thomson, *The Barbizon School*, London, 1891

R. Walker, 'Private collections in Glasgow and the west of Scotland – Mr Andrew Maxwell's collection', *Magazine of Art*, 1894, pp.221–7

R. Walker, 'Private collections in Glasgow and the west of Scotland – Mr A. J. Kirkpatrick's Collection', *Magazine of Art*, 1895, pp.41–7

W. T. Whitley, ed., 'The Art Reminiscences of David Croal Thomson', vol.1, unpublished text, Barbizon House, 1931

5. Catalogue

The sources consulted in the preparation of the short essays on each painting in the catalogue are largely to be found in the literature and exhibition sections in the summary catalogue entries in **Appendix I**.

In addition the author has made use of the following exhibition catalogues in which Glasgow's paintings were not included but in which important essays can be found. These catalogues are arranged alphabetically by artist and, within each artist, chronologically:

Emile Bernard, London and Amsterdam, 1989–90, (in particular the essay by MaryAnne Stevens)

Bonnard, Edinburgh, 1948 (with an introductory essay by Clive Bell)

Bonnard, New York and Cleveland, 1948 (with an introductory essay by John Rewald)

Bonnard, New York, 1964, (with essays by James Thrall Soby, Monroe Wheeler and James Elliott)

Bonnard, London, 1966 (with an introductory essay by Denys Sutton)

Bonnard, Tate, 1998

Braque, New York, 1988 (with essays by Jean Leymarie, Carla Schulz-Hoffmann and Magdalena M. Moeller)

Camoin, Marseille, 1966 (with an introductory essay by Marielle Latour)

Dufy, San Francisco and Los Angeles, (with an essay by Jean Cassou)

Dufy, Wildenstein, 1975

Le Sidaner, Paris, 1989

Le Sidaner, Liege, Carcassone, Limoux-Laren, 1996–97

Albert Marquet, Peintre Français, Montréal, Québec and Ottawa, 1964

Albert Marquet (1875–1947) Plages et Ports, Sete, 1992

Rouault, Edinburgh, 1966 (with an introductory essay by John Russell)

The following were also of assistance:

G. Besson, *Marquet*, Paris, 1929

R. Brielle, *Othon Friesz*, Paris, 1930

J. Cartwright, *Jean François Millet, his Life and Letters*, London and New York, 1902

J. Couper, *Stanislas Lépine (1835–1892), sa vie, son oeuvre*, Paris, 1969

E. des Courières, *Armand Guillaumin*, Paris, 1924

P. Courthion, *Georges Rouault*, London, 1962

M. Gauthier, *Othon Friesz*, Geneva, 1957

Frederic Henriet, 'Le Sidaner', *The Studio*, June 1909

T. Hilton, *Picasso*, London, 1975

Gérard Jean-Aubry, *Eugène Boudin. La vie et l'oeuvre d'après les lettres et les documents inédits*, Paris, 1922

Richard Kendall, *Monet by Himself*, London, 1989

Gilbert de Knyff, *Eugène Boudin, raconté par lui-même, sa vie – son atelier- son oeuvre*, Paris, 1976

J. Lindsay, *Gustave Courbet, His Life and Art*, London, 1973

M. Marquet and F. Daulte, *Marquet, vie et oeuvre*, Lausanne, 1953

C. Mauclair, *Le Sidaner*, Paris, 1928

Sophie Monneret, *L'Impressionnisme et son Époque*, 2 vols. Paris, 1978 and 1980

André Parinaud, *Artists and Their Schools, Barbizon, The Origins of Impressionism*, Bonfini Press, 1994

Dora Perez-Tibi, *Raoul Dufy*, New York, 1989

R. Rey, *Vlaminck*, London, 1957

J. H. Rubin, *Courbet*, London, 1997

A. Salmon, *Emile-Othon Friesz et son oeuvre*, Paris, 1920

J. Selz, *Vlaminck*, undated

A. Sensier, *Étude sur Georges Michel*, Paris, 1873

R. Shone, *Sisley*, London, 1992

V. Spate, *The Colour of Time: Claude Monet*, London, 1992

M. Vlaminck, *Dangerous Corner*, London, 1961

C. Zervos, *Raoul Dufy*, Paris, 1928

LIST OF CONTRIBUTORS

FRANCES FOWLE

Frances Fowle is Leverhulme Research Fellow at the National Gallery of Scotland, Honorary Research Fellow in the Department of Fine Art, University of Edinburgh and is a Trustee of Sir William Burrell's Trust. Her Ph.D., was on the Glasgow dealer Alexander Reid and she has published numerous articles on dealing and collecting in Scotland in the late nineteenth and early twentieth centuries.

VIVIEN HAMILTON

Vivien Hamilton is Curator of International Art and Design, 1800–1950, Glasgow Museums, with particular responsibility for the collection of French and Dutch nineteenth- and early twentieth-century art in the Art Gallery and Museum, Kelvingrove and in The Burrell Collection. She has curated and co-ordinated numerous exhibitions including *The Birth of Impressionism* (1997). Previous publications include the monographs *Joseph Crawhall 1861–1914, One of the Glasgow Boys* (1990); *Boudin at Trouville* (1992), and the catalogue for an exhibition that toured Japan in 1994, *Masterpieces of French Painting from Glasgow Museums*. She also lectures regularly in the Department of the History of Art in the University of Glasgow.

IRENE MAVER

Irene Maver is a Senior Lecturer in Scottish History at the University of Glasgow. Her research interests focus on urban Scotland, particularly the history of Glasgow. With Professor Hamish Fraser of Strathclyde University she co-edited *Glasgow, Volume II: 1830 to 1914* (Manchester University Press, 1996) and wrote a single-volume history, *Glasgow* (Edinburgh University Press, 2000). She is currently researching and writing an illustrated history of Edinburgh for Edinburgh University Press.

MARK O'NEILL

Mark O'Neill has worked in Glasgow Museums since 1990, first as Keeper of Social History, and since 1998 as Head of Service. He has written and lectured extensively on developing new audiences for museums.

HUGH STEVENSON

Hugh Stevenson joined the Art Department of Glasgow Museums in 1971. His duties have ranged widely over the collections, with periods spent researching and arranging displays and exhibitions of Dutch and British art, Renaissance bronzes, local topographical views, sculpture and prints, drawings and watercolours. He has developed a particular interest in the architecture and history of the Art Gallery and Museum building at Kelvingrove and the large international exhibitions connected with it.

BELINDA THOMSON

Belinda Thomson is Honorary Fellow in the Department of Fine Art, University of Edinburgh. As a freelance author and lecturer specialising in French art of the late nineteenth and early twentieth centuries, her publications include general works on the Impressionist and Post-Impressionist movements and monographic studies on Gauguin, Vuillard and Van Gogh. Currently cataloguing a collection of Nabi painting, she curated the South Bank Centre's *Vuillard* exhibition, which opened at Kelvingrove, Glasgow in 1991.

ROSEMARY WATT

Rosemary Watt joined Glasgow Museums Department of Decorative Art in 1975, and has held a number of posts, including Keeper of The Burrell Collection. She is currently Curator, European Art and Design, 1670 to present day, with a particular interest in base and precious metals, and in contemporary crafts and product design.

Index

PHOTOGRAPHIC ACKNOWLEDGEMENTS

We are grateful to the following people and institutions for permission to reproduce their works: ill. 2: Musée Marmottan, Paris, France/Giraudon/Bridgeman Art Library; ills. 3, 52 and cat.36.1: The Courtauld Institute Gallery, Somerset House, London; ill. 4: Helen Birch Bartlett Memorial Collection, 1926.222, The Art Institute of Chicago; ill. 6: © Photo RMN – Pascale Néri; ill. 7: © Photo RMN; ill. 9: Joseph Winterbottom Collection, 1954.326, The Art Institute of Chicago; ills. 17,19,20,21,29, 42 and 68: Annan Gallery, Glasgow (www.annangallery.co.uk); ill. 46: Philadelphia Museum of Art: The Mr. and Mrs. Carroll S. Tyson, Jr. Collection; ill. 47: The Metropolitan Museum of Art, H. O. Havemeyer Collection, Bequest of Mrs. H. O. Havemeyer, 1929. (29.100.38) Photograph ©1987 The Metropolitan Museum of Art; ill. 48: © Photo RMN – H. Lewandowski; ill. 49: Sterling and Francine Clark Art Institute, Williamstown, Massachusetts, USA; ill. 54: Collection of Mr. and Mrs. Paul Mellon, Photograph © 2002 Board of Trustees, National Gallery of Art, Washington; cat.27.1: Photothèque des Musées de la Ville de Paris; cat. 28.1: Collection Fred Jones Jr. Museum of Art, the University of Oklahoma, Aaron M. and Clara Weitzenhoffer Bequest, 2000; cat. 52.1: © Photo RMN – Hervé Lewandowski.

The paintings by Emile Bernard (cat.2), Pierre Bonnard (cat.3), Georges Braque (cat.7), Charles Camoin (cat.9), André Derain (cat.19), Raoul Dufy (cat.21), Othon Friesz (cat.25), Henri Le Sidaner (cat.32), Louis Marcoussis (cat.34), Albert Marquet (cat.35), Georges Rouault (cat.49), Paul Signac (cats. 27.1,54 and 55), Maurice Utrillo (cat.58), Maurice de Vlaminck (cat.59) and Edouard Vuillard (ill.51 and cats. 61, 62, 63 and 64) are all copyright © ADAGP; the works by Henri Matisse (cats. 36, 36.1 and 37) are © Succession Matisse, DACS; and the painting by Pablo Picasso (cat.43) is © Picasso Administration, DACS.

The print by D. Muirhead Bone (ill.16) is © The artist's estate; the painting by John Lavery (ill.22) is ©The Trustees of the Lavery Estate; the photograph (ill.31) is © The Scotsman Publications.